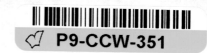
More Praise for
Starting Your Career as an Artist

"Who says there is no clear path to becoming a successful artist? *Starting Your Career as an Artist* is an invaluable resource that demystifies the steps artists should take when starting out. Elegantly and straightforwardly written, Angie Wojak and Stacy Miller have left nothing out—goal setting, the myriad options for exhibiting work, effective networking, legal and safety issues, fundraising, earning income, and so much more. Along with an impressive group of top art world contributors, this book provides information and resources that can help any artist start or maintain a successful practice. This effective career planning guide will be highly recommended to the students and alumni I work with."

—Laura Daroca,
Director of Career Services,
Otis College of Art and Design

"An inspiring and empowering resource for emerging artists. Angie Wojak and Stacy Miller have dispelled the myth of the lonely, suffering artist who is waiting to be discovered, once and for all. From setting up and maintaining a studio practice to career planning and job search, they present strategies for artists across disciplines to develop and sustain fulfilling careers and be successful on their own terms."

—Katharine Schutta,
Assistant Dean and Director of Career Services,
School of the Art Institute of Chicago

Starting
Your Career
as an
Artist

ANGIE WOJAK
AND
STACY MILLER

Starting
Your Career
as an
Artist

A Guide for
Painters, Sculptors, Photographers,
and Other Visual Artists

ALLWORTH PRESS
NEW YORK

© 2011 by Angie Wojak and Stacy Miller

Allworth Press books may be purchased in bulk at special discounts for sales promotion, corporate gifts, fundraising, or educational purposes. Special editions can also be created to specifications. For details, contact the Special Sales Department, Allworth Press, 307 West 36th Street, 11th Floor, New York, NY 10018 or info@skyhorsepublishing.com.

15 14 13 12 11 5 4 3 2 1

Published by Allworth Press, Inc.
an imprint of Skyhorse Publishing, Inc.
307 West 36th Street, 11th Floor, New York, NY 10018.

Allworth Press® is a registered trademark of Skyhorse Publishing, Inc.®, a Delaware corporation.

www.allworth.com

Cover concept by Stephen Viksjo
Cover design by Mary Belibasakis

ISBN: 978-1-58115-853-3

Library of Congress Cataloging-in-Publication Data
Wojak, Angie.
Starting your career as an artist / by Angie Wojak and Stacy Miller.
 p. cm.
Includes bibliographical references and index.
ISBN 978-1-58115-853-3 (alk. paper)
1. Art--Vocational guidance--United States. I. Miller, Stacy. II. Title.
N6505.W644 2011
702.3--dc22
 2011011628

Printed in the United States of America

Dedicated

with love

to the memory of

Kevin Massey

and to our wonderful husbands,

Scott Seaboldt

and Joe Wojak

Acknowledgments

W e wish to express our deep appreciation to the artists, career counselors, colleagues, educators, entrepreneurs, family, friends, and gallerists who supported our work and generously gave us their time in the process of researching and writing this book. We would like to thank them for their ideas and enthusiasm, but mostly for their inspiration and shared desire to help guide the careers and lives of emerging artists.

We want thank our husbands, Scott Seaboldt and Joe Wojak, for their love and support throughout this process. Your patience, technical expertise, and encouragement made this book possible!

Our deepest appreciation goes to Don Porcaro, an artist and a gentleman, for his early and steadfast support of this book and the generous time he gave us.

Thank you to Melissa Potter, for being a real role model, a woman of courage and perseverance, who even in a time of great challenge, gave generously of her time and expertise.

We cannot thank the Guerrilla Girls and Kathe Kollwitz enough for their inspiration, words of wisdom, encouragement, and for sharing their story, all of which played an essential part in the early stages of this project.

Thanks to Alexander Kohst for inspiring us to look outside the box for ways in which artists can truly live a life in the arts and for showing us that success is not about financial rewards alone.

We are grateful to Ted Berger, who continues to push us to think in new and different ways about our field with unceasing clarity and rigor.

For their guidance and support, we are grateful to Tad Crawford and Bob Porter.

We want to express our gratitude to the following people who said "YES" without hesitation to our request for their words of wisdom, which were invaluable in the writing of this book:

Tim Gunn, Claudine K. Brown, Thomas Wojak, Marsha Tonkins, Jean Mitsunaga, Misty L. Youmans, Jennifer Phillips, Robert Thill, Nate Fredenburg,

Dennis Kaiser, Jeff Elliott, Jessica Murphy, Helene Lauer, Asha De Costa, Bill Barrett, Jason Goodman, Jerry Saltz, James Ramer, Simone Douglas, Craig Nutt, Carol Warner, David Terry, Kat Griefen, Sue Schear, Alyson Pou, Elizabeth Heskin, Erin Berkery, Angela Tsuei-Strause, Rod Berg, Brynna Tucker, Judy Nylen, Sharon M. Louden, Alexi Rutsch, Maryellen Schroeder, Olivia Martinez-Stewart, Monona Rossol, Laura Daroca, Radhika Subramaniam, Angela Ringo, Erin Donnelly, Carol Overby, Rhonda Schaller, Kay Takeda, Mia Villanueva, Pam Klein, Andrew Horton and Kate Evanishyn, Steve Viksjo, Angela Yeh, Jann Nunn, Noah Davis, Lester and Charlene Pannell, Troy Pannell, Eric Pannell, Alva Hazell, and all of our AICAD Career Services colleagues!

Contents

PART III: SETTING UP AND MAINTAINING A STUDIO PRACTICE

PART IV: CAREER PLANNING AND JOB SEARCH

Self-Assessment and Developing a Career Plan

☙ 1 ❧

Myths about Artists

There are many preconceived notions and myths of what it is to be an artist. These ideas, which have grown into well-established myths, can inspire emerging artists, but they can also create psychological roadblocks that prevent you from taking charge of your career. In the following section, consider which myths apply to you and how these ideas may be stopping you from taking action to improve your creative life. All artists at one time or another in their careers grapple with these myths, and we all have aspects of these legends residing inside us to varying degrees. We are interested in the aspect of the myth that keeps you from moving forward and accomplishing your goals.

In this chapter, we invite you to take some time and explore artists' myths we've identified, each with both positive and negative ramifications. We've also included some counterpoints, which may help you to adjust any negative mindset you may have regarding your life as an artist.

Myth #1: Artists need to suffer to make good art.

This is one of the most common and enduring of all myths about artists: that of the romantic, idealistic, isolated, starving artist on a mission to make great art. The idea is that the artist is pure, concerned only with the creation of his or her art.

The positive side: This myth gives you an ideal to aspire to. It's who you are at the core and speaks to the transcendent nature of your work. It gives you meaning and guides you on a path to creativity. You feel connected with the great artists in the history of the aesthetic tradition. It gives you reason to live and to work every day in the studio.

The negative side: Adhering to this myth can isolate you. Nothing is ever good enough for you to engage in because it may tarnish your artistic integrity. It can make you feel like any activity other than your work amounts to selling out to the system. Financial concerns are at the bottom of your life goals or list of priorities because money is tainted with a sense of compromise, and it will negatively affect the quality of your work. The system is corrupt, and the art world is a machine that will consume you.

Adjusting your mind-set: Artists need to make money from their work in order to support the creation of more art. The minute you sell a piece of artwork, you are in business for yourself. It is counterproductive to assume that your art will lack authenticity just because you earn income from your work.

Myth #2: Artists are loners.

A common myth is that artists must always work alone. This isolationist myth is rooted in the need for control and can be used to promote the idea that artists can't be a part of a community because their ideas will be stolen. It also evokes an image of the starving artist, working alone in a cold-water garret (see Myth #1).

The positive side: You get a lot of work done if you adhere to this myth. It allows you to concentrate and maintain complete control of your surroundings and your environment.

The negative side: Isolation and control go hand in hand with a lack of community and social network. Isolation can be alienating, numbing, and may lead you to disengage from the outside world. Taken to the extreme, it is physically and emotionally unhealthy.

Adjusting your mind-set: The legendary personas of famous artists promote this myth: Pollock, the rebel artist, secluded himself to paint (and drink); Paul Gauguin lived on an isolated Tahitian island to get back in touch with nature in order to paint. But if you scratch the surface of these artists (and many more), it's a much more complicated picture. Yes, they struggled, but they always remained connected to a community for the sake of their art itself: Pollock never stopped promoting his work, and Gauguin was a brand unto himself. The "back to nature artist," writing letters to his dealer to sell his paintings, is part and parcel of this myth. Innovation rarely comes through isolation, and ideas need community and dialogue in order to be developed and refined.

Myth #3: Artists are victims who need to be rescued.

This myth also relates to the idea that an artist's talent and work should speak for itself.

The positive side: Artists find this appealing because they can avoid taking responsibility for the myriad problems posed by everyday life and financial necessities.

The negative side: This myth encourages a passive attitude toward your career and does a disservice to emerging artists, who may not yet have the tools to be self-reliant or the strategies to succeed on their own terms.

Adjusting your mind-set: The fantasy that someone else will rescue you can keep you from developing the basic business skills needed to support your life, art, and can prevent you from building a community necessary to helping you succeed on your own terms. You need to actively stay involved in your work, no matter where or how you choose to show. Take control of your life!

Myth #4: Artists don't have to deal with business or money in order to succeed.

A common misconception is that artists shouldn't have to concern themselves with the financial side of art. Some artists think that their art will lose its integrity

or that they are somehow inauthentic if they take responsibility for their finances. Real artists don't make art to put over the couch.

The positive side: You're focused on your work, temporarily freed from the anxiety of dealing with finances and the future.

The negative side: You don't have the money to fund your art. You can't afford studio space or materials. Projects may go undone. In the long run, is this kind of anxiety worth it?

Adjusting your mind-set: Think of money as fueling, funding, and supporting your art. Financial security gives you the energy to do your work and the stability to grow your art practice. Distractions stemming from lack of financial security can be worse than giving up a day in the studio to focus on these concerns.

Myth #5: Artists are discovered.

This myth presumes that talent inevitably leads to discovery, which inevitably results in fame and fortune.

The positive side: The dream or fantasy of recognition, fame, loving fans, money, status, and your work in important collections motivates and encourages you. It keeps you in a state of exhilarated anticipation.

The negative side: Unfortunately, talent does not guarantee fame and recognition. Furthermore, fame presents as many problems as it may solve: the pressure to produce a large body of work for a gallery, overexposure, lack of privacy, unrealistic timelines for publicity, everyone wanting a piece of action, time spent chasing the markets or new trends, unrealistic expectations of money management, and showing work too soon. It's a high-energy environment and it can lead to burnout.

Adjusting your mind-set: Fame is a complicated concept to manage. Just because you are known or have some aspects of market success doesn't mean you'll make lots of money. The reality is that few artists become famous enough to support themselves by their work alone. The untold story is that even artists who seem relatively successful are often not just making money from their art. They still have their day jobs! It takes time to mature and build a coherent body of work, to create a unique vision and then get the recognition it deserves.

Myth #6: Teaching is an easy way to support my art.

Many artists assume that when they get out of school, they will teach. It is assumed that teaching is not that difficult, that there are summers off, and that it's easy to get a job. Artists assume that an MFA automatically leads to a tenure-track position and that there will be plenty of time to be in the studio. It's considered a soft job that pays the bills.

The positive side: Teaching can be highly rewarding, often involving working in a community of like-minded people who are interested in the same things you are. You do make a living wage if you work full-time, and you have the security of benefits. Your teaching can feed your art and vice versa. There is a certain order and structure to the academic environment, to which many people respond positively. Schools also provide a built-in community for support and networking, as well as access to equipment, materials, and sometimes space.

The negative side: It is difficult to do your own studio work because you have chosen to have two careers, not one. In higher education, you must keep up a vigorous showing schedule as well as teach. These jobs are competitive, and it is becoming increasingly difficult to get tenure-track positions. Often, artists become adjunct or part-time faculty, with no health insurance or benefits and no guarantee of courses to teach.

Adjusting your mind-set: Teaching can be a great career choice if you have the right personality and skill set. Extra management abilities, people skills, and a love for your material will go a long way in maintaining the balance you need for this profession. Ultimately, you are helping people learn, you yourself are learning, and you can make an impact on someone's life. If you want to teach, weigh the options carefully and make an informed decision.

Myth #7: Artists shouldn't ask for what they want.

This fear of failure and success is a pervasive mind-set that many artists carry with them, consciously or subconsciously: "I'll never make it, so why bother trying at all?" Fear of failure and its associated insecurities can make any artists feel that they will never be ready to show their work.

The positive side: You stay in your comfort zone and keep to the status quo. You aren't succeeding, but neither are you failing outright. You don't have to take risks. You get to maintain a kind of equilibrium.

The negative side: You are going nowhere fast, and you are missing opportunities by never trying. By not being open to commentary, your work may develop at a slower pace. Your confidence can erode with this kind of isolation.

Adjusting your mind-set: Without failure, there is no success. Failure gives you valuable information about what you need to do differently next time in order to succeed. Focus on the process that allows you to do your work. Be open to taking risks.

Myth #8: Artists can only truly make it in New York or Los Angeles.

Many artists believe they can only succeed if they go to New York or Los Angeles, where they think all the famous artists and important galleries are located.

The positive side: You get to think, "When I go to New York, I'll really start my art career." The idea of a concrete destination can motivate you to pursue your artistic goals, driving your career and inspiring your work.

The negative side: This myth narrows your field of vision to one option. You may be passing up wonderful opportunities right where you live in favor of an uncertain future in a competitive environment.

Adjusting your mind-set: While it is true that New York and Los Angeles have a number of important galleries and artists, there are also many centers of artistic activity all around the country and the world. Technology is making it easier for artists to connect and develop new and innovative ways to show their work. Don't be tied to one place in order to create a successful creative working life.

By discussing these myths, we want to help you become more self-aware, to encourage you to believe that you determine your own fate and can take

charge of your career now. We encourage you to replace these myths with positive concepts. You are in charge of your own destiny. You can make money to support your art and still be sincere and authentic. You can create a community to support your art practice.

We can think of no greater inspiration for emerging artists than the Guerrilla Girls, who have generously allowed us to share their words of inspiration for young artists. From their extensive experience speaking out for artists, the Guerrilla Girls have been able to combat stereotypes and myths that artists face daily. The following is an excerpt from their 2010 commencement speech, given at the School of the Art Institute of Chicago.

"The Guerrilla Girls' Guide to Behaving Badly (Which You Have to Do Most of the Time in the World as We Know It)."

Be a loser. The world of art and design doesn't have to be an Olympics, where a few win and everyone else is forgotten. Even though the art market and celebrity culture is set up to support the idea of hyper-competition and to make everyone but the stars feel like failures, there's also a world out there of artistic cooperation and collaboration that's not about raging egos. That's the one we joined, and the one you can join, too. Get beyond the outdated assumption that only a handful of you will "make it." Don't all waste your time running after the same few carrots.

Be impatient. Don't wait for a stamp of approval from the system. Don't wait around to be asked to dance. Claim your place. Put on your own shows, create your own companies, and develop your own projects. To steal a phrase from the Dalai Lama, "Be the change you want to see in the world." In other words, be the art world you want to take part in.

Be crazy. Political art that just points to something and says "This is bad" is like preaching to the choir. Try to change people's minds about issues. Do it in an outrageous, unforgettable way. A lot of people in the art and film world didn't believe things were as bad as we said they were, and we brought them around ... with facts, humor, and a little fake fur. Here's a trick we learned: If you can get someone who disagrees with you to laugh at an issue, you have a hook into their brain. Once inside, you have a better chance of changing their minds.

Be anonymous. You'd be surprised what comes out of your mouth when you're wearing a gorilla mask. We started wearing them to protect our careers, but soon realized it was one of the secrets of our success. Anonymous free speech is protected by the First Amendment. So join that long line of anonymous masked avengers, like Robin Hood, Batman, and of course, Wonder Woman.

Be an outsider. Maybe having a secret identity isn't for you. But even if you end up working inside the system, act like an outsider. Look for the understory, the subtext, the overlooked, and the downright unfair; then expose it. We've empowered lots of people inside museums, universities, and film studios to jam their culture and dis their institutions.

Lead a double life. Be a split personality. Be two, three, four, five artists in one body, like me. I'm an artist/activist/writer/graphic designer. Be a hybrid. Hybrids are so green.

Just do one thing. If it works, do another. If it doesn't, try it another way. Over time, we promise you it will all add up to something effective and great. Don't be paralyzed because you can't do it all right away. Just keep on chipping away.

Don't make only FINE art. Make some cheap art that can be owned by everyone, like books and movies can.

Sell out. If people start paying attention to you, don't waste time wondering if you've lost your edge. Take your critique right inside the galleries and institutions to a larger audience. When our work appears at venerable venues like the Venice Biennale, the Tate Modern, or the National Gallery in DC, we get hundreds of letters from people saying they were blown away by our analysis of art and culture.

Give collectors, curators, and museum directors tough love: (Bear with me, this is a long rant.) It's a pity that public art museums have to compete with billionaire art investors to own significant artworks. And then depend on those investors to donate the works! It's outrageous that art by women and artists of color sold at auction bring 10 to 20 percent of the price of art by white males. It's unethical that wealthy art collectors who put lots of money in the art market can then become museum trustees, overseeing museums that in turn validate their investments. What a lousy way to write and preserve our history! If things continue like they're going, a hundred years from now, many museums will be showing only the white male version of art history, with a few tokens thrown in. You need to keep that from happening. Make sure that museums cast a wider net and collect the real story of our culture.

How can you deliver tough love to the art world? Demand ethical standards inside museums. No more insider trading. No more conflicts of interest! No more cookie-cutter collections of Art That Costs the Most. (Eli Broad, do you hear us?) While you're at it, give some tough love to design and architecture, where women and people of color face a crushing glass ceiling. And finally, educators out there, don't teach a history constructed by corrupt institutions. Write your own!

Complain, complain, complain. But be creative about it. Sure we've done 45-feet-high banners and billboards all over the world. But here are some simpler things we've done: Put anti-film industry stickers in movie theater bathrooms, inserted fliers with facts about art world discrimination into books in museum stores, sent anonymous postcards to museum directors. Want more ideas? How about attaching political hangtags to items in clothing stores, putting up street art or billboards across from your office, slapping stickers on fashion magazine covers. You can probably think up a million better ideas than we can.

Use the F-word. Be a feminist. For decades, the majority of art school graduates have been women. Your class is no exception. But after school, when you find a too-small number of women and people of color in your field, especially at the top, then you know there's got to be discrimination—conscious or unconscious—going on. Don't just put up with it; say something. We think it's ridiculous that so many people who believe in the tenets of feminism have been brainwashed by negative stereotypes in the media and society and refuse to call themselves feminists. And guys, that means you, too. Time to man up, whether you're female, male, trans, etc., and speak up for women. Women's rights, civil rights, and gay, lesbian, and trans rights are the great human rights movements of our time. There's still a long way to go.

And last, but not least, be a great ape.

In 1917, Franz Kafka wrote a short story titled "A Report to an Academy," in which an ape spoke about what it was like to be taken into captivity by a bunch of educated, intellectual types. The published story ends with the ape tamed and broken by the stultified academics. But in an earlier draft, Kafka tells a different story. The ape ends his report by instructing other apes *not* to allow themselves to be tamed. He says instead: "Break the bars of your cages, bite a hole through them, squeeze through an opening . . . and ask yourself where do YOU want to go?" Make that your ending, not the tamed and broken one.

Oh . . . And don't forget to have some serious fun along the way!

ꙮ2ꙮ

Assessing Your Goals as an Artist

O ur culture and the media have trained us all to believe that an artist is someone who lives in a major city and exhibits their work in prestigious galleries and museums. But the reality is that there are thousands of practicing artists and only a handful are showing in those venues. There are many ways to have a successful art career outside of the mainstream venues. Where do you fit?

Begin by taking an inventory of what you have accomplished and where you fit in the art world. This book takes the view that if you are an emerging artist, it is essential to think outside the box with regard to your career. Do not limit your focus to gallery and museum exhibitions; rather, look to more accessible alternative venues to share your work with the world.

TAKE AN HONEST INVENTORY

These questions, developed by Melissa Potter, a practicing artist and faculty member at Columbia College Chicago, were designed to help artists in their self-assessment. You have to know where you are and what you're doing now before you can create the next steps in your working life. These questions cover geography, your social network, and your art community, and help you evaluate how your art practice fits into the marketplace.

Where do you live?

– Are you in a major city with a vibrant art scene?

– How many galleries are there where you live?

– Is your type of work going to sell well in your geographic region?

– Where will your work be most successful? Learn to assess *where* you will have a career, where your work will be accepted.

 Example: If you are an artist doing performance art or highly political work, are you living in an area that will support that work, be open and receptive to it? Do you have an audience for your work there?

Who are your contacts?

- What does your current network look like? Do you have mostly fellow artists as your network, or do you need to broaden your network?

- Are your current activities really giving you access to valuable networking, or do you need to reevaluate or expand them?

- Are your contacts valuable in their sphere of influence, and will they really do something for you? You may also have a contact with a high-profile person, but can you really see how they fit into your work/life?

 Example: If you review your contacts and discover you don't know anyone who hosts exhibits (such as a gallery owner or curator), look at your contact list and try to determine if any of those individuals can connect you with a curator or gallerist.

 See chapter 6 for more information on community building and networking.

What is your work's content, and is your work marketable?

- What are the current trends in the art scene, and where does your work fit? Look at the trends by region: for example, in Los Angeles you might find that color, wide-open spaces, and abstraction are popular. Look at trends by region and be diligent in your research; don't depend solely on the Internet. Talk to people; better still, visit the city or region to do the research firsthand.

 Example: Your art may preclude a commercial career if it involves politically radical performance art. If you can't get the kind of gallery representation that you want or are not located in a major city with an active art scene, look for alternative routes to show your work.

USING YOUR INVENTORY

Use this inventory to see what you already have in place and to determine what's missing. Think of this inventory exercise as a map that you are creating to highlight the options you have not considered. Make a list, or make the inventory visual with a collage or drawings in your sketchbook or journal. Keep this list, because we will revisit your inventory at the end of the book.

Succeed on Your Own Terms

In the process of writing this book, we have had the honor and pleasure of talking to many artists at all levels and stages of development. What we have found is that success is really self-defined. We discovered that most artists we talked to defined success as the freedom to do what they wanted to do and to pursue their passion. It is important that you assess your most deeply-held, fundamental values, as they will ultimately drive your practice.

The artists who feel they are most successful have worked hard to position themselves in the right place in the art world, whether it be an artist who earns her living working 24/7 in the studio to succeed in the high-profile, fast-paced gallery

scene, or the artist who chooses to work in an artist-based, community-run gallery and whose income comes from another source other than their artwork. Both are successful artists, with different desires, needs, and goals, who have carved out fulfilling careers. There are hundreds of ways to define your success. We encourage you to think about all of your goals and values to define a career path that is tailor-made for you.

What is success for you? This is your vision of your life based on your values, not the media's idea of what an artist's life should look like. Your success will always be based on your values system. For example, if you value financial success as your primary value, your idea of success may be to create work that will sell in the marketplace. If you value the process over product, you may not want to engage in the commercial gallery system; instead, you may define success as the freedom to collaborate with other artists on work that may not be marketable.

TAKING TIME TO REFLECT ON LIFE AND WORK

As you prepare to assess your career goals, it is important to allow yourself the time to consider your dreams, your biggest hopes for your life and work. This exercise is inspired by *Vanity Fair*'s Proustian questionnaire, which has often been given to highly accomplished, creative professionals. You can imagine that the interview takes place at any point in your career when you are extremely satisfied with your work and your accomplishments, whether that be next week, in five or ten years, or in twenty years.

We suggest you actually conduct this interview with a friend or family member and have them ask you the questions. You can record the answers or take notes to remind you of the most important points that resonate with you.

Please describe your career to us using the following questionnaire:
1. Tell us about your most recent work.
2. Which artist do you most admire and why?
3. Which artist is most overrated and why?
4. What quality do you most admire in another artist?
5. When and where were you happiest?
6. Tell us about where you live, your studio, and your family.
7. Tell us something surprising about you that many of your closest friends/relatives don't know.
8. You've accomplished so much. Where do you see yourself going in the next few years?
9. How would you describe your career?
10. What was a defining moment in your career? What has been your greatest accomplishment?

INTERVIEW WITH JERRY SALTZ, SENIOR ART CRITIC FOR *NEW YORK* MAGAZINE

The following interview with art critic Jerry Saltz will inspire you to think about your values, goals, idea of success, and how you want to live your life.

Jerry Saltz is a senior art critic and a columnist for *New York* magazine. Formerly the senior art critic for *The Village Voice*, Saltz has been nominated for the Pulitzer Prize in Criticism three times. He was the sole advisor for the 1995 Whitney Biennial. Saltz has also served as a visiting critic at the School of Visual Arts, Columbia University, Yale University, the School of the Art Institute of Chicago, and the New York Studio Residency Program. He lives in New York City with his wife, Roberta Smith, senior art critic for the *New York Times*.

How and why did you become an art critic?

Accidentally. I dropped out of art school with no degree. Or I went to art school for a couple of years and then dropped out and stopped making art. I made paintings from Dante's *Inferno* and I got an NEA grant (that's my silly way of saying I could have been a contender). But I loved art and the art world and wanted to be in it. I wanted to be in the art world no matter what. I was possessed by art but was not the kind of artist who had to make art every day. An artist should *need* to do art, no matter what. I was not an art historian either. I was told I did not go to the right art school, was no good at schmoozing, and was not good at making art either. And I listened to the demons and stopped making art.

I moved from New York City to Chicago in my twenties and did a lot. I came to New York and was lost. I ran a gallery and curated seventy-five shows! I started a gallery in Chicago in my twenties, and that should have been my first clue that I wasn't an artist: the fact that I was spending my time doing things other than making art. Then I became a long-distance truck driver, the only Jewish driver on the road then, driving a ten-wheeler transporting art from New York to Texas. I was alone for years driving trucks and I was reading about art. One day I somehow decided that being an art critic would be a great way to be in the art world. And I believe in what my wife, Roberta, says: that the majority of people in the art world are not artists.

How did you train to become an art critic?

I read art criticism. I'd left school, so I didn't have art history background. I started reading *Art Forum* religiously. I couldn't understand a word of it! Then I tried writing just like they did in *Art Forum*. Writing is the worst thing in the world. It takes over your insides, and unlike an artist, you can't listen to music while you work. It's an awful thing that tears you up inside. I taught myself to write. Of course my writing was terrible! I'm a very, very late bloomer. I didn't start to write until my late forties. I spent a long time in self-exile. I believe all people in the art world are to some extent self-trained. Ninety-nine percent of the art world goes to art school, and that's a great place to learn the language and the secret handshakes. Then you must unlearn what you were taught. It's a great place to form a gang, to make tribal connections. We are all beautiful monsters!

I don't do a lot of reading now. I'm an extremely slow reader, and I have no time. I learn by looking. I see thirty to forty shows a week! Bad art teaches me as much as good art. My wife says that you have to get very, very quiet inside when you look at art, and maybe you will hear things you don't want to hear—maybe

you don't like work of a friend, but you do like the work of someone you find annoying.

I've learned by watching Roberta: I don't speak with artists before I write about them. Some critics do. I interact with artists a lot, but not before I review a show.. The artist had his or her say, now the critics have their say. I want to look at the work and then write about what I received from it. There is no right or wrong. You may think your work is about daffodils; I think it's about scrambled eggs. No matter what someone tells you about your work, even if you disagree, there is some truth in their views. The truth is not that it is good or bad. If no one is writing about your work, there is a truth there too, telling you that people are not responding to your work. Maybe you just aren't putting your art out there, or your work is not triggering something in viewers.

The one thing we are all working for is not fame, money, immortality, or love, but credibility—and if you do too much to destroy that credibility, then you have a problem. I will not write on artists I know well, and I don't collect art; that's a conflict. If I do write an article about artists I know well, I make a point of mentioning it. In the last *Village Voice* column I wrote on a good friend, the first thing I said was that he was a friend and that what I was about to write was biased.

All art is new and experimental as far back as cave paintings. When I see a cave painting, it is *new*. All art is experimental art, a statement about what art is supposed to be, by an artist.

How would you define success for an artist?

Young artists ask me if they should show early in their careers. I say, if you want to, just do it! Most artists don't, but it isn't going to ruin you. I don't think it's going to help, either. But try it and see how it feels. It's good practice, and you might get a huge amount out of it. We all want to dance naked in public. We are the driver. Most people's idea of love is to go home and kiss someone they love, hug their dog, watch TV. But we (artists/art critics) want to be loved by everyone, everywhere for the rest of time!

There's nothing wrong with the thirty-month success, the outer life of art. But the real, inner art life, the thirty-year career, is a life *lived* in art. The definition of success is not money, it's not fame, it's not having beautiful lovers. All these things are wonderful, but this is how I define success: time and credibility. Time— you must have time to make your work. Slowly, you can position yourself not to work your day job so you can go from working five days a week to three days a week in order make your art. Teaching is a good way to do this. Credibility—you may not make lots of money and get on the cover of *Frieze* magazine, but you can still have credibility.

In the end, one percent of one percent of one percent of all artists can have careers like Jeff Koons (whom I like), Damien Hirst (whom I don't like), and Takashi Murakami (whom I like). The art world has about eight artists. Markets made us stupid. They made us think that the best art is the most expensive art, and that's not right. Collectors collect art; that's what they do. They see others collect art, so they collect what the others collect. Collecting is a self-replicating organism.

The vast majority of the art world is not sexist or misogynist, but the art world produces a mainly male system year after year. It is a male success machine. They (the art world) don't do it purposely. No one wakes up and says, "I'm not going to buy women's art today." But it is self-perpetuating; more men show because more men have shown. It is built into the system. It's like celebrity's children being instant celebrities. If Madonna's a celebrity, then Lourdes is too. If men are mostly showing, we think all artists must be men.

But that is only half of the story. I want to hear the other half of the story. As a man who was raised by men with no sisters, the great tragedy of my life is that about 50 percent of art made is not being shown, and I won't see it in my lifetime. Even if it's crap, I want to see it! My art world hasn't allowed the other half to speak. I want to know what you (women) think, feel; I want to see your secret lives.

How do you see the art world today?

There is chaos in the land! In 2007, we hit an iceberg, and the art world went into verticality like the *Titanic* going down—because all the people were on the same sinking ship called money.

I'm not saying money is bad—collectors are not bad, and you need money to make art—but where we are now is that the hierarchies of the art world have been severely disrupted. There is a sense of not knowing what is good or bad, so instead of the system being codified, with all male artists showing, there are lots of opportunities in the swamp. There are bubbles of different things coming up everywhere now. This is actually a great time for artists. People have to be brave and do what they want. There is no need to brand, but a need to be consistent and be the best you can be. You do need to be self-critical, you big artist babies! You must find a way to show your work and stop blaming others. You own 50 percent of the responsibility. If you want more people to see your work, then do it! This is a good time to make a community for your self.

May I speak to young critics?

Sure!

We are not dinosaurs, but our environments are doomed. Magazines will disappear soon. There is no money at all in criticism, and there will be fewer art magazines in the future. I get $100 to spend a month writing a review. So when you say you only get $1,800 for a painting, well . . . So to young critics, keep writing for magazines and for print. But why not form an online art magazine and write about artists *you* want to read about? Artists, you want people to see your work? Then build it—they will come!

Tell us about what you experienced on working for the Bravo show *Work of Art: The Next Great Artist*?

As a critic on TV, I went looking for something in criticism, and it didn't appear. I was only passable at TV criticism. What found *me* were a quarter of a million words produced by people writing about art! The art world is conservative and

snobby. The art world said, "You want to talk to *those* people about art?" And my answer was, "Uh-huh." Instead of one voice speaking to many, there were many voices that could speak to one another coherently.

I am creating a site called "Go Ask the Art Critic," which is only online at *New York* magazine, because there is a horizontal community online like there is on Facebook. Anyone can ask me a question about art. The art critic is not the absolute authority. I'll be in real time, real space, with real people. There is as much possibility in this format as any, criticism contained in the multitudes.

What would you tell newly graduated art students?
Be vampires, but don't be a vampire alone. Hang out with other vampires. Exchange as much human DNA as you can, form gangs, and protect each other. You don't have to come to New York or Berlin. You must not be alone. Make an enemy of envy. Envy will eat you alive and you will die. You will have to work for a living (probably into your forties)! I'm sorry, that's just the way it is. You can't live without money. Don't stop making art! Make bad art!

Why are artists so attached to big art myths?
We're a species that relies on our myths. They self-replicate. I wish you could all be alone in your studio and make your poops and everyone will love you. Get out and see shows. You are the best proponent of your work. We are *all* bashful. I was in my forties before I knew what I wanted to do. I'm still working three jobs: I teach, I lecture, I write. We all have to make money!

If you had a Web site called "I'll Tell You if You're an Artist," what would it be like?
Super tough love. I'd say: it's hot or not, it's art or not art, it's adept but conventional, it's not original enough, or it's lazy, and that's okay. And I'd finish each critique with the words, "Don't listen to me!"

Do you have any final words for our readers?
Be awake, because you're going to be asleep for the rest of eternity.
Artists: I will love you all the days of your life.
If you build it, they will come!
Just work, don't be a baby.
Don't envy others.
Never, ever write anyone off! (Look at this Jewish truck driver!)
And remember KISS: Keep It Simple, Stupid!

Exhibition Opportunities and Community Building

ঙ 3 ৎ

Galleries and Museums

A s an emerging artist, one of the most crucial aspects of launching your career will be determining where to show your work. Commercial galleries and museums are thought of as traditional routes that convey validation and ultimately success, but there are as many different types of galleries as there are artists. In this chapter, we will lay some of these out for you, and you will determine if they meet your goals and are a good fit. As you will see in our next chapter, there are many alternatives to the gallery system.

What is important to know about galleries is that they are there to sell your work. There are structures to these institutions that you need to understand before you enter into a relationship with these venues.

As you read this chapter, keep asking yourself if these venues will achieve your goals for your work and whether they are a good fit for you socially, emotionally, financially, and intellectually. It is important to note that commercial galleries are some of the most difficult venues to access because they usually work with the same relatively small group of artists over extended periods. Remember, you have a choice about where and how your work is shown. You don't have to show your work in a gallery in order to be successful or validated as an artist.

Surprisingly, museums are not what you think they are. For example, museums can be a good alternative to galleries when seeking visibility for your work. We invite you to look at museums in a different light in this chapter.

In this chapter, there are three interviews with experts in the field, who understand the mechanisms and nuances of these complicated systems. Often when artists are starting out, these systems can be intimidating and confusing, so use these interviews to give you insight into how galleries and museums operate.

GALLERIES

Galleries have traditionally been the way that modern artists show their work to the public. It is important to remember that a gallery is usually a commercial

business and that their main goal is to sell work. First, understand the range of gallery options that exist. Gallery venues include:

- Commercial galleries
- University galleries
- Art fairs
- Nonprofit galleries★
- Co-op galleries★
- Online galleries★
 - ★ For in-depth information on these spaces, see chapter 4 on alternative spaces.

Commercial Galleries

Commercial galleries are in the business to make a profit; they buy, market, and sell work. It is important for artists to understand that commercial galleries make many of their decisions based on financial concerns and what they believe will sell. Often, a gallery works with a "stable" of selected artists whose work is shown in group shows and sometimes regular one-person shows. It is essential to understand the financial concerns and structure of galleries: they have to cover the costs of renting or buying gallery space, maintaining the space, hanging exhibits, creating and promoting shows, and hiring staff. Galleries are often known for a particular style of art and build their reputation and commercial value on being the best in that field.

Typically, galleries sell work on consignment, which means that when a piece is sold, the gallery takes a portion of the sale price and then gives the artist a percentage of the sale. At this time, artists most often receive 50 percent of the cost of the sale price.

The benefits of working with a commercial gallery can include: increased visibility for an artist's work, support of increased prices for work, and assistance with outreach to collectors. Galleries select artists they feel will be a good match for their aesthetic and who complement their current "stable" of artists. If a gallery is interested in a new artist, they will often begin the relationship by putting the artist in a group show or place the work in a back room as a test to see how their clients respond. A gallery is often most approachable when it is new and just starting out because they often haven't set their theme or programs yet and may be more open to new artists. It is important to research any gallery you may be interested in approaching so that you fully understand the history, reputation, and profile of the gallery owner. In chapter 5 we will deal with researching galleries, determining a good fit, and creating a strategy for showing in commercial galleries.

University Galleries

Many universities have on-campus galleries and opportunities for artists to participate in exhibitions. These venues can be good for emerging artists to

approach because they are often flexible and open to new artists, new media, and experimental or controversial themes. Be aware that the gallery sits in a larger institution, so the mission of the university will affect the nature of the exhibition program.

Most university galleries are not commercial and are not a venue to sell your work but there are some that do; so exposure, career and résumé building, and networking are often the most important reasons for exhibiting in these spaces. The audience for these exhibitions is typically the university community of students, staff, faculty, and local community. University galleries may host large shows; there are also partnerships between universities and private industries, dealers, and high-end audiences. Not to be overlooked is the built-in audience of the university community that will view your work. If positioned properly, a university exhibition has the added benefit of helping artists make faculty connections. Don't underestimate the university community's potential.

Another benefit of showing in a university gallery is that the experience is a great résumé builder. Plus, exposure to academic review and awareness could lead to interaction with the university community through a lecture or panel discussion or workshop. You should be aware that university galleries often operate with a small budget and may not have huge visibility or large-scale openings and receptions. Private universities may have more budget and personnel support than public universities.

Start researching university galleries by getting a list of colleges in your area of interest. Research their shows, spaces, and get on their mailing list. If you are interested in a college venue, research the mission of the school/gallery and recent exhibitions the curator has produced to see if it's a fit for your work. Try to visit the venue to determine the quality and maintenance of the space, check how well-staffed and secure the space is, see if the gallery hours are reasonable, and view programs.

Nonprofit Galleries

Nonprofit galleries tend not to have a commercial focus. These organizations are usually supported by membership fees, donations, or grants. Grants from local, state, and federal agencies are made available to them as well. They are critical spaces for less well-known artists and host more experimental artworks than commercial galleries. The new genres of performance, installation, and new media art often began in spaces such as these. See the chapter 4 on alternative spaces for more in-depth information.

Co-op Galleries

Artists' cooperatives (co-ops) are funded and operated by artists for the primary purpose of showing their own work. Members share in responsibilities that range from financing the co-op to organizing, hanging, and marketing exhibitions. Members will often get to be in a certain number of shows each year and will help organize shows. See the chapter 4 on alternative spaces for more in-depth information.

Online Galleries

Online galleries are Web-based exhibition venues that feature artists' works and offer them for sale. There are many online gallery options, but it is essential for you to carefully research these sites because they are an evolving venue, and some work better than others. Find ones that best match your work and that you trust are run well. See chapter 5 for more details on online gallery options.

The Artist/Gallery Relationship

The artist/gallery relationship is complex, characterized by a number of subtle negotiations and compromises. As an emerging artist, you need to have realistic expectations of how a gallery functions and approach them with an understanding of the gallerist's point of view. These relationships are an evolving process for both parties. In the following interviews, you will see two perspectives on the artist/gallery relationship: one from an established gallerist and one from an established artist. These two interviews highlight the advantages and challenges that you will encounter when dealing with galleries.

INTERVIEW WITH ELIZABETH HESKIN, GALLERY OWNER OF HESKIN CONTEMPORARY, NEW YORK

Elizabeth Heskin's gallery space is just north of Chelsea on West 37th Street in Manhattan, where she advises clients in acquiring works of art from private offerings on the secondary market and introduces and promotes the work of up-and-coming contemporary artists. Elizabeth's past experience includes directing a gallery specializing in young and mid-career contemporary artists and assisting a private art dealer specializing in Impressionist and modernist painting and drawing.

Tell us how you started your career in galleries.

My father was a painter from Ireland, trained at the Royal Academy in London. I didn't study art or feel I had to make it, but my dad wanted me to be an artist, and I'd go to art museums with him as a kid. Still, I wanted to work in the arts. My first job was at the Met gift shop. I met so many artists who worked there. They were older artists with degrees from art school, and knowing them was part of my education in the arts. One of these artists helped me get a job assisting a private dealer, Anita Friedman, who sold Impressionist and modern work from her apartment on the Upper East Side. I was self-educated and read all the books in her amazing library. I would go to the Frick and do research on the provenance of pieces. I learned to make a deal at a really young age.

I eventually moved to a Soho gallery, even though my salary was cut in half. I became a director at Edward Thorp Gallery and really learned how to run a gallery and put up a show, how to handle sales. I met so many people during those five years.

Then I decided to become a private dealer and work out of my apartment and worked from home for a while. Eventually, I rented a storefront space, and that became my gallery in 2006. Brokering art is my strength, and I actually rely

on the secondary art market more than the primary art market. I love being in the art world; being creative and doing business is a perfect fit for me.

The biggest mistake you can make in this career is to jump in, get a backer or a loan, and open up a shop. That's too fast. In this business, you do not rely on people walking in the door. It's not a store. You need a built-in structure of where your sales will come from before you start to sell—it costs a lot of money to run a gallery.

How do you choose artists to show?

I try to hone in on people whose work I like. I love painting primarily. I like many different styles, but other galleries may prefer to show artists who have highly similar styles. I want to see how an artist works. Studio visits are a big deal for me. Are they doing work for the right reason? Do they seem compelled to make art or are they just in it for the coolness? If you just want to be famous, I don't want to work with you. That is not authentic. It's not about being a star. Less than one percent of artists become stars.

What advice do you have for artists when they have a studio visit from a gallerist?

Let the work and the visit unfold. The artist has to be able to talk about their work or they do themselves a disservice. They may feel intimidated. They should want to talk about their work and communicate about their vision. A common mistake artists make is being disorganized. The space and your work should be organized and clear. It's a real turnoff if the artist doesn't handle their work with care. I suggest putting art on a viewing wall in one place, not all over the studio; turn other pieces against the wall so I can focus on the current, most important work. I like to engage in a conversation and really understand what the artist is saying. Artists need to know their art history, so if I tell them they seem to have been looking at Hans Hoffman, they should not ask me who that is. Be able to put your work in historical context.

How should an artist follow up with you after the studio visit?

Drop me a thank-you note. Handwritten notes are better than e-mails because we all get too many e-mails and I'm more likely to notice a note that comes in the mail. I love a note on a photograph of an artist's painting. Something not to do after a studio visit is to call too much or harass the gallerist.

How should an artist approach you for the first time?

You can walk into the gallery and ask for submission policies, that is okay. Or you can e-mail me your Web site and I'll have a look at the work. It's helpful if the artist understands the workings of a gallery before they start approaching it. I don't like to get a huge submission packet; I feel like they are unwieldy and take away all of the mystery and discovery. I like an unknown, undiscovered artist, so don't overload it. A simple, professionally presented CD or a Web site is all I need to see; keep it short and sweet.

You'll get a gallery's attention from recommendations. It's helpful to have a friend make an introduction—that clears a bit of my process. It doesn't mean you'll get in, but it's a good way to get a foot in the door. If someone walks straight to the back of the gallery and asks me if I look at artists' work, I hate that. I'd rather they take the time to look at the work and express an interest in the gallery. Come to my openings to show you are interested.

What should artists understand about the role of a gallery and how that relationship works?

I like it when an artist can list what they bring to the table. For instance, it's great if an artist offers to pitch in once they're on board, such as offering contacts with potential collectors. The artist needs to be a part of the process. I like for artists to have good records of their own, such as a résumé and good photographs of their work.

I am clear with artists that I am a one-woman show, so this sort of teamwork/ partnership with my artists is necessary. Both art and the art world are about relationships. My role is to generate sales, try to get the artists press, and help artists build their careers. I position my gallery as a place where if I helped the artist's career, I am all for it.

What should artists know about how to behave at an opening?

Mind your turf. If you see a buy/purchase going on, it is not your job to get engaged in the sale. Don't pounce on the buyer or try to navigate the sale. I have seen potential purchases fall apart when an artist got overexcited, pushing himself on the buyer until she walked away.

Can you tell us what you look for in a new artist?

I want someone who is able to talk about their work, is committed to their work, and is not focused on being a star or in this for the wrong reasons. I look for something fresh, new, something I've not seen done before.

Do you have recommendations on how to sustain a long career in the arts?

I used to work for Eric Fischl, and I saw how a major artist lives and works. He just sticks to painting, and he's in the studio all of the time. He's a star artist, but he's not interested in that. I saw him turn down lots of endorsement opportunities because he really just wanted to focus on his art and those things didn't seem authentic. I think he's a great role model to look to. So be sure to have your priorities in the right place. I've seen artists totally switch their styles, and their careers never recover from it. Research what is showing who; look at what your peers are doing and what is happening in the art world.

INTERVIEW WITH DON PORCARO, ASSOCIATE PROFESSOR IN THE FINE ARTS DEPARTMENT AT PARSONS THE NEW SCHOOL FOR DESIGN

Don Porcaro is an associate professor in the Fine Arts Department at Parsons The New School for Design. He shows nationally and internationally and is represented

by Kouros Gallery in New York City. He has been reviewed in the *New York Times*, *Art in America*, *ARTnews*, among others, and was recently the subject of a feature article in *Sculpture* magazine.

What are the different types of galleries that artists can show in?
There are various levels of entry that artists should understand so they know which spaces are most practical to approach. There are entry-level galleries, which, broadly defined, could present a one-night show in a space on the Lower East Side, for example, or in a school or library. Next there are co-op galleries, which are artist-owned and -run, and mid-tier commercial galleries, which might represent young and emerging artists. Then there are the more established top-tier galleries, which show mid-career and established artists, and finally there are the blue-chip galleries, like the Pace Gallery or Gagosian. Young artists should understand that, despite the quick success of some, most need to build their résumés with exhibitions and reviews over time, as it's not realistic to aim at established and blue-chip galleries right out of school. Finally, there are vanity galleries, which are galleries basically for rent, where anyone can pay a fee to have a show for a month.

What do young artists need to know about approaching commercial galleries?
It's important to get out and see as many shows in as many galleries as possible. Get to know their programs and target the ones that are most appropriate for your work. Show your support by going to their openings and make an effort to get to know the gallerists and their artists. Engage them in dialogue about the exhibition and the work and begin establishing relationships with as many fellow artists and dealers as you can. Do *not* walk into a gallery cold with a portfolio, ever, and expect to speak to the dealer or director right on the spot. Instead, ask what their viewing policy is and if they are looking at new work or are willing to make a studio visit. Most dealers will tell you to send them a portfolio in the mail.

Sounds like networking and social skills are a must. What can an artist do if they are uncomfortable with this?
Find the artists in your peer group who share your values and interests and support them by going to their studios, their open studio events, and their exhibition openings. Your circle will widen with time, and those artist friends will often be your strongest supporters in return.

What are some common misconceptions young artists have about galleries?
Artists often expect their gallery to take care of them by selling their work regularly, getting them shows in museums and other galleries, and generally promoting their work constantly. Unfortunately, most galleries do not have the staff or the financial resources to devote themselves to every artist every day. Instead they tend to focus on the artist whose show is currently on exhibit and leave the rest to whatever may come their way. Some galleries will even ask the artist to help pay for the cost

of promotion, such as shipping, announcement cards, and advertising. Even the better galleries will not be able to do everything an artist will want them to do for them, so it's important to remember that. Some of the other misconceptions have to do with the financial structure of sales.

The standard commission is generally 50 percent to the artist, 50 percent to the gallery. If a private dealer outside your gallery sells your work by bringing in the client, they will get a percentage of the sale, 10 to 20 percent, which will be deducted from the selling price, and the remainder will be split between you and the dealer.

What should artists understand about how galleries function and how artists work with their gallery?

Most galleries don't want to sign contracts, and they will often test out a new artist before committing to them. For example, they might put a few pieces of your work in the back room and see if clients like it or test you out in a group show first. This is actually good for the artist as well because you get to see how the gallery functions and decide if you think it's a good match.

Are there any new trends or changes in how galleries are operating lately?

Today there is a greater expectation for the artist to bring in their own social network, including writers, critics, and collectors who have been following and supporting their work. It is advisable to plan on supplementing the gallery's mailing list with your own. Start this list while you are still in school and create a file that categorizes all of your contacts separately—dealers, curators, friends, and collectors.

For a lot of artists, their ultimate dream is to show in a blue-chip gallery. Is there any downside or reality check you can share about showing in such a venue?

A gallery of that level expects a great deal from their artists in addition to producing work. They will require them to socialize with their collectors, as well as with curators and critics, and attend high-profile openings and events. They are presented with opportunities to exhibit their work worldwide and are expected to sustain a level of excellence and productivity that can accommodate the pressure. Not every artist is up for that.

Let's say an emerging artist gets their first show. What can they expect from a gallery?

Expect the minimum, and enjoy the experience of exhibiting your work for the first time in public. Try and learn what you might do differently next time. It will most likely be a group show and an opportunity for you and the gallery to test the waters. It's great if you sell work, but be very level-headed about your expectations. That's not to say that you should lower your standards or settle for improper behavior on the part of the dealer, ever. But you should also be realistic

about what to expect and make sure the terms of your relationship with the gallery are very clear from the start.

Some artists drop dealers every time they feel dissatisfied and move around to different galleries with the hope of finding the perfect one. Eventually this catches up to them, and they develop a bad reputation among the dealers. If you don't feel that being represented by one gallery can do for you what you believe you deserve, there are many ways for you to be proactive on behalf of your own career. And that's a very different and legitimate path that many good artists have taken.

How can an artist maintain a good relationship with a dealer?

If you expect your dealer to be supportive of you, you should support your dealer as well. Go to every opening they have; your presence and support will be noticed. Bring other people with you, such as other clients, artists, and writers. Don't be greedy and sell work behind your dealer's back directly from your studio. That not only undermines their efforts, but undercuts your own market value by selling at a discount. Make sure your gallery's name appears on everything you put out there, so that their name is always associated with yours. That not only gives your work the imprimatur of a reputable gallery, but gives the gallery additional exposure, which they will appreciate.

Conversely, how can an artist sabotage their relationship with a dealer?

By showing or selling behind the dealer's back. You have to build trust. If you want to show elsewhere, you should openly ask permission to participate—for example, in a show at a nonprofit or a school, a venue that's not competing with your dealer. If you've been invited to exhibit with another commercial gallery in another city, you need to establish the terms of that relationship, as it pertains to your terms with your primary dealer. Your primary dealer may want a small commission on all sales, or you may agree from the start that you are free to have your own direct relationship with other galleries. Make that clear from the start so that there will be no misunderstandings later.

Be professional on all levels and at all times. Do not get drunk at your opening or any of your peers' openings. Openings and events are opportunities to make new contacts and meet new people who may be helpful to your career down the line. They're not parties. If your gallery requests anything from you, be it new work or a digital image of a new work, in order to promote you properly, provide them with what they're asking for in a timely manner.

What expectations should artists have of their gallery?

The very first expectation one should have is that the gallery be open during the hours that are posted. That may sound funny, but it's not unheard of for understaffed galleries to open late, close early, or sometimes not open at all for whole days during the course of a show. Second, find out if the gallery pays its artists. Talk to other artists about their experience with dealers and do online research to see if there is any history of financial misdeeds.

JURIED SHOWS

In addition to showing in galleries, there is also the option of showing in a juried exhibition. Juried shows are competitive group exhibitions. Artists should be cautious of participating in these venues due to the costly nature of juried shows. Consider the budgetary costs of participating, including application fees, insurance, crating and shipping of work, and travel expenses. Research shows to see if they fit with your work and have a good reputation, good audience, and press. Is the fee being charged just to cover the gallery's rent or operating expenses? Are they promoting your work in this one show? What are you getting out of it? Is it worth it just as a résumé builder?

Ask yourself: does the show advance your goals? Determine who is on the jury. Does your work fit with the gallery, and is it a good fit for you? Are they going to actively try to sell your work? Are there cash awards, and if so, who has won them in the recent past? What is the history of the juried show; has it been going for a few years, and how much press and respect have their most recent shows received?

ART FAIRS

Art fairs are another type of juried competition. The art fair is a commercial venture that has grown enormously in recent years. Art fairs were originally set up as an alternative to the gallery scene, but many are now very well established and highly structured. There are various levels and kinds of art fairs; some are well-known and prestigious (such as Art Basel and Art Miami), and others are less well-known and may feature more affordable art. Art fairs sometimes focus on particular media and themes and the artwork is often shown over the course of a weekend or a few days.

To choose a good fair, consider which events feature artists at your level, draw lots of visitors, have real sales happening and at good prices, and have a good reputation. Also consider the cost of the booth, fees, crating and shipping your work, and travel. While participation in an art fair may not be financially practical in the early phases of an artist's career, these fairs can be a valuable research tool for artists seeking to understand current art trends. For more detailed information on how to select and survive an art fair, see *Art/Work* by Heather Darcy Bhandari and Jonathan Melber.

MUSEUMS

Often, emerging artists don't think of museums at all because these seem like such imposing, well-established, formal institutions. But museums can be even more flexible than galleries and feature theme-oriented group shows, so there are more opportunities for artists seeking exhibition venues. Museums often have larger budgets than galleries and have greater revenue streams, so their exhibits can be more encompassing than commercial galleries. Curators of museums have the interest in showing new artists, but may not be able to get out to either studios or

art fairs and are therefore more open to artists sending them materials. Museums are a great venue for emerging artists to think about, but you must do your research to determine if the museum is a good fit. It is important to research the curators before you approach a museum. At large museums, there is often a full-time curator; at smaller museums, there may be guest curators. One good way to get involved in showing at a museum is to attend their openings and get to know both the shows and the staff.

The following interviews explore museums from two points of view. One is from a well-established museum professional with an overview of how art museums work and the other is an excerpt from an interview with an individual artist who works with museums.

INTERVIEW WITH CLAUDINE K. BROWN, DIRECTOR OF EDUCATION FOR THE SMITHSONIAN INSTITUTION, FORMERLY DIRECTOR OF THE ARTS AND CULTURE PROGRAM AT THE NATHAN CUMMINGS FOUNDATION

Claudine K. Brown is the director of education for the Smithsonian Institution. She is responsible for defining the Smithsonian's education program. Her focus is the Institution-wide plan for educational initiatives, assessment strategies, and funding. Brown oversees two of the Smithsonian's educational organizations, the National Science Resources Center and the Smithsonian Center for Education and Museum Studies, and coordinates thirty-two education-based offices in museums and science centers.

What are the prospects for artists getting into museums today?
Community and regional museums have open calls for artists, and museums in small cities often look for local artists to exhibit. There are also teaching opportunities in museums for artists, as well as the ability to participate in public programs, special events, and residencies. Artists should be on the lookout for opportunities to work with museums that exhibit work in keeping with their artistic directions. They should also be aware of museum and art center residencies that culminate in an exhibition.

How do artists go about getting into these institutions?
Gaining entry into these institutions often requires knowing or becoming familiar with a particular museum's culture. Awareness is key. There are a number of strategies for gaining entry. It is important to make sure that key players in these institutions get to know you. For example, get to know a curator's work. Follow their career. Find out what work resonates with them, who their work is aligned with, and who they work with. They may work with auction houses, representatives from commercial galleries, and other curators. Museum curators also go on studio visits, especially for group exhibitions.

Artists must be able to be aggressive without being offensive. They should develop strategies for marketing themselves. Make a list of people (curators, critics)

and send out announcements to your shows. Be strategic—make sure to include all of the people who you want to know about your work. This might include collectors and dealers. Then there is whether you use a light touch or heavy touch. A light touch is about having a presence in the field. A heavy touch is when your pursuit is so relentless that you turn people off. Something in the middle is preferable.

What are some tips for communicating with curators or critics?

Be responsive. When someone contacts you, respond to the inquiry in a timely fashion. You can't wait too long because the person with whom you are engaging may be working on time-sensitive deadlines. They might not be able to use your work if you wait too long to respond. Responding in a timely fashion is key.

Be accessible. Be careful of how you sort and block your e-mail. Sometimes a block can filter out a curator or gallery person with whom you are attempting establish a relationship! Additionally, it's often the case that curators or dealers are not the people who will initially be in contact with you—it will probably be their assistants. Everyone is important in this process!

Protect your profile. You may opt to have a blog or an active profile on a social networking site. You may "friend" critics, gallery reps, or curators. These sites are often someone's first impression of you. Your work, opinions, and values are often revealed on these sites, so bashing others is not an advisable course of action. Think carefully about how you wish to represent yourself. An affirmative and effective communication strategy is important for you to gain access to the important people in the museum world and for them to gain access to you.

What kind of strategy would that be?

Prepare for an opportunity—be ready! Have your packet—a recent bio, résumé, and JPEG images of your work—ready to go so that you can respond to a request within forty-eight hours. Also, your Web site and blog must be updated with clear, well-cropped images. There must be a consistent look to the quality of the images. If you have older images that are not as clear, you should redo them so that the quality is consistent.

Discipline is important as well in promoting yourself and managing your career as an artist. Do not submit old work. Reviewers comment and are concerned when they see the same work year after year. Update your work regularly. Remember everything that you send out represents you at this current moment in time. Your products must always be of the highest quality. If you are printing a postcard, it should be an accurate representation of your work. If images are poor, they reflect on you as the artist and how you represent yourself. Be prepared!

What about applying for opportunities through museum programs? Can you describe some common mistakes artists make?

Some museums encourage artists to apply for residencies. Meeting deadlines is important. Don't wait until the last minute to apply. When doing so, follow directions carefully. If you don't submit a complete application, your application

may not be accepted. Make sure that you send the appropriate attachments. If you are invited to proceed to the next level, you must follow through!

Your career is your responsibility, and you must be knowledgeable about your field. Read publications, go to see others' work, and share resources with other artists. For example, artists often get into exhibitions because of referrals. You are in the business of referrals!

In down periods, create new venues for showcasing work. Think outside the box. Use or create public exhibition spaces. Coordinate with others to create group exhibitions. Create opportunities when they are not readily available.

What are the current trends you can describe in museums?
Generally, when there are economic downturns, there is not a lot of money to create new exhibitions in museums. During these periods, many museums create exhibitions featuring works from their permanent collections. It may be difficult for museums to pay loan fees or fees for outside scholars to write catalogs during fiscally challenging times. But hard times also make institutions rethink why they do the work they do in the first place, and eventually things normalize.

Museums identify partnering institutions so that exhibitions may travel. They identify communities that are exhibiting the same types of work. Artists' voices are as important as their work. Different artists will approach similar subjects in different ways. Artists who are exploring similar issues generally know each other. There is an arts ecosystem, which is not linear. Get to know the artists in your ecosystem!

How would an artist go about understanding this art ecosystem?
Here is an exercise: follow an exhibition that travels and see how it is defined, marketed, and programmed in each community. Museums have different missions and values. Why did each host curator choose this exhibition? How is it displayed in each museum setting? Are works from each museum's permanent collection added to the exhibition? Are there galleries in the local communities representing artists in the exhibition, and if so, are they doing companion exhibitions? What kinds of work are their constituents attracted to?

How do galleries fit into this system with regard to museums?
There are some partnerships between museums and galleries. If you want to show in a major gallery, you need to have enough work in hand for the gallery to show. If you are fortunate to get a show in a good museum but not a gallery, then use the museum show to get gallery representation. And vice versa.

Can you talk about the materials that museums and galleries generate to promote artists' work?
When thinking about products such as catalogs, postcards, note cards, etc., think about what images are related to the show. The artist needs to think about how the museum will promote their work and what images to negotiate with regards to promotion. Reproduction rights are important to know about as well. What

will be on the cover of the catalogue—our work or someone else's (if it is a group show)? Since artists are not paying for the products, they aren't on hand to make the decisions about the products. The products enhance the value of your work and increase exposure to the work.

Another issue that needs to be negotiated is, if there is a group show and it travels, will the museum or gallery pay for the travel and hotel expenses for the artist? A negotiation of a possible honorarium that is appropriate and viable is important for both parties.

Final words?

Do your research! Find out how museums come to engage with artists!

In the next interview excerpt, we look at museums from an artist's point of view and explore how collaborating with museums has positively affected her career.

EXCERPT FROM AN INTERVIEW WITH SHARON LOUDEN

A graduate with a BFA from the School of the Art Institute of Chicago and an MFA from Yale University, Sharon Louden is a professional artist whose work has been exhibited widely and is held in major public and private collections. She has taught at various colleges and universities for the past twenty years. For more details, please see *www.sharonlouden.com*.

Tell us about showing in museums.

When I first graduated with an MFA, I had no idea how to approach a gallery, but was given some great advice: I was told that by showing in museums, I could gain the attention of galleries and acquire some experience with having my work engage with a public audience. Exhibiting and working with museums has been a source of creative bliss for me, since they exist outside the commercial part of the art world. I enjoy collaborative experiences with curators and everyone involved in a museum, such as the board of trustees, the education department, and even the docents! It's a healthy environment and wonderful context in which to share my work with the public. If I were to give advice to another artist about showing in museums, I would say that just like anything else, you must do your homework to find a curator at a museum who understands and corresponds with your visual vocabulary. Finding the right person to work with is essential. Having done your homework and established a dialogue with a curator, you'll have taken your first step to a healthy, collaborative exchange. The goal here is to not only have your work exhibited, but to also hopefully have your work acquired by the museum.

❧4❧

Alternative Spaces:
Breaking the Rules to Break Through

> *Be the change you want to see in the world.*
> —Mahatma Gandhi

We want to introduce you to an exciting arena of alternative spaces. The following are highlights of why the alternative route is a viable option for starting your working life in the arts.

The options are limitless

Alternative space options are limitless, whereas mainstream gallery opportunities are limited. These options are so much bigger than what the pristine white walls of a gallery can contain. Artists should consider taking their art to the streets and sidewalks, the air, the earth, and the Internet.

Artists have greater control

By exploring alternative spaces, you, the artist, have greater control. The benefits of alternative spaces can include having more control over commissions and how your work is presented as well as the ability to exhibit your work unmediated by a dealer. Artists can speak directly for themselves and to their audiences.

Now is the time

Alternative spaces are more important than ever as we see an economic environment in flux and traditional institutions faltering. Alternative spaces are essential for creating new opportunities and avenues for artists and their work. There is also a large movement toward artists building their community and collaborating, which can create supportive environments for artists' work.

Broader and faster access to an audience

Technology and new communication systems are allowing artists faster and more direct access to larger groups of people through the Internet and other media. The world is getting "flatter," and communications are getting easier, more affordable, and creating new and diverse avenues for getting art to an audience. Alternative methods of communication such as Twitter or Facebook can generate instant communities and spontaneous encounters.

Options for work outside the mainstream

Too few artists whose work involves difficult subject matter or experimental media are welcomed or represented in mainstream galleries. Alternative spaces are often laboratories in which to experiment with new and diverse ideas and can be a great testing ground for new work. These spaces can help artists define and build their audiences, as well as communicate with them. Artists can use alternative spaces to get their work out.

Visibility for artists

In cities or towns without major art scenes, it is essential for artists to use alternative spaces to make their work visible to the public. Artists living in rural areas, for example, are banding together to create alternative collaborations, supportive communities, and exhibition alternatives. For instance, a new model for visibility and fund-raising for artists is based on the community-supported agricultural model. This model involves a reciprocal relationship between artists, farmers, and consumers. Everyone gathers for a community meal and listens to artists present project ideas; at the end of the event, a vote is taken and the artist selected wins the money from diner's entrance fees.

EXAMPLES OF ALTERNATIVE SPACES

Alternative spaces have always been an effective way for artists to juxtapose their message against a status quo art market and gallery scene. These spaces have also long been a source of community and support among artists. Gordon Matta-Clark's "Food" project from 1971 is an early example of an alternative space. Matta-Clark created a restaurant and exhibition space that employed many artists; activities in the space included serving soup flavored with bones and would encourage diners to make jewelry from the bones.

Artists created alternative spaces as a direct response and counteraction to the formal and structured commercial gallery scene. Alternative spaces began in the 1970s (with some aspects dating back to the fifties), when artists began creating works in storefronts, abandoned buildings, street corners, loft spaces, and unused factories. Public spaces never before considered for art were explored. Artists were thinking intentionally about the relationships between public and private spaces and what they meant, challenging the notion of the classic white box gallery

and the status quo it represented. Artists wanted to have direct contact with their audiences and bring their art to a larger community; many of these events were audience-driven.

The new genres of performance arts, such as happenings, events, installation, and new media art, first began in alternative spaces. These spaces and work were often temporary, ephemeral, and noncommercial. Because the work often was controversial in nature (body and identity politics, social politics) and therefore did not fit into the commercial market of the gallery system, alternative spaces offered visibility. Alternative spaces offered exposure for artists who were emerging, working with nontraditional mediums or genres, were underrepresented and were of diverse ethnic backgrounds. Some of the best-known alternative spaces in New York City include: the Kitchen, Metro Pictures, PS1 (which later became part of the Museum of Modern Art), and White Columns.

There has often been a dialogue between alternative spaces and the commercial gallery system. Currently, the boundaries between the two are more blurred than ever, as commercial galleries take the newest and best ideas and talent from alternative venues. Alternative spaces, over time, have often co-opted the structure and hierarchies of commercial galleries, even when the venues have been traditionally artist-run. Therefore, the longer an "alternative" organization has been around, the more formal they may get, and the more they may resemble a commercial gallery's functions. Today's alternative spaces are still used as showcases for emerging talent, offering room for experimentation and new cultural trends.

Now, when the economic challenges closely resemble those of the 1970s period that originally gave birth to alternatives, artists are discovering the necessity and value of creating new alternative and nontraditional venues for their work. Increasingly, artists are revisiting the core concepts, questioning the use of a static, physical location for art. Now, what is being explored is earth as canvas/laboratory, using limited time frames and temporary spaces to engage the audience in activities that is in themselves the art experience. We want you to take inspiration from these examples and consider making your own opportunities. In this chapter, we will explore some of the alternative spaces you might consider for your work, followed by a chapter on strategies for how to find or create the ideal place to show your work.

Cooperative Galleries

An artist's cooperative (co-op) is an exhibit space created by a group of artists who join together to create their own exhibition opportunities. Members share in responsibilities that range from financing the co-op to organizing, hanging, and marketing exhibitions. All co-ops are a bit different, but usually members share in the cost of running the gallery and may pay monthly or annual membership fees. Usually, members help organize shows, and each member will get to be in a certain number of shows each year. Co-ops may also occasionally show the work of nonmember artists.

There are pros and cons to any co-op experience. On the positive side, a co-op offers visibility that might not otherwise be available to an artist in the early

stage of their career or to artists in rural areas and smaller towns and cities. A co-op can be a great way to build a supportive community of fellow artists, and it allows artists to take charge of their own exhibits. Artists' co-ops can offer invaluable opportunities to curate your own shows, collaborate on projects, and create and market your work. Co-ops can also be a great place to attract and cultivate great mentors and collectors.

On the downside, an artists' co-op may not get the level of press coverage, visibility, and prestige that other non-artist-run venues may get. There are, however, some well-established and high-profile co-ops that get significant coverage. When considering joining a co-op, artists should make sure the group's mission is one that you believe in and that the people working there are artists you like and respect.

An example of artists' co-ops include:

- A.I.R. (Artists in Residence) is the first cooperative created for women artists in the United States. The group was created in response to the problem of women artists in the late 1960s lacking places to exhibit their art. The goal of the gallery has been to provide a professional and permanent exhibition space for women artists to show work of quality and diversity. A.I.R. offers a fellowship program for emerging women artists, serves to maintain a political awareness and voice, in order to bring a new understanding to old attitudes about women in the arts. See an interview with A.I.R. Director Kat Griefen at the end of this chapter.

Nonprofit Art Spaces

Not-for-profit organizations have a 501(c)(3) tax-exempt status. In other words, all the financial gains made by the organization must be reinvested into the organization, not created for profit—thus the term *nonprofit*. Another way to think of it is that these organizations are not supposed to have a commercial focus. You too can be a 501(c)(3) "mini-organization" as a working artist. These organizations tend to be supported by membership fees, donations, or grants from local, state, and federal agencies. The downside is that there are many rules and regulations to abide by for this kind of status.

Nonprofit art spaces often show more unknown artists and more experimental artworks than commercial galleries. The new genres of performance, installation, and new media art often began in spaces such as these. These spaces can range from more formal institutions to alternative spaces, from well-run organizations to less structured ones. Some have informal styles of management, while others are more formal. They also vary in size and in terms of the numbers of artists who are involved with them. Some of these spaces are time-sensitive, are set up for a day or for a month, and some evolve over years into powerful, effective community art centers.

The chances of getting into a nonprofit space are generally greater than those of showing in a commercial gallery, which generally keeps a static roster of artists. But nonprofits can move through artists and shows rapidly, meaning that they are actually open to seeing new work and showing new artists. To decide

which nonprofit spaces are a good fit for you, go to their Web sites, read their mission statements, and ask your peers for their recommendations. See chapter 5 on creating an exhibition strategy for more tips on approaching alternative spaces.

All alternative nonprofit spaces have unique stories of how they started and generally have one-of-a-kind missions. Here are two examples:

ABC No Rio in New York City (Go to: *www.abcnorio.org*) started out with a group of artists who took over an abandoned tenement building in the Lower East Side in 1980 to exhibit their work, create happenings, provide a space for experimental bands to play, and create politically-inspired programs such as "Food Not Bombs," which is still in operation today. ABC No Rio is a collectively run center for the "pollination" of artists and activists in order to create a "venue for oppositional culture." As Steve Englander, the director, says, "Our dream is a cadre of actively aware artists and artfully aware activists."

Another example of a nonprofit art space is AS220 (Go to: *www.as220.org*). The mission of AS220, located in Providence, RI, is to "provide an unjuried and uncensored forum for the arts. If you live in the state of Rhode Island, you will get an opportunity to exhibit or perform at AS220. AS220 is part Incubator and part Bazaar. We build new audiences and infrastructure for artists to stimulate the cultural mulch in Rhode Island."

Street Art and Art in Unusual Places

Street art is any art that is developed and produced on or in the street, and it is usually illicit in some way. Historically, graffiti art produced in New York City during the economically devastated 1970s was the start of this movement. Graffiti artists worked their text-based "tags" on subway cars, abandoned lots, buildings, and any place where they could work quickly and avoid the police. Their work aimed at social commentary and produced unique styles. They took names that identified their work, and some became well-known through gallery exhibitions. Taking its historical roots from graffiti art, street art includes: traditional graffiti artwork, sticker art, stencil graffiti, street poster art, video projections, public art interventions and installations, flash mobbing, and guerrilla art. The messages of street art are as diverse as the mediums with which they are created. Street art has become an international movement.

Street artists speak directly to the public. Frequent themes include social activism and cultural commentary, such as "adbusting" and "subvertising," or it can be an untapped space for personal work. Street art is a fast and challenging venue that can reach a maximum audience.

Many artists are no longer waiting for galleries to discover them. They take matters into their own hands and create their own exhibition venues. The possibilities for what form these exhibits will take are endless: artists are creating exhibits on rooftops, in empty lots, in garages, and in portable exhibitions such as traveling shows on bicycles or even in taxi cabs.

The following examples may inspire you:

Banksy

An example of a supremely individual street artist and activist is Banksy (a pseudonym). Although his true identity is unknown, he has become an internationally-known street artist, making statements about current issues from London to Palestine. Banksy stencils spray-painted messages and imagery on walls, telephone booths, mailboxes, and other city surfaces, creating scathing and sometimes humorous commentary on social and cultural issues. His Web site states: "Banksy neither produces or profits from the sale of greeting cards, mugs, or photo canvases of his work. He is not represented by any of the commercial galleries that sell his paintings second hand and cannot be found on facebook/twitter/myspace etc." To find out more, go to *www.banksy.co.uk*.

Tattfoo Tan

Tattfoo Tan is an artist who has created a mobile art project called "Sustainable Organic Stewardship (S.O.S.)." The artist, who has an interest in agriculture and organic food, hopped on his bike and set up a series of teaching tools on how to care for the environment, make compost, and grow food. He attends fairs, schools, and community events to teach and to create art. Learn more about Tattfoo Tan and his inspiring S.O.S. pledge at *www.tattfoo.com*.

Locker 50b

Locker 50b is a gallery in a small school locker. While still a student at Virginia Commonwealth University, Virginia Samsel turned her locker into an exhibit space featuring small-scale work. The artist went on to curate exhibitions featuring more than two hundred artists over several years. Several years later, Samsel donated the locker exhibit space to the university, and Locker 50b continues to actively exhibit artists' work. To learn more, go to *www.vcu.edu/arts/locker50b/*.

Navin Gallery

In 1995, Thai-Indian artist Navin Rawanchaikul created the Navin Gallery Bangkok, a mobile art gallery, in the back of a taxi, inviting his fellow artists to put on installation shows in it. The project expanded to Bonn, Mexico City, and Birmingham. In another inspired project called "Taximan," a superhero from Taxi planet comes down to save the world from the villain, Millennium Man. In "I Love Taxi," Taximan comes to New York City for encounters with New York taxi drivers in "Taxi Cafés" set up in Madison Square Park and PS1.

We hope you are inspired by these examples of artists who have taken their art and their messages to the street. Be an innovator and look for the exhibition opportunities that may be right in front of you.

Artist Collaborations

There is a long and distinguished history of artists gathering, finding a space, and collaboratively creating a show together. These shows can be informally assembled or highly organized, small in size or large. A multi-artist show can extend your circle of colleagues, introduce you to new works and ideas, allow you and the other members of the collaboration to set the parameters of the show, find you a mentor, strengthen your peer relationships, or set the stage for other opportunities. Artists have launched their work, and groups of artists have started movements, through collaborative efforts. Kathe Kollwitz of the Guerrilla Girls says, "It's a

kick to collaborate. You have to try and leave your ego behind and be able to love another person's ideas. Community starts in art school, and you can continue it after/outside of school, no matter what kind of art you make."

Collaborative projects are not limited to exhibitions; they can also be as creative as the following examples.

Art-o-Mat

Clark Whittington, from North Carolina, collaborates with artists all over the country in an art vending machine project. He solicits small artworks the size of cigarette packets in order to sell them to the public ($5 per artwork) through old refurbished cigarette vending machines. The proceeds of the individual artworks go back to the respective artist. The recipient gets an original work of art and instantly becomes a collector. There are currently nearly four hundred participating artists from ten different countries. You can find art-o-mat machines in art centers, coffeehouses, galleries, museums all across the country and even in a Whole Foods store. As his Web site states, Whittington has been "kerplunking art and vending art and culture" since 1997. Whittington is always looking for new artists and believes, "it's a small baby step to getting people to live with art." To find out more, go to *www.artomat.org*.

Three Wise Goats

Alexander Khost, a New Jersey artist, had a revelation one day in his studio in New York City, when his brother Peter Khost, who was not an artist, put a dash of paint on a canvas Alexander was painting. Vexed but intrigued, Alexander invited Peter Khost to participate with him on the painting. What was a one-off invitation turned into nine years of collaboration with his brother, who learned how to paint while participating in the project, and a friend, Frank Gaughan, in a partnership that is now officially called the Three Wise Goats. Each season they stage an exhibition of their new work.

Public Spaces

An interesting phenomenon in the use of alternative spaces is the pop-up gallery. Pop-up galleries and other limited-time exhibition spaces are hard to categorize; they cross disciplines and mix venues. There are individuals and groups of artists all over the country who are challenging the notion of how art is shown and how it reaches and interacts with an audience.

Working in a public space offers a host of unique opportunities to engage with communities, have dialogues with other artists and the public, who may not be the same audience as that of the traditional art world. Artists can seek out these opportunities by researching calls of entry for art in public spaces. Or artists can create their own venues by finding spaces such as abandoned buildings and empty storefronts, where, in the current economic climate, artists' works are increasingly welcomed as a sign of activity and cultural vibrancy. An excellent resource for anyone interested in public art is *The Artist's Guide to Public Art: How to Find and Win Commissions* by Lynn Basa.

Showing your work in public spaces is a great networking device; it's good publicity for your work and creates visibility, even if it doesn't lead to immediate income. It gives you the chance to respond to and incorporate an audience's reaction into your work, a process that can be as valuable as producing the original work. It can influence your art and create new directions for where your work can take you; it often opens up dialogues with other artists or communities.

The following are a few good examples of this mix of genres that have come together to create a public art project.

No Longer Empty

No Longer Empty is a nonprofit group that responded to the economic downturn in New York City by revitalizing empty spaces such as vacated storefronts to create public art exhibitions. To learn more about this project, go to *http://nolongerempty.com*.

Slideluck Potshow

Slideluck Potshow hosts multimedia slideshows combined with potluck dinners in cities around the world. The group is "dedicated to building and strengthening community through food and art. For each event, artists submit up to five minutes' worth of images and guests bring along delicious food to share. The evening begins with a couple hours of mingling and dining on home-cooked dishes, and then the lights are dimmed, the crowd is hushed, and a spectacular slideshow commences." To learn more, go to *www.slideluckpotshow.com*.

The following interview is with a curator whose career has largely focused upon exploring alternative spaces with artists.

INTERVIEW WITH RADHIKA SUBRAMANIAM, DIRECTOR AND CHIEF CURATOR, SHEILA C. JOHNSON DESIGN CENTER AT PARSONS THE NEW SCHOOL FOR DESIGN

Radhika Subramaniam is the director and chief curator of the Sheila C. Johnson Design Center at Parsons The New School for Design, where she also teaches. She was the director of cultural programs at Lower Manhattan Cultural Council. She has a master in anthropology degree and a PhD in performance studies. Her curatorial practice is cross-disciplinary and dialogic, committed to public pedagogy, critical urbanism, and political and social justice.

Can you tell us your perspective on what it means to be a curator?

Curating has been shifting from the institutional caretaking of collections to a more mediating role. My own practice has been dialogic—creating conversations both with and between artists and audiences—and fundamentally tied to places and ideas. It's an active process of engagement with artists, even more so because a lot of the work I've done has been in the public realm. It's also a kind of research, not of art history or identifying a contemporary trend, but about ideas of the public, memory and history, places and social interactions. I like helping someone think through an idea or inviting someone to think through a site or context with me. It's more collaborative and interventionist work.

What should artists know about working with curators?
Don't assume the curator is the authority or that the curator simply executes a project. Know that there is the possibility of collaboration, or there can be, especially for site-specific work. One has to enjoy that relationship; be open to conversations about changes and adjustments.

Can you tell us about Art in Odd Places?
This is a grassroots, artist-driven, public art project first started by Ed Woodham in Atlanta during the Olympics, as part of a cultural Olympiad, which he revived years later in New York City. Since 2008, he has focused on 14th Street, and in 2009, he contacted Erin Donnelly and me to be guest curators. We worked as a team, put out an open call, and finally chose sixty artists to develop projects to present on 14th Street. The street was a wonderful resource with great historical depth and geographical breadth—a divide between uptown and downtown, with a rich history of protest, vaudeville, and burlesque, manifesting a range of transformations, almost emblematically, from east to west. As curators, we framed this context to explore the theme of the festival "Sign," but we also created the structure for a festival that could draw audiences. We worked with artists to identify sites, help develop their work in those contexts, provide introductions when necessary. There's no way you can compete against the scale of New York City itself, so it becomes important to figure out how you situate your project. We also encouraged artists to look at multiple levels of engagement—the regular passerby as well as different sorts of local communities, including office workers, tourists, bodega owners, and residents—which are different from art audiences, and to consider to whom and where the work had resonance.

What are some of the valuable things artists gain from participating in a public group exhibition that is often ephemeral and not sales-oriented?
The impetus for this sort of work is different. It's about engaging with a place. It's not inherently better or more "relevant" than showing work in a gallery, but it's driven by a different kind of openness to publics. A grassroots project like Art in Odd Places also creates a unique form of camaraderie among artists. There is no compensation at issue here. No one is being paid, neither the artists nor the curators, and it results in some very generous forms of collaboration. We were also aware as curators that we could give artists other kinds of infrastructural support. We tried to provide information and context for doing such work. We also had several workshops that were quite practical in terms of thinking about the legal issues, regulations, stage management, "dry runs," immediate audiences and passersby, staying safe while performing, and so on.

How can exploring public art and alternative spaces enhance an artist's career and art practice?
Nontraditional contexts can have nontraditional results. If you, as an artist, open yourself to diverse locations, contexts, and audiences for your work, you may find that your work takes a different turn. New concerns migrate in. You may find

unexpected audiences. It's possible that these are non-art audiences, but sometimes this can be a happier home, because it's actually the right place to further the sorts of questions, issues, or artistic experiments in which you are engaged. So it's less about saying, "I must find a *place*—gallery, museum—that will show my kind of work," but rather, "My kind of work has the possibility of connecting to various coteries of interest." Then, the world feels like a bigger place.

ALTERNATIVE FUNDING MODELS

There are many new and interesting ways to bypass applying to foundations, grants, fellowships, and residencies through alternative funding sources. Communities have used technology to generate ideas for alternative funding sources. Here are a few examples.

Commission Clubs

The model of the commission club is an excellent innovation for these difficult economic times. The idea is that a group of people can contribute as much as they can afford individually, in amounts that might otherwise have gone to for a dinner out or a trip, in order to collectively create a pool of money to commission a work of art, which would then be attached to the donors for perpetuity. Not a bad trade for missing a couple of dinners out!

Kickstarter

Kickstarter's opening site headline is "Fund and Follow Creativity." It is an online portal that assists artists in soliciting funding for creative projects. Kickstarter is a platform for artists across disciplines to introduce projects to the general public, establish a funding goal, and then wait for the financial support to come in from friends, family, and any other interested parties. Look for details at their site: *www. kickstarter.com*.

Hybrid Models: Entrepreneurial Artists' Collectives

In this case, hybrids are similar to starting your own business venture: a combination of an art gallery, artist's studio, school, and communal group. Artists are banding together to create artistic ventures that sometimes combine artists' work spaces with restaurants, gallery spaces, and workshops that provide equipment and resources and training opportunities.

Good traits to have if you're going to do this: a tolerance for risk, an entrepreneurial spirit, an interest in community building, good organizational skills, a willingness to work long hours on administrative work, strategic planning and budget experience, a comfort level with being in charge, collaboration skills, and energy and optimism in the face of challenges and setbacks.

Some examples of hybrids include:

3rd Ward

3rd Ward is a member-based design center for creative professionals in Williamsburg, Brooklyn. Artist Jason Goodman cofounded 3rd Ward, which provides resources, opportunities, and networking events to their members and the community. The

space houses photo studios, a professional wood and metal shop, a digital media lab, and a large interdisciplinary art education program. 3rd Ward is a great example of artists applying their creativity and entrepreneurial skills to create a community and sustain their careers. See a full interview with the creator of 3rd Ward in chapter 15 of this book (*http://www.3rdward.com/*).

Mess Hall

Mess Hall is a cultural center based in Chicago where artists host exhibitions, discussions, film screenings, workshops, concerts, and "brunchlucks" (brunch + potluck).

According to the organization's Web site, "Mess Hall is an experimental cultural center. It is a place where visual art, radical politics, creative urban planning, applied ecological design, and other things intersect and inform each other." To learn more, check out their Web site at *http://messhall.org.*

We would like to introduce you to one of the first artist-run collaboratives, still in operation today, through an interview with its current director, Kat Griefen.

INTERVIEW WITH KAT GRIEFEN, DIRECTOR, A.I.R. GALLERY

Kat Griefen has been the director of A.I.R. Gallery since 2006. Griefen is also an independent curator and the New York coordinator for The Feminist Art Project. Her recent exhibitions include "Material Matter, American Abstract Artists," at "A.I.R. Gallery: The History Show, works and archival materials from 1972 to the present," with Dena Muller and Carey Lovelace at A.I.R. Gallery and at New York University's Tracey/Barry Gallery.

Tell us about A.I.R. and its history and mission.

A.I.R. (Artists in Residence, Inc.) Gallery was founded in 1972 as the first artist-run, not-for-profit gallery for women artists in the United States. A.I.R. opened in response to the fact that gallery doors were closed to women artists in the 1970s. Women's art was often political, ephemeral, about personal lives, and therefore considered unsalable. More than 90 percent of galleries in the United States were not showing any women artists in the 1970s. Initially, the interest was in creating a place for art that couldn't find a home. The founding members of A.I.R.—Dotty Attie, Maude Boltz, Mary Grigoriadis, Nancy Spero, Susan Williams, and Barbara Zucker—asked another fourteen women artists to join them. They established their mission: to advance the status of women artists by exhibiting quality work by a diverse group of women artists and to provide leadership and community to women artists. We are still doing that today.

From the beginning, A.I.R. held a "Monday Night" program series, later called Current Issues Series. Through these free, public programs, many significant women artists and art professionals also found a place to showcase new work and ideas at A.I.R., including poets (Patti Smith, Anne Waldman), performance artists (Holly Hughes, Carolee Schneemann), filmmakers and video artists (Joan Jonas, Ana Mendieta), curators, critics, and art historians (Lucy Lippard, Rosalind Krauss,

Marcia Tucker, Roberta Smith, Arlene Raven), and gallerists (Betty Parsons, Holly Solomon, Kathryn Markel). These are only a few of the many distinguished participants in the gallery's diverse programs, which ranged from theoretical panels to round table sessions to evenings devoted to the practical aspects of art making to professional development programs.

How is your artists' cooperative structured and run?

The basic membership of A.I.R. is kept at twenty-two New York artists who, through monthly board meetings and participation on active committees (Finance, Membership, Exhibitions and Open Calls), are the governing body of the gallery. The member-artists determine the direction of the gallery and vote in new members. In the early years, the artists helped "sit" the gallery each month, but now a professional staff takes care of most of the administrative work. Each artist is in charge of her own exhibition; that is, she curates and installs her work, allowing for experimentation and risk not always possible in commercial venues. Integral to A.I.R. has always been professional practices programs for artists. We are a dues-paying structure, but we are also funded through government support, family foundations, and generous individual donors. We have a diversified funding strategy that also includes benefit exhibits and events. How do you build community, share your techniques, and sustain community over time? As times have changed, so have the needs and makeup of the organization and therefore the programs. We've adapted by listening to our members, constituents, and audiences. For example, in the 1980s there was a backlash against feminist art. As government funding dried up, the individual members had to get creative to cover the financial gap. At the same time, the gallery membership decided to extend the programming into a larger community and the National Artists Program was established. The National Artists Program offered women from across the country and the opportunity to exhibit their work in a New York City gallery, where they could gain exposure to critical attention and an opportunity to network with other women artists from across the nation.

In 1993, the members, particularly Stephanie Bernheim, again recognized the need for change, and our fellowship program was established. Now, each year, six outstanding emerging or underrepresented women artists join the program, which does not involve any financial commitment, but instead is a kind of launching pad. The elements of the program are a solo show, professional practices workshops, monthly meetings with their peers, studio visits with art professionals, and mentoring. This is an artist-run structure and we encourage our artists to support each other and share resources.

In 2010, the National Artist Program was expanded to include international women artists to foster a global dialogue. The national and international members enrich the gallery by offering a broader view of current art practices and introduce regional and global perspectives, issues, and visions.

Who are your members?

Our members are all women artists, although we do offer opportunities for men to exhibit in some group exhibitions as well. I am pleased to say that our membership programs are open to self-identified women/transgender women artists. Through open call–based exhibits, invitationals, and our alumnae program, more than five hundred artists exhibit with us each year.

The programs are open to artists in all fields of the visual arts working in any medium or material. And we work and partner with many arts professionals and art organizations: academics, curators, professors, critics, museums, other galleries, etc.

We also reach out to teachers in undergraduate and graduate programs to offer our opportunities to younger artists. Regularly, groups from colleges, elementary schools, and local high schools visit the galleries for a tour and a discussion of the exhibits on view and the gallery's history.

What is the secret to your success, and why do you think you've been able to last as long as you have?

The success of A.I.R. is that it has never closed its doors, even when we have struggled financially. The secret is to stay relevant and be responsive to changing needs in your community as well as the funding community. Most important is to listen to your membership. As director, I have a good relationship with the board and staff because it's based on mutual trust and careful planning, as well as some willingness to take risk and pioneer new areas. I try to keep our relationships open through dialogue.

Have the exhibition opportunities changed for women artists since A.I.R. opened?

Despite all the efforts made by women artists and advocates like A.I.R. Gallery, things have not changed as much as we would have liked. Statistics indicate that of artists showing in Chelsea (New York City) between 2006 and 2007, only 23 percent were women (*http://www.brainstormersreport.net/ArtWorldOpp.html*). That's not very high, I'm afraid. These statistics show that it's still necessary for a gallery like this to advocate for women in the arts. At the same time, due to amazing efforts by women artists and art professionals nationwide, the past five years have shown a huge surge in interest in women artists and feminist art, including recent large-scale exhibits such as "WACK, Women Art and Revolution" curated by Cornelia Butler and "ELLE@CentrePompidou"; the founding of new institutions such as the Elizabeth A. Sackler Center for Feminist Art at the Brooklyn Museum and the Feminist Art Project; and significant publications such at MoMA's new *Modern Women*. This is has been encouraging, as our vision continues to be to work with women artists at all points in their careers, offering them opportunities to exhibit, build community, find resources, and grow in their work and careers.

❧5❧

Creating a Strategy for Exhibiting Your Work
by Rhonda Schaller

R honda Schaller is an artist, gallerist, private creative/career/life coach, and author of the book Called or Not, Spirits Are Present. *She teaches creative visualization, career strategies, and professional development courses for New York's School of Visual Arts in the MPS Digital Photography program and School of Continuing Education.*

Art is a conversation. Your work is both a product and a dialogue that you are having with yourself and a particular audience, a targeted audience. What connects the work and your audience is you. The more you know yourself, the more you know your work, and then the more you know your market, the better you'll get at placing it in the venues that are the best "fit." And the better you'll get at transforming existing models into a form that fits your needs.

The art world is a market-driven business, like stocks, like real estate, like most commodities, and it is changing, as is the entire world market for art. The good news is that everything is in flux right now, and a lot of the old models are dying and new models are rising up everywhere. This is great because the majority of artists were locked out of the old gallery models. It has been said that the entire world is a gallery, and I believe that to be true. There are many exhibition alternatives available to you. Pick the alternatives that allow you to create and market your vision with a sense of authenticity.

Art at its very essence is a medium of exchange, an exchange of ideas and perceptions that happen out in the world. You need to truly understand why you make your work, and who you think will benefit from experiencing your work. Think of everything, if you can, from the point of view of your audience. How do they relate to what you have to say? And what do they really want from you and your work? Those insights will help you make the right choices to move your work into that all-important exchange of ideas, wonder, beauty, and money.

I have found that art schools do not teach how the art world functions and what you, the artist, should do or what you need to know. Even if the market

for art is changing and new models need to be created, you need to know how it has worked, how it works currently. Then you can make choices that fit your aspirations and goals.

As a serial entrepreneur, a working artist for the last thirty years, and an independent gallerist for five years, I advocate for an alternative mind-set with an entrepreneurial component. Based on my research and what I have learned from talks with independent curators, curators of museums, wealthy collectors, everyday people who love art, and reading blogs—I especially like Ed Winkelman's (http://edwardwinkleman.blogspot.com) and Derek Sivers (http://sivers.org)—I have collected a lot of information I would like to share with you. This will help you to create a do-it-yourself (DIY) model for developing your exhibition strategy. It's not as hard as it sounds, and in this chapter I will take you through the steps to get there. You need to create an economic base for yourself and an exhibition strategy in which you can share your vision with others.

EMBRACING AN ALTERNATIVE MIND-SET

Let's take a moment and define alternative. It can be a space where you show (a venue that is not a traditional commercial gallery, as discussed in the previous chapter), and it can also be defined as a strategy (why you show), and it can be a thought process (how you create your showing opportunities). In other words, by alternative, we are referring to spaces, mind-sets, and strategies that are not mainstream, and in some cases, can be unexpected, surprising, and unique depending on the audience to which they cater.

An alternative mind-set is a way of thinking outside of the traditional box on how to reach an audience and develop a conversation over time within a community you build. Building an authentic conversation over time with an audience is the heart of making your work public. Making it public in alternative spaces or spaces you create allows you an enormous amount of control over the medium and the message. You also need to know what success means for you. Then, you can target your message and create a strategy to help you reach out and create a community for your work, an audience for your work, and a following for your work. This is what is going to sustain you and help you feel good about your choices.

When you choose to exhibit and to make your work public, especially in alternative spaces, you are participating in a movement that states that art is necessary, for you, for the health and well-being of the culture, and for the renaissance of the human spirit.

THE ART WORLD IS CHANGING

The world of gallery representation is not what it was ten years ago. Many of the old rules and models no longer apply or even exist. I wonder whether the economic system of the old gallery model has run its course and outlived its usefulness. It's time for a change from the model of the art gallery, the art star, the

"I must be in New York City or another major urban art center," all or nothing, sometimes totally ego-driven career model.

When something is old and dies, something new is born. Renaissance means rebirth. I think it is time for artists to create a more satisfying lifestyle and career path for ourselves. Create a conscious movement to rethink and reevaluate what we value, to make a difference and make a living. It requires a whole new way of thinking, an alternative mind-set where we think for ourselves, make our own decisions, and offer quality and value to our audience, something people can believe in especially while the world is in enormous economic flux.

Whether you are freshly graduated, an emerging artist, or mid-career with years under your belt, this current changing climate gives you an enormous amount of freedom to do something brand new, authentic, and sincere. As an artist, you have a great opportunity before you.

Your credibility as an artist does not have to rely on fame or glamour. It relies on your message and your craftsmanship. It relies on relationships you build that can bridge your work to that audience, either directly when you self-produce or indirectly when you go through a dealer or curator.

WORKING WITH DEALERS AND CURATORS

Art dealers are a part of the art-as-commerce equation. Curators are part of the art-as-education equation. Artist-run galleries, co-ops, alternative spaces, juried shows, and the Internet are making it easier for artists to find a market on their own. It comes down to relationship building. It takes time and effort, but it is the most important aspect of being an artist. Throughout your career, you will need to build relationships with one or more of the following: dealers, curators, collectors, critics, friends and family who will buy your work, and other artists. Let me define some of these potential partners for you so you can understand the roles and value of each.

Art dealers are a part of the private partnership with artists and clients. They are part of an art-as-commerce equation. A gallery dealer is sometimes called an art dealer or gallerist. Art in galleries is shown to sell. When working with an art dealer, it means that art is for sale through the dealer. Venues can include commercial galleries, art fairs and expos, corporate art consultancies, private dealers doing private deals, and private showings or salons.

Newspaper reviews are egalitarian, and self-producing artists can find their way into the "public" press easily. Online Webzines and blogs are great ways to get the word out about your work as well. However, a commercial gallery can provide additional market opportunities beyond what an artist might find on their own. A dealer can help raise prices if they have a strong collector base, and that is nothing to sneeze at. And, if they have a decent advertising budget, can create higher audience traffic through well-placed articles and more reviewer opportunities with art magazines. This can lead to higher price points. Museum or exhibition curators are part of the public partnership; this is the art-as-education equation. Art is loaned to, underwritten, funded, or purchased by an institution.

Curators create shows to educate the public. Art is shown as part of a larger theme. Venues can include: nonprofit galleries, museums, university galleries, public for art projects, public commissions, and artist residencies.

Some artists who operate outside the art world structure have a harder time ending up in museum collections and private collections, and the dealer is the main contact to enter into established public collections. I have found it satisfying to create relationships with museum curators and collectors directly as an artist, and have found my way into their collections through those relationships.

Independent curators are part of both the private and public partnership. They are not affiliated with an institution, they create exhibitions around a central theme, they select artists that fit that theme, write proposals to/for alternative spaces to house their ideas. Work is usually for sale but not always. Shows can be underwritten or funded. Venues can include: alternative spaces and art salons, university galleries and public spaces.

ALTERNATIVE MODELS VS. COMMERCIAL MODELS

So how do you innovate during these interesting times and make a living? How do you create an art career step by step in an alternative universe? One way is to brainstorm new ideas and collaborate with other artists. Another is to place your work in the right communities, with the right audience. Always assess what matters to you and do your research. There are new groups and new ideas being created daily by fascinating business-minded artists and innovators creating their own models. A great example of this is No Longer Empty (www.nolongerempty. blogspot.com). Here you have a collaboration of curators and artists working together in a private/public partnership exhibiting work in vacated storefronts and properties around New York City. I especially like this quote from their blog: "We see an opportunity here to create something positive from the current (economic) climate. Art can thrive in this environment and lead the way towards creative ways of thinking and dealing with these changes ... installed not in traditional gallery or museum settings but in the public domain, suggesting new models of community art."

Everywhere you look you will discover new models of community and art. Here is a way for you to engage in it: challenge your thinking and creative process with a plan. This exercise will help you with the steps to getting your work seen by creating your own exhibition plan.

Make a chart with the following answers to these questions:
1. What is your idea?
2. What excites you about your exhibition idea?
3. If you have a few ideas, what do you like best about each one?
4. Where did this idea come from? How did you come up with it?
5. How will you get others excited about your show?
6. Who will you reach/invite, and why?
7. What steps can you take to turn your idea into a plan?
8. How can you make sure your momentum is not lost?

9. Who will you ask to help you?
10. Who would make a good collaborator? Why?
11. How will you research the right venues for this idea?
12. Make list of three to ten possible venues, with pros and cons for each.
13. Create a timetable with deadlines: what will you accomplish and by when.

ALTERNATIVES VENUES THAT USE COMMERCIAL MODELS

There are many different types of alternative spaces to show your work and to help you develop an audience. Five years from now there will different venues to discuss that have not even been created yet.

Some of the alternative spaces with entrepreneurial aspects/frameworks are art registries and flat files, online galleries, artist communities, co-ops, collaborative spaces, artist–run spaces, nonprofit galleries and art centers, artist fairs, open studios, private art salons, studio galleries, public art commissions, online auctions, eBay, lobbies, subways, taxi cabs, street corners, empty lots, building walls, fields—any space that can be redefined and transformed through art. Plus, there are juried shows, open calls, artist residencies, public art projects, guerilla art happenings, unconventional commercial galleries, university galleries, and museum collections and biennials.

Be selective with the alternative galleries you target. You have to know exactly where your work falls within the art world, alternative or commercial. Just as in commercial galleries, established alternative venues that work only with feminist mid-career artists (for example the A.I.R. Gallery, a women's co-op) will not be a good fit for emerging younger artists who've never shown before unless they state that in their submission guidelines for a particular program or exhibition call. If you make spiritual abstract paintings in oil, then don't approach galleries known for sculptural installation work or who specialize in Korean video art. Spend months visiting venues and Web sites looking for the right fit and understanding the submission criteria.

ONLINE GALLERIES, ART REGISTRIES, ART FILES, JURIED SHOWS, AND OPEN CALLS

Many curators and gallerists find artists for shows by looking through online galleries and art file sites, viewing collections of JPEGs of images that artists submit to registries and house online. Curators of nonprofit galleries and art centers will use them to curate their own shows.

I like online galleries and portfolio sites. I run an online gallery at *http://www. rhondaschallerchelsea.com*. Many years ago I remember being included in "Night of 1,000 Drawings" show at Artist Space in support of their mission. It was because I had my slides on file in their art registry and was invited to participate; drawing sold, and I had a new collector to add to my mailing list. Independent curators will visit art registries to find artists to include in their proposals for shows. Online files consist of Web site portfolio sites of groups of artists, where independent curators

and alternative art dealers and art reps look for artists. When I was running my bricks-and-mortar gallery in Chelsea, in New York City, I always looked at Web site portfolio sites for lesser-known artists for my group shows. I also would advertise on my Web site and created calls for entries.

Many curators like to "discover" artists on their own, and these registries and sites are a good place to have your work. Being part of artist registries and online art files can lead to exhibition opportunities, and sales to private collectors from all over the country and the world. Research the ones you feel an affinity toward, either because of their mission statement or you can relate to the other work they have on file. Google them, see if they are being talked about on blogs or if there is any feedback to help you pick and choose. Then follow your intuition; if it feels like a good fit, go for it.

To begin to create a visibility trail, it is important that people be able to Google your work. In addition to your own Web site, there are portfolio sites that have multiple artists. There are some wonderful online galleries to be a part of, and then there are those to avoid. You will have to decide, based on your goals, which ones make sense to you.

Again, research the reach of each site, see the artists who participate, and research what a variety of artists likes or dislikes have been with their involvement. Then, weigh it against your goals. Are you looking to increase your audience, experience, or sales? Ask yourself, which online gallery has work that you relate to and feel you would like to be a part of? Every artist needs to decide what the ROI (return on investment) is for any exhibition, and then budget and participate or not accordingly.

A few sites I like are Retitle.com, Artslant.com, Saatchi online, Ugallery.com, boundlessgallery.com, sculptr.com, and wooloo.org. There are many others. There are some artist communities online where you might want to consider uploading images, résumé, and artist statement. People sometimes use a combination of portfolio sites.

Lately I've seen artists begin to use LinkedIn for slideshares of their work, which I find to be a really interesting development. LinkedIn is a professional networking site that has forty-five million users! Many people collect art, and I would be curious to see how audience development builds for artists using this site. Some old standards are deviant art, absolute arts, artists register, and let us not forget eBay storefronts. The artists PsychesMirror and Mark Kostabi made great use of eBay for sales of paintings and drawings, and many more do as well.

Having your art seen is simply part of being an artist, period. You decide what kind of conversation you want with the public, and then it's simply a case of learning how to handle the business side of your transactions. That includes marketing, shipping, sales, and taxes. It is not hard to do: if musicians can do it, fine artists can do it. There is a wide range of channels to work with.

Now, how do you decide which ones are worth the effort? We go back to your goals. Who do you want to find you? Where do they hang out, and where will they look for what you have to offer? Talk to other artists who are using these sites, and ask questions! Find out through networking and researching if your audience visits the sites you are considering. If you do not know, then try it for a

while, and then assess it. Is the return on your investment of either time or money being returned to you in ways you want, in ways that make sense for you? As an exercise, create a chart, such as on the following page, to list and compare the different types of alternative spaces you are considering approaching.

Type of Alternative Space	How does this space fit in with my goals?	Who do I know who has done this before?	Who can I contact for advice?	Next Steps: 3–4 things I can do to move this idea forward	Deadline: When will I do this
Example #1: Open studio show (self-produced)	I want to increase my audience and sell work. I want to practice putting up a show and seeing how it feels to have my work in the public eye.	3 artists I know (Frida, Kiki, and Louise) all have done this before and said it was a blast.	Frida has done this loads of times and will tell me what I need to know. If I can't reach her, I'll e-mail Kiki and ask her out for coffee.	1) Call Kiki and pick her brain on what to do and when to do it. 2) E-mail Andy and Sal to see if they will do this with me. It will be more fun to do it with a group I trust. 3) Make a list of all the people I know who I can invite. Keep adding to it until the show. 4) Pick a date to have the show, and have something to aim for and look forward to.	Tomorrow Thursday Start today and finish by Jan 1 (day of the show)
Example #2: Join a pop-up gallery	I want to expose my work to an established art audience and gain experience showing in a gallery-type setting. I want to see what it's like to pack, ship, install, hang, and then market to a public I don't know.	Rachel, Matt, Sam, and Joe	Louise started an impromptu gallery in the empty lot on Avenue Q and would have a lot of great advice on how to pick a space and submit	1) E-mail Sal and ask if we can get together to talk. 2) Take high-res photos of my recent work 3) Update my artist résumé and bio for my submissions packet. 4) Make new work.	Wednesday Sunday and Tuesday, Friday Saturday and Monday Start on Sunday and finish by March 1

DO YOU WANT TO PURSUE AN ALTERNATIVE OR COMMERCIAL ROUTE?

Self-producing is a term that covers creating your own shows and showing in alternative spaces. When you self-produce, you pick the alternative venues you want to show in or create your own, choose what you will show and when, then do your homework on the right fit in the right venues or locations, and go all out promoting yourself.

You may plan to go after a commercial gallery—even an unconventional one, which may have a lot in common with alternative spaces, but is still in the business to promote visual artists and sell (like Mixed Greens, *http://www.mixedgreens.com*). If so, you have to ask yourself if your work belongs in the commercial art world. If you want to sell your work, where does it fit? This is an important question to ask yourself. Not all artwork belongs in commercial galleries. Not every show has to sell. Not every artwork needs to be seen in a major city.

If you are going to look for a gallery setting to showcase your work, you have to know if they show work that is not for sale, or only for sale. What is the price point, who do they feature, who do they cater to, and why should their audience care for your work? An important question to ask: do they accept submissions or not?

What enhances alternative spaces and alternative galleries is that there is always a community aspect to the space: a belief in the noncorporate underpinning to its reason to exist. Plus there are many alternative spaces that show affordable work and create a sustainable living for their artists.

A great example of this is the Bread and Puppet Theater's Cheap Art Philosophy. Bread and Puppet, started in the 1960s by founder and director Peter Schulmann, is a politically radical puppet theater based in Vermont. The Cheap Art movement was launched in 1982 by the Bread and Puppet Theater in direct response to the business of art and its growing appropriation by the corporate sector. Cheap Art ranges in price from five cents to fifty dollars and anyone can participate. To read more about this inventive concept, go to *http://breadandpuppet. org/cheap-art-philosophy.*

As you research the spaces to show or opportunities to create, you need to ask yourself how this space fits in to your overall plan. Let your research guide your decisions, help you plan out your next steps, and help you determine what to show, where to show, and who to invite.

You need to figure out or at least begin to ponder who your market is. Why do people want to see your work? Why do they want to own your work? You must begin a journey to define your niche and your market to determine the route you want to take to promote your work. Make no mistake, you need to do this as a self-produced artist, showing in your own spaces or with alternative spaces and independent curators. You need to do this in a commercial gallery as well, so you pick the right ones to target and know their audience so you can pitch your work effectively and build a collector base with them.

Here are a few important questions to ponder:

- Is your work for sale or salable?

- Is your work for show? Can it be owned or simply experienced?

- Where do you think your artwork belongs in the art market?
- How will your work will be viewed and in what context?
- Whom you would like to reach with your art? Who is it for? And why should they care?
- Who is your audience or potential audience? Who is your market?
- Are you reaching the people you want to reach through this venue?
- Are you gaining experience, contacts, press, building audience, enriching community through this opportunity?
- Does this venue help you meet your goals, short-term or long-term?
 - ★ Is this a one-shot deal or will this opportunity lead you toward others?
- If you show, what is the return on your investment of time, energy, and money to promote it? Which galleries cater to your audience?
- Who are you developing a dialogue with? Where do they congregate?
- Finally, where is work in your style, by artists with your aspirations and dreams exhibited?

Every showing opportunity, every collaboration, has lessons to be learned in the process, and if you keep your eyes on creating a variety of experiences over time, you'll learn to discern the right experiences for your work. You'll build a following one show at a time and learn by taking risks. Along the way, don't forget to collect e-mail addresses for your database!

Do Your Research!

I can't emphasize enough how important it is to do your research. If you are embarking upon an exhibition submissions push, then I suggest that you dedicate time to do your research every week. Commit time to research by putting it on your calendar: one day a week to visit spaces, Web sites, read blogs and journals every week. Stay on top of the trends. You won't regret it. You'll become educated in the fields in which you want to show your work. Your goal is to know your audience, know your options, and to place your message into the conversations where they fit.

The Art in America Summer Guide is one great resource of many. You will find lists of commercial galleries, alternative nonprofit spaces, independent curators, museum curators, university galleries, and more in order to research good matches for your work. One summer I made a large prospect list from the AIA guide, matching prospects with my work. I developed a submissions packet and query letter and, with the help of a part-time intern, sent out a catalogue with a note to introduce my work across the country. This one effort resulted in seven shows and one museum purchase.

Don't worry if you're not sure where your work belongs. You will discover it. You will learn a lot by trial and error. Keep a sense of humor. Take the time to start

going to shows, reading art magazines and journals, go online to check out blogs, talk to other artists, and assess the scene to figure this out. This is the best way to research your potential markets or showing venues, whether they are commercial, self-produced, or alternative. When you know what you want, you can research cities across the U.S. and countries abroad to fit your vision.

A targeted strategy based on your research is key. Once you have done your research and understand who your potential market is, make a list of the spaces and venues that will give you the visibility to reach your potential audience. If you want to promote your work to a large variety of people and venues, it will take work and time. But the right strategy based on good research will pay off your entire career and save you from needless rejection.

Without good research, you are flying in the dark. A targeted search is the key to your strategy and an important step in building your art career. So you are promoting yourself in productive ways that create new opportunities and relationships.

Self-Produced Exhibitions vs. Working with Commercial Galleries
Let's compare self-producing and working with a dealer. Self-producing means creating your own shows in a variety of spaces, exhibiting in alternative spaces, or working with independent curators or artist–run co-ops. Working with a dealer means working with a gallerist who will promote and sell your work for commission off of the proceeds of sale, normally 50 percent.

Advantages of Working with a Commercial Gallery
The advantages of working with a commercial gallery in my view can include:

- Reviews in major art magazines
- Larger audience and higher prices
- Easier access to senior curators who control purchase awards for museums
- Greater likelihood of high volume sales
- Feeling validated as an artist

There are advantages to working with a good gallery dealer beyond what an artist might find on their own. The right dealer can be the main contact to enter into established public collections. Dealers can place articles and create more reviewer opportunities with established art magazines. If they have a good following, and a decent advertising budget, they can create higher audience traffic through well-placed articles and more reviewer opportunities with art magazines. This usually leads to higher price points and an expanded audience. A dealer can also provide market opportunities and help raise prices if they have a strong collector base that relies on their advice and is worth their weight in gold.

For some artists, working with a dealer is a matter of validation: they feel "real" and get an ego boost from identifying as an artist in a gallery, whether they make any money at it or not. If this is the meaning of success for you, then you

need to build a business plan around it. Ask yourself: does wanting validation from a commercial gallery hinder your ability to realize your goals or fuel your action steps?

Disadvantages of Working with a Commercial Gallery
Disadvantages can include:

- Finding a gallery who will work with you in the first place can be a dispiriting adventure, ego-deflating, and downright frustrating and demoralizing
- Once you get a dealers attention, it can take years before your first show
- Making enough money to split with the dealer
- Not being allowed to take creative risks in your work
- Not being able to deviate from a style that is selling well
- Being locked into a relationship and a showing cycle that is unfulfilling

Finding a gallery who will work with you is very hard work and can take a long time if it happens at all. There are more than four hundred galleries in New York City alone, and the majority do not have a submissions procedure and are initially not terribly friendly toward artists. The ones who are usually do not work with artists who do not have a track record. It can be a dispiriting adventure, ego-deflating, frustrating and demoralizing going gallery shopping.

Once you get a dealer's attention, it can take years before your first show, so you need a lot of patience. When working with a commercial dealer, a lot of artists complain about not being able to deviate from a style that is selling well. You still have to network, you still have to market, you still have to pay for some expenses out of pocket when working with a gallery—just not as much or as hard as being self-produced.

Working with a commercial gallery does not mean they do all of the work for you, that they make you a star, that you are set for life, or that you still don't have to pay out of pocket for advertising or other show-related costs. It is a business partnership, not a supportive family. Dealers do not make you a star. There are no guarantees when working with a gallery that your work will sell or sell enough to make a living. With the changing economy, the gallery model might go the way of the dinosaur.

Advantages of Being Self-Produced
The advantages of being a self-produced artist can include:

- Control over your exhibitions and what work you show and where
- Tailoring your market message for your style and changes in style
- Ongoing dialogue that can support your work with alternative or fringe folk
- Not sharing the proceeds of sales and choosing your price point
- Deciding how often you want to show

- Not being locked into one space or one city or one style
- Independence in creative direction and installation freedom
- Being your own boss and an entrepreneur

By self-producing your own exhibitions, you can create relationships with museum and university curators as well as collectors directly. You can get newspaper reviews, art zines, and blog write-ups directly. In addition, you can create your own market and loyal collector base. It also can include showing in alternative regional out-of-the-way spaces that may or may not be commercial, but provide sales and a livelihood.

Disadvantages of Self-Producing Your Own Exhibitions
The disadvantages of being self-produced include:
- Having to work at creating, promoting, marketing, funding, etc.
- Creating a marketing plan and sticking to it
- Sustaining a creative business on your own initiative
- Maintaining your studio practice day to day
- Handling the finances, budgets, sales tax
- Being your own boss and an entrepreneur

The hardest part of being self-produced is sustaining a creative business on your own initiative. You are your own boss, which is both good and bad, because it is up to you. You have to work at creating a body of work, promoting and marketing, and getting funding for it. You will need to create a supportive community to support you. And you will need passionate, inspiring people around you to maintain your studio practice day to day.

Both being self-produced and working with galleries have advantages; both have disadvantages. I hate being told what to do, so I love being a self-produced artist. I have loved being a gallerist (nontraditional) and choosing the artists I promote. The key for me has always been control of the message, control of the medium. You have to find what works for you.

If you choose the commercial gallery route, what *NOT* to do:
Stop sending unsolicited JPEGs and slides to hundreds of galleries that you do not know. Stop sending unsolicited e-mails with JPEGs. Stop sending unsolicited packets in the mail. Stop going into galleries with a CD or your portfolio in hand and asking them to look at it and being insulted when they say no. *Stop.* They will not discover you that way; you will only annoy them.

You need to learn good solid business principles. That means being targeted in your approach if you want a dealer to really consider your work. Know which dealers are accepting submissions and know the dealers for whom you are the right fit. Do your research. You should choose the gallery that's right for you by

carefully studying their curatorial ideas and exhibition program to make sure it is a good match for your work. Know if they have a submissions policy and procedure. Begin a networking plan to meet them at their level—make conversation about *them,* not about *you.* Build a relationship. Over time, stay in touch, build the network, and have patience with the results.

When I had my bricks-and-mortar gallery in Chelsea, I would get a thousand unsolicited submissions via e-mail every year. I still get them, and I have moved my gallery to an online format. *I delete unsolicited submissions.* Not because I am mean—I am a motivator, a gallerist who loves emerging artists and helping others. I will not look at unsolicited work unless I have posted a call for submissions on my gallery Web site, and neither will most other dealers I know. Why? Because they are busy positioning the other artists they have already made a commitment to work with. When I have the time to look at artwork from artists I do not know, I state it up front. Then, I look, I comment, I curate—life is good.

Do not send submissions to a gallery that you have never even been to. Visit the gallery many times during the season and look at different shows they host to make sure their curatorial style is the right fit for your work. Visit their Web site and review the shows they curate and the lists of artists they have exhibited. How do you compare in terms of style, level of success, and medium? Is the gallery accepting submissions at this time? You must know this in advance *before* sending your "I am an artist looking for representation" e-mail if you want to seriously be considered for a show.

THE POWER OF CREATING YOUR OWN OPPORTUNITIES

I started Ceres Gallery in 1984, in New York City, when I was twenty-six years old, just a few years out of art school with a group of women. We created a space for women to perform and show, which is still going strong twenty-six years later. In 1998 I created the Rhonda Schaller Studio, now called Schaller + Jaquish Art Projects, where I transformed my working art studio into a gallery. As I painted, I showed hundreds of artists and sold 80 percent of their work, plus my own inventory each year.

I believe that your role in society is to elucidate, illuminate, entertain, educate, transform, represent, and dictate culture and ideas for the greater good. How you do it is totally up to you. You have enormous freedom to participate in the cultural exchange of ideas and commerce.

The mainstream art world has limited resources and outlets. The alternative art world has limitless resources and outlets. The odds of your creating a career that involves your art making, your art vision, and making a living from that vision solely depends on your ability to create a vision, form a community, develop a plan, and market your message professionally. Then work your butt off—embody the entrepreneurial spirit in your creativity, and there really is no stopping you. Take a risk, be inventive, collaborate with others, start a movement.

❧6❧

Community Building and Networking for Artists

In order to launch and sustain your career, you will need to cultivate relationships with a supportive community of fellow artists, art world professionals, family, friends, and mentors. Many artists struggle with the disconnect between their vision of the artist working in the studio and the professional development tools, such as networking skills, they need to sustain their practices. While an artist needs to dedicate significant time to working alone in their studio and focus on developing their work, they also need to understand that producing their work is only part of their life as an artist. The art world operates on reciprocity, and relationships are often the key to connecting with jobs and finding exhibition opportunities. The support of your community will be essential for sustaining your motivation and commitment as you launch your career.

A strong community can also support your emotional well-being and enrich your artistic practice. Artists often perceive the art world as having limited opportunities and therefore view their peers primarily as competition. This isolationist attitude, which is sometimes rooted in a fear of public exposure and rejection, is self-defeating. Working alone in the studio can also be depressing and unproductive if you don't give yourself a break from being inside your own head.

Artists need to recreate the community they once experienced as a student in art school, where they were surrounded by peers and faculty who gave them regular feedback. Making the transition from school to life is a challenge because in college, artists work in a highly structured environment with support services, classes, exams, end-of-year shows, and a community of fellow artists. But the whole rhythm and structure are suddenly gone once you leave school. Artists must learn to create their own goals, structure, and community. In order to sustain a lifelong career, artists need to open themselves up to the risk of sharing their talents, time, and information with others.

BUILDING YOUR COMMUNITY

The first step in building your community is determining who you want to have in your network and what role you want them to play. Take stock of who is

in your community now. Consider who your family, friends, and colleagues are. Do you need to reach out to new people? What are your weak spots in regard to your career, financial, and personal needs?

ASSESSING YOUR CURRENT CONTACTS

While it may sound calculating to analyze your friends, families and colleagues in relation to your career, this is an essential part of building a community to support your arts practice. Your friends and family share the desire to see you succeed, so think of that if you balk at this exercise. Begin by classifying your friends, family, and current contacts by the role you want them to play in your life and what you want them to do for your career or other needs: colleague, curator, friend, mentor, et al. Look at how your friends function in relation to your career. You can mix business and pleasure, so consider if a person is a friend or colleague and assess how you want to interface with them.

Next, consider how close your relationship is with your current contacts and think about how close their relationship is to you and how strong an impact they have on your life and work. Note if the contact is someone you have a more distant relationship with; this could be someone who you are exposed to but not someone you can call on for immediate help. Look closely at these more distant contacts, is there someone there you want to transform into a closer contact with more immediate impact on your life? If so, how can you nurture that relationship to create a closer bond? For example, perhaps a faculty member you studied with in graduate school has a blog—try commenting on their blog posts, send them show invitations, and invite them to speak at an event you are organizing. Small gestures and opening up these brief dialogues can help relationships become closer and richer.

NETWORKING AS A MIND-SET

The following are tips for how to make networking a habit, a mind-set, and a tool for your career.

Understand that the art world is a *small* world; everyone around you is connected and can have an important impact on your life. From the receptionist at a gallery to your former classmates, all have connections to people who matter, and someday they could become someone with power, so it's important to be gracious to everyone and to help others when you can. That gallery assistant you took the time to chat with could become a gallery owner someday!

Pay it forward: speaking of helping others, don't forget that relationships do develop over time and someone you help today (a fellow artist whom you recommend for a part-time job or help find a resource) could be in a position to help you tomorrow. Make generosity a habit.

Be theoretical about building your support team: Who is your cheerleader, your hero or role model? Who supports you for funding and for professional mentoring? Consider who writes and works in your style or with similar themes

and ask yourself if you need to nurture relationships with people who are more attuned to your sensibilities and interests.

Diversify your community: ask yourself if your community has people both inside the art world and outside of it. Your art contacts should also be diverse. For example, you shouldn't just have contacts who are fellow studio artists. Develop friendships with curators, gallerists, educators, and other arts professionals. Also be sure your community has geographic variety, extending beyond the city or town where you currently live. You never know where the next opportunity will come from.

Your network should support your core goals and values; your network building should be meaningful and follow a plan, not be scattershot. Think about the goals you began to articulate when you read chapter 2 of this book. Does your current network support those career goals?

Try the following exercise to see who is in your network and what relationships you want to further build on. Document your current contacts and start a wish list of contacts on an Excel spreadsheet. List your current contacts broken into sections:

- Existing Network: Who do you know now? Where are the gaps? List those you currently know well and have strong connections to: art colleagues, friends engaged in arts, all other friends, supervisors from past internships and jobs, faculty you've worked with, art world contacts, such as gallerists, art handlers, anyone you can think of.

- Distant Network: Now list people you can reach but just barely know through your existing network.

- Desired Connections: Next, list people you don't know but want to have in your network. Look at your self-assessment and consider your work and whether it best fits with alternative or commercial spaces. Your style of work and your geographic location should inform this "wish list" of contacts, but don't limit yourself either. Who can your alma mater help you contact through their alumni association?

The following are networking tips from Angela Yeh, president and founder of Yeh IDeology-Design, Strategy & Innovation Recruitment.

Join the Community Where Your Goals Are

Network with your target community in mind. Think about your goals and the makeup of the community. Find organizations, trade shows, people, and industries that meet your goals. Go to those events and get to know the people in those communities, because often they care about the same or similar goals and they can help you reach your goals.

Listen

Think of networking as a collaborative activity. People think the first stage of networking is blasting out to the world what you're looking for. But what people

don't realize is that true networking is an art form, and if you understand it, it's about collaboration and helping others around you that can also help you. The smartest creative people I know have several goals they are trying to reach, and they help those around them if they can to reach their respective goals. If you help others to help them reach their goals, oftentimes they will help you in return.

Craft Your Headline

People need to know who you are and what you're striving for when they meet you. Before jumping into networking, like anything else in life, you need to start with thinking about how to describe yourself and define your goals. Think about how to describe the headline of who you are and your top one to three points in just two minutes to any new person you're meeting. Pique the listener's interest in a minimum amount of time to generate interest in a longer conversation (at that moment or later). Go ahead and practice this on people at any social event you're at. Keep trying a few different ways to describe yourself and see how people respond. Over time you'll see how people respond to your different headlines you're testing and you'll get better at crafting your message.

Connect

Networking, in a sense, is a barter, and it's investing in the community where your goals exist. Listen, understand, and respect other people's goals, and do what you can to help them with their goals; chances are others will take the time to listen to you, respect you, and ultimately help you with your goals as well. You have to give in order to receive. Be sensitive to the goals of the people you network with.

ACTIVATING YOUR NETWORK: AN ARTIST'S PERSPECTIVE

Artist Melissa Potter says, "I'm using Mad Mimi, one of many e-mail marketing utilities used to create branded, newsletters, and promotions. It's *great*! I do mailings about my work, and if people want to be taken off, so be it [only one person has requested it, though, out of seven hundred]. I add my real and somewhat distant networks to these mailings. Every time I do it, I get at least one distant network person writing. For distant network building, artists need to understand that time is a key factor.

"You have to put in face time on openings and events. One of my colleagues was sick of trying to network in, and he got gutsy. He went to each gallery and asked for ten minutes of the gallerist's time. A few said okay, and he showed his portfolio, and made follow-ups. Well … he got a couple of shows! Now, for years, I would have told artists *no way* to this method. The point is, sometimes it pays to break the mold within reason, and it can be an effective tool. Asking friends to network you with their networks is, of course, one of the best ways in. But parties, readings, events, and social gatherings remain probably the best. Holding open studios can also be hugely helpful."

Do Your Research

Dedicate time to networking and research to build your connections. Stay up to date on new shows (through online resources, magazines, newspapers). Designate

a day each week to spend an afternoon just wandering the galleries or museums—this is both a social/networking activity and to inform your art practice. Be disciplined about dedicating time to this networking and research.

NETWORKING BASICS

Networking is not something you remember to do sometimes; it should be infused in your daily life and the way you need to think every day. Think of networking as creative community building to support your art, gain exposure, and receive emotional support and feedback to enrich your art. Networking and community is about engaging in a dialogue with others and not isolating yourself in your studio. The following are a few basic networking concepts to always keep in mind:

Always have business cards on hand.
Business cards are great for networking—they have all the pertinent contact info, your organization/business affiliation, your area of expertise, and they are much easier to carry than a stack of résumés! You never know where or when you'll find a great networking opportunity so keep them handy. Be sure to ask for a business card as well and add to a Rolodex and/or immediately enter the data into an Excel sheet.

Learn from the extroverts and don't be shy.
Networking with perfect strangers takes guts. If you're naturally a shy person, this can be hard. Try practicing in your everyday life with simple conversation starters such as "How are you?" or "What do you think of this exhibition/new artist?" These small comments can lead to an introduction and more. If you are going to an event such as an opening or reception, take a friend (a more extroverted one!) to the event and first observe how they and others interact; then make an agreement that you will both speak with at least three new people and give your card to them. Remember, just be yourself and be curious about the people you meet, be an active listener.

Start off asking for advice, not favors.
When meeting someone for the first time or when on an informational interview, don't go straight for the job or exhibition opportunity. Start with asking for advice. It's never a good idea to straight out ask someone if they have a job opening or if they can get you into a gallery. Introduce yourself and let the conversation evolve naturally. People love to hear themselves talk and like to help others. So if you play your cards right, a job or exhibition opportunity could come along during a first conversation or even months from then.

Give relationships a chance to grow.
"Out of the blue" networking: just don't do it. Make networking a daily part of your life, not just something you do when you're suddenly out of work or need advice. Networks have to be built and cultivated over time. Remember, whoever

you are working with in whatever capacity can become a powerful person in the art world and assist you, so never burn bridges and be willing to help others.

Always say thank you.

After meeting with a new contact or interviewing for an opportunity, send a handwritten thank-you note via snail mail that *same day*. This is a good opportunity to thank the person for their time. This small, personal gesture will set you apart from the others.

Stay in touch.

You've made some contacts, now keep in touch! Drop a line or shoot an e-mail off to your network. Make sure each correspondence is meaningful and well thought out. Try to stay away from impersonal mass e-mails. Keep your contacts updated on any professional news such as a new exhibition. This will keep you top of mind. Send a nice card around the holidays wishing them a happy New Year and holiday (make sure the card is not religion-specific). These easy, but thoughtful gestures make a difference!

Try writing.

When you think of networking, try thinking a bit outside the box. You don't have to start by going to openings and directly chatting up strangers. You can make great connections by getting creative with written communication. Think about your preferred means of communicating with others. Maybe you feel more outgoing when you use online/social media and are more willing to reach out to others through e-mails. The networking outreach you conduct can be a much quieter process than you might imagine. The artist Joseph Cornell overcame his shyness and communicated through letters and sent postcard collages and notes to people he admired.

Networking Exercises

Try one of the following exercises and see where they lead.

- Take one person you want to be close to but are not, and share an article with them. Say that you thought of them and thought they would be interested in the article. You can also e-mail people links to stories and resources.

- Share a book with a friend or colleague you don't see a lot.

- Three times a year write a fan letter to someone you really respect. They don't have to be in the arts!

Further Networking Ideas

- Invite artists and people you admire to speak at your school or organization and be sure to plan out anything specific you want to discuss with them should the opportunity arise.

- Try setting up an informational interview with someone you admire or with someone in a position you are interested in. This type of meeting is about collecting information and seeking advice, not asking for a show.

- Join professional organizations and attend lectures, panels, and then introduce yourself to speakers and attend receptions afterward and collect business cards.

- Volunteer with a nonprofit organization, a museum, or professional arts organization. Expose yourself to new information and new communities. Get a bit out of your comfort zone. Get involved with your community, active in politics or volunteer for a cause you believe in—try networking *beyond* the immediate arts community you might think of. Cast a wider net.

- Join your alma mater's alumni chapter and be active! Offer to be a guest speaker or serve on a committee or panel discussion. Offer to critique undergraduate student work. See chapter 10 of this book for detailed information on how to utilize your alma mater in developing your career and expanding your network.

- Social networking allows you to connect internationally. There are so many online projects and communities you can participate in the arts from afar.

Networking with Peers
There are many opportunities for you to network with your peers, who are potentially your greatest supporters. Here are a few options for how you can stay actively engaged with your peer group:

- Participate in a critique group. A crit (or critique) group is a gathering of artists on a consistent basis who workshop their artistic production together. Some of them are by invitation while others are hosted by professional organizations. Any artist can start a critique group to benefit from the consistent and informed feedback it can offer.

- Hold an open studio.

- Visit other artists' studios on a regular basis and invite them to yours.

- Explore artist collaborations.

- Access equipment and materials from collectives and co-ops and workshops and get to know your fellow artists.

- Create your own exhibition and/or curate a show of other artists' work.

- Participate in an artist's residency. Though these are competitive venues, they are an ideal setting for expanding your network.

INTERVIEW WITH MELISSA POTTER, MULTIMEDIA ARTIST AND EDUCATOR
Melissa Potter, a multimedia artist and faculty in the Interdisciplinary Arts Department at Columbia College in Chicago, started a critique group called ART364B in the tradition of the feminist art collectives of the seventies.

Tell us about how you started your crit group, ART364B.

The impetus was that I have a full-time job and I felt, since I didn't have a gallery, I really needed a critical environment and a group to give me consistent, ongoing feedback. In early 2005, I invited seven great women—six artists and one curator—and they unanimously agreed to participate.

There is great diversity in the group between age and practices; one artist shows in Chelsea galleries and earns a significant income from her work, two of us are academics, and then there is the curator. I looked for great artists at the right stage in their careers; I think this has led to the longevity of the group. I also needed people who could commit to at least five years together, who had the right personality and would be available to consistently meet. The group empowers us all to be active artists and supports us so we can remain professional.

How do you organize your meetings and what do you discuss?

We have complex discussions around women, family, and art, and we have diverse opinions. Our conversations are not rote; they are robust, scary, and life-affirming, too. We have gone through many of life's trials and rewards together. Now that I've moved to Chicago, we usually do our crits through Skype. We spend two and a half to three hours in conversation and each member gets twenty minutes. I've found that if you are clear about what you need, you will usually get it. For example, I will tell the group the day before a crit that I need them to focus their attention on a particular challenge I'm dealing with in a piece, and they do.

What other activities does your group do besides discuss work?

We exhibit together and as a group help promote each other's work. In 2010-11 nanomajority.com featured our group for six months: every month our resident curator selects one of us and we are featured in an open forum about our work online. We also exhibited our work together at New York University. We also work on professional practices together. We develop and send out show applications together and help each other with tasks like setting up Web sites.

Where does your group name, ART364B, come from?

Our group is all about empowering women to be artists and I see our group in the context of the feminist movement. We are definitely not ladies who lunch! Linda Nochlin, the art historian and critic, taught the first class at Vassar in the 1970s on women artists and her course number was ART364B.

What are some challenges of working in a crit group?

When we started the group, we were all based in New York, but now that I've moved to Chicago, we have to work by remote, so there are sometimes technical challenges with Skype or other online media. But we make it work, and we use e-mail to "backfill" when it doesn't. We also do monthly notes; they really create consistency and depth.

We're women balancing our careers, some our careers with families; we have to balance personal issues with professional ones. There's an ebb and flow to the

conversation and sometimes you need to ask the group for personal support, such as encouragement to take some time off when you need to. Art careers change, so sometimes we're not all on the same page. The longer we are together, the more able we are to weather those changes and stay focused on the long haul. What we've accomplished is remarkable in this limited-attention-span world!

Social Media

As you launch your career and make serious efforts to build your professional network, it is important to remember that everything you put up on the Internet is *public*, even when you believe it is private. Since social media is an essential part of sharing your work with the art world, we continue this discussion in chapter 15.

Elevator Pitches for Artists

Often, you only have two to three minutes to connect with someone at an opening, in an elevator, or in a chance encounter on the street. It is therefore important to have in mind how you can succinctly share what you are currently doing, pitch your work, and keep them in your networking loop.

MENTORS

One of the most important members of your community should be a mentor. Throughout your career you should be connecting and engaging with other artists, teachers, and industry professionals you respect and who have the experience and knowledge base to help you in your career. A mentor is someone who serves as a role model, who can offer you moral support, is an advocate for your work, is a good friend and teacher, and can offer you professional advice. They may introduce you to other professional artists, collectors, and gallery owners. A mentor may recommend you for jobs or for gallery representation. Jason Goodman, executive director and cofounder of 3rd Ward, a design center for creative professionals, suggests, "Put together your own council of advisors made up of people you respect. Take them to dinner once a month. They might not always have the right answers but they might have the right questions."

How to Identify and Nurture Mentors

Finding a mentor isn't as easy as deciding one day that you're going to pick one out.

Usually a mentoring relationship grows naturally and often slowly, as a result of an existing relationship. For example, a faculty member you really worked well with might be someone you stay in touch with for years after finishing their class. And they may show signs of being open to ongoing conversations about your work and career. So it's important to be on the lookout for strong relationships you are building with more seasoned artists and industry professionals and be sure to maintain and nurture those connections.

On the subject of identifying a good mentor, Tim Gunn says, "It's important to have a guru for counseling and advice. A good mentor is someone who supports

you and is an advocate for your work. They should have the capacity to understand your particular work, they should get your DNA. You should find someone who has the ability to give you tough love and honest feedback. You don't want to look to someone who is an enabler of a negative mind-set and bad behavior. It is a bad idea to work with someone who may be coddling you or acting as an enabler, encouraging you to behave badly or have delusional attitudes toward the art world [that could lead to isolation]."

Once you have a relationship with a mentor, you also have responsibilities toward your mentor. You should:

- Always treat them with respect and courtesy and graciously thank them for their time and support. That might mean a handwritten note after an introduction or helpful meeting or it might involve treating them to lunch or inviting them out for coffee periodically.

- Follow up on their advice, connections they make for you, etc.

- It's a two-way road: You may grow out of mentors you grow out of, become their peers, and then need new mentors. And it is a two-way street in that you need to also give them assistance/help when you can. You will likely have more than one mentor in your career and might have more than one at a time.

INTERVIEW WITH THE GUERRILLA GIRLS

The Guerrilla Girls are an anonymous group of women artists who use facts, humor, and outrageous visuals to expose discrimination and corruption in the art world, politics, film, and pop culture. They are the authors of hundreds of posters, billboards, books, stickers, and actions. They try to twist an issue around and present it in a way that hasn't been seen before in the hope of changing some people's minds. They wear gorilla masks in public and take the names of dead women artists as pseudonyms. Their work has been seen on the streets of Montreal, Mexico City, Shanghai, and many other cities, in exhibitions at the Venice Bienniale, the MoMA New York, the Tate Modern London, the Centre Pompidou Paris, and many other institutions. It's also been passed around the world by their supporters, who use it as a model for their own crazy, creative activism.

Can you speak about the importance of alternative spaces and thinking outside the "white box" of the commercial gallery scene?
Remember there are many art worlds out there. The best one might be the one you make with other artists and friends. Don't wait around for the system to give you the stamp of approval, create your own exhibitions—on the streets, in cyberspace, in empty storefronts, bus stations, lobbies, subways, hospitals, etc. See how people respond to your artwork, both those who don't know anything about art and those who do.

Can you talk about the importance of community?
The myth of the genius artist making great work alone is just that, a myth. Artists are a part of their time and are influenced by each other, and by everything else that's

going on in the world: politics, music, books, TV, film, social justice movements, etc. When we started twenty-five years ago, we were a bunch of women who couldn't put up and shut up about the low, low number of women and artists of color in NY museums and galleries. We were annoyed, we were angry, we had a new idea about how to do political art—and we also had community. It's great to have colleagues. We have great fun putting our posters up on the streets together.

It's a kick to collaborate. You have to try and leave your ego behind and be able to love another person's ideas. Community starts in art school and you can continue it after/outside of school, no matter what kind of art you make.

How has the art world changed since when you started, and what are some current obstacles for young artists?

At the entry level, there are more opportunities for artists to participate in galleries. There are more women and people of color showing. But museums are still lagging way behind. And sustaining one's career has become more difficult. We hope all artists succeed in the world of museums and galleries. But you also have to speak up against the system. Work hard to be part of the system, if that's what you want, but work even harder against it. The world of artists is great, but the art world isn't. Wealthy collectors are much too influential. Museums do not cast a wide-enough net to really preserve our culture for the future. Don't let them get away with that.

Can you tell us about how the Guerrilla Girls work?

We formed to be an action group, not a talking group. We produce stuff—lots of stuff—we don't just talk about it. Over time, all that work has added up to something meaningful and transformative. That's the story of anyone who makes art, or makes trouble in the art world.

What words of encouragement would you like to share with emerging artists?

Keep positive, empowered, feel good about your work, and be dedicated to it. Go where your ideas take you. Don't worry about failure. Keep your sense of humor alive. If I'd been told years ago I'd devote a huge part of my life to my anonymous Guerrilla Girls' practice, I'd never have believed it! The Guerrilla Girls feel so lucky to have been able to do this work and have people connect to it.

What's up next for the Guerrilla Girls?

One recent work is a street poster about hate speech against women throughout history. Not much has changed from Confucius to Rush Limbaugh: you can still say horrible things about women in public, things you couldn't say publicly today about any other group. Our forthcoming new book, *The Guerrilla Girls' Hysterical Herstory of Hysteria and How It Was Cured, from Ancient Times Until Now*, will be printed and distributed soon. We're doing new projects about art, culture, and global women issues, including a film about how feminism "don't get no respect." We'll be visiting the offices of museum directors and trustees and telling them

a thing or two. And, as always, we're doing talk/performances, exhibitions, and workshops in cities all over the world. Lately we've been in Southern California, New York, Minneapolis, Rio, Sao Paolo, Vitoria, Spain, Scandinavia, and Seoul.

Setting Up and Maintaining a Studio Practice

❧ 7 ☙

Setting Up a Studio

CREATING A STUDIO

Being an artist is a full-time job. From all of the interviews that we have conducted with artists and art professionals in the field, the consistent message from all is that committing time to being in the studio has to be your number one priority.

Without the actual work, there can be no other actions taken. It's that simple. Creating a dedicated studio space for your practice, even if it is in your garage or home, is the first step to making the commitment of being an artist.

Dedicating Time to the Studio

It is important that you get in the studio as much as possible, every day if you can. Get in the studio on a regular basis, even if you find yourself sometimes sitting and contemplating your work or doing administrative tasks to support your work. It is recommended by more seasoned artists that you set aside a block of time each day or each week to focus on the business aspect of your practice, such as researching and applying for grants and residencies, documenting your work, or corresponding with galleries.

Hitting a Wall

How do you avoid procrastination? How can you limit distractions? What are some bad habits to not establish or to break free of early on? Even taking the time to clean your studio is an activity that is valid and supports your practice; it might even relax you! Bring in a fellow artist or a writer or poet to talk about your work and get a fresh perspective. Journaling about your work is a great way to move through whatever is on your mind and will help you move forward.

Resources for Studio Space

If there is no money for a studio, there are organizations that will give you temporary studio space or will actually have space you can rent out cheaper than market rates for a certain period. Look into organizational support for studio space,

check out museums' programs for artist studios, and certainly think of residencies as studios. See chapter 18 for more information on residencies.

Working at Home

If you work in a studio within your home, there are many considerations to take into account. On the positive side, it's a short commute! Also, working from home is of course less expensive for an emerging artist and may seem like the only option available to some. On the other hand, working from home can be highly problematic. Being at home, there are often family distractions, and you may have trouble focusing your attention on your work for long periods. In addition, some artists can overextend themselves when working from home because they can't pace themselves and separate work time from private time. There are also health hazards and concerns that are magnified when working from the home. Materials can migrate from your studio into your living space and kitchen, creating potential health hazards. Artists often eat in their studio and get materials on their hands and ingest the paints and other hazardous materials. This is a particular concern for artists with children in the home. See chapter 8 on health issues for artists.

Working in your studio, whether at home or in a studio separate from your house, it is important to be aware of how the long hours can make you feel. Isolation can be a pressing issue and slowly build over time. You can feel alone and depleted rather than invigorated. You need to keep a balance between your studio and your art community. If you work alone, whether at home or in a separate studio, you should make a conscious effort to bring guests into your studio, such as fellow artists from a crit group you develop. See chapter 6 for more ideas on how to build a supportive community and create a crit group.

Sharing Studio Space or Going It Alone

Many artists choose to share studio space with other artists for a variety of reasons. A great benefit of sharing a studio is having the shared rent, community, feedback, and inspiration from other artists. Studio visits, other collectors, and guests visiting fellow artists can benefit you and build your network. Possible problems with group studios include clashing work habits: for example, you may prefer well-organized materials and a clean studio but work with a studio-mate who is disorganized and untidy, or they may be overly chatty and social and distract you from your work.

STUDIO CONSIDERATIONS

Location, Location, Location

It is wise to find a studio in a popular neighborhood with an artistic community so that you can readily get visitors into your studio. Try to identify an up–and–coming, hot area to buy in (this is also about long-term financial investment). It is also important to feel safe in the neighborhood you work in, so consider things like availability of public transportation and foot traffic.

When considering spaces to rent, think about the types of materials you are using and having the right lighting, windows, ventilation, and renters' policies. You may need approval to use certain materials and tools like welding machinery or flammable materials. How big are the doors, and can you get your pieces in and out? How high are the ceilings? Are there noise issues such as residences nearby? You need to be able to use your materials and not be concerned about noise created by things like welding.

Consider buying space in a neighborhood that is still affordable. This could be the long-term investment that pays off over time and allows you to remain in a desirable neighborhood even after it's been discovered. Note: if you rent a studio in an up-and-coming neighborhood, landlords are infamous for kicking out the artists who trailblazed and reinvigorated the area and will seek tenants who can pay higher rents. So buying, perhaps with other artists, could be a perfect solution. We encourage you to take this option seriously; there are loans available for buying real estate.

Insurance

Insurance is a complicated issue but worth looking into, depending on the circumstance of your studio practice, whether you are working at home or in a commercial building. Depending on where you are working, you will have access to different types of insurance. In case of disasters such as fires or thefts, it is essential you understand how best to protect yourself. See chapter 8 of this book for information on health issues, insurance, and disaster prevention measures.

INTERVIEW WITH THOMAS WOJAK, MASTER PRINTER AND EXHIBITING ARTIST

Thomas Wojak, master printer and exhibiting artist, is the owner and founder of the W.O.R.K.S, a screen-printing studio established in 1972 in San Francisco. The studio is committed to edition printing for artists and designers. Thomas also teaches as a senior adjunct professor at California College of the Arts while he maintains his own creative practice. His work is exhibited nationally and internationally.

Can you tell us about your experience with finding studio space?

To find a studio, look at the less desirable locations and get there early to establish your studio before the area becomes too popular. Try to negotiate a longer lease at a lower rent.

The more exact and careful you are about constructing the lease, the better. In San Francisco in the late 1990s during the dot-com boom, a lot of artists were kicked out of their studios and landlords renovated the space to get higher rents from high-tech businesses. There were lots of evictions.

Can you tell us about the live/work space where your studio is?

I work in a live/work space that I developed with my girlfriend, artist Misty Youmans, in historic downtown Vallejo, CA (the North Bay of San Francisco). I

was looking for a centrally located area, something near San Francisco that had live/work options. I had lost my San Francisco–based studio when the building's landlord kicked out all the artists to make way for higher-rent tenants during the dot-com boom. I found out that Vallejo had passed a live/work ordinance that took commercial buildings and allowed mixed use though the area had been only zoned for commercial purposes originally. Vallejo wanted artists to come downtown and transform commercial spaces into artists' studios and make the storefronts more interesting and encourage foot traffic downtown. The city even helped me by getting permits with cash incentives.

How can artists find live/work programs and spaces?
Go to City Hall and find out if the city/town has mixed use permits that allow work/ live space. I contacted the Chamber of Commerce to ask about available spaces.

Some small towns won't have live/work permits in place, but may be open to mixed-use permits with some coaxing and persistence.

What are your recommendations for young artists getting studio spaces set up?
Just get a lease, if possible. This will give you some protection. Lots of artists don't get a lease at all.

Make sure you ask for amendments in the contract if you want to justify a longer lease, etc. Offer landlords a longer commitment if they give you a lower rent. Landlords often don't like long leases, but if you offer to make renovations, you could use that to bargain for a longer lease.

Include information on planned improvements in the contract; be sure they are allowed.

Don't view improvements you make as loss to you financially, since over time costs are amortized. You get the use of those improvements over many years.

Be sure to do things legally! Make sure you do everything up to code if you renovate. Often, young artists do things in a slipshod manner, and code violations and fire hazards can contribute to evictions.

Any tips for emerging artists?
Apply for internships and residencies after graduation. The main reason I see artists give up and stop making work is they don't have a studio. You need to have a studio space to call your own, even if it's your bedroom or garage, you need a dedicated space. Many graduates go together and rent commercial space to share; this also helps you maintain the community you built in art school.

THE STUDIO VISIT
Being properly prepared for effective and engaging studio visits is an essential part of becoming a professional artist. You may have studio guests for a variety of reasons. Friends and colleagues may visit your studio to view your latest work and discuss how it is progressing and give feedback. Curators, gallery owners, and

collectors may visit your studio to determine if they want to represent your work, include you in an exhibition, or buy from your collection. These guests will expect you to describe your work, which can involve defining your process, inspirations, any messages or meaning in your work, and the background/history/context of your work. In a sense, this is very much like putting your artist's statement into a dynamic dialogue.

It's All about Attitude

It's perfectly understandable that emerging artists (and even the most seasoned artists) find the studio visit to be stressful and somewhat mysterious. A common mistake is to assume that your work speaks for itself, so you don't have to. If you enter into a studio conversation with the wrong attitude, you can come off as passive or negative during the meeting, and that isn't helpful at all if you want the guest to feel engaged with you as the creator. Be in the right frame of mind for the visit. You're being brave to have someone over in the first place, but you have to be ready to hear all sorts of feedback and don't let yourself become defensive.

Another common preconceived notion artists have is that each studio visit should end in a tangible result (i.e., a show or a sale), or it is a failure and not worth your time. But you need to view the studio visit as a learning and networking opportunity. You should consider each studio visit as a chance to gain valuable insight into how different viewers perceive your work and as a means of gauging how well you succeed at communicating the ideas and messages you intend.

These visits also teach you how to engage in a meaningful and positive dialogue with guests. You will learn to negotiate with viewers and steer conversations toward things you feel are most important. It is essential that you learn to be a good listener and not become overly defensive if your guests' questions or comments seem critical.

Setting the Stage: Arranging the Studio

First things first, clean your studio! No one expects for an artist's studio to be spotless, it's your work area after all! But do make the effort to show your guest that you are considerate and take care of the basics. Mop the floor, clean the bathroom, and prepare clean cups to serve your guest a beverage. Be sure you have thoroughly cleaned two chairs for you and your guest to sit on during the visit.

Clear out everything you can but the recent art you want to show. This means placing older work or works in progress in a separate area of the studio or in storage. You may want to keep older work near at hand in the event a collector has an interest in seeing the evolution of your work.

Timing and Refreshments

Be sure you consider what time of day the visit occurs and plan refreshments accordingly. You don't want someone leaving because they are thirsty or hungry.

If you have a choice, it is best to avoid studio visits at a mealtime or you'll need to provide food. It's best *not* to drink alcohol yourself during a studio visit or open studio but you can offer a guest white wine in the evening. Remember,

you wouldn't drink while you are working, and you want to appear like the professional that you are and be fully in command during the studio visit. An example of a simple and thoughtful gesture is to present guests with a plate of cookies or a bowl of cherries and a beverage such as water, coffee, or tea served in nice, clean cups. At a minimum, any guest to your studio should be offered water and a clean seat.

What to Show and How Much to Show

One of the most common studio visit mistakes is showing too much work. Edit! Select only your best and most recent work to show. Store or tuck away any older work so the viewer won't get distracted or confused. You want to keep the conversation focused on your most recent body of work. Set out the work you want to focus on and prepare to show it in a professional, clean format. You will essentially be curating your own work and should clear off a clean wall where you can put up and take down pieces throughout the conversation.

Demonstrate respect for your own work in how you handle your pieces during the visit. If you mistreat a piece in front of a collector that demonstrates you don't think it is valuable, then your guest will also perceive your work as lacking value. For example, when showing works on paper, you should not pull out a broken-down, old portfolio that's jammed with work falling out the sides. You should have paperworks nicely formatted, sorted, and protected under glassine.

Depending on how your work space is set up, you may have a section of the studio that is a work space your guest may want to view. But if the guest is a collector and you want to focus the conversation on your recent work, it can be a time-consuming distraction to show your guest where you have projects in process. You will have to decide what to show each guest, based on feeling out the visitor and what they want to see. So if they indicate they want to learn more about the process (and this can be a valuable piece of information/insight into your work), then you could show them, but you need to be able to steer the conversation back to your current work.

Additional documents to have on hand for guests include your CV, artist's statement, business card, recent show brochures or postcards.

Do Your Research: Preparing for Different Guests

Make sure you know who is walking in the door! Research is the key to being prepared and getting the most out of each visit. Before they arrive, you should know what to expect from a particular dealer, curator, collector, or gallery owner. Prepare by learning the history of the person visiting. Start by doing online research about the individual and learn their professional history. Visit the gallery your guest represents and talk to other artists who might know them so you can gain insight into their interests, personality, and what they typically behave like when visiting studios. If you have a curator visiting, you need to know *what* they are currently curating or what their past shows have involved.

Try to speak with another artist that your guest has worked with, and try to gauge what the guest's personality is like and learn if they tend to do brief visits or long visits. Some collectors will want to drop by for twenty minutes and others will expect to stay for over an hour. A European dealer may want you to be like a family member and expect a very in-depth, warm, and personal conversation, while a U.S. dealer may want to just sell your work and not have an interest in knowing you on a more personal level.

You'll also need to develop skills in being able to read different people's personalities, energy levels, etc. For example, if you have a quiet person visiting the studio and they aren't saying very much, you may need to send out little feelers and see how they respond. For example, you might prompt the guest with a brief statement about your work's inspirations—"I've always been interested in Jasper Johns"—and that may prompt them to express themselves. Maybe they start talking about the narrative/subject matter or what they focus on may totally surprise you and jump-start a conversation. By prompting them, you will see what they are looking at most closely and get a sense of what they are drawing from your work.

How Much to Share

A good way to prepare for guests is to review your artist's statement for ideas and develop the ability to "pitch" your work in a clear and concise manner. Practice talking about your work in quick sound bites of two or three minutes. Try a mock interview with someone and role-play as if you were meeting with a curator or collector. Have a friend interview you and then ask them to write out a statement based on the meeting and you write your own version and then compare the two. Do your spoken and written words mesh? Is what you are saying *really* about the work, or are you digressing or unclear?

Think about what you do and don't need to say. It is important to consider what and how much to share. Don't over share and talk about your whole life. This person is *not* your best friend. Sometimes artists have a misconceived notion that these conversations will/should resemble class critiques, as when they were students and all thoughts and issues could be shared and out on the table, but remember, this is not school, and this person is not here to help you develop your work. Rather, you are presenting yourself as a professional with a coherent body of work that is fully realized and ready to be shown.

In the next interview, we get an artist's perspective on the studio visit.

EXCERPT FROM AN INTERVIEW WITH SHARON LOUDEN, EXHIBITING ARTIST AND EDUCATOR

A graduate with a BFA from the School of The Art Institute of Chicago and an MFA from Yale University, Sharon Louden is a professional artist whose work has been exhibited widely and is held in major public and private collections. She has taught at various colleges and universities for over the past twenty years. For more details, please see *www.sharonlouden.com*.

What should artists expect from a studio visit?

Expect nothing from it except the hope of learning from a dialogue about your work and something about the person who is coming to visit. A studio visit can be an introduction to your work and an opportunity to learn about another person's vision—to share a dialogue with that person. Sometimes there are a lot of expectations from a studio visit, as it's quite natural to think that something might come from it. It's enough, though, to think that a studio visit is a wonderful event for the artist to share the work with others and for visitors to experience the work in an intimate setting.

The studio visit is also a time to develop a relationship in a private setting that is the artist's place of creativity. There are many different ways to conduct a studio visit, but I like to focus on a relaxed exchange between the visitor and the work and what the viewer can bring to the dialogue. I also like to pace my studio visits like a dinner party, where you're greeting guests as if they were coming in to your home in a welcoming atmosphere. Perhaps a PowerPoint presentation with some animation might be included. Or you can show some work on the wall, on a table, or on a shelf, moving through the space and creating a dynamic flow. And always follow up the visit with the essential thank-you note (handwritten, of course)!

Having people visit your studio is about building community. I like to think that artists can have a fluid exchange in a studio setting, relaxed and yet intimate—place for dialogue that can be extended elsewhere.

PRICING YOUR WORK

The price you set for your work often hinges on the context: where are you selling the work (a city, a small town, a small or a large gallery, a café, your studio), and your experience level, your exhibition history, and your past sales track record. A gallery, if you have one, sets the pricing. It is important to be logical in this process, not emotional; don't overvalue the work because of the passion you have about the piece. But also don't undervalue your work out of modesty or insecurity. Do your research and see what other artists are charging for their work; be sure you are comparing to your peers, artists at your career level, showing work of similar size/scale/medium, in your area. Every artist has the experience of holding on to work they might have been able to sell, so keep in mind one of the best mottos to have in your head is to allow the work to move on. Three overarching factors you can consider in developing a price for your work are time, materials, and overhead (such as studio rent, etc.). Another factor is to consider how many pieces you produce in a year and how frequently you are showing. And finally, don't forget the paperwork: be sure to draft an invoice and keep a record of your sales. A book that covers pricing issues quite effectively is *The Artist's Guide* by Jackie Battenfield (Da Capo Press, 2009).

OPEN STUDIOS

Open studios are a terrific idea because they offer emerging artists the chance to practice studio visits and engaging others in conversations about your work. There

are many different kinds of open studios, including individual open studios, group open studios with a few of your friends, or citywide open studios and walking tours. Open studios can be one or two days or a full weekend. Some cities host major, citywide open studios such as the Boston Open Studio Coalition and San Francisco Open Studios.

An open studio involves opening up your studio to groups of people. Open studios give you the chance to practice talking about your work and gain experience interacting with a variety of people. By fielding questions and hearing comments, artists can gauge how the public responds to their art, gain feedback, and be inspired. An open studio is also a great way to grow your audience, learn how to market your work, build your mailing list, and expand your network. Open studios can also provide good practice in learning how to hang/present your work for the public.

The thing about open studios is that you never know what might happen. You don't know who might walk in the door—you might have four guests or you might have more than a hundred. Open studios can be very uneven and unpredictable in terms of the people you'll get and responses you will elicit. It is important that you don't set unreasonable high expectations or expect to make huge sales. Be aware that many of your guests may just be looking and not buying. Be open to guests' comments and don't let yourself become bitter or disillusioned if the open studio does not lead to a sale, a gallery connection, or other preconceived ideas. Think of it as an opportunity to build buzz about your work, gain interpersonal skills in dealing with guests in the studio, and as a community/network-building exercise.

Here are a few tips on setting up your own open studio:

Do your research and self-assessment to decide if you are ready for an open house, feel confident that you are ready to share your work with the public, and decide if you are ready to commit the time and energy to properly organizing an open house.

Decide if you want to have an individual or group open house. If you want to work with a group, next you need to find other artists to work with.

Be mindful that the success of an open house is often related to how desirable the neighborhood is, to get lots of foot traffic. If your studio is off the beaten track, develop a strategy for how you'll get visitors to your neighborhood (try working with other artists in your building or nearby, work with local businesses to plan how to jointly drive traffic to the area).

The following are basic steps and timeline for setting up an open house:

1. Create a timeline/plan, get an Excel spreadsheet to track what you need to do. Plan with at least a few month's advance notice.
2. Determine the duration of the open house, decide if it's one day or all weekend. If this is your first open house, try starting small with a one-day open house, and be sure you are committed to being in your studio for the duration of the event.
3. Determine budget for refreshments and promotional materials. Save money by doing it all online!

4. Research and develop a contact list using your current network, research, etc.
5. Create promotional tools: e-mails, press releases, maps, postcards, etc.
6. Get friends to help you at the event with greeting and refreshments and sign in.
7. Create takeaway artist's statement, your bio, CV, and optionally, a pricing list.

The following interview is a candid view of starting your art practice and shows how launching your career in the arts takes fortitude, hard work, and courage. Noah Davis is an emerging artist who shows on both coasts.

INTERVIEW WITH NOAH DAVIS, EXHIBITING ARTIST

This artist creates a uniquely personal narrative in his psychologically charged paintings by sourcing imagery from found photographs, art history, and autobiographical events. At once a storyteller, a surrealist, and an astute social commentator, he often represents the quiet, forgotten moments in American history.

Tell us about the show you're curating.
I'm curating a show at my gallery, Roberts and Tilton, in Culver City. I had the idea to do an artist-run show and came up with a concept to do an exhibit inspired by a Monet painting called *Waterloo Bridge, Gray Day*. The concept of the show is gray, not just as a color. It's been a great process of going to lots of artists' studios to select work. I have selected a cross-generational group of artists, ranging from an eighty-one year-old woman to a current student at Cal Arts. I chose every artist for a reason: each shows a different area of gray and the artists represented are themselves like ranges of gray with different levels of success and age.

It must be interesting to come from an artist's perspective and now be playing the role of a curator.
The curator/dealer in me comes out in wanting a particular piece, but then there's the artist in me that is thinking about what is right for the artist. This process has taught me a lot about how galleries and artists work, and I've learned what it feels like to put the shoe on the other foot and experience the process of a curator. It was an eye-opener.

As an emerging artist who has been showing for about four years, can you share how you transitioned from your college studies to being a working artist?
When I was in school, I loved art but didn't know where I fit in. I didn't feel I was good enough to be an artist and was thinking about going into administrative work. And even though I was in school, I was keen on looking at art as much as possible. I actually left college without finishing my degree, and I

felt defeated. I had to get a job and washed dishes for a year in the back of Pastis in the Meatpacking District. It was a humbling experience, coming from the ego of an artist in college. I was still making my artwork, but I wasn't making much money.

Without a job I couldn't get a job in New York City to save my life, so I came to LA to do public art. The process was a little too slow for me, but I learned a lot and was going to artists' studios and seeing how artists lived. I thought, this *is* possible. Then I got a job at MoCA working in the bookstore, for $8/hour three days a week, and I was so excited. It felt like I was getting closer to culture and exposed to the museum world. I started seeing the art world getting bigger and bigger, and at the time the art world was booming. At the MoCA bookstore, I discovered *Letters to a Young Artist* (Darte Publishing, 2006), and that was the pivotal moment, reading that book, especially James Marshall's piece.

I used to go out and do the whole social scene, but then I just closed myself up alone and painted. It was a lonely period, but it was my coming of age. Everybody threw me under the bus, but I learned from it. When I was passed over for a promotion at the bookstore, I quit. After all those years of bullshit jobs, painting became my day job, and I worked really hard. It was a return to painting, but at that time (in LA), nobody seemed interested in painting. I loved the meditative quality of painting. I showed the two paintings I made that were awesome, and I remember at the show I was so embarrassed. I overcame the fear of putting myself out there. It was an exorcism of sorts from the buildup of so much time not doing art, and then it was all released. I decided this is it! I have no control. Painting is all I'm going to do.

Tell us about your first group show and what it was like selling your first pieces.
I showed the two paintings in a group show and sold the work and was immediately picked up by the gallery. When I got that first check for $1,500 after years of getting $10/hour, it was great. I thought, are you kidding? I am so grateful for the appreciation of art and that people would spend that much money. The first thing I understood was that all of the money I made had to go back into the art to keep my practice running.

How did things change for you once you had gallery representation?
The gallery wanted five more completed paintings immediately. I tried doing different things like performance pieces, so I wouldn't get pigeonholed, and collectors and galleries didn't like that at all. That's the first wall I hit. I hadn't reached where I wanted to go yet with my art, but I didn't want to confuse people by jumping from material to material and from idea to idea. But it was frustrating, because I didn't want to be perceived as just doing this one thing.

I'm still in the process of figuring out my work, and I don't know what I'm doing a lot of the time. I am looking at other artists and thinking about what I want to be. I don't rely on representation though. Even if I do something based on performance work, everything I do is being framed/formatted as a painting. I took

the trope of conceptual art and applied it to painting, so I'll paint a performance like it's documentation of the work. So this still allows me to explore new things and have a lot of freedom, but it gives the collectors what they want to see. The medium stays the same but the ideas change.

What should artists know about working with galleries?

The most important thing is to do your research before you approach a gallery. Go into the gallery and really get to know it well, learn who all the artists are. You should know the whole roster of artists who show there and feel that you fit in there. Approach the gallery and offer to give them a piece on consignment. What do they have to lose? Understand your value and what you have to offer and that you have the potential to make the gallery money.

A gallery's role is to sell what you give them, and they get half. They've never given me money that I haven't earned. Artists expect that they've "made it" if a gallery represents them, and they think a millionaire is sitting behind the table, but the gallery had to pay rent, staff salaries, and pay themselves. I had the same misconception about galleries, expecting them to take care of everything. Never think you are bigger than the gallery. It's a small world, and all the gallery owners know each other; don't think you can outsmart them. Establish the relationship you want with a gallery immediately, so if you want them to be your exclusive gallery, get that in place. I personally think it's best to show at multiple galleries, if you can. Galleries do have access to rich people, which most artists don't.

Any other tips about starting your career?

You have to be prolific. You don't have to show everything you make, though. Treat your practice like a job and plan to work eight to ten hours a day. Once you have to feed yourself and live off your art, you realize it's better to be extremely busy.

❧ 8 ❧

Health, Safety, and Emergency Relief for Artists with Monona Rossol

There is no hazardous chemical that isn't being used in an art department somewhere, right now.

—Monona Rossol,
industrial hygienist specializing in arts safety,
founder and president of the nonprofit Arts, Crafts,
and Theater Safety Corporation

In this chapter, we will discuss how artists can create healthier studio environments and effectively use their materials while remaining safe and environmentally conscious. Many materials artists use in their everyday practice can be potentially harmful to both their health and the environment, but the biggest danger is lack of information. Remaining knowledgeable and vigilant about actions such as appropriate storage of materials, cleaning, disposal, proper ventilation, etc., is imperative to preventing long-term damage to both your health and the environment. This section is not just for artists but also for art teachers, art students, arts administrators, crafts people, and hobbyists.

HOW GREEN IS YOUR STUDIO?

Let's start with a brief exercise to identify the top five materials you most use in your studio, and then review some basic assumptions artists make about their practice.

List the five top materials you use in the studio:
1.
2.
3.
4.
5.

Set this list aside, and at the end of this chapter, review this list and consider if these are materials you should further investigate, use more safely, or get rid of entirely.

The following are common assumptions artists make about their materials. All artists make these assumptions to some extent, but these are important ideas to investigate. In this chapter, we will address these assumptions.

1. If a product is sold on the market, it is safe.
2. If you work with a material, you know what it is capable of doing.
3. Artists have learned to be skeptical of safe practices as a badge of membership in the arts subculture.
4. Licking and pointing a brush with your mouth is a safe and age-old practice.
5. Artists do not work with hazardous materials.
6. Artists are exposed to hazardous materials only occasionally and therefore are not at risk.
7. Working long hours in your studio every day, you have a healthy knowledge of the materials you are working with.
8. Putting art materials into an unmarked jelly jar is good practice.
9. Art materials are not chemicals.
10. Artists feel that a risk is worth taking because of the excitement of the materials and the potential of the product.
11. Artists are casual with the materials they're working with because they feel they know them so well that they don't have to worry about them.

HISTORICAL BACKGROUND ON ARTISTS' HEALTH AND SAFETY

The hazards of fine arts have been recognized since at least the eighteenth century, when Bernardo Ramazzini, the "father of industrial medicine," discussed occupational risks to stone carvers and painters. In his 1713 tome *De morbis artificum diatriba* (*The Diseases of Workers*), Ramazzini described hazardous materials that continue to pose risks to artists today. "For their liability to disease there is a more immediate cause," he wrote, "in materials of the colors they handle and smell constantly, such as red lead, cinnabar, white lead, varnish, nut-oil, and linseed oil, which they use for mixing colors; and the numerous pigments made of various mineral substances."

The brilliant colors that characterize many of the Old Masters' works were created with the use of toxic heavy metals, materials that caused disease in artists such as Rubens and Renoir. According to physicians Lisbet Milling Pedersen and Henrik Permin at Hviolovre Hospital in Copenhagen, Denmark, the inflammatory rheumatoid arthritis suffered by Paul Rubens (who had one of the first cases of the disease described in the literature), Auguste Renoir, and Raoul Dufy, as well as the scleroderma that plagued Paul Klee, can be linked to the bright and clear colors that dominated their canvases. While there are many theories about why Van Gogh had numerous mental and visual troubles, it seems likely that the flake white (lead carbonate) he used both as a pigment and canvas primer and the chrome yellow (lead chromate) color of which he was so fond are implicated.

In the middle 1980s, safety practices began to change for school and university art departments. This was because many states began passing Right to Know

laws, which mandated that employers provide detailed training and technical information to all workers who use toxic chemicals. In 1987, this law became a federal regulation enforced by the Occupational Safety and Health Administration (OSHA). School and studio art materials qualify as toxic materials, so today, almost all art schools come under either a federal or a state Right to Know law. While there still are areas of the country that ignore these rules, most good schools now provide this training for their teachers, custodians, and other workers; at the very best schools, that information is also part of the curriculum for students.

Then in 1999, the Environmental Protection Agency (EPA) began to focus on schools and on art materials. Art materials contain many substances that are damaging to the environment, and a number of schools were cited and fined for improper storage and disposal of their materials. Today, most arts organizations, schools, universities, and professional studio artists have EPA waste disposal programs.

DANGEROUS MATERIALS AND EQUIPMENT IN THE STUDIO

We want to give you a brief sampling of the kinds of materials artists commonly use that are toxic and need to be seriously reviewed and potentially replaced or used with greater safety precautions. Diseases from exposure to toxic materials can be acute or chronic (such as skin inflammation from extended exposure to solvents and allergies to chemicals). Allergies are as big a concern as toxicity.

The three main ways in which artists can be affected by toxic materials are through dermal exposure, inhalation, and ingestion.

Skin exposure: There are a number of ways that skin contact with chemicals can affect you.

- The skin itself can be damaged or destroyed by acids, alkalis (bases), solvents, and many corrosive or irritating substances.
- Once the skin is damaged, the same chemicals can penetrate deep into tissues or even enter the blood stream to travel all through your body doing damage.
- Some chemicals penetrate the skin without damaging it or showing any evidence of having passed through your skin. Examples are many solvents including methyl alcohol (wood alcohol) and the benzene in gasoline and metals such as mercury and lead.
- Some chemicals can cause skin allergies such as wood dust, metals like chromium and nickel, and many natural substances such as natural rubber, molds, and natural solvents like citrus oil.

Inhalation: Inhalation is complex because it depends on where the inhaled substance is deposited in the respiratory system. For example:

- Large dust particles land in the sinuses and upper respiratory tract (e.g., the bronchial tubes). Generally, these are transported by the mucous lining on these surfaces to the back of your throat where they are swallowed. Any toxic substances are then deposited in your digestive system.

- Very fine dusts will deposit deep in the lung's delicate little air sacs. Irritating or corrosive dusts can damage these structures. Soluble particles will dissolve and enter your blood stream. And insoluble (inert) particles will remain in the lungs indefinitely, maybe for life. Some of these can cause scar tissues (e.g., silica from clay) or even cancer.

- Solvent vapors and gases are not particles. Instead they are molecules that always pass through the membranes in the air sacs and into your blood stream to affect your brain and other organs.

- Spray mists are particularly hazardous because they may contain many substances. For example, paint spray mist will contain toxic solvents, pigments, and many other chemicals used to make up the body (vehicle) of the paint. They can be inhaled and deposited in the lungs just as large and fine dusts can.

Ingestion: We've already seen how dust particles can enter our digestive tracts from the lungs, but eating or drinking in art studios in another way that small amounts are ingested. Storing art materials in food containers has also resulted in ingestion of large amounts of materials—and not only in children!

Physical hazards: There are also physical forces which can harm your body even at a distance. For example, the infrared radiation emitted from hot kilns can cause cataracts and other eye damage. The ultraviolet radiation from welding can cause skin and eye burns and skin cancer.

- Physical stress on your body can also harm you. Examples are back injuries from lifting and repetitive stress injuries to the back, neck, hands, and wrists from computer work.

- Loud noises and music can permanently damage the little hair cell receptors in your ears leading to hearing loss.

- Often artists will have a combination of various risks in their work.

Now let's look at some of the hazards found in common types of artwork.
Painters: Some of the toxic materials painters use include:

- pigments which are either metal-containing (inorganic) and likely to contain lead, cadmium, chromium, cobalt, and many other toxic metals, or organic pigments which are unstudied for toxicity but which in chemical classes are often suspected to cause cancer and other long term damage;

- solvents (if you oil paint) such as turpenoids (replacement solvents for turpentine which is even more toxic and shouldn't be used); and

- oils such as linseed or walnut oil which left on rags can spontaneously catch fire.

Printmakers may be exposed to:

- pigments in the inks which are similar to those used in painting that may contain lead chromates, cadmium, and toxic organic pigments;

- a great number of solvents are used in printmaking for many purposes such as cleaning presses, rollers or plates; and
- acids are used to etch plates for intaglio or to modify stones or plates in lithography. Included may be nitric, hydrochloric, acetic, tannic, phosphoric, and more. New and safer etching processes use ferric chloride or electrolytic baths.

Sculptors: No other group of artists is exposed to such a wide variety of toxic substances. Sculptors may be exposed to:

- Sculptors can be exposed to silica and other highly toxic mineral dusts if they work in stone or clay.
- If artists weld or do foundry work, they are exposed to ultraviolet and infrared radiation, burns, metal fumes, which can cause diseases ranging from metal fume fever to manganese Parkinson's disease (from mild steel), and silica from braking foundry molds.

Stained glass artists, glassblowers, enamelists, and potters may be exposed to:

- Lead compounds (and frits) are in glazes, and lead pigments provide many of the colors in glass or enamels. Glaze dust, dust from grinding glass, or the fumes from firing glazes, glass or enamels can contain lead. Lead can cause effects beginning with loss of mental acuity, irritability and progressing to severe nervous system and kidney damage. In stained glass, the use of lead solders and cames can add significantly to exposure. There are lead-free solders and cames which should be used instead.
- Other metals still used in some stained glasses, enamels, and glazes include all those same toxic metals used in paint and printmaking pigments plus many more. such as rare earth metals and sometimes uranium. For example, dichroic stained glass is usually made with a thin layer of uranium on the surface. Uranium oxide is still found in some potteries and glass-blowing studios where it can be used to make orange and brown colors which are not only hazardous to the artist, but to their customers. The only ban on uranium use in the arts is on enamels for jewelry.

Photographers:
Today, more and more schools are teaching photography using digital processes exclusively. These digital processes usually only require building spaces and environmental controls needed for any ordinary computer-intense program. The old chemical photography processes, on the other hand, require special ventilation and proper disposal of chemicals. For example, silver ion washed from photographic paper during developing into fixative and hypo solutions requires either that the solutions be run through a special silver recovery unit or picked up by a hazardous waste contractor.

Many of the chemicals used in historic photographic processes also produce wastes that are highly regulated and costly to dispose of legally. Cyanotype and blue print processes produce wastes containing ferrocyanate chemicals which are regulated in waste water as cyanides. Many early processes such as gum printing and bromoil produce regulated wastes containing chromium compounds. Selenium toning, as its name implies, produces wastes containing selenium. Some of the chemicals themselves are hazardous, requiring the use of special storage units, enclosed mixing areas, eye wash stations, chemical gloves, and other protective gear.

Early photographers accepted the typical darkroom chemical odors without realizing they were harming their health over time. Today, proper ventilation should be installed, which usually involves custom-designed systems to capture the gases and vapors near the developing trays. The rates at which air must be exhausted from these systems and replaced by clean air is done so at a high energy cost.

All of these factors collectively give photography a high carbon footprint that many schools and individual artists are no longer willing to support. However, for those determined to continue to use these processes, there are books★ explaining the hazards and suitable safety precautions.

★ Susan Shaw and M. Rossol, Overexposure: *Health Hazards in Photography*, Allworth Press, 1991, and M. Rossol, *The Artist's Complete Health & Safety Guide*, Allworth Press, 2001

LEGAL RESPONSES TO HAZARDOUS ART MATERIALS

Art materials present a danger because, even today, they are exempt from other consumer laws such as the ban on lead in consumer lead paint. In the past, only short-term (two weeks) animal tests were required; these tests cannot identify substances that cause long-term damage such as cancer or birth defects. For these reasons, asbestos-containing art products such as instant papier-mâchés and clays routinely used to be labeled nontoxic.

This should not happen today, because a law passed in 1988 and in effect since 1990, the Labeling of Hazardous Art Materials Act (LHAMA), requires warning labels on products containing known chronically hazardous substances. This law requires a toxicologist to assess the products' ingredients and certify that the labeling they required is sufficient for consumers to use the product safely. However, the manufacturer pays the toxicologist for this certification, which creates a built-in conflict of interest. As a result, LHAMA has serious deficiencies:

1. Substances requiring labeling must be known to possess chronic hazards. Yet most organic pigments and dyes used in art materials have never been tested for chronic hazards. In this case, the toxicologist can label these untested products "nontoxic" by default—even if the product contains pigments that are in chemical classes that the National Toxicology Program says can be predicted to cause cancer if tested!

2. Some tests used by the toxicologists to determine toxicity are faulty. For example, a test in which materials are placed in acid is sometimes used to determine if the toxic substances in the product will be released in the digestive tract. This test does not consider that in addition to acid and water, our digestive tracts use bases, enzymes, cellular activities, heat, and movement to dissolve materials. Only after there were poisonings and deaths from "nontoxic" lead ceramic glazes were these tests abandoned by the toxicologists certifying glazes. That same acid test is still used to evaluate some other art products.

3. Faulty methods are used to determine when the amounts of toxic substances in art materials will result in a significant exposure. Toxicologists who estimate exposures during art making usually have never created or taught art themselves. They often do not consider the artist's intimate contact with their materials, crowded classrooms, tiny home studios, poor ventilation, lack of sinks, and other conditions common to home studios and schools.

4. The hazards of materials used in ways other than the label directs are not considered. Artists and teachers traditionally use materials "creatively." For example, melting crayons for candle making, batik resist, or for other processes causes these "nontoxic" products to release highly toxic gases and fumes from decomposition of the wax and from some of the pigments.

While the law has had a positive effect in identifying products containing massive amounts of substances with ingredients that have been tested and proven to cause cancer or other chronic hazards. But it is important to remember that this law will not protect you from these same chemicals if the certifying toxicologist decides you will not be exposed to significant amounts. Further, all those untested chemicals are "nontoxic" even when they are expected to be toxic or cancer-causing on the basis of their chemical structure. Therefore, it is important to be careful with all art materials.

ISSUES FOR SCHOOLS

A variety of laws related to health and safety laws affect colleges and universities, including the Occupational Safety and Health Act, the EPA's Resource Conservation and Recovery Act, state workers' compensation laws, and local fire prevention laws. In addition, students, if injured due to the negligence of the teacher or college, can sue both the teacher and college.

The OSHA Hazard Communication Standard (29 CFR 1910.1200) or state law equivalents applies to all employees in the United States who are exposed or potentially exposed to hazardous substances at their workplace. The purpose of the Hazard Communication Standard is to ensure that the hazards of all chemicals produced or imported are evaluated and that information concerning their hazards is transmitted to employers and employees by means of comprehensive hazard communication programs. Such hazard communication programs must include container labeling and other forms of warning, material safety data sheets, and employee training.

STUDIO SAFETY 101

Whether for the individual, classroom, department, or institution as a whole, safety is about taking precautions to preserve the health of the individual, the environment, and the community. It is a necessity to take the time to consider and assess the risks associated with any art-making activities for your own personal health, your family's, and your community's. There are very basic health issues that can be addressed with good common sense.

Step 1 – Become Knowledgeable

Know what is in your art materials. Often the label is not very informative, but every manufacturer should be able to provide additional ingredient information in the form of a material safety data sheet (MSDS, see appendix). In some states, manufacturers do not have to provide an MSDS unless it is being requested by an employer and the product will be used in a workplace. But any art material manufacture who will not provide one to you should be crossed off your list for being an irresponsible supplier.

Take a look at the MSDS. If it withholds the names of the ingredients as trade secrets or for any other reason, also consider finding another supplier. If the ingredients are listed, look up additional toxicity information on the Internet or in textbooks. The MSDS also provides fire, safety, and a lot of other useful information. Some of this data will take a little education to understand. If your school has not taught you how to interpret this data, there are many sources for it. One resource is the ACTS Web site, where there are free data sheet on "Understanding MSDSs."

Step 2 – What You Can Do
Methods of Preventing Exposure

Know the components of the materials you are using. Substitute materials known to be potentially hazardous with less hazardous materials. The work area should be properly ventilated and materials should be stored properly. Personal protection equipment should be used at all times.

Keep Studio Work Separate from Food/Kitchen

Use food preparation utensils or containers for food only. Even if something is used just once in the studio, never use it again in the kitchen. A surface, utensil, or container appearing clean may be porous and contain hazardous residuals that can migrate into food and then be ingested.

Properly Equip the Work Space

Smoke detectors should be installed and regularly checked. Obtain a fire extinguisher appropriate to the materials present, and learn to use it in a relaxed setting, before a panic situation makes learning difficult. Store flammable materials in an approved container, such as a flameproof cabinet. Keep the studio free of dust. Post emergency phone numbers by the telephone so they can be found easily and immediately when needed. Use a cardboard box with plexiglass top and rubber gloves for mixing pigments. Set up an eye wash procedure in your studio.

Clean Studio with Proper Equipment

Floors and counter surfaces should be hard and smooth for easy and thorough cleaning. Fabric floor coverings trap dusts and spills, which evaporate and become airborne later. Don't sweep! Sweeping can stir up dust, which may remain airborne for days while you breathe it. A wet mop or sponging is preferred. Always clean up spills immediately using techniques appropriate to the materials.

Ventilate Properly

First, let's look at what doesn't work. A fan blowing air around the room is not ventilation. It only provides turbulence, which can stir up dusts and increase airborne dusts. Window air conditioners also are not ventilation. These units draw air in, cool it, and blow out this same air. The filter in an air conditioner will not trap any fine dusts, vapors, or other air contaminants.

Real ventilation systems must be designed to fit what you are doing and how you are doing it. It may take some professional advice. Some processes simply should not be done without a qualified engineer designing a proper system. An example is etching with nitric acid. There is no approved air-purifying respirator for this acid and ventilation is your only option. Monona Rossol says, "If you don't have adequate ventilation, you just can't do nitric acid etching safely. If you are creating small amounts of toxic vapors such as from solvents evaporating from oil painting work, you may be able to set up a dilution ventilation system. This could consist of a window exhaust fan at work level, near which you place the easel, and an open window or other source of replacement air on the other side of the room. It is important to remember that fans do not create air; they only move it. If you don't replace every cubic foot of air your exhaust fan removed from the studio, then the air doesn't exhaust."

Store Materials Safely

Date materials according to when you received them. Keep containers tightly closed when not in use to prevent spills and evaporation. Keep materials in their original containers to assure that containers are suitable for the specified material and the contents are properly labeled. Never store materials in food containers! A soda bottle is expected to hold soda; an orange juice carton, orange juice. The risks of using food containers are great, as you or someone else could make a fatal mistake! If a storage container other than original packaging must be used, label it clearly and thoroughly with all of the information from the original container. Don't store high above reach or in glass containers that can break. Don't store incompatibles together: for example, acids and alkalines or bleach and ammonia.

Plan for Fire Prevention

At a minimum, you should have a working and tested smoke detector and fire extinguisher. But there are a multitude of other concerns to consider, including review of how you dispose of rags that may be covered in combustible materials and where and how you discard turpentine.

Personal Protection

One of the easiest ways to start to protect yourself is by wearing appropriate clothing. Avoid skin contact by wearing gloves, long sleeves, long pants, and full-

cover shoes. Use a separate set of clothes to work in and always change out of them to go home. Leave these garments in the studio to avoid carrying dusts into other living areas. Wash them frequently and separately from other laundry. If too much paint or other compounds gets on your work clothes, throw them away so they don't penetrate into your skin.

Protect Your Skin and Body

If skin contact occurs, wash with water and mild cleansers. Never use solvents or bleaches to clean your skin. These can impart more danger than the original offending material. Some solvents are readily absorbed through the skin and move directly into the blood stream and to internal organs, while others remove skin oils, a natural protective barrier, making penetration of other materials possible. Painters: don't lick your brushes to a point, as this can greatly reduce ingestion of dangerous pigments.

Choosing protective eyewear requires knowledge. Safety glasses with side shields should be worn when doing task during which particles may fly into your eyes. Chemical splash goggles should be worn when pouring or working with corrosive liquids. There are also goggles for dusts and ones that are sealed for protection from very fine dusts. Contact a reputable supplier of safety eyewear and explain exactly what you will be doing for advice on the right equipment.

Masks and cartridge respirators should be used only after ventilation, using safer materials, and every other option has been explored. If you are employed to do the artwork, it is a violation of the OSHA regulations for your employer to let you wear a respirator until a medical professional has certified that you have no heart, lung, or other health problem that could be made worse by the breathing stress caused by wearing the respirator. Next, the employer must have you professional fit tested by someone trained in one of the OSHA-approved fit testing methods. Next you have to be formally trained to know how to use and maintain your respirator. For example, you will find out that the chemical cartridges and some types of masks are only to be used for eight hours. Buying a new set of cartridges every day can be expensive and each type of mask or respirator is limited in the type of contaminant it will capture.

If you are working freelance as an artist, the OSHA regulations do not apply to you. But the chances are good that if you simply go to a store, buy a mask or respirator, and stick it on, that you will not be well protected by it.

Use the right gloves for the kind of work you do. For example, if you are a welder, use leather gloves. Remove jewelry and tie back long hair that can be caught or tangled in work. After working in the studio, always wash hands before eating, drinking, smoking, applying makeup, or other personal hygiene.

Two Simple Ways to Promote Safety

It is important to quit working when you are tired, as the chance of an accident increases with fatigue. Long work periods can also result in high exposure levels, and the body needs adequate time to recover from the exposure and to get rid of pollutants.

Always provide your doctor with precise information about the materials you use in your work. Symptoms of chemical poisoning may appear to in a cold or flu symptoms. A simple test may be able to detect the difference, if your doctor knows what to look for.

A Word about Home Studios

About half of all artists work at home, and of those, about half work in living areas. That increases the chances of eating, touching, and breathing art materials. When working in the home, the artist's working environment pose greater risk, due to lack of awareness, ventilation, or other variables, and may result in greater exposure periods than those occurring in a studio outside the home. Children should not be living in a home where toxic art materials are used.

Long-term Consequences

Some types of chemical exposures are cumulative, meaning chemicals entering the body are not flushed out and larger amounts may accumulate in the body. Another hazard is the risk of multiple chemical exposures. Some chemicals may be relatively safe when used singly, but can be dangerous when combined with other materials. Since it is impossible to test all combinations, individuals should minimize exposures. Much information related to art hazards comes from knowledge of industrial situations and consequences.

INTERVIEW WITH CRAIG NUTT, DIRECTOR OF PROGRAMS FOR CRAFT EMERGENCY RELIEF FUND (CERF+)

The following is an interview with an important person in this field of artists' health and safety issues. Craig Nutt, director of programs for the Craft Emergency Relief Fund, has worked tirelessly to protect the artists' work and personal safety.

What is the mission statement of CERF+?

CERF+ safeguards and sustains the careers of U.S. craft artists and provides emergency resources that benefit all artists. CERF+ accomplishes its mission through direct financial and educational assistance to craft artists, including emergency relief assistance, business development support, and resources and referrals on topics such as health, safety, and insurance. CERF+ develops, promotes, and maintains resources for emergency readiness and recovery that benefit all artists. CERF+ also advocates, engages in research, and backs policy that supports craft artists' careers. CERF+ is working with partner organizations to build a better safety net for artists across the United States.

Can you tell us a little about the Studio Protector, the Artist's Guide to Emergencies, which recently came out for artists?

We give grants and loans to craft artists whose careers are threatened after health issues or disasters. Our experience helping artists after Hurricane Katrina cemented our commitment to disaster preparedness for artists, and we created the Studio Protector as a result. We wanted to be proactive in helping artists prepare before disaster hits and to think about preparedness as it relates to their careers. The Studio Protector has two parts: an interactive, quick-reference wall guide and a complementary online guide (*http://www.studioprotector.org*), which is a comprehensive digest of general, medium-specific, and disaster-specific

information that guides the user through all aspects of emergency management. Experts in fields such as conservation and emergency management contributed content to both pieces. The Web site also includes video interviews with artists who share what they have learned from going through emergencies.

The Studio Protector includes:

- Safeguarding – All-purpose business practices to help protect your work space, your art, and your career.
- Disaster Planning – How to prevent and prepare for an emergency in your studio.
- Disaster Warning – Things to do *if* you have time during a disaster.
- Disaster Relief – How and where to get emergency assistance within and outside your community.
- Cleanup – First steps to reclaiming your work space after a disaster.
- Salvage after a disaster – How to save your art, assets, archives.
- e-Salvage – Retrieving electronic data and recovering electronic equipment.
- Rebounding – Moving on and getting back to work.

What is the most important step an artist can take to protect his or her work and career?

One of most important things an artist can do is to get business insurance. Most artists do not realize that their homeowner's (or renter's) insurance does not cover their art, their tools and supplies, or cover them for liability if they are in business. If you sell or offer work, you are in business, as far as insurance is concerned. Homeowner's insurance does not cover liability for business practices. If you participate in a studio tour and someone falls and breaks their leg, they or their insurance company can sue you, and your homeowner's insurance will not cover it because it happened during a business activity. Or suppose you are showing at an art fair and your booth blows over injuring someone. A business liability policy would cover that.

Consider the cost/benefit ratio of paying a few hundred a year in insurance vs. $100,000 in legal fees (win or lose), plus a settlement for medical bills and/or pain and suffering if you are found to be at fault. Just as you would not drive a car without insurance, you should not operate an art studio without insurance. A manufacturer's and contractor's liability policy covers you anywhere you go, such as a craft show or street fair. It's wise to get it. You can often purchase a business owner's policy (BOP) that includes property and liability in a single package, and if your property value is relatively low, it may not cost that much more than liability alone. Also, you should be aware that regular insurance policies do not cover earthquake or floods, so special insurance for those risks needs to be purchased if there is any chance you could be subject to those risks. Fortunately, the lower your risk, the less the insurance costs. You can find

information about flood insurance at *floodsmart.gov* and get a quick estimate of what it would cost.

What can artists do to safeguard their computers?

Back up your computer! Make copies of special documents and not just your tax returns. Make sure you put this in a safe location. In fact, it's wise to keep that information in what we call an "SOL" or Safe Off-site Location. That is someplace fifty or a hundred miles away from your studio that is unlikely to be affected by the same disaster that affects your studio. Some disasters, like Katrina, can affect a whole region.

Don't keep all your backups in your studio! If there is a fire, it will destroy both the originals and the backups. You can back up on a digital "cloud" site like Carbonite or Mozy. A portable drive that you can take wherever you go can work as well. Try to have multiple backup strategies to be safe. Check out the blog on CERF+'s Studio Protector Web site *www.studioprotector.org* for step-by-step information on protecting your studio.

The following interview is with Monona Rossol, one of the most important advocates for artists' health and safety in the field. With her ceaseless energy and efforts, she has brought to light many previously ignored issues and problems that artists face today.

INTERVIEW WITH MONONA ROSSOL, FOUNDER AND PRESIDENT OF ARTS, CRAFTS, AND THEATER SAFETY

Monona Rossol is the founder and president of Arts, Crafts, and Theater Safety (ACTS), a nonprofit corporation dedicated to providing health and safety services for those in the visual and performing arts. Rossol is a chemist, artist, and industrial hygienist with more than twenty years of specialization in visual and performing arts hazards.

What kind of work do you do, and why are you so committed to it?

I'm an industrial hygienist, which sounds like I clean teeth in a factory. But actually, I'm an expert on workplace health and safety. My specialty is safety in art schools, studios, and businesses.

I became committed to this work when I was working my way through art school. I already had a degree in chemistry with a minor in math and worked as a graduate teacher and research assistant in the chemistry department for my tuition. One day it occurred to me that the same chemicals I saw in the chemistry labs were being used in the art school: acids for etching, solvents for painting, metal compounds for sculpture patinas, and so on. The chemistry labs had eye wash stations, special ventilation, and safety training. The art department had none of these things. So I presented these safety issues in some of my MFA seminars. The teachers and my classmates didn't want me to talk about this subject, which only made me more interested in it. And I've never stopped talking and learning about it.

What are the most toxic materials artists use in their studio that you recommend that must never be used? What do you recommend these chemicals replace them with?

There is nothing too toxic to use—if you have the right training, the right ventilation, and the right safety equipment. The problem is that training takes time and education, and ventilation and safety equipment are expensive. Most schools are not properly equipped to do many of the processes they teach. In fact, most are actually breaking occupational and environmental laws.

For example, to regularly use lead such as lead ceramic glazes, lead solders, bronze casting alloys that contain lead, powdered lead pigments, or sanding or spraying paints that contain lead, the school is required by law to place personal air-monitoring equipment on each exposed employee, such as teachers and the janitors that clean the rooms. The level of exposure found in these monitors then dictates the precautions that are supposed to be taken, which can involve regular blood tests, showers, changing rooms, and more. I rarely see schools doing this, which means the way schools are equipped and functioning now, lead is too hazardous to be used.

Other metals such as cadmium and chromium have similar regulations. The silica dust from ceramic clay should also be monitored. Solvents are very hazardous; they should not be used without ventilation to draw solvent vapors away from you while you work. It goes on. But I repeat, if the proper training, equipment, and precautions are in place, almost anything can be used safely.

Technology is playing a more important role for artists in the creation of their work. What are the dangers working with equipment such as computers, scanners, and the like?

Scientists disagree about the dangers of the electromagnetic frequencies (EMF) generated by these and other electronic gear. They all know that very high levels of EMF will cause cancer and other bodily damage, but the effects of the low levels produced by digital equipment is not clear. In any case, it takes many years to develop chronic health effects, so it will be a long time before we have enough data to know for sure.

Until then, use common sense. The back of a computer tower is very "hot" with radiation. Place the back near a wall. Keep the laptop off your lap. Read the small print warnings and advice that come with all this gear and heed that advice.

Is there one discipline in the field of art where artists are exposed to the most dangerous materials? Or do all the disciplines (painters, sculptors, printmakers) have about the same amount of exposure?

Every medium can be either relatively safe or very hazardous depending on the materials one chooses to use. For example, printmakers who want to use nitric acid and Dutch mordant for etching need to have local exhaust ventilation systems, eye wash stations, emergency showers, special acid cabinets for storage, and more. But prints that are just as beautiful can be made by etching with ferric chloride solutions or electrolytic equipment. These processes are so much safer that they barely need any ventilation and very little safety equipment.

It's the same with every medium. There are now water-washable oil paints that can even be used safely by pregnant students. There are highly toxic mold, making resins based on urethane that can be replaced by a far safer alginate materials and so on. It's up to teachers to keep up on these fields and introduce students to the safer materials, rather than teaching with materials they learned to use years ago in school.

It is also important to understand that "safer" materials are not "safe" materials. In order to make paintings or prints that will last for hundreds of years, we need to use toxic pigments. In order to make art out of metal or clay, ores and minerals must be ripped from the earth and processed. To cast with plastic resins, highly toxic petrochemicals must be used. It is essentially impossible to make any of the traditional arts truly "safe" or "green."

What environmental precautions do you believe will be most helpful for artists to implement in their studio when they are just starting their careers?
The first and most important precaution is not to use any toxic materials in a studio in your home or apartment. Always keep art making separate from eating, sleeping, and everyday living activities.

Setting up a separate studio space for a particular medium often requires the services of an industrial engineer to design ventilation to fit the space. Artists starting out on their own are unlikely to have enough money to do this right. Doing it wrong can damage your health and people around your studio. So the most important precaution is to learn about the safer materials and use them until you have to money to set up ventilation for the hazardous ones.

Who knows? Maybe you will get so good at using the safer materials that you will produce excellent artwork without the more toxic ones. That's better for you and better for the earth.

What are the best resources for artists to understand and inform themselves with to help stay healthy?
I would also counsel artists to take some basic chemistry. They will be using chemicals intimately and experimenting with materials. They need to know what they are doing.

Forty years ago when I was in school, we had a required course called Materials. This class taught us the basic chemistry of paints, glazes, clays, resins, solvents, acids, and the other substances we would use. We all hated the hard technical stuff, but we came to rely on it later. A course like this should be required again in every art school, along with a safety and environmental component.

What are the most important issues facing artists today in the health and safety field? Why is it so important for artists to pay attention to these issues?
I think the most critical issue is the exposure of pregnant students to art materials. This is one area where there should be no compromise at all. Students who are, or may become, pregnant are in every college class. These women should never be

exposed to solvents, lead, cadmium, and many other chemicals used in art. Yet they need to be able to take a full complement of art courses.

For this reason, every school needs to offer many courses that only employ safer materials. That means that everyone in that classroom must also be using only the safest materials. For example, if the pregnant woman uses water-washable oils or acrylics, but other students in the same class are using traditional oil paints with solvents or are leaving their paintings from previous classes in the room to dry, the pregnant woman is still exposed to solvents in the air.

There needs to be safer classrooms for pregnant or potentially pregnant students. These classes would also be suitable for students with allergies, breathing problems, or similar disabilities.

What actions can artists take to help themselves and their communities? How do actions taken by artists impact a larger society?

I think I saw the best model in Australia in 1986 and 1987 when I worked there. At this time (I'm not sure it is the same today) every art teacher and artist belonged to a union. Even an artist working alone in the far outback would be a member of the Artists' Union. This way, they all had a say in the political policies that affect artists. They could speak as a large group rather than as individuals and affect governmental regulations and laws.

In Australia there is also the Council of Trade Unions that provides expert health and environmental advice and services to all types of unions. I worked for them briefly as well and was highly impressed by the knowledge of their technical people and quality of services to artists.

Here in the U.S., everyone seems to be out for himself/herself, and as a result each single individual is essentially powerless. We can't even be sure to keep our jobs, our homes, our savings, or our health. I think we need to form unions or other types of organizations that will enable us to work together for what we need. Why should the employers and big corporations be the only ones organized and powerful?

Are there communities of artists who are doing this work or is this an individual endeavor? If there are groups of artists working on this issue, who are they and how did they get the support they needed to do the work?

There are a few good organizations. One is CERF that provides financial help for craft artists who have had studio fires or other personal disasters. There are other groups like the American Crafts Council, the Surface Design Association, the College Art Association, and the National Council on Education in the Ceramic Arts, but they really don't have much of a voice. I personally think that when these organizations also accept funding from the art materials industry and corporations, they tend to serve the interests of their donors.

Perhaps if we all joined one or more of these organizations, became very active and vocal, and made sure that members became the dominant source of income, we could be the ones that set their policies and goals.

Do you think it is hard to motivate artists on to do this work? If so, why? If not, why not?
It is hard to get artists to work together because the culture of self-promotion and greed affects us just as it affects others in this country. We now learn as part of our art education how to attract attention to our work, get publicity, shock and awe our viewers, and measure our success in dollars. And we study and admire the recent artists that have succeeded in exactly this way. We've mistaken self-promotion for talent and technique. And oh, how it shows in the galleries.

Each of us needs to decide what our artistic mission is—what it is we really want to say or show to the world. And we need to think about whether that message is important enough to dedicate our lives to it. If not, there are other careers that will not damage the earth with toxic substances or put our health at risk.

RESOURCES AND ADDITIONAL INFORMATION
Below is a list of who to go to and who is on top of the latest information on the ever-changing science of health and safety issues in the arts.

Occupational Safety and Health Administration (OSHA)
OSHA aims to assure the safety and health of America's workers by setting and enforcing standards; providing training, outreach, and education; establishing partnerships; and encouraging continual improvement in workplace safety and health. OSHA offers many resources designed specifically for smaller employers. The agency wants to encourage all businesses to establish safety and health programs and find and fix hazards to prevent workplace injuries and illnesses. Contact information:

U.S. Department of Labor
Occupational Safety & Health Administration
200 Constitution Avenue
Washington, D.C. 20210
Phone: (800) 321-OSHA
Web site: *www.osha.gov*

Art, Crafts, and Theater Safety (A.C.T.S.)
A.C.T.S. is a not-for-profit corporation that provides health, safety, industrial hygiene, technical services, and safety publications to the arts, crafts, museums, and theater communities. A part of the fees from the organization's consulting services goes to support free and low-cost services for artists.
Contact information:
Arts, Crafts, and Theater Safety
181 Thompson Street, #23
New York, NY 10012-2586
Phone: (212) 777-0062
Web site: *www.artscraftstheatersafety.org*

The National Safety Council
The National Safety Council saves lives by preventing injuries and deaths at work, in homes and communities, and on the roads through leadership, research, education and advocacy.
Contact Information:
National Safety Council
1121 Spring Lake Dr.
Itasca, IL 60143-3201
Phone: (800) 621-7615
Web site: *http://www.nsc.org/Pages/Home.aspx*

INSURANCE RESOURCES

Now that you've read about health and safety issues, now may be a good time to review your own health care policy. Having health insurance is an ongoing challenge and necessity for artists. Consider exploring options for access to insurance plans that may be offered at a discount through your alumni organization or freelancers' organizations. Two organizations you can look at are:

Fractured Atlas
Fractured Atlas is a nonprofit organization that serves a national community of artists and arts organizations. They "help artists and arts organizations function more effectively as businesses by providing access to funding, health care, education, and more, all in a context that honors their individuality and independent spirit."
Web site: *http://www.fracturedatlas.org/site/insurance/*

The Freelancers Union
In New York, Freelancers Union offers eligible members PPO or high-deductible plans through Freelancers Insurance Company (FIC). Freelancers Union also offers health insurance in other states through United Healthcare's Golden Rule Insurance Company.
Web site: *http://www.freelancersunion.org/insurance/explore/*

LINC (Leveraging Investments in Creativity)
LINC partners with the Actors Fund to deliver information and resources to artists, organizations, and communities on options for affordable, local health care and health insurance through the Artists Health Insurance Resource Center (AHIRC). LINC understands that access to quality, affordable health care is one of the most difficult challenges facing U.S. artists, indeed, many Americans, today . . . LINC is committed to helping artists gain access to this information and to cultivating programs across the U.S. designed to improve access to affordable, quality health care and health insurance for individual artists of all.
Web site:*http://www.lincnet.net/health-insurance-for-artist*

Career Planning and Job Search

ᘛ9ᘚ

Writing Résumés, CVs, and Artists' Statements

I n this chapter we will discuss the written tools used to support an artist's career, including artists' résumés, CVs, cover letters, artists' statements, and bios. These materials are all a part of the process of introducing your work to potential employers, buyers, residency programs, galleries, and other exhibition venues.

It is important to be thoughtful in how you prepare these documents. For example, artists often make the mistake of underestimating the importance of their résumé because they think their art should speak for itself. However, you will not always be present when viewers see your work, and in many instances, your audience will make initial judgments of your work based solely on your written materials. Think of these documents as tools that will give you the chance to describe your art and work history to those who may otherwise not have the opportunity to view your work in person or meet you face-to-face.

RÉSUMÉS AND CVS

It is important to understand that there are different kinds of résumés. We will outline structures and give examples of each résumé and discuss when and how to use each one. The length and content of these documents depends on the number of years you have worked on your field. Although these documents are a foot in the door, they do not get jobs/opportunities by themselves; rather, they position you to try for an interview or opportunity. These documents should take into account the basic needs of both the artist and those reading the document.

The Artist's Résumé

An artist's résumé is different than a traditional résumé that is used for job applications because it focuses exclusively on artwork and does not include experiences that are *not* directly related to your art practice. You should tailor your résumé to each specific opportunity you are applying to. Your résumé is not a laundry list of everything you've ever done; rather, it packages you for particular

galleries or job opportunities. The artist's résumé outlined in this chapter is a framework on which to build.

Purpose: Applications to residencies, graduate programs, grant applications, and submissions to galleries.

Content: The artist's résumé gives a history of your education, exhibition experience, awards, and publications. It highlights your qualifications for a grant or particular exhibit.

Format: An artist's résumé is anywhere from one to four pages long depending on how long you've been working in the field. Unless you already have an extensive exhibition career, your résumé should be relatively brief. It is generally shorter than a CV.

Special Features: The focus of the artist's résumé is on exhibitions and written pieces such as press about your show career.

The Curriculum Vitae or CV

The CV is a type of résumé that is traditionally used to apply for college teaching positions and other academic opportunities. There is often confusion regarding the difference between a CV and an artist's résumé. A curriculum vitae is much lengthier than an artist's résumé because the CV is a record of all your professional activities.

To help develop your CV, while in school or after you graduate, find your favorite professor's or colleague's CV online and use those documents for research. Think about what you can do to build your CV and fill in what is not on your document, such as administrative work, graduate student committees, attending conferences and presenting at conferences, and writing articles.

Purpose: These guidelines are specifically recommended for longer CVs that are generally used for applying for college-level teaching positions or other academic opportunities. The main purpose of a CV is to highlight your education and teaching experience. Be mindful you try to fill in the types of academic requirements of someone going into the teaching field.

Content: The CV is a complete record of all your professional activities and should include teaching experience, exhibition history, and publications—see a complete list of categories later in this chapter. It is important to note, that commonly there are individuals outside the art department to which you are applying and who are involved in the search process. These individuals may not be familiar with the specifics of arts-related fields, so it is critical on your CV to be clear and concise about what you have accomplished.

Format: A CV is a work in progress, and it will be short when you begin your career and become longer as you proceed. The short CVs highlight your most important activities, while longer CVs are a complete list of all your professional accomplishments. Note: the shorter CV has recently been requested for more general administrative employment, museum positions, and elementary and high school teaching jobs. Currently, a shorter CV is used for pre–K-12 teaching applications.

Bibliographies and Publications:
People get confused between bibliographies and publications. Bibliographies are for references about your work while publications are what you have actually written, for example, an article, a book, etc. CVs also feature committees, advisory boards, research experience, and professional organizations. According to College Art Association's standards and guidelines for CVs, "The bibliography is a record of material about you. Articles, reviews, catalogues, radio and television interviews, etc., are placed under this heading." The publication section "describes the material that you have written. From time to time, an artist will review a show for a magazine or be asked to write an essay for a publication about some contemporary art issue."

Day Jobs/Basic Business Résumé
This résumé format is used to apply for jobs that may or may not be art-related.

Purpose: This résumé highlights education and work experience for the purpose of securing employment in a wide range of areas. Fine artists often need to create this version of their résumé when they are applying for day jobs, which might include graphic design work, administrative work, internship, gallery assistant positions, art handling, or part-time or temporary work.

Content: Unlike the artist's résumé, this document should include various work experiences such as non-art jobs, depending on the position you are applying for. This résumé contains all of your education and work experience and special skills that might be useful in administrative settings.

Format: This résumé is usually only one page, two at the most.

Special Features: Includes computer and technical skills, languages, and all work experiences. This résumé is not limited to focusing on your studio practice.

WHAT ALL RÉSUMÉS AND CVS REQUIRE

- **Use chronological order.**
 Remember to list your most recent accomplishments first and proceed backwards chronologically. Whatever format you decide on, be consistent throughout the document.

- **Make it easy to read.**
 The reader should be able to scan your résumé for the most important information in a matter of seconds. Galleries and potential employers get hundreds of résumés every year and they will often scan your document at a glance. Your résumé will be much easier to read. Don't overthink the font—forget fancy fonts and make sure it is easy to read and not smaller than ten point or larger than twelve. Traditionally Times New Roman is used for academic CVs.

- **Only include what's relevant.**
 Don't include information that isn't related to your fine artwork or to the particular position you are seeking! Gallery owners and potential

employers can research you online, so don't embellish or include experiences that have no relationship to your art practice and work. Keep your résumé and CV focused on the gallery, grant, residency, or job for which you are looking.

Using Action Verbs

Use action verbs to describe your responsibilities and accomplishments. Use past tense verbs except to describe a current position. The more consistent your language and presentation, the easier it is for the reader to absorb. The following are good examples of verbs for résumés and CVs: *administered, analyzed, assembled, compiled, coordinated, designed, developed, directed, fabricated, guided, illustrated, installed, led, organized, rendered, researched, reviewed, strengthened, streamlined,* and *volunteered.*

The following are the main categories that usually appear in an artist's résumé. Keep in mind that as an emerging artist, you should not expect to be able to have content and experiences for all of these categories. As your career progresses, you will undoubtedly need to add new categories or make changes in your format.

Contact Information

This includes your name, address, phone, e-mail, and Web site if you have one.

Don't use an e-mail that seems unprofessional or too casual. Be sure you list your current e-mail and phone numbers that you check regularly. Birth date is optional for an artist's résumé, but galleries can request your birth date. When you create a résumé for a gallery show, it's often asked for/included. But birth dates are *not* required for CVs or traditional job résumés.

- Don't include Facebook pages and other social media on your Web site or links to video, etc., unless you have created an account just for professional interactions.

- Be sure your name/contact information appears on each page in case pages get separated.

- Make sure you get your cell or landline phone message set to an appropriate message. If you share a phone line, tell the other people using it that you are checking for professional messages/watch what message they put on the machine.

- It is important to be consistent in how you use your name/spelling, so it's always searchable, for example, use Mary K. Smith every time, not Mary Kirk-Smith.

Education

This section should include year, degree, school, and location. Only list college-level degrees; never include high school or awards received in high school. Do not put in GPA. For a job résumé or CV, education should be the first category that appears on your résumé if you are a recent graduate and goes at end of the résumé if you are more experienced. If you are writing an artist's résumé for a gallery,

however, education may be listed at the bottom of the résumé, after your show record and other professional accomplishments. Include certifications and any special awards, workshops, or special study abroad. Don't list specific coursework. If you have more than two awards, break out into the separate awards section that will appear later in the résumé.

Exhibitions

If you have a number of both solo and group exhibitions, you can create two separate categories, but if you only have a few shows, then you can combine them into one list but note which are solo shows. Your exhibition record should be listed chronologically with the most recent show first. You can include a confirmed show that has not yet happened (but not speculative shows that you hope to do). Open submissions are not ideal to include, and exhibits in restaurants may seem unprofessional, so only include those if you have very little exhibition experience.

Format: Solo Exhibitions

Year, title of show, venue, city, state, curator or juror

Example:

2011 *Lawrence of Arabia and the Desert of Souls*, Jury Show, Smithwick Gallery, New York, NY

Selected Exhibitions

Listing your show record is not about quantity. This is another strategic section for you to think about, not a big laundry list of lots of shows. Galleries want to see if you are a good fit. Given your career trajectory thus far, look at gallery's artists and see if you are of similar experience/caliber. Your résumé should show you are a perfect fit for a gallery. You may want call this Selected Exhibitions and include all solo and group shows. You can also include the Web site for the exhibit, if there is one.

Awards, Grants, Fellowships

List the year, name, description, and location. These can go together, but if you have a lot in both categories, they can be separated depending on how many you have.

Residencies

List the year, name, and location. Be sure to put in a sentence about what you did there and what was special about it. For example, "Completed a series of paintings on the Gobi desert." If something isn't obvious in the title, briefly explain it. A common mistake is not checking the exact name and proper spelling of the residency, so check that this is all 100 percent accurate.

Bibliography

This section lists reviews and mentions of your work in books, magazines, newspapers, catalogues, and reviews. Make sure you use proper format to describe these documents such as the criteria listed in the Modern Language Association and Chicago Style manual.

Whatever format you use, you must stay consistent.
The following is an example:
Marcy Booker, "Exhibits Unhinged," *Art Forum*, no. 398 (March 2011): 87.

Publications
Publications are what you have actually written: for example, an article, a book, etc.

Collections
This is not a required section of your résumé, and as an emerging artist, it's not likely that you will have collections to list. But if you do include this, give the year, title of collection or collectors' name, city and state.

Speaking Engagements or Artists' Workshops and Demonstrations
List the year, title of speaking engagement or workshop, and brief description, lectures and panels.

Commissions
If applicable, include the year, title, venue, city and state.

Media Coverage or Press
For television or radio, list host and title of show, segment of show, station name, and date. For online press, use Web site addresses. Be aware, in the case of blogs for press, you should only use well-established blogs, either of major organizations or linked to recognized, respected journals, journalists, and art historians, not a friend's blog or Facebook page. Some will say don't include online press/blogs, since so often online press is not reliably professional.

Work Experience
This section includes work experience that is related to your fine arts practice, not necessarily any other work done for pay. This section is optional. Examples of appropriate work experience include working as an artist's assistant, art handling, gallery assistant work, or internships if you are just completing your education. But do not include non-art work such as waiting tables. This section can also be titled Current Employment or Other Experience.

MOST COMMON MISTAKES ON RÉSUMÉS AND CVS

- Typos, not checking your spelling and grammar. If you apply for an opportunity and your résumé has ANY mistakes, often you will not be considered.

- Including old/irrelevant information, making it too long (over one page unless you are a mid-career professional or doing a longer CV to teach/show work).

- Using a font type that is illegible. Certain types do not read well. It's good to use common types like Palatino and Times New Roman.

- Using a word document. Always create a PDF or JPEG file to ensure that the viewer can open your document and view it exactly as you intended. If you use Word, there are problems that crop up, such as accidentally leaving the edits/markups viewable on the final document. This can be avoided by creating a PDF or JPEG.
- Don't embellish or make things up. This is a public document that lives in the public sector.
- Make it into a PDF for e-mailing to ensure it is readable. Beware of using a word document without converting it since it can be translated incorrectly and format goes wrong depending on user's computer.
- If sending in hard copy, don't use bright colors, don't overthink the paper quality, don't include imagery in the background

What does NOT belong on a résumé
- Your photo
- Social security number
- Large/distracting imagery
- Street address/phone number of work contacts/employers
- Good rule of thumb: leave off political affiliations and volunteer work for religious or political groups unless directly related to the position you are applying for.
- References will be on a separate page.

Further Résumé and CV Writing Tips
To ensure that you keep your résumé or CV updated, if you have a show you should immediately add it to a master document that contains all of your exhibition and work history. Work on these documents when you don't have to use them and you'll avoid frustration later.

For ideas on content and format, look at artists' résumés on galleries' Web sites or look at the résumés of your professors or of artists you admire.

Get feedback on your CV or résumé from colleagues and from your alma mater or college's Career Services.

SAMPLE ARTIST'S RÉSUMÉ

To get you started, here is an example of an artist's résumé. You should always be aware that you must tailor each résumé or CV specifically for each individual, unique opportunity. Consider what is being asked for by a grant, teaching position, residency, or exhibition venue and be sure your submission materials all fit those requirements.

Artist's Résumé for Galleries

Sunita A. Merhar

1977 Costello Lane
Brooklyn, NY 86958
212-555-5555
artistname@gmail.com
www.sunitawork.com

EDUCATION

New York University, New York, NY
Master of Fine Arts, Painting, 2011

Massachusetts College of Art, Boston, MA
Bachelors of Fine Arts, Sculpture, 2010

AWARDS AND HONORS

2011 Keaton Memorial Award, Outstanding Student in Fine Arts,
New York University, New York, NY

SELECTED SOLO EXHIBITIONS

2011 *Artfully*, solo show, ASP Gallery, Chicago, II
2010 *Sunita A. Merhar*, solo show, Kashuk Gallery, Boston, MA

SELECTED GROUP EXHIBITIONS

2011 *Final Thoughts,* Massachusetts College of Art, Boston, MA
2010 *Perspectives,* Massachusetts College of Art, Boston, MA
2010 Group #9, juried show, The Space Gallery, Boston MA

RESIDENCIES

2008 *Artist-in-Residence,* Virginia Center for Creative Arts, Amherst, VA

PROFESSIONAL EXPERIENCE

2010 Graduate Assistant, New York University, New York, NY
Art and Design Education Department
Responsible for teaching beginning-level drawing courses.

BIBLIOGRAPHY

Marcy Booker, "Unhinged," *Northeastern Arts Magazine*, no. 498 (March 2010): 58.

COVER LETTERS

Each time you submit your materials, you must include a cover letter to explain why you are approaching the particular gallery and how your work relates to and fits into the gallery.

In this brief letter, you will express enthusiasm for the opportunity and highlight your qualifications, pointing out parts of your résumé. You can use your artist's statement as a jumping-off point for describing your work. Make sure the letter is directed to the right person by name, that you write the letter thoughtfully for the job at hand (this is not a form letter!), and double-check that you are spelling the organization or gallery's name exactly right.

The following is an example of a cover letter based on a letter developed by artist and professional practices counselor Asha De Costa. Remember that the first paragraph is used to tell the reader who you are and why you are writing. If you were referred by someone in particular, give their name. The second paragraph is used to describe your work and explain why you believe it will be a good fit for the gallery. The last paragraph is for thanking the reader for their time and consideration. Be sure your name, address, contact information, and Web site (if available) are listed either at the top or bottom of résumé. Consider designing a simple letterhead with all of this information.

Artist vonArtist

10 Dieffenbacher Street, Sleepy Hollow, NY 11247 • (555) 555-5555 •
artistx@gmail.com

July 4, 2011
Ms. Elena Trapp
Director, Arts Gallery
Laurel University
10 Broadway Street
New York, NY 10034

Dear Ms. Trapp,

I am writing to apply for the gallery assistant position at Laurel University. I have extensive experience working in university galleries in New York and have assisted curators for numerous exhibitions, handled data entry, and maintained records. In addition to organizing events, I have coordinated panel discussions and speaking engagements for students and alumni. My creative problem-solving skills combined with the knowledge I developed through working in university gallery settings makes me the best candidate for this position.

Additional highlights of my accomplishments include:

- Collaborated in planning and executing the annual graduating senior art exhibition.
- Initiated communications with administrators within the school to promote programs and workshops.
- Managed database to track exhibition artworks and oversaw budgets for exhibitions.

The mission of your gallery, which supports advancement of women in the arts, is also closely aligned with my own arts practice and interests. All of these traits will make me a valuable member of your gallery staff. I welcome an opportunity to further discuss my qualifications and enthusiasm for this position. Thank you for your time and consideration.

Best regards,

Artist vonArtist

ARTISTS' STATEMENTS

An artist's statement is an introduction to your work and describes your influences, goals, philosophies, and methods. It is a tool used to help the viewer better understand and appreciate your work. The statement is often used for applying to a gallery show, residency, grant, graduate school application, or teaching position. It can also be used for an exhibition catalog, press packet, reviewers/articles, or your Web site. The statement can even help dealers and galleries sell your work and can be useful for cover letters.

The artist's statement begins with a brief overview of your work's basic ideas, followed by a paragraph about how those ideas are represented in the work. This is your chance to talk about the evolution or history of your work and describes your influences, materials, process, and can include where your work fits into contemporary art world or art history. When you write your statement, just imagine that the reader has never seen your work before. If there is something about your work that people don't seem to understand, you can address that in the statement.

An artist's statement can have many uses and should be viewed as an extremely versatile and essential tool you will use for many purposes. It gives you validation, visibility, and goes beyond what a résumé or CV can tell about your work. It's also a useful tool to prepare oneself for conversations that will occur during studio visits. The artist's statement is a work in progress that you'll be revisiting many times over the years as you explore the ideas you are working on and clarify your thoughts. Think of the artist statement as a tool that enhances your art practice.

Why Artists Resist Writing

Artists often hate the process of writing an artist's statement because they think their art speaks for itself. Or they use the excuse that artists don't have to write well. Think of this as a tool to help people who don't know your work be able to look at it more effectively and get people more interested in learning more. By writing this statement, you as the artist provide the viewer with the way that you want your work to be assessed.

Getting Started

Start by writing about another artist's work that you admire or try interviewing a fellow artist and try writing a statement about each other's work. Give your writing to partner and then rewrite your own statement. Try writing in your speaking voice; it may help to record your voice as you speak about your work with a friend. It's often easier to talk about work than write about it, so this exercise is great for loosening you up and getting at things you may not have even articulated to yourself before. Use your master's thesis paper to start ideas. Brainstorm, make an outline, write out a first draft, edit it, proofread, share with a colleague or friend, then edit and proof again.

Be concise, be clear, and be specific. Always think about the audience you are writing for and what your statement is being used for. Get a journal just for taking notes for the statement. Try taking notes throughout the process of making

a piece. Start working on your statement now, when you have lots of time to revise it and rethink it; don't wait until you need one.

Format

The statement should only be one page long, consisting of just one or two paragraphs. The most common mistake artists make is writing a statement that is much too long. The document should be single-spaced, use basic type, and be written in a legible font size (12-point font). The overall page should be very simple with no added graphics.

Examples of Topics/Questions to Prompt Writing

What is your work about? Start by thinking of describing the who, what, when, why, and how. The following are questions to prompt you and make you consider how to articulate your themes, materials, influences, metaphors, and techniques.

- What kind of tools and materials do you use and why? This is a process question, not a list of media you used.

- What is the process you use to go about making a work of art/starting a work of art in your studio?

- What sources do you draw inspiration from? Caution: be wary of overemphasis or reliance on comparisons to specific famous artists, which can take the reader's attention from you and place it on someone else.

- How do your techniques support the content of your work?

- What drives/inspires you to do your work, and what is the subject?

- When did you do this work/how does it fit into your overall body of work? Why is this work different than other work being done in your field?

- What ideas are you exploring in your work?

- What message do you want to convey?

- What issues, themes, social or political views influence your work and how?

- How does your background (education, life experience) influence your artwork?

- How does your work relate to the current art scene?

Common Artist's Statement Mistakes to Avoid

- Don't use grandiose statements, clichés, empty expressions, long explanations, or rants.

- Don't list every material you have used.

- Don't think of this as your résumé. Do not include the entire history of your work.

- Do not write a poem, and do not write only three sentences.

- Do not describe your childhood or personal life unless it is directly relevant to the work.
- Don't use a bragging tone.
- The statement should be written in first person. Don't refer to yourself as "the artist."
- Be sure to proofread for grammar and spelling.
- Avoid using weak phrases like "I am trying to" or "I am attempting" or "I hope," which suggest that you are unsure of your statement and suggest insecurity.

Try the following exercise to generate ideas for your own artist's statement. Complete each of the following statements by reflecting on your current work and areas of interest:
1. When I work with …
2. I am reminded that …
3. I begin a piece by …
4. I know a piece is done when …
5. My work fits into the art world in the following ways …

The following is a strong example of an artist's statement by Jann Nunn. Nunn holds a BFA in sculpture from the University of Alaska Anchorage, attended Skowhegan School of Painting & Sculpture in 1991, and earned an MFA in sculpture from San Francisco Art Institute in 1992. Nunn is currently professor of sculpture at Sonoma State University.

Jann Nunn

Artist's Statement

My work in sculpture, installation, and performance gets to the heart of the issue, place, or space at hand. My research leading up to a site-specific, situation-responsive project involves an investigation of history, story, psychology, and/or physiology behind the project. In my work, I seek to convey significance through symbolism that communicates my ideas with authenticity and relevance.

My content-driven work involves both conceptual and poetic sensibilities. I want the work to be beautiful; that kind of draw-you-in beauty that lingers long enough until the ideas fall into formation in the viewer's conscious mind. Not unlike words in a poem, material selection, presentation considerations, and scale play off of each other to become something greater than the sum of their often-unrelated parts. Disparate materials such as steel with glass or fabric may be used in a single work to accentuate duality or tension. I'm not afraid to tackle themes in my work that range from intimately personal to overtly political issues.

For more than twenty years, I have primarily constructed large-scale sculptural installations, ephemeral works, and performance art pieces. While my work usually embodies a physical presence; the craft is considered and often laborious, it is the ideas that are paramount. In addition to my studio work, I have created large-scale outdoor works in public places for Burning Man 2001; Portland Clifftop Sculpture Park in the UK; SKYART Festival in Anchorage, Alaska; the Sonoma Community Center in Sonoma, California; and most recently a permanently-sited Holocaust and genocide memorial sculpture on the campus of Sonoma State University in Rohnert Park, California.

Jann Nunn, Oakland, CA 2010

❧ 10 ❧

Making Your Alma Mater Work for You

When starting your career, one of the simplest and most effective ways to build your network and find professional resources is to utilize the career services and alumni relations offices at your alma mater (the university you graduated from). These services are often free or may involve an annual membership fee. Begin by contacting your undergraduate and/or graduate school's career services and alumni relations offices to learn what is available. Also, if you did not attend college or complete a degree, there are still networks you can access. For example, if you take a continuing education course at some universities, you might be able to access some form of career development support.

Also, you should check to see if state or federal career support is available, especially if you live outside of a major city. And don't forget to tap into your local library, which often has more online resources than you may imagine!

UTILIZING ALUMNI RELATIONS

Getting in Touch

The alumni relations office at most universities will offer graduates a variety of services, programs, networking opportunities, and discounts. The best way to learn what is available is to log on to your university's Web site and locate the alumni office's contact information. Often the Web site will have full details on alumni services but you can also simply call or e-mail the alumni office directly to ask for information.

Most universities' alumni and career services offices also host a LinkedIn account and a Facebook page, and some have Twitter accounts. These social media resources are excellent ways for alumni to network with one another, learn about professional development programming, and stay updated on new resources. Jessica L. Arnold, director of alumni relations at The New School says, "We now post all sorts of information in social media related to opportunities to show work, art contests [for instance, recently we posted one for a call for photography with a $70,000 prize!], in addition to usual opportunities and events at the university.

This year we held our first exhibition of alumni work in Miami during Art Week. Those selected will have the chance to have their work on display across the street from the Museum of Contemporary Art around the biggest fine arts event. Alumni who have not stayed in touch would not have known about the opportunity because there was only an e-mail. Alumni who don't have a current e-mail on file with us and are not following us and their school/department in social media are really missing out!"

Online Profile Checklist

When you are looking for a job or doing any form of career networking, it's important that you manage your public image. Employers and professional contacts will often Google applicants and decide who to interview or work with based on what they learn. That means editing your profile or setting it to "private." Select appropriate photos of yourself and delete other things that may seem offensive, immature, or unprofessional. Be sure you update the following:

- Facebook
- LinkedIn
- Your job board profile/résumé (on whatever boards you currently use, whether college-related or other such as Monster)
- Twitter
- Your personal/professional Web site

Alumni Services

The following are the types of services and discounts that many universities offer their graduates. Be sure to make use of *all* of these services and get on your alumni relations' mailing list for updates.

Online Alumni Networking

Many colleges now offer some form of alumni networking that is accessible through an online database. After alumni register with the database, they can often sign up to connect with alumni in their field and seek career advice, ask to shadow someone more senior at their workplace, ask alumni specific questions by e-mail, or request an informational interview. Some colleges also offer mentoring, which can involve connecting you with more experienced alumni who can offer in-depth advice, career guidance, and sometimes professional connections.

Online Job Boards

Many colleges offer alumni access to an online job board. These sites offer job postings, freelance work opportunities, volunteer work information, and other career resources. Do not assume that because you are a fine artist and may not be seeking a traditional job, these job board resources are not of use to you. There are often fine arts–related opportunities and resources posted to these boards. For more information on job boards, see the career services section of this chapter.

Networking Events

One of the best services that colleges offer to alumni is a variety of networking opportunities. These can be hosted on campus, at various locations near the college, and around the country/outside the U.S. where there are local/city alumni chapters. These events can take the form of casual receptions such as cocktail parties or they may be built around specific topics or programming. For example, alumni offices may host a networking event immediately following a panel discussion on careers in art and design.

There may also be special alumni chapters that gather regularly to host guest speakers and encourage networking at the event. Also don't forget to attend any class reunions.

Alumni Membership Cards and Discounts

Alumni should always inquire about alumni membership cards and related benefits. Alumni often get discounts or free passes to museums and other cultural institutions. Alumni may also qualify for discounts at gyms and reduced subscriptions on newspapers and other publications. There also may be an alumni credit card program with special benefits.

Discounts on Classes

Some universities offer alumni access to free or discounted continuing education courses. And some art schools offer free or affordable life drawing classes to alumni.

Alumni Magazine

Be sure to get on the mailing list for your alma mater's alumni magazine, either by hard copy or online. The alumni magazine is useful not only for staying updated on what your fellow alumni are doing but it can also be a promotional tool for you as a professional. Let your alumni magazine's editor or your alumni services director know updates on what you are doing and see if they will include your recent accomplishments in class notes or even interview you for an article.

Opportunities to Be a Guest Speaker

Many universities welcome alumni to serve as critics, review student portfolios and senior thesis work, and serve as panelists for their career offices. This type of work is a great way to improve your résumé and to network. Serving your alma mater in this manner is an active way to engage with your school, current faculty, and young artists. You might also offer to serve on an alumni committee to plan a class reunion or participate in other committees your alumni office might host.

CAREER SERVICES

Most universities offer their graduates access to some form of career services. These services are sometimes free but may involve an annual membership fee. The career office often helps alumni to connect with job opportunities and offers access to a

variety of career development resources and programming. The following are the types of services many universities offer:

Online Job Board

As mentioned in the alumni relations resource list, these sites offer job postings, freelance work opportunities, volunteer work information, and other career resources. Many of these sites also host free online portfolios for artists so make sure you are fully aware of what your college's job board is capable of, specifically for visual artists. These sites sometimes also host an alumni networking tool that can be highly useful.

Career Counseling

Career advisors can offer alumni advice on topics such as career development strategies, résumé and cover letter feedback, and guidance on how best to present your portfolio. Be sure to ask if your career services office has a career counselor who specializes in the arts, preferably with a fine arts focus. This is an effective way to work out questions you may have about your career.

Career Development Workshops and Panels

Career services offices frequently host career development workshops ranging from general career topics such as job search fundamentals but may also host arts-specific workshops. These workshops are terrific tools for advancing your career and can be a good way to jump-start your professional development work. As an emerging artist, you may feel isolated in your day-to-day professional life, and by getting out of the studio and attending a workshop at your alma mater, you give yourself both professional tools and an emotional boost by reconnecting with your school and fellow alumni.

Résumé, CV, and Portfolio Review

Career services offices often offer free access to résumé and CV review. A counselor will edit your work and make suggestions on how to improve the content and design of your résumé or CV. If you attended an art college, advisors are often able to offer alumni a review of their portfolio or application packet for job, residencies, and graduate school applications.

Online Resources

Career offices often offer a Web site with information about special programming and with access to career development resources. For example, some schools host career services blogs with recent articles and observations on recent developments in art/design industry and helpful career development tips.

Reciprocity with Affiliate Universities

In addition to offering their own career services resources, some universities have made arrangements for job board and career counseling access through

other colleges with which they have made reciprocity agreements. For example, sometimes a public university that is part of a larger, statewide university system will allow graduates to utilize another school's resources. This is not common, so check with your college's career office to ask about such services.

CAREER RESOURCES FOR TEACHERS AND COLLEGE FACULTY

Many artists who teach are not aware of the many benefits and professional development and funding opportunities available to them. The following are examples of the types of benefits that educational institutions often offer teachers.

Faculty Professional Development Funds

Many institutions offer faculty and staff the opportunity to apply for funds that support their professional development. This can include travel funds to attend conferences or conduct research. Check with your school's human resources office, faculty affairs office, or with your academic program's administrative office to learn what may be available to you.

Teaching and Research Assistants

Faculty members are often able to hire students as either graduate teaching assistants or as research assistants.

Use of Studio Space and Facilities

Some institutions give faculty access to private or shared studio space and also may offer access to facilities such as on-campus printing and photography studios.

Free Classes

Most universities offer faculty and staff access to free classes. This benefit is often extended to faculty's spouses and family.

Faculty Networking

Faculty members are often given the opportunity to network with one another. This can sometimes be as simple as a holiday cocktail party or it can be a more structured event such as the opportunity to serve on a committee with other faculty.

Free Technology Courses

Some universities offer faculty free computer classes and may also allow faculty access to on-campus computers and printers.

Special Events

Faculty members are often given free access to programming such as film screenings, panel discussions, and career workshops offered at their institutions.

Insurance and Benefits
Faculty members are often offered health, life, and dental insurance in addition to vacation and sick days. Faculty may also be eligible for retirement accounts that are supplemented by their institutions. Be sure to check with the human resources office to ensure you are taking advantage of all available benefits.

Discounts
Educational institutions often offer faculty discounts at gyms, local museums, and other cultural institutions. Some schools also offer discounted rates on newspapers.

Faculty Exhibitions
There are sometimes opportunities for faculty to exhibit their work on-campus. It's important to inquire with your academic program leadership to learn about any future exhibits that you might take part in.

⫷11⫸

Graduate School

G raduate school is one of the most commonly expected transitions from undergraduate to a professional life in the arts. All too often, the decision to attend graduate school is made quickly, based on preconceived notions of what the degree will offer (i.e., a teaching career, gallery access, validation/professional credentials). This is a highly personal, major decision. In this chapter we want to help you sort through the issues and give you the tools to make an informed decision. The price of a graduate degree is higher than ever and you need to enter into this next stage in your development fully aware of your options.

Many factors are involved in selecting a graduate school. Do your research. To help you get started, we have put together a list of the major areas and questions to use in your search for your ideal graduate school.

Research tip: get your information from as many sources as possible and pose the same questions. Talk to admissions, program chairs, faculty, current students, graduates, professionals in the field such as your past teachers.

DEGREE PROGRAMS

The Master in Fine Arts (MFA) is a terminal degree that is considered the equivalent of terminal degrees such a PhD in other fields. According to College Art Association, "The MFA degree demands the highest level of professional competency in the visual arts and contemporary practices. To earn an MFA, a practicing artist must exhibit the highest level of accomplishment through the generation of a body of work. The work needs to demonstrate the ability to conceptualize and communicate effectively by employing visual language to interpret ideas. An MFA candidate must be able to prove not only strong conceptual development, but also the skillful execution of tools, materials, and craft. This includes programs rooted in innovative uses of technology, collaborative work, or interdisciplinary projects."

An MFA is required in order to teach in higher education. The MFA is generally a two-to-three-year program. A Master of Arts (MA) is a briefer program

of study, is usually completed in two years or less, and is broader and more general than then MFA. The MFA can be pursued in an independent art school or at a liberal studies university. In an art school, studying art is central to the academic experience. The student body at an art school is primarily artists, but at a liberal arts school, the student body is mixed, so there is a community of different majors.

The PhD in Visual Art, sometimes called a PhD in Visual Practice, generally requires innovative research that is based on artworks and not a written thesis. This new visual arts academic program is to provide the opportunity for a professional practicing artist to focus on advanced research in their studio work and to expand the horizons of studio practice through the study of art theory and philosophy. It can also provide further development for a teaching artist within the academic world.

The MFA is still considered a terminal degree in the visual arts, although the PhD in Visual Studies is beginning to take hold in America, modeled on the established British PhD in Visual Practice. This degree is sometimes seen as a bridge between studio practice and academic scholarship. Majors of research for this advanced degree can include painting, sculpture, photography, electronic arts, multimedia, printmaking, ceramics, and textiles. Programs vary, although the standard formal defense of doctoral dissertation (in this case, studio work) based on original research is generally required. Research questions are required although the basis for the work is the visual arts.

In the following, two education professionals discuss the nature and relevancy of a PhD program in the visual arts.

Bill Barrett, executive director of the Association of Independent Colleges of Art and Design (AICAD), says, "In the late forties, early fifties, the College Art Association declared that the MFA was a terminal degree for fine artists. This was a time when doctorate level degrees did not exist in studio art areas. Thus began a largely successful attempt to get universities to recognize the achievements of artists/faculty and to gain some parity with PhD holders. Lately, the doctorate degree in visual arts has developed in a number of countries, mainly the U.K., where, as part of a quality assurance system, 'research' [implying the PhD degree] became an increasing part of how higher education funding was determined. But doctorates in studio art are still quite rare in the U.S., where the MFA is still considered the terminal degree in art and design. Until there are more programs available and more people holding the doctorate degree, it will not be required for artists, even those wishing to teach at the college level. Pursuing a PhD or a doctorate degree might be appropriate for someone who wants to focus on research, but at this time, it is not required for advancing your career."

Simone Douglas, director of the MFA in Fine Arts program at Parsons The New School for Design, says, "PhDs in art and design are embryonic in the USA but well in place in other parts of the world. Currently, the MFA degree is the terminal qualification in the USA for teaching at degree level in art and design. However, if you were considering a global career in teaching or had an eye to the future in the USA, then you would be well advised to undertake a PhD program, as they are the terminal degree in many parts of the world.

"At a time where art and design schools are increasingly located within universities, it is critical to consider the future implications for the fields of art and design if they remain the only disciplines without the option of a PhD. Art and design are not the only disciplines to have undergone this revolution—medicine, law, architecture, to name but a few. These disciplines have each had to determine at various points in history whether and how a PhD would enhance and support the discipline. Interesting to note that the questions currently being asked about the relevancy of a PhD in art and design were also asked of the MFA as it was being introduced into art and design programs."

Douglas continues, "It is true that making work within the context of a PhD is not the best option for everyone. A PhD program enables you to pursue an intense period of engagement with a sequence and development of idea sets and working methodologies. It brings you into context with other artists/designers and researchers across a range of fields that you may not have encountered outside of that framework. This can happen in a multiplicity of ways, cross-programs, conferences, exhibitions, publications, and research labs."

TEACHING OPTIONS

It is often promoted that the MFA is a stepping-stone to a teaching position in higher education. While this can occur, more often than not, it will not lead to a full-time teaching job. Teaching in academe is another career, and often educators in higher education will speak about their teaching and art career as separate. If you are someone who can live a complicated life and who truly loves to teach, this is certainly a rewarding career path.

PROFESSIONAL GOALS

Attending graduate school is a big commitment. The following are some reasons why you may want to attend graduate school:

- To create a professional body of work.
- To have time to focus purely on your work in order to get to another level.
- To develop insight and communication skills to be articulate about your work.
- To create a network of fellow artists.
- To find and cultivate a mentor.
- To gain teaching credentials.
- To advance in your career with credentials in order to increase your salary or advance you to another level at your job.

On the flip side, the following reasons are NOT recommended for attending graduate school:

- To "escape" from economic and life realities such as an economic downturn. This is perfectly understandable and may not necessarily be a negative reason to attend. But think carefully about this, since attending school often means

accruing debt, and you may be jumping into graduate school prematurely before you have a defined purpose for attending/before your artistic development is at the right stage.

- Sometimes students feel they need the structure of a school setting at this stage in their life. They may fear that they will not do their work if they aren't in a college program.
- As a reaction to indecision about career direction and financial concerns.

CHOOSING THE RIGHT TIME

Timing is a major issue in deciding whether to attend graduate school or not. Graduate school requires a minimum of two to three years of study, during which time most students are accruing a substantial financial debt. Your reasons for attending graduate school should be as clear as possible to ensure your financial and time commitment are aligned and that you get the most out of all of the academic and non-academic activities. After all, whether you are going to a state or a private school, you will incur financial responsibilities.

There are many reasons to go to graduate school. They are to advance your art-making practice, clarify your thinking about your work, and articulate the art theory that informs your studio practice. This is a unique time as an adult to work in a rarified lab of creativity, ideas, and dialoguing with your peers. Many of the relationships you establish in graduate school will be with you for the rest of your life, especially when it comes to mentors. In many ways, with good planning and clear goals, this is your launching pad into your professional career as you become more articulate and concise in describing who you are as an artist.

While some artists choose to enter graduate school immediately following their undergraduate programs, many choose to gain professional experience before entering graduate school, bringing with them the skills and focus to use graduate experience to advance their professional careers. It has been observed that younger students just out of undergraduate school sometimes tend to use graduate school for socializing activities more than advancing their professional careers.

THINGS TO CONSIDER WHEN SELECTING AN MFA PROGRAM/ GRADUATE SCHOOL

The following are essential questions to ask both yourself *and* the institutions with which you may interview or from the admissions office. In addition, you may want to seek out current students and recent graduates to ask them some of these questions. Tip: ask when there is an open studio event and go, and talk to students who are in the program.

Location

The choice of where you study is important because you will be building a network of contacts that is largely based in that community and you may stay there for many years.

Some things to consider:

- Proximity to family, friends, community.
- Making a fresh start in an unknown city vs. staying where you have a familiar environment. There are pros and cons to both.
- Location in a major city or a smaller community.
- Safety of both city and campus neighborhood location.
- Access to cultural institutions such as museums.
- Arts scene and community.
- Cost of living, housing.
- Public transportation.
- Moving costs.
- Job opportunities to support yourself during and after course of study; internships and artists' assistant opportunities.

Faculty
Who is on the faculty, and what is their reputation both inside and outside the institution? Do the faculty actively engage in their careers, and where do they exhibit? Where did the faculty earn their degrees? Are the faculty known as good, effective, and caring teachers? Do you admire the faculty's work and respect them as educators?

Are they on campus and known for being accessible and working with students rather than being in competition with students or focused on their own careers? How many faculty are full-time vs. adjunct, and what is their relationship and commitment to the institution? What is the student/faculty ratio, and how many faculty teach in your area of interest?

Does the program feature visiting artists and critics? Who are they? How many times do they come each semester, and how long do they stay? Do they teach in the master's program? Do they just lecture, or do they give critiques/ work with students in the studio? How does your work relate to the faculty's work, and is that important or not?

You need an advocate on the faculty to support your work and be your mentor.

Program Reputation
It is very hard to know what the reputation of a school is without being involved in the actual professional life of the community. But in your research, you can keep this in mind and ask questions that may get to issues of reputation. Bill Barrett, executive director of the Association of Independent Colleges of Art and Design (AICAD), says, "College Art Association has a great guide to graduate school programs and gives detailed information on many programs. When choosing an MFA program, keep in mind that each program is very individual so try to

visit the physical campus if at all possible. Walk around, meet faculty, and see the work. It becomes a very personal experience so you need to decide if you fit in there. It's critical to see what it's like in person and not just go by a catalog. Pay attention to the style of the school and consider how accepted you will feel there. Is the program/style of the school flexible and open or highly structured with lots of oversight and direction? Or is it less structured, more independence and responsibility for your own work and direction? Talk to students and find out what they think, and if the admissions department won't provide the opportunity for you to talk to students, then you may want to do that on your own."

Here are some things to consider:

- Is the program/school respected in the art world?
- Are there visibility and exhibition opportunities through the school?
- Are there well-known alumni?
- Ability to advance your career through the school.
- Focus and philosophy of school.
- What programs are available in your area of interest, and how many and what kind of classes are offered/required?
- Are there study abroad options? If so, where and in what disciplines/areas of study?
- What is the philosophy of the school, and is it aligned with your work? For example, if the school is conceptually based and you are doing figure drawing, you may not receive the support you need.
- What is the overall size of the program? How many people are majoring in the program you want to pursue, and how many students are in each class?

Facilities

Facilities are the key to whether you can make your work or not and are essential to your health and safety. This consideration includes not just facilities for making your work but also for physical and mental health. It is essential for fine artists to have a dedicated, private studio space in which to focus on their work and have the privacy that makes it conducive to taking risks.

- What is the campus like? Is there a campus, or is the school located in an urban area?
- Is there independent studio space for each student?
- What is the equipment, and are there safety procedures in place?
- Are there individual studios for students? In what year do you receive your own studio?
- What is the state of classrooms and equipment?
- Is there specialized equipment for areas of study such as a print studio, photography lab, metal or wood shop?

- What technology is available both in the classroom and in the dormitory? Are computers and software updated regularly, and is wireless access available throughout the school?

- Is there a gallery on campus, and how much opportunity is there for student exhibitions?

- Is there a good library system? What kinds of visual arts collections are available?

- Is there a place to work out and stay healthy/a gym?

- What is the university housing like? Is there abundant and affordable on-campus housing?

Financial Considerations

Obviously this section is one of the most important considerations in your decision-making process.

- Cost of tuition

- Health insurance

- Financial aid packages

- Teaching assistant opportunities

- Scholarships

- Art supplies and books

- Technology access, labs, and equipment

- Housing and meals

- Transportation

- Social life

- Ongoing family/personal financial obligations (for example, you may have undergraduate loans to consider)

Student Body and Community

Student body and community are difficult to gauge when you read or briefly visit a school, but you can get a better idea of the makeup of the community by visiting the campus in person and considering the following questions.

- What is the makeup of the student body? Are they all from the same region, from across the country, or international?

- Does the school reflect and support your background? Is there diversity of ethnic and socioeconomic backgrounds?

- Size of school and size of the classroom enrollment.

- Is there an active student life on campus? What extracurricular activities such as clubs, sports teams, and social clubs are available?

- What is the overall quality of life for students? Is there a dating scene, health care, access to gym facilities, food?

Professional and Career Support

This section asks whether there is good professional support for you as you become more involved in your career. The type and amount of career support offered at art schools and universities varies widely. Career support is not always seen as central to the graduate program, but these services often hold the keys to moving your career forward. Here are some services that are essential to any program in the arts.

- Career services offers a wide range of services and support including résumé critiques, internship and job fairs, online job boards, career development/ alumni panel discussions, one-on-one career advising, portfolio reviews, and other resources. An important question to ask of a school you are considering is whether or not there are career advisors/programs dedicated to the arts or if the career services office is a generalist career counseling service.

- Is there access to internship and other professional development opportunities? Many graduate students want to work as assistants to more seasoned artists.

- Do you have access to alumni? Often the alumni relations or career services office will offer current students and graduates access to an alumni networking system. Find out what benefits and levels of access the alumni relations office will give you after you complete your degree.

ALTERNATIVES TO GRADUATE SCHOOL

Many artists take the time in between undergraduate and graduate school to develop their own work at their own pace. Here are some options to ponder that may in fact prepare you to get admittance to a graduate school later in your career.

- Enter the workforce.
- Start to show.
- Try a number of different fields: for example, work part-time in teaching to see if you like it and if it's worth the time and financial commitment to graduate school.
- Explore residencies and artists' co-ops.
- Work for another artist and learn the trade.
- Start a business or a freelance career.
- Create your own alternative space or gallery.
- Work on a start-up online.
- Assist in a gallery to learn the business side of the art world.
- Take some time off to travel.

THE FOLLOWING IS AN INTERVIEW WITH JAMES RAMER, DIRECTOR OF THE MFA PHOTOGRAPHY PROGRAM AT PARSONS THE NEW SCHOOL FOR DESIGN.

Ramer shares his firsthand perspective on the application and decision-making processes for potential applicants. His work spans photography, sculpture, and installation.

How should an artist choose to get an MFA degree?

It's important to have clear goals and objectives before entering into an MFA degree program. Ask yourself: What is it you want to get out of a program? What do you want to accomplish in the two years of graduate study? What set of ideas do you want to explore?

What is the unique contribution to the field your work will make?

In these graduate programs, we can't create artists, but we can nurture them. We can challenge them. We can provide an understanding of history and context for their work. We can provide a vital community to work in. One should be clear as to why you are pursuing graduate study. It is not a good idea to go to graduate school to "find yourself" or to become a teacher. By definition, these are professional degrees. Be honest with yourself. Entering for the wrong reasons can prove disastrous.

In choosing a school, look beyond the faculty work and look at what kind of student work is being produced. What ideas are the students grappling with? What does their work like? Is this a conversation that you want to participate in and grow from? What are the facilities like? Can you produce the work you need to make? Is it an environment that you can see yourself working in for two years?

Location is also critical. There are many art centers in the country and around the world such as Los Angles, Chicago, London, Berlin, and increasingly Beijing. If your ultimate goal is to live and work in New York or London, why go to school in Tulsa? If your work is dependent on location or other specific resources, why would you choose a city that removes you from the source of your work?

Finally, ask yourself what kind of environment and resources will assist you in achieving and optimizing the goals you wish to achieve.

Choose accordingly.

How should artists go about choosing the right time to go to graduate school?

It is a good idea to put some distance between getting your BFA and your MFA. It helps to bring some world experience and maturity to your MFA years. A BFA provides context, while an MFA should serve in assisting you in defining your unique point of view and help you answer the question of what you are adding to the field.

It really is a privilege to give yourself this kind of time to work. You should enter when you are truly able to take full advantage of it. You are entering a marketplace of ideas, and here at Parsons, we look for applicants with good ideas to bring to the table. Each class redefines the conversation and shapes the community with a set of fresh and timely ideas. It's their discussion and their decision how they choose to shape their world.

What professional practices do you recommend for an emerging artist?
Develop rigorous and sustainable working methods in your practice. Bad art will get you nowhere.

Participation is key. Art is a social endeavor. Get out of the studio and meet people. It's good for your art and your career. Engage fully with the world. The field sustains itself on the new and different. It needs new ideas to survive. This is an advantage for the emerging artist. The best ideas will rise to the top.

Have a plan. Artists face the same challenges as any other type of start-up. Be prepared to address these demands. While there is no formula, there are some practical things that can be done such as developing a career plan. In your planning, think beyond the romantic vision of what an artist is. It's important to undertake your planning with a global view of how this ecosystem works. Who are the players and what are the needs of the art world are. Artists should seek new and unique configurations for their practices. Your considerations should be strategic and solutions practical.

⚜12⚜

Gaining Experience and Earning Income: Internships, Jobs, and Studio Assistant Positions

I am always between two currents of thought: first the material difficulties, turning round and round to make a living; and second, the study of color.
—Vincent van Gogh
in a letter to his brother, Theo

O ne of the most difficult aspects of launching a career as an artist is learning how to balance an art practice with earning a living. In this chapter we will discuss internships and how these experiences give emerging artists valuable insights into the way professional artists and the art world operate. We will also explore the types of jobs that artists can do to earn income outside the studio. Many universities do not provide artists with essential career information on the business of art and do not help them develop practical strategies for earning a living. But with thoughtful planning and exposure to various models of how other artists have financially supported themselves, emerging artists can create a work/life balance that fits their personal and professional goals.

INTERNSHIPS AND ARTISTS' ASSISTANT POSITIONS

One of the best ways to gain insight into how the art world functions is by assisting a seasoned artist or by interning in a gallery. Emerging artists have often been isolated in academic programs and have not had the opportunity to observe how a professional artist's studio practice operates. Interning with an artist allows you to gain exposure to how the larger arts community intersects with the studio practice. Often this is a wake-up call to young artists who do not understand that artists must dedicate time and energy to the business side of art.

An internship can take many forms, but the most common experiences emerging artists seek out are internships assisting established artists. Such an internship might involve working one or two days a week for a few months

or could involve working several days each week over the course of a summer. Often, the intern will assist with basic functions of the studio, such as stretching and priming canvases, organizing the work space, mixing paints, assisting with fabrications, traveling to pick up supplies and run errands, assisting with documentation of work, and administrative tasks such as filing documents and computer data entry. Sometimes internships are paid and sometimes they are not. Artists should be wary of staying in an unpaid internship for an extended period of time (see the "Artists Beware!" section in this chapter).

Reasons to intern with an artist include:

- Learning about the practices and protocols of the art world firsthand.
- Developing a mentoring relationship with a professional artist who can offer career guidance, technical training, and support.
- Starting to build a professional network and gain art world contacts.
- Learning how artists interact with other professionals such as fabricators, dealers, collectors, and art handlers.
- Learning how artists run the business side of their arts practice.

How to choose an artist or internship:

- **Be selective.** Artists should be selective and strategic in choosing an internship experience. You need to be able to define why you want to work for an artist. If you don't have a good reason, then try interning in a gallery or nonprofit and get another point of view on how the art world works. This will broaden your scope for long-term career options and a deeper understanding of the art world.
- **Choose wisely.** Select an artist whose work and career you respect. However, be aware that the most famous artist(s) may not be the best fit for you personally. A famous artist may have a national reputation but have a difficult personality, may be abusive to staff, have a habit of asking interns to do lots of personal errands, or may have too many interns and not give you any significant responsibilities.
- **Get recommendations.** Ask faculty and fellow students and artists to suggest artists to approach. But by the same token, have the courage to approach any artist you want to; after all, they are just people, and they can always say no but will often say yes!

How to manage the artist/assistant relationship:

- **It's not all about you!** Understand that it is not true that an artist's success is your success. Remember that you are there to assist the artist with his or her work.
- **Be humble and work hard.** Don't expect to be given lots of the artist's undivided attention to your interests or to be given high-level responsibilities

right away. Yes, you will be getting coffee for someone at some point! You need time to build a good, trusting relationship with the artist before you begin asking for career advice or additional responsibilities.

- **Be a good observer.** As an artist's assistant, you will need to get past the personality of the artist you work for and get into the substance of the job.

INTERNING IN GALLERIES AND MUSEUMS

Some artists choose to experience internships in many settings for a fuller understanding of the art world and may do an internship in an artist's studio and then intern in a gallery or museum. An intern in these settings can gain a deeper understanding of roles and relationships between artists, the media, galleries, museums, curators, and buyers. A gallery or museum intern may help with installing exhibitions or assist with maintaining collections and learn about roles of staff and functions of the organization. Interns may also assist with archiving, event planning and marketing, and administrative work. These experiences can be a terrific way for artists to learn how an exhibit is managed from beginning to end.

An internship experience is often a turning point in how emerging artists view the art world and can drastically alter their career direction. For example, an artist, Alex Khost, we interviewed interned at a gallery and the experience completely changed his attitude toward his role as an artist in relationship to commercial galleries. As a gallery assistant, he did everything from greeting clients to balancing the gallery owner's checkbook. During the internship, Khost observed how the gallery ran their daily business operation and selected artists and marketed their work to clients. By observing the gallery setting from within, Khost discovered that he did not want to participate as an artist marketing his work in such a commercial way. He saw that he would have to make compromises with his work and his way of interacting with the public if he chose to participate in the commercial system. Khost decided that he wanted to retain his passion and freedom to create his artwork, free of the need to satisfy a commercial gallery market. He chose to earn his living as a user interface engineer so that his own fine arts work would be free of the confines of fitting into a market, and he instead shows in alternative spaces.

Interns Beware!

Be careful your internship does not become a full-time job and that you don't continue interning or assisting an artist for too long a period, unless it is an arrangement you really feel is benefiting your career. It's good to assist an artist if you are invested in their work and want to learn how they make their art and it continues to be meaningful for you. But if you work for someone too long, you risk the danger of losing your own aesthetic and becoming a clone of the artist you're assisting, and the artist may come to rely on you too much. You are interning to learn, to observe, to grow in your own work, and to synthesize what you learn from the artist.

Also, be aware that artists will often mix the personal and professional and ask assistants and interns to do basic administrative work and personal tasks such as grocery shopping. This is certainly not uncommon, though if carried to the extreme, it can be abusive. Know that if the artist's studio is separate from their home, there is a slightly lesser chance of the personal and professional tasks mixing than if they have a live/work studio space.

WHERE TO FIND INTERNSHIP OPPORTUNITIES:

- Your alma mater's career services or alumni relations office often hosts an online job board with leads to internships and alumni contacts.
- Ask your friends and colleagues to introduce or refer you to artists.
- Speak to faculty in your alma mater's fine arts department.
- Use the Internet to research your favorite artists, determine those who live and work in your area, and find their contact information through their personal/work Web site or through their dealer.
- Consider using professional arts organizations' Web sites to seek out opportunities.

INTERVIEW WITH CAROL WARNER, EXHIBITING ARTIST

Graduated from Parsons The New School for Design in 2007 with an MFA in photography and related technologies. She lives and works in New York City. Her multimedia real estate installations explore the American Dream and examine how photography shapes social, cultural, and personal expectations.

Tell us about how you initially found your internship and then how it changed into a job.
I got my internship with Leon Golub and Nancy Spero through another student at my college who was assisting the two artists and knew they needed a summer intern. And I really enjoyed it, so I kept interning for them as a paid assistant for two years.

What type of work did you do during the internship?
My work was a mix of everything, both art-related and personal. There were usually three interns at a time. Golub would paint, and as his assistants, we doused the work over and over with rubbing alcohol until the acrylic paint got gummy and then we used meat cleavers to scrape down the work through layers of paint.

I did administrative work too. I'd write checks, type letters, pack work for shows, keep track of what was shipped where. I would also do grocery shopping for the staff's lunch and the artist's personal grocery shopping. They had a live/work studio. In the art world, lots of boundaries get crossed into personal life. If

you assist someone in a studio that is outside the home, there is less chance of crossover. But every environment and every artist is different.

What did you learn about art as a business?

Assisting an artist was the first time I saw somebody making art as a business. You show up nine to five and you make art. Before I interned, art making seemed isolated to school and was not seen or experienced in the context of the professional art world business. I discovered that art still has integrity while being attached to the consumer aspect of the studio, although it has an added layer of having to satisfy other people's needs outside the studio. For example, you see the artist grappling with developing their art and issues in their own art, while at the same time they are preparing for exhibits and working with dealers.

Unlike college students studying law or business, who assume they will make money after graduation, art majors assume they won't make money unless they somehow engage with the professional side of the art business, through being an assistant, for example. You need to understand that layer of the dealer relationship. I was aware of that layer of commerce every day when I assisted Golub and Spero.

What did you learn about the art world?

I learned about the differences between various artists and the wide variety of arts communities from doing multiple studio assistant jobs. I learned about the relationships between artists since other established artists worked in studios adjacent and would come over for lunch; the community building was good to observe. I got to see the relation between art writers and the artists, and watch how the artist navigates an interview. I learned that artists can make money and how.

Going to openings and observing attendees helped me learn about the different audiences and customers for different artists. For example, at Golub's openings, the crowd was political, intellectual, and serious. Another artist, by contrast, would have lavish openings complete with after parties and flamboyantly dressed supporters. I got to see artists individually working and then also saw how they fit into the bigger picture. There is not one art world. There are dozens, and some don't even overlap.

I think that a convenient way some artists make excuses to not engage in the art world is to think of themselves as outsiders, but that's just giving up. Young artists need to learn which art communities they fit into by having lots of internship/studio assistant experiences in the art world. Young artists can start to build their own community or network by working in an artist's studio, in a gallery or museum, as well as attending openings and other art events.

What tips do you have for someone just starting his or her first internship or artist's assistant position?

- You should know you are not making your art; you are making their art.
- Take care of yourself physically, and be aware of health considerations that the artists you are assisting may not even know about.

- As a woman, you have to navigate what you are willing to do, since everyone is expected to be macho and keep up with the physicality of studio maintenance or work that can involve moving heavy objects. You are not a victim and can bring consciousness of dangers of toxicity and heavy lifting to the artist's attention. It's okay to speak up.

- Go ahead and reach out to your favorite artists! When I wanted to work with Louise Bourgeois, but was too intimidated to approach her, Golub and Spero told me to cold-call her—because, they said, artists are just people like you and me.

Tell us about your most recent work and how you are now working with your own interns.

Recently I worked with a group of young interns while installing a new site-specific work for the exhibition "Weaving In & Out," through an organization called No Longer Empty. It reminded me that when the relationship between the artist and the interns is optimal, a collaboration takes place that draws on collective energies and strengths. I was trying to figure out how to recreate by hand a pattern on an area rug. I was looking for a very specific result but was not sure how to do it. Four interns helped me map out a course of action and implement the plan, ultimately achieving the desired effect. I think the internship is successful when everyone contributes and learns something.

JOBS: EARNING INCOME AND SUPPORTING YOUR ART

One of the greatest challenges that artists face is finding a way to earn enough money to live while still having the time and freedom to do their art. There is a commonly held stigma that artists who earn their living from something other than their art are not successful. Many artists assume that they are failures if they have to take a job and don't earn their income directly from their art. But the reality is that most artists don't make their money solely from their art, especially at the outset of their careers. It often takes many years for artists to reach a point in their career where they can earn their living primarily from their art. In fact, the majority of artists earn their income from a combination of a job in addition to their art.

Brynna Tucker, an artist and associate director of Career Services at Pratt Institute, says, "Professional development for fine artists is a very tricky thing to teach. For one, a fine artist needs to spend uninterrupted time in the studio to push ideas, techniques, and focus on their work. Discipline in the studio is the core of developing as an artist. But making the work is only part of it. It's a two-prong process, the second part being getting the work out there. The most pressing professional development issue for a beginning fine artist is to recognize that their studio practice and the work they do to get their work out there are not likely to generate income. Eventually it will, but starting out it is not as likely. This means that most emerging artists need a third part, an income source. Juggling your studio practice, the work you put in to applying for opportunities to get your

work out there, and a day job is not an easy. What compounds this issue is that art school isn't cheap and loans are a real factor for artists."

Artists may consider the subject of money to be distasteful and in direct opposition to what they perceive as the purity of their art. They may believe the myth of the starving artist, who is dedicated solely to his or her work, and think that artists shouldn't have to be concerned with money. But without a stable source of income, artists can spend time and energy struggling to survive, and that detracts from their ability to focus on their art. Think of money as the fuel that will support and enable your artistic practice. You need a work/life balance whereby you make enough money to pay for your living expenses and art practice while providing you with hours that are flexible enough to allow you to focus on your art.

Finding the Right Work/Life Balance

There are many positive aspects to finding the right job that will allow you to sustain your studio practice and may even help grow your professional network, all the while providing income for necessities like housing, food, health care, and other necessities. Artists have to think like entrepreneurs when developing a plan for earning income and must be creative and flexible about how they apply their creative talents and skills to earn income.

Alyson Pou has been making installation and performance work for more than twenty years (*alysonpou.com*). Pou has also played many other roles within the arts community, including curator, producer, presenter, and teacher. She has been part of the staff of Creative Capital since 1999 where she has designed and implemented the Professional Development Program and currently serves as that program's director. On work/life balance, Pou says, "For every single artist I've ever encountered, the most important issue is deciding how to set up their life to support their work. It's about finding the right balance of time and money. In other words, how to earn enough money to be able to spend sufficient time making your art. Accomplishing this requires more than worry and anxiety, it requires long-term planning. You need to look at your total income, then at how much time and money is required to support you and your artistic practice. If you make a pie chart that reflects the percentages of your income, you can decide how to methodically shift those percentages. For example, if a teaching job provides 90 percent of your income and sales of work provide 10 percent, you may decide you would like to shift income from work sales up to 30 percent in, say, two years. This provides you with a concrete objective for which you can create an action plan. Concrete information and action always trump the emotional point of view when it comes to time and money."

For every artist, there is a different solution for what works best, whether that's a full-time art-related job that provides stability or a part-time position that allows flexible hours. Consider the following questions as you develop a picture of your ideal job or work situation that will create a work/life blend for you:

- Does the job have flexible hours and allow you the time to do your work?
- Does the job leave you with enough energy/emotion to pursue your work, or are you too exhausted to focus?

- Are you earning as much money as possible in the briefest time possible to leave the maximum time for your art making?
- Are you earning enough money to support your basic living needs?
- Does the position give you access to health care and other benefits?
- Does the job help you to advance your art career through connections, access to materials/equipment, or further development of your craft?
- Is the job enjoyable and challenging? Does it fit with your values, personality, interests, and skill sets?
- Do you prefer a stable, full-time job or a freelance or part-time situation where you have a flexible schedule?

Making Choices That Support and Enhance Your Art Practice

It is essential that you choose a job that is a good fit for you and that doesn't compete with or even defeat your creative energies. A good way to begin is by deciding what skills you could gain or enhance through the work: for example, a sculptor might benefit from a paid job in welding, or a painter might benefit from the contacts and art world knowledge they gain in a job as a museum educator. By contrast, a bad choice of work would be a job that you find stagnant, boring, easy, or meaningless. If your job involves long hours, doesn't have flexible hours, and the pay is not significant enough to offset the time you spend there, then you will likely have no time or energy to pursue your art. If your job is so physically and emotionally exhausting that you are depleted and can't do your art at the end of the day, it's time for you to reassess your work situation.

Assessing Your Skill Set

According to Jennifer Phillips, career development director at the School of Visual Arts, "Many artists don't understand the 'real world value' in the skills they have acquired through four years of college. They often seem to have one vision of what they want to do [understandably, because they have been fighting so hard to find their voices as artists] and are unable to recognize how many amazing jobs can be accomplished with their existing skills and talent. I want them to realize that opening their own studio in a garage in Bushwick and painting all day is not the only option. A day job is okay; forming an economic base is not a bad thing. They can take jobs that allow them to support themselves and grow their network of creative professionals while continuing to practice their craft." A good place to begin thinking about what type of work you can do is the take inventory of your skills, personality, values, and education.

What skills do you have?

- Consider what skills you most want to use and what skills you most want to avoid using.
- Communication Skills: Think about your writing, public speaking, and sales skills. How might these translate into a job?

- Administrative/Computer Skills: List your computer skills, consider what software you have fluency in. Can you manage a budget and handle record keeping?

- Physical Skills: Can you repair and construct things? Do you have great physical strength? Do you have experience with handling, moving, and packing art?

- People Skills: Are you skilled at managing people? Do you enjoy working as part of a team?

- Art and Design Skills: So many artists have a broad range of art and design skills that can be applied to a variety of positions. Consider graphic design, illustration, interior design, photography, Web design, and window display work.

What kind of work arrangement do you want?

It's important to find the right work balance that you are comfortable with and that balances your artistic identity/practice with your financial and personal needs. Find new role models for work/life balance, and don't assume artists all have to live and support themselves in the same way. The famous American poet William Carlos Williams worked full-time as a doctor while he wrote beautiful modernist poetry. You can be incredibly productive and make authentic work that is true to yourself while earning income to support yourself. Consider which of the following arrangements best suits your temperament and preferred work arrangement:

- Full-time with stability and benefits
- Freelance work
- Part-time work with flexible hours
- A position that is extremely challenging with lots of different responsibilities
- A job that is predictable and not too stressful

What kind of organization or work environment do you prefer?

It is important to ask yourself what type of work environment feels right to you. Consider the following types of workplaces and think about what will fit with your personality, energy level, and values:

- A nonprofit with a great mission you believe in
- A quiet, stable environment with a predictable routine
- An exciting place where each day is different and you meet new people daily

Transferable Skills

Jean Mitsunaga, director of career development at Art Center College of Design, says, "Identify ways to apply your art practice and skills into commercial ventures; and importantly, be open to all possibilities. You have to acknowledge that employers value your unique problem-solving and storytelling skills. Keep your heart and your passion and don't feel that you're compromising your art by taking on assignments to pay your bills."

It's important to understand and value the unique skills you have from your studio practice and education, such as:

- Creative problem-solving: This is probably one of your strongest assets, one that most prospective employers are looking for, and you have gained these skills from continuously solving aesthetic problems confronting you in the studio practice.
- Research skills – In order to create your artwork, you need to do extensive research, whether it's in art history, literature, social norms, or contemporary issues.
- Financial skills such as budgeting (example, you are always budgeting and comparative shopping for studio supplies).
- Organizational skills and multitasking: Artists have to be organized about their practice and must multitask in order to accomplish their work.
- Self-directed and independent worker: Artists are usually by nature very capable of working on their own for sustained periods, and this can be an asset in many types of work.

You can either get a job that directly relates to the arts or, as many artists do, you can chose to work outside their field for various reasons. Some artists may want to save their creative juices, energy, and ideas for their own art and to preserve that for their own studio time. For example, there are artists who prefer to wait tables, tend bar, or do accounting work. But if you choose this route, then ideally you should do this in the *most* lucrative way possible in the shortest amount of time, so if you work in a restaurant where the tips are particularly high, that is a good plan. There are artists who work at high-paying jobs such a real estate sales and then are able to take off months to pursue their art. But a warning: if your work is not art-related, is full-time and takes up a lot of the hours of your day, *and* you are getting no arts industry payoff like networking opportunities, then unless you make a lot of cash, you need to ask yourself if it's worth the payoff if you don't have the time to do your work.

An example of an artist applying their fine arts skills to interesting and rewarding work is Angela Ringo. Angela holds an MFA in painting and a BFA in fabric styling and merges these multidisciplinary skills in her role as a trend forecaster. She applies her knowledge of art history and her visual acumen to anticipate trends and cultural movements. In addition, she uses her awareness of cultural and social shifts to pinpoint where trends are heading. Angela says, "Being a trend forecaster is not necessarily about what your personal tastes are, but rather about being able to see relevant trends the rest of the world will eventually get on board with. In this work, you need to be articulate and able to communicate through the languages of different disciplines of design and visual culture like graphic design, product design, and fashion. You have to have a desire to do extensive research and the curiosity to dig deeper. I focus primarily on interiors and home fashion but continually examine textiles, international fashion, and the world of fine arts. I have to know which designers and artists are hot or socially

relevant and make visiting museums and galleries a regular part of my life. If you are interested in this field, it's important to have a strong knowledge of art and design history and I found my own background in interdisciplinary design curriculum to be extremely helpful."

Teaching Jobs

Teaching is one of the most common fields that artists enter to support themselves. It is a terrific, rewarding profession for someone who is truly interested in working with others to help them grow. It is also a great way to work in an arts-related field that will help you build your professional network through other faculty and may give you access to materials and equipment for your own practice.

However, there are many misconceptions about the teaching field of which artists should be particularly aware:

- To teach at the university level, an MFA is generally required. Also, there are *very* few full-time, tenure track jobs. While there are many adjunct opportunities, these positions often come with no benefits and no guarantee of steady employment.

- To teach at the K-12 level, a master's degree in art education is required in order to retain a teaching license. And licensure varies from state to state.

- There is intense competition for teaching jobs at all the most desirable levels (high school through college). Artists may go through years of additional training to gain the appropriate credentials and licenses, only to discover that the only openings in their community are for grade school or middle school or only for part-time teachers with no assigned arts classroom.

Teaching is a rich, honorable profession that can provide practicing artists with an income and inspiration for their work. If you are considering teaching, see chapter 18 for more details on how to pursue a teaching career.

Arts Administration

Administrative jobs at universities are often a great fit for artists who appreciate the added benefits of access to free education and technology classes, networking with art industry professionals and faculty, and access to equipment like printmaking studios and computers. These positions are often full-time, and there are opportunities for admissions counselors, office assistants, lab or shop technicians, alumni relations, and development personnel. There are also arts administration jobs with nonprofits, government art agencies, cultural affairs organizations, and foundations.

Museum and Gallery Work

The mission of most museums is to acquire, preserve (maintain and store), and display art as well as educate the public about the collections. Museums large and small are institutions that hire artists. Depending on the size of the museum, there will be the number of jobs available at any one time. One of the best ways to get a job in a museum is through an internship, contacts, or looking at the Web

site of an individual museum employment center. The American Association of Museums also has a job site that lists all available jobs in museums in the country and increasingly abroad. The types of jobs vary depending again on the size of the institutional departments. Museum jobs vary widely and tend to break down into the following categories: administrative, curatorial, educational, and maintenance. The list below indicates a few of the types of jobs that may be found in an art museum depending on its size and staffing.

- Museum educators
- Gallery/security guards
- Art handlers/technicians
- Curators and department directors
- Grant writers
- Registrars
- Librarians
- Conservationists
- Carpenters
- Photographers
- Designers for exhibition design, publications, Web
- Fund-raisers
- Event coordinators
- Gift shop and restaurant staff
- Public relations/publications

The advantage of working in a museum setting is, of course, being around the artwork and being in contact with other like-minded people who are passionate about art. The challenges are working with the public and generally the salaries are low.

Jeff Elliott, a departmental technician in nineteenth-century modern and contemporary art at the Metropolitan Museum in New York, says, "I am a painter/sculptor, and I get a burst of energy after work, inspiration from being in the museum. But you have to carve out a physical space and the time to do your own artwork. You have your work, you have your passion, and you have your sleep time! An important key to creating is to have that great balance of who you are and what you do, artist first and technician second. I started out as a guard at the Met first. If you could harvest all of the art talent in the Met staff, you'd have an arts renaissance!"

INTERVIEW WITH DENNIS KAISER, TECHNICIAN AT THE METROPOLITAN MUSEUM OF ART IN NEW YORK

Dennis Kaiser is a painter who lives and works in New York City. He shares a studio, home, and life with his wife, Elizabeth, and daughter, Sally.

What do you do as a technician at the Met?

I've worked at the Met for nine years, the first five as a technician in modern art, the last four as a tech in the American Wing. A technician is basically an art handler, and there are technicians in each department of the museum. They are the primary maintainers and handlers of their department's collections. They're involved with the installation of art throughout the building, in the permanent galleries, and in the special exhibitions. There's a lot of movement of art throughout the building on any given day. If it's not for installation, it may be for photography, or for conservation, or for outgoing loans or incoming examinations. A lot of art is also moved to accommodate researchers and scholars. It takes a long time to get to know the building. New exhibitions come and go every three months or so. Some galleries stay the same for long periods of time; others have new rotations every few months. The Met is like a living organism. Sometimes the changes aren't so obvious, but there is constant movement.

What are some of the things you enjoy about your work?

I enjoy installing the special exhibitions. It's a huge collaborative effort among many different departments and with lenders from all over the world. The curator oversees it all. They are the director of the show. We work with packers to uncrate the art, and with designers and curators to space and place them. Sometimes riggers are involved, sometimes carpenters and painters.

I have to know how to handle a lot of different types of art, from small, delicate porcelain to large paintings. We place a lot of sculpture and move lots of furniture. There are more than thirty technicians at the Met. Most, if not all, of the other positions I work with (lampers who light shows, packers, conservators, designers, painters, curators, administrators, guards) are practicing artists within their fields. I'm a painter.

I like being here when the museum's closed to the public, on Mondays, or late at night or early in the morning. Being in a gallery by yourself with the art is a very intimate way to experience the work. I can get really close to it. I'm spoiled now. Interestingly, I've come to love the backs of paintings.

I've also had a chance to meet and work with some artists I admire such as Robert Rauschenberg, Merce Cunningham, Chuck Close, Kara Walker, and Sean Scully.

How did you get your job at the Met?

I'd been working as a set carpenter when my wife and I went to see a show at the Met. The show was Casper David Friedrich's "The Moon Watchers." I enjoyed the show a great deal, but strangely enough, the color of the walls made an impression on me. Then I looked around and saw how nicely the show was arranged, how everything went together and seemed so thought out. I thought they must have carpenters and painters on staff here. I inquired the next day and found out that the Met employed more than two thousand people! I hadn't given it much thought before; I only went to museums to look at the art. I asked about job openings, and though they weren't looking for carpenters or painters, a job had just been posted for a departmental technician in the Modern Art department. They had told me

a technician who had worked at the Met for forty-one years had recently retired, and they were looking to fill the position.

They called me in for a written and a practical exam. The written test involved some general questions about art history and about the art and artists in their collection. There were also some general art-handling questions, like how would you center a certain-size painting on a certain-size wall. I was asked what the accession number on a piece means. I didn't know, but from the number I deduced that it probably dealt with when an art object is brought into the museum and how it's numbered to become part of the collection. Common sense goes a long way on these tests. After the written test, there was a practical test, where I was observed handling different types of art in front of a panel of eight people—curators, technicians, conservators. I was a little surprised at the amount of people when I walked in the room. I was asked to run the gauntlet of handling pieces of art—packing a delicate object, placing a chair on a platform, moving a large painting with another art handler. I also had to frame a small painting. They also had me go up in a rig that rises to two stories, probably to see if I would panic over the height.

I think I was relaxed, but not too casual, and I didn't panic when asked to do something I wasn't familiar with. I had done carpentry before working at the Met, and that background certainly helps, but the pace is much different in a museum, and sometimes there is more delicacy about the work. You have to take care, but not be afraid of the objects.

Can you talk about some memorable moments at the Met?
We recently hung Vermeer's *Milkmaid*, which the Vermeer show centered around. That was a lot of fun. I didn't know we were going to do it until I walked into work that morning. Ten minutes after I hung up my jacket, I was in a storeroom with one of the most famous paintings I'd ever heard of, along with an entourage of Met people and couriers from the Rijks Museum. We uncrated it, put it on sawhorses, and I think my breathing stopped. It made a very good first impression. After a few reverent moments, we put it on a side truck, took it to where it needed to be, and put it on the wall.

What are some of the challenges of being an artist working in a museum setting?
One big one for me is art overload. I reach a saturation point and I'm not really taking much in. Everything becomes just an object. And sometimes that saturation makes it difficult to keep an open and clear mind when I want to do my own painting. Looking at art can be inspiring, but it can also take away some energy from doing your own thing and making your own. There is such a thing as the burden of influence.

INTERVIEW WITH MISTY L. YOUMANS, MANAGER OF INSTITUTIONAL GIVING AT THE SAN FRANCISCO MUSEUM OF MODERN ART

Misty L. Youmans is a practicing artist and manager of institutional giving at the

San Francisco Museum of Modern Art (SFMOMA). She received her BFA from the California College of the Arts (formerly California College of Arts and Crafts) in 1996, double majoring in painting (with High Distinction) and printmaking (with Distinction).

Can you tell us about what you do at the museum?
My official title is manager of institutional giving, foundation and government relations, which is much too lengthy! In other institutions I would probably be called a grants manager. My primary responsibilities include preparing grant requests of $25,000 and less to support exhibitions, education, conservation, special projects, as well as general operating support; preparing progress reports to all grant makers on the status of the projects they fund; donor stewardship; correspondence, calendaring, and database updating. In other words, my days can vary wildly from very basic clerical tasks to highly confidential, challenging grant requests, and everything in between.

What do you enjoy most about your job, and how do you apply your fine arts training to your work?
I've spent fourteen years in the nonprofit world, and only one of those years being in a non-arts environment, and found that I really, really need to be around the art and the people who come to enjoy it. It's very important to me to be able to see the results of my work, and when I'm having a bad day, I just go into the galleries and look at my favorite works, and then I remember why I'm working so hard.

I chose museum work in large part because it keeps me involved in the arts community, but doesn't require that I do "creative" work while on the job. I don't want to pour all my creative juices into my job and not have anything left for myself at the end of the day.

Would you say your work at the museum balances with your own practice?
As mentioned above, I would have a tough time with a job that required me to be creative or to make things that were arts or crafts related. I've reverted to my roots and have wholeheartedly embraced the crafts tradition, ironically, at a time in which even my alma mater, California College of Arts and Crafts, changed its name to California College of the Arts. SFMOMA very actively supports the working artists on its staff (and there are many!) through such staff activities as the annual Staff Art Exhibition and Arts and Crafts Holiday Sale.

Can you share ideas on the types of museum positions that fine artists can successfully pursue with their BFA or MFA educations?
Many positions at SFMOMA require a bachelor's degree, with a strong preference for some sort of an arts background of some sort, including art history. There are certainly positions that require more specialized training, including conservation, registration, etc. But just about any position at SFMOMA would be benefited by knowledge of the arts at any level. Here, once someone gets onto the staff, there

are ways of making oneself known and working from department to department, as your skills allow.

Any words of advice for artists interested in your type of work/grant management?

Writing skills are key, as is a willingness to learn and to be open-minded about all types of art. I was pleasantly surprised while in college to learn I could write well, and that gave me the confidence to pursue my current position, along with having already been an employee at SFMOMA for several years. I would advise someone looking to break into this field to take classes in proposal writing at places like the Foundation Center, to keep up with the local arts scene in their community, and to apply for grants and residencies for themselves to gain a sense of what is required. In my case, the fact that I had been involved in the Bay Area arts community for many years, along with several at SFMOMA, was vital to me in getting my current job. The biggest challenge? Getting your foot in the door.

Design Work

If you have design and computer skills, there are many options for full-time, part-time, and freelance jobs in the following areas:

Graphic Design: This work requires very strong computer skills in programs such as Illustrator, InDesign, and Photoshop. To work in the field, you must have a portfolio that demonstrates your design skills, including strong knowledge of layout and typography. You may work full-time as a staff person at a magazine, advertising agency, or newspaper, or there are many freelance opportunities in the field.

Photography: Photo skills are extremely marketable. There is work in commercial photography, portrait photography, wedding photography, photo retouching for magazines, Web site, and blog photography. It's important to understand that the majority of opportunities are freelance rather than full-time staff positions but that flexibility might be just what you, as a fine artist, are looking for.

Web Design: If you have an aptitude for Web-based design, this can be a lucrative job opportunity that can often be pursued on a freelance basis. One of the most inspiring artists we interviewed for this book works as a Web developer for a major publishing company while maintaining a studio and showing in alternative spaces rather than traditional galleries.

INTERVIEW WITH NATE FREDENBURG, ART DIRECTOR AT TIPPETT STUDIO

Nate Fredenburg was educated as a fine arts printmaker. He now makes his living creating creatures for feature films as an art director at Tippett Studio.

As an art director at Tippett Studio, what do you do?

Tippett is known for computer graphics (CG) character animation for live-action films (so it's not animated films). My job is to supervise the building of the digital environments and characters by our modelers and painters. Sometimes I'm involved in preproduction to develop key art and concept art on shows in

development. We have to marry our characters into a photographic plate or image where they often interact with real people. We make 3D models and then animate them in the computer.

What did you do in the latest Twilight movies?

We created all of the werewolf characters. We did a lot of research to create realistic characters and then made them look like they belonged on the screen in the midst of live-action shots. We sent our artists to a wolf preserve to photograph and study wolves in captivity and watched documentaries to study the movement of wolves. I'm currently up to my eyeballs in werewolves because we're creating eight new wolves for the last two Twilight movies now.

What do you enjoy most about your work?

I've been doing this for eight years and the glamour of the projects has worn off— what I enjoy most is the talented people I work with. I've trained supported many artists on our pipeline. When you are a supervisor, you're making pictures *through* other people, so you have think of your team of artists as your tools to create your art/vision.

Can you tell us about how you translated your fine arts education and the skill sets you learned into a career in computer graphics?

I got my BFA in printmaking at the California College of the Arts and then earned my MFA in printmaking at the School of the Art Institute of Chicago. During my last year of graduate school, I had that panic-stricken moment of wondering how I was going to earn a living and what to do with my art education. I considered teaching but decided to take a class on Macromedia Director during my last year of graduate school. Then I moved back to the Bay Area during the dot-com boom and worked at start-ups and learned computer tools like 3D software on the job. I also spent lots of hours at home teaching myself and creating samples.

When Tippett studios hired me, the lead artist said, "The reason we hired you was your printmaking background and the great technical skills you have. We figured you would learn computer skills quickly and that your fine arts education gave you a clear aptitude for technical problem solving."

How did your career progress at Tippett Studio?

I started as a CG painter and now I am an art director. One of the things I do is I hire other artists. I find that students coming out of animation programs often don't have the traditional fine arts skills we need. The core foundation skills of sculpting and drawing are essential for modeling and painting jobs at Tippett. When I speak at art schools, I try to impress on students that the fundamental skills they get, like anatomy and color theory, are invaluable, and I can't teach you those on the job. It's good if you come to us with those skill sets. I encourage graduate students of digital arts programs to think of themselves as directors of their own short films and suggest they enlist the help of other students to get their pieces done rather than do it all themselves in a mediocre way.

You serve as a graduate school advisor and mentor at art colleges and area high schools. Can you tell us about that?

I've always had a love of teaching, and what I enjoy about my job now is helping other artists bolster their skills. When I was still in college, I was a work-study student and would work the phone bank and call prospective students to talk about the value of an art education because students and their parents often deal with anxiety about what to do with an art education.

At the Art Institute, I review thesis projects and give students critical feedback. And even now as a graduate of CCA, I talk with students whenever I get the chance about how those skills translate to what we do at Tippett. These students often don't know the breadth of skills and application of skills they are learning. I think it's nice to flirt with the idea of being an art star at first, but so few will ever become that 1 percent who do have that career. So artists need to be open-minded and think about a career that draws on their creativity and interests.

Do you have any further words of advice for emerging artists?

Hold on to your curiosity and love of learning. Expose yourself to as many opportunities as you can. Doing an internship is a real eye-opening experience, so you can quickly see if your idea of what a job is matches up to what it really is. An internship opens up worlds to artists about ways their skills can be applied. Artists have great problem-solving sills, both visually and in dealing with people; they can find a viable solution in a short amount of time.

INTERVIEW SKILLS

For whatever internship or job opportunity you choose to pursue, it is essential to be well prepared for interviews. If you are nervous, try role-playing the interview with a friend or with a professional such as a career counselor or faculty member. The following are interview tips developed by the Career Services staff at Parsons The New School for Design:

Be Prepared

- **Do your research.** Research the organization to gain a firm understanding of their work, visit their Web site and read their mission statement, talk to friends, faculty, and other colleagues about the organization to gain insight into the culture and people. Employers will be impressed when you demonstrate your familiarity with what their organization does.

- **Come to the interview with questions to ask the employer.** It shows your interest in the job and can start a lively discussion. See examples of good questions to ask in the next section.

- **Dress the part.** Dress professionally for the interview. Think about the dress code in the industry and dress accordingly. It's always better to overdress for an interview.

- **Be on time.** Arrive five to ten minutes before the meeting (no earlier, no later). The extra time will allow you to compose yourself and focus on the impending interview.

- **Be confident (or pretend to be!).** Make eye contact and be prepared with a firm (but not crushing) handshake.

- **Promote yourself.** Be ready to sell yourself by practicing talking about your experience, greatest strengths, career goals, and accomplishments. Be sure you are prepared to explain why you are a good fit for the particular position. Focus on the highest levels of your skills that you can transfer from the old job to the new job.

- **Watch your body language.** Be aware of body language during interviews and control any nervous habits such as twirling your hair, swinging your leg, etc.

- **Be prepared.** Fully review the job description before the interview and have thoughtful questions prepared. Bring at least two copies of your résumé, a list of three references, and samples of your work if relevant to the position.

Interview Questions

Interview questions usually focus on the candidate's abilities and skill sets, professionalism, and experience. Always be sure to actively listen to the interviewer and truly interact with them; don't answer in one-word or one-sentence responses. You should also be aware of focusing on the interviewer's needs, not your own needs. Be prepared to mention anyone you know who has a connection to the job, and show enthusiasm!

The following are standard questions:

1. Tell us about yourself.
2. What interests you about this position, and why do you want this job?
3. What do you know about our organization, and what appeals to you about working with us/in this field?
4. Give us an example of a difficult situation you handled in a past job.
 There is no right or wrong answer, but again, do not be negative. The employer is interested in learning about your process in solving a situation, and they want to assess your character and personality. Prepare a story with a happy ending—no family or personal situations, use neutral examples.
5. Why do you think you would be a good candidate for this job? Why should I hire you?
6. What are your weaknesses? Or what professional development needs do you currently have and how are you addressing them? This is another trick question that you can sidestep by indicating that you have all the skills you need for this particular position. You can always say that you work too hard!
7. What are your long-term career goals/where do you see yourself in five to ten years?

Good questions to ask the interviewer:
1. What did you like best about the person who held this position previously?
2. Can you tell me what upcoming projects or exhibits you are preparing for/ are on the horizon?
3. What are the principle issues and challenges facing your staff or practice right now?
4. How would you describe the duties of this job?
5. Can you describe a typical day here?

Discussing Salary

Before your interview, you should research what the likely salary for the position will be. Research salary ranges for the type of job/industry, level of the position, and for the location of the job. You can do this by using the Internet for research (*www.salaries.com*) or by talking to friends, family, and colleagues who may be familiar with the employer and be able to guide you on appropriate salary ranges.

Do not bring up salary yourself during the first interview unless the employer does first. Oftentimes, salary is discussed in a second interview, once the employer has decided they are interested in making an offer. If you bring up salary too soon, it is a turnoff to employers who will think that you don't really care about the job.

If you are offered a position and the employer asks what salary you are looking for, you can say, "I expect a salary appropriate to my qualifications and demonstrated abilities." Or you can ask, "What do you have in mind? What is the range?" Or if pressed, you can offer," I'm looking for a salary in the upper [insert a range]."

Thank-You Notes

Always send a thank-you note to an employer immediately after your interview. Hiring managers see many candidates, and anything you can do to remind them of your interview will improve your chances of being hired. Write a note on a letterhead or nice stationery and make it brief. The letter should reiterate your enthusiasm for the position. It is alright to send an e-mail thank-you note in the interest of speed, but many hiring managers appreciate a handwritten note because it shows a personal touch.

Follow-Up and Handling Rejection

Do not repeatedly contact an employer after an interview. If you are calling or e-mailing an employer over and over to ask about a position, they will feel harassed and you may ruin your chances.

Also, it is important that you not overreact if you are rejected for a job. Just because you were not a fit for a particular position doesn't mean that you won't find another opportunity with the employer in the future; you should not take the rejection personally. In fact, if you are rejected for a job, stay in touch with the hiring manager, thank them for the opportunity to interview, and ask them to keep you in mind if there are future openings that they feel might be right for you.

ᘓ13ᘔ

Exploring Teaching Options

This chapter will help you determine if you want to teach while pursuing your art career. It is important to explore the reasons you want to teach before you start down this path. Teaching is a demanding profession that takes a lot of energy, effort, and time. The cliché of having time off in the summer is often why many people choose to teach, but this myth of short hours and long months of vacation is not the reality most teachers experience. It is a much more complicated scenario; teachers may get a couple of months off, but all good teachers work during their months off, plan and prepare for the upcoming year in order to excel in what they do. In fact, most teachers will tell you that they rarely ever have a Sunday that is not filled with work preparation!

Here are some good basic questions to ask yourself in order to find out if you should consider a career in teaching:

- Do you like to work with people? This is one of the most important assets to have in teaching; this is a public profession.
- Do you like public speaking? Do you like to lecture, critique, and advise?
- Can you juggle two careers at once: teaching and your studio work?
- Do you enjoy interacting and exchanging ideas with children, teens, or adults?
- Do you enjoy watching people grow and change?
- Can you take instruction from a superior?
- Are you comfortable working in an institution that has numerous protocols and often well-defined systems?

To get inspired, sometimes it is good to read about other artists who were great teachers. Two come to mind: Hans Hofmann started his own art school and taught a generation of artists including Lee Krasner and Red Grooms while also succeeding in his own painting career. Another great teacher to investigate is Thomas Hart Benton, whose most famous student was Jackson Pollock. While Pollock is said to have thought Benton's traditional teaching methods and style

gave him something to rebel against, Pollock's work reflected Benton's teachings even after his work moved toward abstraction.

Both Hofmann and Benton used their teaching to fuel their work and their students informed their practice. There are many more examples of great artists who were also dedicated and inspirational teachers. If you have experienced one in your lifetime, it may help you decide on whether to pursue a teaching career by having a conversation with them.

TEACHING OPTIONS

When talking about teaching, most people think about college-level teaching, but there are many venues in which to teach art. For each teaching option we describe in this section, we will provide a reality check, listing its advantages and disadvantages.

Art Museums

Art museums have excellent opportunities in which to teach. Art museums offer teaching options mainly through their education departments and adult programs. Museum educators teach in the galleries to a wide range of audiences: from preschoolers, school-age children, adults, and seniors to special-needs audiences. Artists can also offer adult lectures and workshops for museum visitors. Museums' education programs often have opportunities for teaching children and adults.

Pluses: Working with art objects, studying art history, and the possibility of interacting with contemporary artists. Of note: large museums often pay better than small museums.

Minuses: Generally low pay, often freelance without benefits, can involve long hours and working on weekends.

Colleges, Community Colleges, Universities

The major difference between these different kinds of schools is whether they are private or state and federally funded. There are also a few different avenues into teaching positions in these institutions. The options consist of being a visiting lecturer, a workshop instructor, or an adjunct, assistant, or associate faculty member. Each one of these teaching positions has its own specific role and salary scale.

Pluses: Diversity at community colleges, smaller classes at private colleges, job security if full-time, tenure and potential job security, teaching adults can involve less discipline problems than with children and teenagers, often have good facilities in private and large universities, access to equipment and studios.

Minuses: Working in a bureaucracy, the process of getting tenure can be difficult, lack of full-time and tenure track opportunities. Often, there are big classes at universities. In poorly funded institutions, there may be a lack of facilities. Most positions are adjunct, with no job security or health benefits. Teaching at this level generally requires an MFA degree.

Continuing Education at the College Level

Continuing education at the college level is usually a separate department unto itself with a director and instructors. Programs vary depending on the school. The range of clients these programs serve can range from children's classes to teen programs to adult courses. Often, continuing education classes are created by the instructors. These programs are great ways to get experience and to see if teaching is a good fit for you.

Pluses: Artists can create and propose classes that fit their expertise and areas of interest. Teaching in continuing education can be a great foot in the door and may lead to adjunct and part-time faculty work.

Minuses: Teaching in continuing education has fewer guarantees than teaching in other settings; for example, if class enrollment does not meet the college's requirements, classes may be cancelled. There are also rarely benefits such as access to health insurance.

Public Schools: Pre-K, Elementary, Middle, High School

Each age level in public schools, whether it is on the elementary, middle, or adolescent level, has unique developmental assets and challenges. It is important to know if the age range of the students you wish to teach are the ones you enjoy working with and find exciting to teach.

Pluses: Tenure is still an option; salaries are clearly communicated and structured with a public salary ladder. Pensions, health benefits, and the rewards of working with children are all pluses.

Minuses: A heavily regimented schedule, working in a bureaucracy, classroom management and discipline challenges, class sizes increasingly large, varying degrees of facilities. Some schools have more robust art departments than other schools.

Private Schools

Private schools have fewer education requirements than public schools do to start your teaching career. Private schools offer an easier access into the teaching profession, with more focused and sometimes specific curricula, as in religious schools.

Pluses: Generally smaller classes and more tailored curricula, often smaller communities in which to work.

Minuses: More oversight of the classroom by administrators and parents, lack of job openings, pay and benefits vary from school to school.

Tutoring and Teaching Private Art Classes

Tutoring is great for an artist who likes to work one-on-one with a student. Students can come to the artist's studio for private lessons.

Pluses: One-on-one work relationship, you have control, can become a rewarding mentoring experience, you can set your own salary and schedule.

Minuses: Recruitment and keeping students over a period of time.

Community Art Centers

Community art centers are generally communities of passion carved out by an individual or a small group of like-minded people who feel strongly that the arts are good for their community. These centers are gathering places for young and old and offer a variety of classes that usually meet the needs of the constituents.

Pluses: You have creative control of subject matter and how you teach it.

Minuses: You have to make it happen; centers can be disorganized at times and can lack resources.

Artists-in-Residence

Artists-in-Residence programs offer artists a prolonged period of time to work with students often on a single, focused art project. These programs can exist in public schools, art centers, foundations, or colleges. They are excellent ways to enter into the teaching field.

Pluses: You create your own work, you may get a studio/room/board, you often get to work on one large project with a group of excited students.

Minuses: These are part-time/temporary jobs, there are a limited amount of these kinds of teaching opportunities, they are often competitive.

Lectures, Workshops, and Demonstrations

A great way to gain teaching experience and earn income is teaching workshops and special lectures. These may be onetime demonstrations or only last over the course of a few days, rather than over a semester. Universities, community centers, and art and craft organizations may offer such opportunities.

Pluses: Building an area of expertise, you can pick and choose the topics you teach, this is freelance work, so it's great for flexibility that allows artists time in their studios.

Minuses: This is freelance work without benefits, pay scales vary, you often have to pay taxes on this work as freelance income.

Alternative Teaching Venues

There are a myriad of small programs embedded in public and private schools that are excellent teaching opportunities. For example, professional development workshops are a growing industry in public schools, such as portfolio reviews for students in art departments who are preparing for the college entrance procedures. Summer camps are excellent ways to start teaching students of all ages. Teaching abroad can offer a range of international schools from K–12 to the college level. These international schools employ English-speaking teachers and can be exciting places in which to work.

College-Level Teaching

Teaching in higher education is very attractive for many artists because of the security and benefits it offers, such as a steady paycheck, health benefits, insurance, sick leave, vacation pay, sabbaticals, and periods of time not teaching classes in the summer. Unfortunately, the competition for these teaching positions is

fierce and there are more qualified artists/educators than jobs. The job guarantee is also less stable than it was in past decades, as tenure is being eroded and replaced with contracts. Most schools currently rely heavily on adjunct or part-time faculty who get paid per course with no health care benefits, so full-time positions are rare. Therefore, if you desire to enter this field of education, it is wise to have a plan and realistic expectations. Since competition is so great for these few job openings, it is also good to have a mentor to help you when you first get started.

There is another issue to consider seriously about choosing this path and that is working as a full-time faculty member requires a large commitment of your time. It is a career in itself, filled with lectures, demonstrations, advisements, grading, evaluations, faculty meetings, presentations at conferences, and institutional events. Not to mention, academia often requires professors to publish articles, papers, books, and essays. Tenure can be an all-consuming goal. In other words, to keep up your art and be an educator, you may be taking on two full-time careers.

This could be an exciting life to lead, or it may make it difficult for an artist to do his or her own personal work. It could also be said that academe and an artist's studio work can come into conflict when the norms of academe demand conformity while the studio demands experimentation. Yet the advantage to this arrangement is that your teaching can feed or inform your artwork and vice versa. It can offer a connection to the world, compared to the often solitary work of a studio practice (that is, if you are a visual artist). There are schools that are flexible and encourage creativity in their educators. Try and match your personal philosophy with the school's philosophy.

EXCERPT FROM AN INTERVIEW WITH SIMONE DOUGLAS

Simone Douglas is director of the MFA in Fine Arts at Parsons The New School for Design and has taught at institutions and run visual research projects internationally. Douglas says of the teaching profession, "One of my BFA university teachers suggested that I apply for a one-semester teaching contract that had become available. I had not seriously considered teaching until that moment. It turned out to be a pivotal appointment. When I completed the contract, I had taught in both theory and studio classes, managed a program, written curriculum, sat on committees, and taught a diverse range of students across the full year range of the degree. As a result, I gained an enormous amount of experience in a short period of time. It gave me a formative experience of the fullness of teaching and participating in a creative academic community. I was hooked. It set me up for my future positions. I reflect on this period when I advise my students, some of whom may not have considered teaching.

"Why teaching? It is a continually evolving job, never static. Teaching engages you with ideas. You contribute to your field via your own practice, and also via the programs that you might shape. You must like working with students to enable them to develop into self-reflexive artists who may go on to practice, teach, curate, write, and more. You are part of the development of the student, often over a long period of time.

"When looking at candidates for entry-level teaching positions, I don't expect that they will have an extensive CV in teaching. I look for a diversity of experience that may inform their teaching practice: Have they evidenced being actively engaged in the field? Have they been exhibiting? What projects have they initiated or been involved in? Have they held a TA position? What course did they TA for? What duties did they undertake as a TA? What other related teaching experience do they have? Workshops, full courses, etc. What courses have they undertaken in their degrees? Do they have the training to teach potentially in theory courses/in studio? Technically, conceptually? The more diverse and in-depth your experience is and the more willing you are to teach a range of courses, the more employable you are."

Requirements for College-Level Teaching

The MFA, a terminal degree, is a nearly universal requirement for teaching in all higher-education institutions. It is important to know that an MA is no longer considered an adequate degree for teaching in higher education. A healthy, active exhibition history is also critical to being qualified to teach studio classes. The catch is that you must have previous teaching experience, and therefore adjunct teaching, continuing education, and being a teaching assistant in graduate school are essential in order to start your career. At some colleges, such as art schools, often a high-profile artist with a robust exhibition career will be able to teach without a graduate degree, but this is becoming rarer.

PhD programs in the visual arts are new and controversial. See the graduate school chapter of this book for different opinions on these new programs.

Adjunct or Part-Time Teaching at the College Level

Working full-time or part-time is important to think about when you begin to assess whether you wish to enter this field. Most college-level teachers have no choice and must start with a part-time job, but going in with a plan is a good idea. If you want a full-time job at a college but can initially only get a part-time job in the institution, knowing you want a full-time job is critical, because then all your efforts go into making a full-time job a reality. Many artists start out part-time in higher education and don't have a plan. They often stay in part-time position for years when they want more stable employment.

Bonuses of Adjunct Teaching Work

Among the many positive aspects of adjunct teaching are access to studios, equipment, meeting people, a built-in arts community, meeting famous artists, networking, a stimulating intellectual environment, and free classes. Health care is sometimes offered to adjunct faculty, but often is not.

Seeking Jobs in Higher Education

To get started on your job search, become familiar with college and university jobs; seek them out on job boards at the colleges you are interested in and learn what is needed to apply. The College Art Association offers members access to

a job board with postings for art historians, studio art faculty, art educators, arts administrators, and many other categories. Try networking and getting connected to faculty and chairs in schools you want to approach; see if they can connect you with hiring managers or give you a heads-up when openings in your area occur. Your alma mater's online job board is also a great place to seek out postings.

Teaching in a university's continuing education program (whether for adults' or children's and teens' programs) or being a teaching assistant during your graduate program is a way to get a foot in the door to teach adjunct or full-time at a college. These jobs are great résumé-building experiences. Starting out can be a challenge: you may have to vigorously seek out teaching opportunities, and you might have to teach for minimum wage or even no pay.

Unions
Finally, a word about unions. Unions are beginning to make their way into academe. They exist for the purpose of protecting faculty's rights and supporting clear, fair, and logical methods of establishing salaries and promotions. These unions have become more prevalent in higher education because of these institutions' reliance on part-time faculty. Be aware of these politics, do your research, and be informed!

Getting Certified to Teach Pre–K-12
Like teaching in higher education, there are many advantages to teaching in pre–K-12, such as job security, a steady paycheck, benefits such as health insurance, a pension, and a teacher's union, which can offer loans on cars and homes as well as life insurance. You are working for the state and the federal level, so your benefits are generally quite good. Tenure is also a factor. In pre–K-12, tenure is usually received within three to five years of your hire, depending on the district you work in. Each state varies with this procedure, but when you enter tenure, you have a certain amount of protection from the forces around you. When you become an educator in elementary or secondary school, you join a strong community of colleagues who will become important relationships in your life.

The other side of this equation is that you are teaching in a bureaucracy and should think about your feelings about institutional work. By this we mean there will be meetings to attend, lesson plans to create and standardize, evaluations by your superiors, parents to deal with, and state and federal regulations to adhere to. That being said, the students are usually why a person enters into the teaching arena. There is no better pleasure than to watch your work impact and affect positively another human being. There is great satisfaction in this endeavor.

Requirements for Teaching K-12
In order to enter the pre–K-12 grades, you'll need to get professionally certified to teach art in elementary, middle, or high schools. This certification is in conjunction with an undergraduate or graduate degree program. Each state has different requirements for this process, but all require a certain amount of credits in order to be certified. For example, the following is a sample program of the

courses you *may* need to take: developmental psychology, child development, adolescent development, introduction to teaching art, education seminars such as history and current issues in education, as well as supervised fieldwork or student teaching. Student teaching is the most important component of your art education training, offering experience in the classroom and networking with your supervising teacher, who can become your mentor and help recommend you for your first job.

Make sure that you ask whether you need a terminal degree in art, an MFA, or an MA in education in order to teach in your state. You might get certified in one state, but if you move to another state, you may have to apply for an additional certification there, which may involve another set of classes and credits.

It is important to understand the amount of time this art education certification process will take if you have your bachelor's in art, not in art education. See if you can transfer classes from your undergraduate to your certification—some states may accept some classes. Be aware that this coursework can take as much as two additional years of class work to complete. The following are important things to consider as you prepare to embark on the certification process.

Types of Certification

Make sure you understand what types of certification you need in order to teach K-12.

Generally, certifications are issued for work in specific grade levels. These include early childhood, childhood, middle childhood, adolescent, and all grades. Each state is different, with some offering a certification covering all grade levels.

Required Tests

Generally, you will also need to take two or more tests the state requires in order to demonstrate what you have learned. These tests generally do three things: First, they measure your knowledge on a certain topic, such as art history. Second, they measure your knowledge about classroom management, institutional knowledge, and regulations, such as who you need to go to if there is an issue in the classroom. Finally, some states require a test on general knowledge. In some states, you will also need to take two additional certification workshops. For example, to get certified in New York, you must take a child abuse workshop and school violence prevention and intervention workshop.

Where to Get Certified

Check the Internet to look for city, state, independent, and private schools' certification programs, which are often in continuing education departments. Teachers' unions also offer these classes as well.

Salaries for Teachers in K-12

Your salary level depends on the school district in which you teach, the amount of degrees you have, and the amount of ongoing professional development classes you take during your teaching career. A positive aspect of teaching in pre–K-12

is that there are salary charts that are clearly outlined and made public. There will be little mystery about how to get a salary increase and what that increase will be.

FINDING JOBS

Finding teaching jobs is much more competitive than you may imagine and you might not be able to teach at the grade level you desire. High school jobs are highly desirable, and people don't leave/retire for years. School systems must advertise jobs in their local newspapers and on their Web sites. Go to individual schools and get to know the administration and faculty. Substitute teach or volunteer at schools you are interested in. Try to get your student teaching job in the system or school you want to work in. In some states, special-needs art classes are a great way to break into a school; it could be part-time or full-time work. Within large schools, there are special programs where you may find a place to find an entry-level position, such as a special program that combines art and literacy. Schools, as well as hospitals, are increasingly interested in art therapy graduates for certain positions.

CREATING A TEACHING PACKET FOR JOB APPLICATIONS

Creating a packet to apply for a teaching position takes time, so begin the process as early as you can. Preferably, create this packet before you begin applying to jobs. Give yourself the proper amount of time to create an excellent packet. The purpose of a teaching packet is to get an interview. The packet won't necessarily get you the job, but it will go far to introduce you to potential employers.

Teaching packets vary according to what the job application requires. It is imperative that you carefully read the instructions for what is asked of you to submit for a job review. Schools may ask for one, two, or three things from this list. This packet list can apply to both college level and pre–K-12 jobs. It is also important to have these items written and designed before starting a job search. Here are the basic items in a teaching packet:

- A cover letter.
- A CV and or an artist's résumé. Sometimes an employer will ask for both. See chapter 9 for examples.
- Transcripts from your graduate school. (Sometimes these documents are required to apply for a position in higher education.)
- An artist statement about the body of the artwork you are submitting for the application. See chapter 9 for detailed information on artists' statements.
- A teaching philosophy.
- Sample curricula.
- A digital portfolio of your artwork. (The most common mistake of applicants is not to read the instructions as to the format in which these images should be sent. The criteria will vary from school to school, as does the number of images required.)

- Printed labels for your images on the CD or DVD digital portfolio. (No handwritten labeling on these items!)
- A printout of your images with a list of the title, date, material(s), and dimensions of each piece. (This list must correspond to your digital portfolio.)
- Examples of your students' artwork. (The number of examples will vary for each application, though ten to twenty seems to be the norm.)
- Clean, readable copies of favorable exhibition reviews or media coverage.
- Well-designed exhibition promotion materials, such as an invitation cards or announcements.
- A list of references. (Read the instructions as to how many references you will need. Three is the general number. Some schools require reference letters included in the packet. Others will ask for them if they wish to interview you.)
- A business card with your name and contact information on it.
- A self-addressed, stamped envelope (SASE) for a return.

Tips on preparing your packet:

Read the instructions of any job application carefully and follow it precisely! Many a job has been lost on this first round by not following directions and submitting incomplete or unsatisfactory materials. Label everything professionally, avoiding handwritten notes on CDs or other materials. Be neat and make sure things are not falling out of the packet. It is helpful to create a table of contents so the recipients know what you are giving them. Finally, you should have multiple résumés in your packet so it's easy for a committee/hiring panel to review your CV without having to make copies.

TEACHING PHILOSOPHY

Teaching philosophies are essential for any teaching packet, whether you are applying for K–12 positions or at college-level schools. They are difficult to write because they involve thinking about what you believe in. For example, if you believe everyone can learn, then your teaching philosophy must reflect this belief system. In other words, you need to ask yourself: what are my core values?

Stephen Brookfield writes in his book *The Skillful Teacher* (1990) about creating a teaching philosophy and how it can be useful during times of difficulties: "A distinctive organizing vision—a clear picture of why you are doing what you are doing that you can call up at points of crisis—is crucial to your personal sanity and morale." Commenting on a career in teaching, he says, "Teaching is about making some kind of dent in the world so that the world is different than it was before you practiced your craft. Knowing clearly what kind of dent you want to make in the world means that you must continually ask yourself the most fundamental evaluative questions of all—What effect am I having on students and on their learning?"

An exercise to start to get at your core education values is to write a paragraph on a good and a poor learning experience you have had in school. We are all experts in education because we have all participated in schools for many years; therefore, embedded in these experiences are your feelings, beliefs, and thoughts about how you view learning. It's the best way to get into a discussion with yourself about these learning values.

Here is an example:

A good learning experience: When I was in sixth grade, I had a teacher whom I loved. Her name was Miss Morris. I had trouble reading, so she would stay after school and help me to read. She gave me books I could read and I was excited by them. She was interested in what I had to say about them. She listened to me and would sit for what seemed to be hours, patiently helping me struggle to learn how to read in English.

Here are the core values pulled out of this brief story:

- Learning can be pleasurable and exciting at the right level of the student.

- Learning is a struggle at times.

- Teachers help students.

- Teachers are committed to students.

- Teachers can open up new ways to learn.

- A good teacher has patience and listens to her students.

A poor experience in school will help you identify even stronger learning values because you will object to all the negative aspects of the experience. Inside each of these experiences is the start of your philosophy of education. Next, put sentences to these core values and begin to build a paragraph of the most important ones. Keep it short and simple, at the most one page in length. Also, remember to keep all sentences in present tense, first person.

INTERVIEW WITH ALEXI RUTSCH BROCK, ARTIST AND TEACHER

Alexi Rutsch Brock is a teacher, painter, printmaker, and independent curator. She is on the Gallery Boards of the Pelham Art Center and the Art Board of Museum of Arts & Culture in New Rochelle, NY. She is currently working on linking New Rochelle High School art curriculum to the Getty Center and PBS Art21. Her site is *www.AlexandraRutsch.com*.

Tell us how you got interested in teaching.

I went to the School of Visual Arts with the full support of my parents because they were both artists. At the end of my freshman year, I found out about an art education program and decided to minor in education. The second day of my art education class, they had us teaching. I taught a second-grade girl watercolor resist with crayons and she said, "It's magic!" I was hooked! I still have her painting and can remember her name. I decided then and there to do a double major.

What was it like when you started teaching high school?
At first it was scary, because as a twenty-one-year-old when I started teaching high school, I was only three years older than the seniors. But I related to them extremely well because of our closeness in age. That gap is bigger now, but I feel I am very good at relating to kids. I have patience and compassion, and with that I feel any adult can deal with a kid, or each other, for that matter. Another scary thing for me was when I first started teaching was that I'd never taught five classes a day, five days a week. The most was three classes in a row, once a week.

What do you like about teaching high school?
I like high school because I have the students every day. Also, the maturity level of the students from fourteen to eighteen makes them fun to work with, especially with the excitement of the college preparation classes. They have great conversations at this age, and I love how their brains work. Our facilities are great, and the student body is phenomenal to work with each day. We have great parental support of our programs, too. Most of the art teachers I work with are showing artists, and that makes a huge difference because we bring real-life experiences to the students. We enhance our teaching with visiting artists, Portfolio Day, trips to museums, and so on.

What are some of the challenges of teaching?
The administrative demands and the need for more financial support are a challenge. There is never enough money for your dream curriculum. Students often have personal and emotional needs, and I find I'm often in the role of therapist, social worker, and parent; but using the art to help students get through their teen years is exciting and fulfilling.

How does teaching feed your art practice?
The students inspire me every day. The students keep my brain sharp, keep me in the loop with current trends, and amaze me with their ideas and individuality. They have so much talent. I feel that the Internet has matured their senses of design and imagery so much. The one thing I really miss about college is the large group critiques. I try to do this with my colleagues, which helps.

PART V

Your Artistic Practice

ᴎ14ᴙ

Your Studio Practice as a Business
By Carol Overby

C arol J. Overby earned an MBA from the University of Chicago in order to help creative people manage their businesses, and continued with a consulting practice for more than years. She is now assistant professor of Design + Management at Parsons The New School for Design, where she teaches business and management subjects.

This chapter will help you think about the financial realities of being a fine artist and give you some ideas for surviving and thriving. The information in this chapter will assist you in thinking about your business as an artist. For any legal or tax issues, be sure to consult an accountant or a lawyer. The best advice is to deal with money issues from the very beginning so you can avoid scary situations like:

Tax audits

Not having enough money for necessities like rent, food, and art supplies

Being evicted from your home or work space

WHY WEAR ONLY ONE HAT?

Now that you're a professional artist, guess what? You're also a business. If you're creative enough to make great art, you're creative enough to take care of yourself and your business as an artist. You definitely have the intelligence and creativity to understand the business end of your art and to handle your finances. There are many sources of help; here are a few:

- Volunteer Lawyers for the Arts (*www.vlany.org*) provides legal services for artists and nonprofit arts organizations.

- New York Foundation for the Arts (*www.nyfa.org*) provides resources, workshops, and other support for artists and arts organizations that originate in New York State.

- The ArtBiz.com (*http://www.aboutus.org/TheArtBiz.com*) is the interactive Web site for NYFA (see above).
- Arts Resource Network (*www.artsresourcenetwork.net*) is a Seattle-based provider of arts workshops, services, and resources for artists and arts organizations.
- The Art Business (*www.squidoo.com/artbusiness*) is a community Web site that brings together many blogs about the business side of art.

One definition of creativity is the ability to have divergent thoughts and wear more than one hat, so don't fall into the trap of thinking that you'll lose your artistic creativity if you learn to be businesslike. Your creativity will be your greatest ally; what I'm offering here are just some examples and tips to get you going in useful directions. Don't forget that avoiding the business aspects of your art can suck up more emotional energy than tending to business regularly. If you do tend to business, you can avoid the primary reasons *any* business fails:

- Not selling enough at high-enough prices (this rests on your ability to produce something different to and better than other artists, and to publicize it well)
- Too many expenses
- Not paying taxes
- Letting clients take too long to pay
- Not keeping a cushion of funds to get you through a disaster
- Lack of planning and organization

Your main goals are to keep good records, make ends meet, and take care of details that will allow you to prosper into the future. I interviewed Jane, a painter based in New York City and Maine, to find out how it can be done. Throughout this chapter, Jane's example will be used to illustrate how an artist can manage their finances.

Jane worked her way through a fine arts degree in Philadelphia and went straight into the military(!) to catch her breath, learn to be a cook, pay off student loans, and paint. When she returned to Philadelphia, she found extra-cheap housing and worked as a waitress three long days each week with a four-day block of time for her in-home studio. By keeping expenses to a bare minimum, Jane saved enough to take a decrepit shared studio (with a toilet but no shower) in the country for a year; there she created a body of work that helped her snag an art-colony residency. Her great portfolio and increased credibility from this residency resulted in some sales, but she was totally intimidated by New York City when she moved there for love. Once again the key was finding rock-bottom living space: a bad neighborhood, with two people squished into less than three hundred square feet ("less time for housekeeping, more time for art"). However, a full-time job was also necessary. Administrative and computer skills landed her decent-paying jobs in the art world, where she learned a lot about the business of being an artist and picked up new administrative skills in—accounting??!!

Jane recalled, "Once I had some skills, I was able to make myself indispensable as a freelancer to a niche market and go back to working fewer days a week. For me, long-term full-time employment is a trap: it's enslavement, and you're treated like furniture. They have no respect for the time you need to put into your art and think that since they're paying your benefits you should just shut up." As she has become a valued freelancer, she has flexibility and is now able to schedule long (unpaid) vacations to paint.

Jane and her partner stayed in their tiny down-market home and shared an ultra-cheap studio in a blighted neighborhood, renting from another artist and doing construction work themselves. Security was an important issue: good locks, good lighting, not too far to walk, and always a place to sleep in the studio when working late. Her routine became job, then nap in the studio, then paint.

From the very beginning, Jane and her partner kept good records of expenses and income from art, freelancing, and her partner's art-handling business; they also minimized expenses and paid their taxes. Because of these good habits, they built an excellent credit history and were eventually able to buy a small house in Maine. The security of home ownership, along with disability insurance and regular payments into Social Security, helps them avoid worries about the future.

You may be thinking, "But I'm not like that! I'm an artist, and getting good advice won't change me into a businessperson!" Like Jane, you will need to make an internal shift: she says she had to "change how I see myself, making an emotional transition to becoming a business and marketing person inside myself—someone who can deal with my artwork professionally, as if it was someone else's career I was managing." While you're working on that emotional transition, let's start your business setup.

KEEPING RECORDS

Now that you're a professional *and* a business, you'll need to keep records for two very important reasons:

1. Filing your taxes accurately so you don't pay too much and so you don't get audited.
2. Collecting information that will help you make better plans and decisions.

Life will be a lot more manageable if you separate your business money from your personal money, and one easy way to do this is to open another personal bank account titled "[Your Name], Artist." If you want to be more formal, you can contact your local county clerk and file a DBA (Doing Business As) certificate for about $100, then take the certificate to the bank and open a business account as your artist account.

Ideally, you will also designate a new or existing credit card *exclusively* for business use.

Here are the types of income you will deposit in your artist account:

- Grants and fellowships

- Sales of artwork

- Fees for giving lectures, consultations, or workshops
- Income from renting out part of your studio
- Loans from your personal account

And here are examples of expenses that you'll pay from your artist account or your artist credit card:

- Rent and utilities for studio space (*not* for living!)
- Construction costs for improving your studio space
- Computers, equipment, and furniture used *exclusively* for your artwork
- Art supplies and materials
- Fees to studio assistants
- Exhibit expenses such as framing, display cases, shipping, transit insurance
- General insurance: fire, theft, liability, disability
- Promotion and publicity
- Commissions/gallery fees
- Research: books, education, memberships, subscriptions, attending shows or performances
- Travel that is necessary and exclusively for your artwork
- Entertainment, such as food/drink expenses for openings

Eight Steps for Simple Record Keeping and Tax Filing

1. Set up a shoe box or large envelope at the beginning of each year. Label it "Artist Expenses 2011" (for example) and put *all* of your business-related receipts in it all year.
2. If you paid cash for anything, mark that receipt "CASH" in big letters and write the category on it.
3. Make sure all artist income and expenses go through your artist bank account or artist credit card.
4. If there's not enough money in your artist account, make a loan to the artist account from your personal account.
5. Save a hard copy of your business bank statement and business credit card statement every month, and give a category to each amount on each statement (use the categories above, and add others). Then save all the statements in a file or envelope for the year.
6. If you mistakenly paid a personal expense from the artist account or credit card, mark it clearly as "PERSONAL."
7. If you mistakenly paid an artist expense from your personal account, write yourself a check from the artist account to pay it.
8. Hire a tax preparer who is familiar with tax considerations for artists.
9. Take the marked-up statements (see examples) and all receipts marked "CASH" to him at the end of the year.

Your tax preparer can be a good source of advice, especially when you're ready for a higher level of record keeping and business operation. You may decide to incorporate or begin using a computerized system such as Quicken or QuickBooks. Another important topic to discuss with your accountant is whether your main aim is to show the maximum possible income to establish credit, or to try to minimize taxes—you can't have it both ways. This may affect how you categorize that trip to Costa Rica: was it 100 percent tax deductible as a business expense to research colors of water, was it 100 percent vacation, or 50/50?

In addition to financial records for taxes, you need to keep good records of all your works of art (even after they're sold). It helps a lot if you give each work a unique title or number, and write that title and the completion date on the piece. Then you can make an index card or computer file for each work, including an image of the work and listing:

- Title
- Date completed
- Dimensions
- Materials
- Where it is stored
- If it was sold, show
 • Date sold
 • Buyer (including contact information)
 • Price to buyer
 • Means of sale: gallery (which), direct (how), agent (who)

There are also online sites where you can display and catalog your work, many of which provide systems for keeping these records.

Let's consider the decisions Jane made in setting up her business. She has never incorporated as an artist (too much trouble), she uses Quicken computer software for her record keeping so she can review what she's been spending, and she and her partner decided to show maximum income from the beginning so they'd look good enough on paper to buy a home; they also wanted to pay enough into Social Security for their old age.

So here are your record-keeping dos and don'ts:

DO

- Use a computer to keep files of all your works and to invoice clients.
- Open a separate bank account (and credit card, if possible) exclusively for business use: your artist account.
- Hire a tax preparer who is familiar with tax considerations for artists.

- Deposit all business-related money into the artist account, and make all business-related payments from the artist account.
- If you don't have enough money in the artist account, make a "loan" to the business from yourself.
- Put a shoe box or large envelope near the door so you remember to dump all your business receipts in it. It's good to write on each receipt the business purpose and how you paid it. Start a new one for the new year.
- Keep all of your business records, including bank and credit card statements, together in a cardboard box or an accordion file until the end of the year.

DON'T

- Don't pay artist expenses from your personal bank account or credit card.
- Don't make artist deposits into your personal account.
- Don't take cash out of your business account.

MAKING ENDS MEET

The two ways of putting more money in your pocket are make more and spend less. To earn more, you can sell more art, get more grants, work more hours at your other job, get higher pay at your other job, or use that fabulous creativity to figure out something else.

Make More from Your Art by Getting It Seen

Jane developed excellent credentials from her residencies, learned a lot about presentation from her art-world full-time jobs, and made good contacts with architects and decorators through her freelance work. She targeted corporate collections because "my work is more visible there than in private collections, and they like big art. But corporate completely drops out in recessions."

Make More from Your Art by Getting Paid Better

These tactics and others will be covered in the chapter on marketing, but another aspect of bringing in more money is getting your pricing right: high enough to command respect and reward you, but not so high that no one will buy. Jane says "don't take cheap to the point that it [messes with] your future." Set prices in a professional range if you want to be taken seriously.

When you visit Web sites or galleries, be sure to check the prices on pieces that have already sold and are in some way similar to your art. Then think about how you and your work compare in terms of reputation, materials, size, style, and publicity, and make a guess about how the same gallery might price one of your works. Lastly, divide that guess in half to allow for the gallery's 50 percent share.

The *minimum* price you can accept is the amount it cost you to make a piece; make sure to add in the hours you spent on it, multiplied by your hourly rate (try $20/hour at first).

Always have a price in mind before you begin to talk with a possible buyer, and decide how much you're willing to negotiate. Also think about what non-monetary benefits will come from this sale: Will the piece be displayed where other potential buyers will see it? Is the buyer interested in more work from you? Will the sale increase your reputation?

Most importantly, agree on the terms of payment, write up a sales invoice like the one attached here, and have the buyer sign the copy you keep. Here are some possible payment terms:

- You receive a check for payment in full, and deliver the piece after the check clears your bank (delivery on clearance of check).

- You receive cash in exchange for the piece (cash on delivery or COD).

- You receive a partial payment (usually half), with the balance due at a specific date.

 Do not let the buyer take the piece without giving you some money and signing the sales invoice: this is the legal document that proves the buyer owes you money.

What do you do when a buyer does not pay the balance when promised? The first step is a friendly phone call or e-mail to ask how they're enjoying the work and remind them that payment was promised on a specific date. You can also send out a copy of the sales invoice to them with a note that you hope they're enjoying the piece and a highlight or circle on the due date. You can make another contact in about two weeks and ask if there's any problem-then continue to contact them politely but regularly.

Make More from Other Sources
Major sources of money for artists are grants and day jobs—which are explained in chapters 12 and 18—as well as support from family (especially a spouse or partner). You may also be able to make investments that bring in money in the form of dividends, or rent from real estate. Jane's first studio was rented from another artist who had been able to buy an industrial building and convert it to studios.

Spend Less on Personal Expenses
If you're pursuing art that you love, spending money on yourself becomes less important. Since your home is the largest expense, you might live in a tiny home, spending most of your time in the studio and entertaining there; share with roommates; take advantage of any special programs for artists (such as Artist-in-Residence zoning); or move into raw space and do your own construction. Other strategies are to move somewhere with a low cost of living: cities experiencing renewal, such as Detroit and New Orleans; communities that are deliberately welcoming artists, like Peekskill, NY; and rural areas.

Medical insurance, especially if you decide to have children, is a large and important expense. The best way to get it is as a benefit from your job or your spouse's, but if your total income is very low, you may qualify for government-assisted medical care. For food and transportation, you can continue student life of cooking cheaply at home and using a clunker or bicycle for transportation. Don't forget that if you have a car, insurance is much cheaper outside urban areas.

Spend Less on a Studio

You won't be able to afford a studio at all unless you keep your personal expenses to absolute minimum. Jane's method was to decide how much studio space she needed, find others to share, and then find the cheapest locations—which are usually in not-too-safe neighborhoods. To improve security, she looked for a smaller building with a resident owner or other artists around at odd hours; also, a location close to transportation so she wouldn't have to walk too far alone, or one where she could drive up to a securely-locked door or fence. Once she moved into a space she liked, she worked hard to be a great tenant—paying her rent on time, being considerate of neighbors, offering to contribute to the cost of improved security—and was able to get a long lease to protect herself from being gentrified out by rent increases.

Figure Out How Much You Need

A little planning will help you see where you can spend less and earn more. Knowing the reality of your finances also helps you separate anxiety from facts. We've included a form here, or you can use a spreadsheet program like Excel, but a simple piece of paper also works. Start by writing down all your monthly personal expenses, by category, and adding them up. Your monthly bank and credit card statements will give you good information. Don't forget to include saving for occasional expenses like travel and gifts, and allow for taxes. Then add up all your professional expenses. Lastly, add up all your regular monthly income. By comparing the amounts, you can start to plan how to increase income and decrease expenses to bring your budget into balance.

If you plan a major project, you can go through a similar process to identify all of the expenses (including any income you won't make while you work on the project) so you can put aside enough money or apply for a grant to cover expenses.

Manage Your Student Loans

Repaying your student loans can take a big chunk out of your budget, but there are some strategies for managing them. Start by getting counseling from your college or art school. Schools are required by law to give you counseling about your loan when you leave, so *make sure* you get this counseling, even if you have to go back to your school. Loan counseling will give you a lot of information, such as

- The legal terms and conditions of your loans
- The amount of monthly payments
- What kind of repayment plans are available

- What options you might have for deferment or forbearance
- Possible ways you might get loan forgiveness or cancellation
- Whether you can repay more quickly without a penalty
- The pros and cons of consolidating your loans: this can affect your options for the future, such as loss of the grace period or forgiveness options
- What happens if you default: this can include ruined credit, legal actions, money taken from your paycheck and tax refunds, collection fees, and the loss of deferment and forbearance options
- Tax benefits you might take, such as the student loan interest deduction

Source: *http://www.finaid.org/loans/loancounseling.phtml*

You may be able to have some of your loans forgiven under special circumstances, such as teaching in impoverished areas, military service, and some volunteer programs. Doing this right after school (like Jane's service in the Merchant Marine) can relieve some of the pressure on your finances.

If you have questions or problems about your student loans, first ask your school's financial aid office for advice or referrals to government-sponsored counseling agencies. When you seek information on the Internet, remember that any address that ends in .com is a profit-making organization and probably more interested in making money than in helping you. Better sources of information are .gov sites such as *www.studentloans.gov* and *www.studentaid.gov* and .org sites such as *www.finaid.org* and *www.mappingyourfuture.org*. Before you sign any agreements to change any of your student loans, be sure to get advice from a reputable source.

CONCLUSION

By now you may feel overwhelmed by the amount of work it takes to manage your business as a professional artist. Don't try to do everything at once, and certainly don't try to do it perfectly; instead, refer back to this chapter over time and tackle tasks one by one. Each small step you take will reduce your anxiety and leave you more emotional energy for the work you love.

↱15↰

Getting the Word Out: Promoting Your Work

Self-promotion is essential for artists and involves both how you communicate about your work and how you present yourself to the world. In this chapter, we will give you some tools for promotion and share examples of how artists have used their creativity to promote themselves and advance their communities.

The promotion tools below will allow people to know who you are, what you do, and what you produce (whether it is a print, a performance, a sound piece, a painting or sculpture, or other work).

BUSINESS CARDS

This is your most basic marketing tool to be used on a daily basis. A business card helps others to immediately get your name and contact information and will help people remember you after an event. Even with no budget, you can have business cards. There are free or inexpensive Web sites that create professional business cards. Think of these as 1" x 2" platforms for your creativity. It should include your name, e-mail, and optionally your phone number, Web site, and mailing address. You can give business cards to peers and work colleagues at conferences, panel discussions, lectures, and openings. Since you never know when you will run into someone of interest, you should *always* carry business cards with you. Invest in a simple business card holder that you always keep on hand and you should keep a couple in your wallet at all times.

POSTCARDS

Postcards can be used as calling cards, promotion for a show(s), studio visit, or open studio takeaways. They can and should feature your work. Again, they can be used in the same way as a business card. A postcard also serves as documentation of your creative working life over time. As with all marketing materials, be sure to match the style of your work/personality so it's true to whom you are and an extension of your work. Don't use imagery unless it's top quality with excellent illustrations or photographs.

PRESS RELEASE

A press release is an in-depth overview of a show you are in, with precise, accurate information on when, where, what it is, and why it is. It is targeted for specific publications and media. Accuracy is critical because this is a public document, and any mistake (typos, grammatical errors, incorrect times or dates) can brand you/your event as unprofessional and may cause an artist or organization to lose opportunities.

INVENTORY LIST

The inventory list is a record (including photos) of all of your work that you've created, whether sold or still held in your collection. This is an archiving document that you will need as a mature artist for documentation of your history and also as an ongoing résumé builder. This document is absolutely critical for many reasons: to keep a record of where your work resides/its current status and where it is (on loan, exhibit, consignment, rental, sale, donation), to whom you've sold your work, which artwork it is (title, materials, size, edition, dates), price your work has sold for, name/address/phone/e-mail for whoever has the piece currently, and any anticipated return dates. You should also include any exhibitions or shows your work is currently being shown at so that you can track where pieces are traveling. This list doesn't have to be complicated, so you can use a notebook or create an online database (Excel is recommended). This list is important for your taxes as well, because artists must earn a certain amount each year in order to claim expenses. Be sure you get a good digital image of each piece before it leaves your studio.

TRACKING AND SALES SHEETS

A tracking sheet is a record for all of your applications: in-process applications to grants, exhibition applications, and gallery and museum solicitations. This document is important because it's a research tool; it helps you to review where you are having success in showing your work, and it's essential in maintaining a record of your communications with organizations. Create your own tracking sheet that makes sense to you. What kinds of things are you applying for? For each application, you should document the following: date of submission, name and contact information of the organization or fund, and dates/record when you have been in touch with them. Also note anything you included in your submission materials: slides, CDs, prints, artist's statement, bio, self-addressed stamped envelope. Also consider creating a sales sheet, a simple record of sales history. Again, think of this as a potential research tool to determine your market.

WEB SITES AND SOCIAL MEDIA

Web sites and social media are essential in promoting your work; these are the perfect tools for artists because they can be used creatively. Use your creativity outside of your studio to create a dynamic, simple, clear, and effective Web site. Do

your research: look at Web sites you like and model your site after theirs. Typically included in an artist's Web site are images, bios, statement, upcoming exhibits, mailing list/guest book, contact info, press information, and links. Remember, this is a totally public domain, and the material and comments you include should be professional. Don't include or overlap with your personal life. For example, don't include in a professional Web site any vacation pictures, every school project, personal photos, or anything not fine arts–focused. See the upcoming section on how to manage your online profile.

There are pros and cons to setting up a site yourself vs. hiring a designer. For example, if you create the site yourself, you are in control and the cost is cheaper. Or you may want to hire someone who can create a more professional–looking site with better navigation, but the cost could be steep. If you are not comfortable with creating your own site, consider bartering with a Web site designer or colleague to build your site.

EMERGING MEDIA

There are constantly emerging new technologies; by the time this book is published, there will surely be even more methods for promotion than we have included. For example, consider using an iPhone or iPad to show your portfolio at the drop of a hat in a very user-friendly, dynamic way. Keep an eye out for new applications and tools, as these constantly change.

Alex Khost, an artist who shows in alternative spaces and works as a user interaction engineer at Meetup.com, considers the impact of digital technology on artists: "As artists reflect, react, and interact with the world around them, often choices have to be made with regard to the advantages and disadvantages any given technology can have upon their lives and their artwork. As the tools become more complex, so do the implications—the benefits of a paintbrush as an artist's tool, for example, are much easier to understand than the enhancements of a digital social network upon one's artistic influences and audience. Digital technology has made artistic collaboration and influence all the more possible and likely, but it places pressure upon the artist to retain sensitivity to all of the senses, their surroundings, and the social interaction of the here and now. The artist is left with the challenge of using technological tools to collaborate, find influence, and influence others, while retaining tolerance, variation, a distinct sense of style, and a sense of local issues and community."

MANAGING YOUR DIGITAL PROFILE

As a professional artist, you need to manage your digital profile. Erin Berkery, a career advisor at Parsons The New School for Design, developed the following tips:

Think about what your online profile says about you during your career development, job search, etc. What do we mean by social media? Twitter, Facebook,

LinkedIn, Myspace, Blogger, etc. If it's online, then it is part of your profile, and this includes how you post responses or create threads on other people's Web sites.

Mistakes That Can Affect Your Prospects

Posting negative comments about an employer or prospective employer or colleague on Facebook is a big mistake. You can forget how many people you are networked into. Your employer can see if you have been on Facebook and other social media during work hours.

Where to Start

Step 1: Search for yourself online. If you have a common name, search for your name combined with past employers or school affiliations.

Step 2: Use an aggregate such as *dogpile.com*, which searches Google, Yahoo, and Bing.

Step 3: Set up alerts such as *www.google.com/alerts* to alert you if your name comes up, so you are aware if anything strange or damaging appears.

How to Control Your Online Profile

1. Start with what you have posted on Facebook, LinkedIn, etc., but also comments you've made in forums.
2. Reset privacy settings.
3. Update and delete photos you may have posted that appear unprofessional.
4. Edit your blog entries and delete damaging or unprofessional comments.
5. If your account is full of incendiary material, consider deleting your account and starting over.

CREATING A MAILING LIST

Every artist should build and maintain a contact list that is uniquely their own. Every person you meet goes into a document (such as an Excel spreadsheet) you update and categorize and have a special notes section. Try to get into the habit of doing this right after you meet someone.

A mailing list is a work in progress; it's a list of present and future contacts.

Make the building of your mailing list into a challenge and a game. Try having a goal (and a habit) of putting in five names a week. The following are types of organizations and individuals that should be in your list. Refer back to chapter 6 of this book for ideas on activating your network.

- Art world professionals: curators, art consultants, critics
- Press and media
- Personal supporters: friends and family
- Regional museums
- Directors of galleries and alternative spaces

- Nonprofit spaces
- Interior designers and architects
- Editors of art and design magazines
- Local newspapers and TV stations
- Facebook and other social media
- Collectors
- Faculty
- Everyone who signed in to an exhibit or open studio in which you were featured

Specific individuals' names should be used. Tell your hometown publications what you are doing. Find out about free listings in magazines and newspapers in your area. Keep people on your mailing list, even to those who never respond, attend your shows, or live nearby, so that you stay in their minds—you never know where a contact may lead. Another resource to consider is the public relations office of any organization you may belong to that will promote your work.

Your mailing list should include information such as individuals' names, e-mails, and addresses; where you met them; if they bought a piece; which piece they bought; when, where, and for how much they bought that piece; who introduced you/friends in common/who referred you; and their school/gallery/ organization affiliation. It is helpful to consider your mailing list as a history of your work, of who constitutes your community, and not to just think of it as serving a sales purpose in the immediate future.

DETERMINING WHO YOU WANT TO REACH

In order to effectively promote your work, you must do research on the audience for your work and define your competition. Begin by asking yourself who your role models and peers are; who is doing work similar to yours, and how have they positioned themselves? Where are they showing? We strongly suggest you commit a day out of each week to doing this research and administrative work to support your work.

Susan Schear of ARTISIN, LLC, is an arts business professional who says, "It is important to market yourself and your art. Although most of you, as artists, would prefer to hire an expert to manage your marketing, for most this is not realistic. If you choose to make money from your art, then you need to think of yourself as being in business and having an art practice. Many of you are challenged by the idea of pricing and selling your work, even though getting your work out into the 'market' [or 'marketplace'] and selling your work is part of your goal. As an artist, consider the differentiation between your 'process' and your 'product.' Process is the part of making your art where the market does not interfere. If you, as an artist, are making work for a specific market or place, you need to consider your work

as product driven by the market [and the customer or client] you are targeting. Selling your work does not mean you are selling out; selling your work offers you the opportunity to make more work and provides you with the opportunity for more success in your art practice."

Here are some suggested questions to help you build a promotional profile of who you want to reach with your work, such as likely buyers or potential collaborators. This will be an essential part of building your contact and mailing list. It may be helpful to refer back to the self-assessment inventory exercise we did in chapter 2 and use that information as inspiration from which to build a detailed description of your artwork and its potential market/buyers.

In the following section, we revisit some of the questions we posed to you in chapter 2 for a different purpose: goal setting. Use the following set of questions to create a list of people you want to reach with your work.

- Describe your work briefly. What makes your work unique from anything else in the art world?

- Who has been interested in or bought your work in the past?

- Where do they live, and what are their special interests?

- Are they involved in the art world, attending shows regularly?

- How did you network with these collectors, through friends?

- What organizations or group affiliations do they belong to?

- What books, blogs, magazines, and Web sites do your buyers read regularly?

- Who are your peers, competitors, and collaborators? Think about your fellow artists and where they show and who collects similar work to yours; do research to understand where your work fits best.

PORTFOLIOS AND SUBMISSION MATERIALS

At the core of documenting your work is creating good images. You will use this imagery to prepare your materials for submission to galleries and museums, grants, residencies, teaching positions, workshops, events, lectures, and much more. This documentation is also essential in maintaining a record of your work over time. In this section, we will discuss portfolios and materials to include in submission packets.

The Artist's Packet: Submission Materials

Artists' packets vary according to each opportunity or venue being approached. Note: everything in the packet should be labeled with your name and contact information in case of any pieces being separated from the others. The basic materials you will need to have prepared prior to any submission application are as follows:

- Cover letter
- Résumé or CV

- CD/disc or photos of your portfolio, showcasing your most recent work
- Image list (includes printouts of all images with detailed information)
- Bio (a one-paragraph description of your professional history)
- Artist statement (see chapter 9 for further details)
- Favorable reviews, articles, press, show announcements
- Self-addressed, stamped envelope (SASE)

Portfolios

The word *portfolio* can be used in a variety of ways, but in this section we are referring to samples of your work that will be included in a submission packet. A portfolio is generally a group of ten to twenty images of your best and most recent work. It should consist of a series of related images, demonstrating a body of work that is coherent. This should be carefully considered so that you select particular work tailored to the particular opportunity or venue you wish to approach. Artists should keep a master digital copy of their portfolio, with all of their images shot at high resolution; then they can prepare a disc or prints as needed. Increasingly, galleries are asking for some type of digital portfolio (particularly at the beginning of a working relationship) since this way there is no returning or lost materials.

The following are a few guidelines on presenting your work professionally:

- **Labels**
 Labels should include the work's name, title, date of artwork, and dimensions (height, width, and depth). Do not use unprofessional-looking, handwritten labels. Always use printed labels, and avoid using cheap materials such as old or bent folders and papers. Although it may seem time-consuming, it is very important to label your files on both disc and hard copy in precisely the same order so they exactly match up.

- **Order of Work and What to Include**
 Your images should be organized in a visually effective sequence and begin with your strongest work. Follow instructions and don't include too many pieces. It is best to show fewer pieces, all of which are strong, rather than a huge selection of work that may have weak elements. Do not include works that don't relate to one another or are unfinished. Only show current or recent work.

A Few Notes on Digital Images

- Use JPEGs of the right size or you can get disqualified from consideration; be sure you are using the right format.

- Be sure you understand how to resize images and use for different computers, Mac and PC. Be sure the resolution is good.

- Be sure the file opens and looks clear, is formatted correctly, and is rotated/oriented correctly and not too big or too small.

The following is an interview with David C. Terry, who discusses artists' submission materials and effective documentation. David has worked for years reviewing portfolios for the New York Foundation for the Arts fellowship program and is an advocate for artists.

INTERVIEW WITH DAVID C. TERRY, SENIOR OFFICER/CURATOR, ARTISTS' FELLOWSHIPS & AAE, NEW YORK FOUNDATION FOR THE ARTS (NYFA)

"At NYFA, we look for an artistic vision within a specific discipline. A consistency or a voice in the work is what we want to see. One problem we see with MFAs now comes from broadly interdisciplinary studies, which lead to final bodies of work that may appear disjointed or unrelated due to variety of media. If the mediums used are too diverse and the content is too diverse, that does not lend itself to our fellowship program. We want to see a clear vision, see great technical skills, and see where the artist is going.

"Good documentation of work is not a problem, but a huge problem is people not following directions on how to submit. The artist's statement is two hundred words or less and should not use lofty art jargon but rather describe your work as if you were talking to your friends. Don't talk about someone else's work when you write a statement or discuss your own work in person. The *first* thing lots of artists say is that their work is a lot like another artist's, and that does a disservice to your own work—you are essentially promoting someone else's art instead of your own. Also, your work is being viewed in a subjective context that changes day to day, and the moods and dynamics of the committee vary.

"An artist's portfolio will be involved in every aspect of your career, whether it be going for a job, writing a publication, your Web site, your archives, exhibiting your work, or preparing for an interview. If you don't have good images, you can't accomplish any of these things properly. You have to spend time and money on this task. This is a record of your life! It's got to be excellent, not just good but excellent. The art can't just talk for itself. If you don't have a good image, you don't have good artwork in others' eyes. Some artists think the art itself should transcend the visual document, so the actual piece rises above the photo/image. This is such a crucial component that it can make or break your career because 90 percent of artists don't take this task seriously enough."

The following is an interview with Jason Goodman, who is a great example of an artist who has applied his creativity and marketing savvy to developing a unique, entrepreneurial career and a thriving artists' community.

INTERVIEW WITH JASON GOODMAN, EXECUTIVE DIRECTOR/ COFOUNDER OF 3RD WARD

3rd Ward is a member-based design center for creative professionals with two locations in Williamsburg, Brooklyn. 3rd Ward provides resources, opportunities, and a dynamic-

creative network to their members and the community at large. The space houses photo studios, a professional wood and metal shop, a digital media lab, shared and private office space, and a large interdisciplinary art education program. Throughout the year they also offer events and opportunities for artists. 3rd Ward was started in 2006, and by 2010, there was an annual income of roughly three million dollars.

How did 3rd Ward get started?

I originally thought I would be an architect or sculptor, but I began my career as a photo assistant and worked in construction and discovered that I enjoyed interior design work. I was working as a contractor for a developer in Brooklyn, and I'd told him about an idea I had to start an artists' design center. One day the developer approached me with an offer to let me take over the lease and renovate a semi-vacant warehouse and to transform it into an active arts space.

To raise money to renovate the space and start generating income, we started throwing giant warehouse parties (which were illegal!) for the first year and a half so we could raise cash. We even had fire breathers and bands. So Monday through Friday we had art/programming and then Saturday we hosted parties. This built buzz for 3rd Ward and put us on the map, so more members came. Now we don't do those parties but still host big events.

I didn't have a business plan when I started and learned how to make a spreadsheet pretty quick. And we had to think about how to make an industrial space interesting but functional for artists' work. We started with just a front desk person, then added a wood shop manager, and then a marketing director who taught us how to market 3rd Ward and reach people with a clear message. Later we hired a membership director, education director, a financial team, and a bookkeeper.

Can you tell us about your marketing message and how it's evolving?

In the early years of 3rd Ward the message was, "Hey, come make things here! We're a place where people come to make things!" but moving into the future, the message is going to be, "Hey, New York, here is the place where people make cool things, come hire them!" I want to provide a place to sell members' work and market their talents. They have furniture designers, emerging photographers. We want to focus on telling our members' stories, not just our story.

What are some things to consider when thinking about marketing yourself?

- What is your message?
- Who is your audience/who do you want the message to go to? Identify your core constituency; you can't please everybody.
- Who do you want to say it to?
- What's the method/chain you want to say it through?
- How much will it cost to get the message out?
- How much will you earn/sales after paying to get the message out?

What do you want people to know about 3rd Ward?

At 3rd Ward we obsess over our members' needs. We listen to what they say and watch what they do. We have eight hundred members, a hundred classes each quarter, and four to five thousand students take courses. It's a co-op funded by members' fees, not outside funders. 3rd Ward has seventeen full-time staff and employs freelance teachers, bartenders, musicians. The biggest surprise has been that the co-op is not just artists but a mix of designers and artists. We are a place where people come to make things. I think of 3rd Ward as my living sculpture. In addition to all the business and marketing management, I art direct, photo shoot, and curate gallery exhibits.

We encourage our readers to rethink what "success" means to them. Can you talk about success?

A failure can teach you just as much as success. Put it in perspective, be able to see failure as a part of the path to success. Take chances, don't see failures as mistakes. I think of 3rd Ward as a place to take risks. The key to success is to observe before you act. Stand back from yourself and adapt. See what everyone else is missing. Look at everything as a series of systems fueled by people's motivations. What is the system at hand, how it's creating relationships, be aware of factors like economic systems and who is putting that in place and what are their motivations? Example: the retail gallery system is fueled by a select few collector's motivations to exchange art/commodities. How can you look at the flaws in the system to expand people's consciousness about what it means to be a body on this planet? The person who is able to adapt and survive is the one who can come to the crucial information and make a decision fastest and put it into action quickest. This is a skill you can learn: what is really happening and what is the crucial thing at the center of it and how can I make it work?

Can you tell us about your bike program?

I'm a big bicycle advocate and give away a bike to every member. I design bikes, too, and by giving them away, I put more bikes on the street, giving a clear message about what 3rd Ward stands behind, and it's permanent marketing with cool kids riding their bikes all over Brooklyn. I'm currently designing a custom bike for people who make things to carry things on their bikes more easily.

What tips do you have for emerging artists?

- You have to keep a studio practice. Make it a practice. The day you stop having a studio is the day you stop being an artist. I strongly advise you don't work at home.
- Put together your own council of advisors made up of people you respect. Take them to dinner once a month. They might not always have the right answers, but they might have the right questions.
- Never, never quit. You might be right around the corner from success.
- Identify your core. You can't please everyone.
- Brancusi said, "Create like a God, command like a king, work like a slave."

❧16❧

Legal Resources, Contracts, and Gallery Relationships

This chapter is drawn from Tad Crawford's *Business and Legal Forms for Fine Artists,* Third Edition (Allworth Press, 2005), *Legal Guide for the Visual Artist,* Fifth Edition (Allworth Press, 2010), and *The Artist-Gallery Partnership* (Allworth Press, 2008). All material is reproduced with permission of the author.

> *Business art is the step that comes after Art. I started as a commercial artist, and I want to finish as a business artist. After I did the thing called "art," or whatever it's called, I went into business art. I wanted to be an Art Businessman or a Business Artist. Being good in business is the most fascinating kind of art. During the hippie era people put down the idea of business—they'd say, "Money is bad," and "Working is bad," but making money is art and working is art and good business is the best art.*
>
> —Andy Warhol,
> *The Philosophy of Andy Warhol:*
> *From A to B and Back*
> *Again*

ARTISTS AND THE LAW

Whether you agree with Andy Warhol or not, as an artist you must be capable of resolving business and legal issues. In this respect, a greater familiarity with art law and other sources of support will help the artist. Artists should never feel intimidated, helpless, or victimized. Legal and business considerations exist from the moment an artist conceives a work or receives an assignment. While no handbook can solve the unique problems of each artist, the artist's increased awareness of the general legal issues pertaining to art will aid in avoiding risks and gaining benefits that might otherwise pass unnoticed.

This chapter is designed to provide information with respect to the subject matter covered. The reader should review this material with the understanding that the publisher is not engaged in rendering legal, accounting, or other professional services. If legal advice or other expert assistance is required, the services of a competent attorney or professional person should be sought. While every attempt is made to provide accurate information, the author and publisher cannot be held accountable for any errors or omissions.

ARTISTS' GROUPS

Artists' groups provide a valuable support network. Many of the groups offer newsletters and other information services of value to their members. A few provide legal services, while others lobby for legislation favorable to artists. Health, life, and even automobile insurance are frequently offered at group rates. Some of the groups promote art by sponsoring shows, publishing books, or maintaining slide registries of art.

Within the boundaries of the antitrust laws, certain groups publish surveys to help members determine fair pricing practices. A number of the groups have codes of ethics, which dictate standards for both business and art practices in the profession.

Joining an artists' group can be an important step for an artist in terms of protecting rights and advancing his or her professional prestige.

LAWYERS FOR THE ARTS

The search for a lawyer is often time-consuming and disheartening. Not only are fees high, but many lawyers are not knowledgeable about the issues encountered by artists. Standard techniques for finding a lawyer include asking a friend who consulted a lawyer for a similar problem, calling a local bar association's referral service, or going to a legal clinic. All of these approaches have merits, but today the artist may be able to locate a knowledgeable lawyer with far greater precision.

The very definition of an area of the law as "art law" is an encouraging sign for the expertise lawyers will bring to the artist's problems. The literature and educational programs for lawyers have vastly increased. Many law schools now offer art-law courses, and bar associations are paying greater attention to art and the artist. The selected bibliography shows how many art-law books are now available for lawyers.

Equally encouraging are the lawyers across the country volunteering to help needy artists. Both volunteer lawyers' groups and artists' groups, several of which maintain rosters of attorneys who will help members at a reduced fee, are good resources to use when seeking a lawyer with art-law expertise. Such referrals may result in finding lawyers who either do not charge or work at more affordable rates. Up-to-date information on the volunteer lawyers closest to a specific location can be obtained from one of the following established groups:

CALIFORNIA
California Lawyers for the Arts (*www.calawyersforthearts.org*)
Fort Mason Center
Building C, Room 255
San Francisco, CA 94123
(415) 775-7200
cla@calawyersforthearts.org
or
1641 18th Street
Santa Monica, CA 90404
(310) 998-5590
UserCLA@aol.com

ILLINOIS
Lawyers for the Creative Arts (*www.law-arts.org/*)
213 West Institute Place, Suite 411
Chicago, IL 60610
(312) 649-4111

NEW YORK
Volunteer Lawyers for the Arts (*www.vlany.org/*)
1 East 53rd Street
New York, NY 10022
(212) 319-2787

THE VISUAL ARTISTS INFORMATION HOTLINE

The New York Foundation for the Arts operates a toll-free information hotline to help individual fine artists in almost any discipline. The hotline number is 1-800-232-2789. The hotline operates Monday through Friday, from 3:00 to 5:00 PM eastern standard time. Artists may also e-mail their questions to source@nyfa.org.

The hotline is primarily a referral service. The staff provides the details of a wide variety of programs and services that are available to artists. The hotline does not assist nonprofit groups.

Among the topics on which the hotline offers referral information are grants, fellowships, scholarships, workshops, slide registries, emergency funds, health and safety, insurance, artist communities, international opportunities, public art, studio space (for artists in Manhattan), legal information, job information, publications, exhibitions, competitions, how to apply for grants, and how to market art.

BASIC CONTRACTUAL TERMS FOR THE SALE OF ORIGINAL ART

If a purchaser decides to purchase a work, the artist should at least insist on a simple written contract in a form such as the Model Bill of Sale on page 209. It can be a brief form stating no more than the artist's name, the purchaser's name,

the date, the title and description of the piece sold, the price, the sales tax due, if any, and the total amount payable. By including this basic information, the bill of sale is useful as a record of the transaction in at least two ways. First, it helps keep track of sales for income tax purposes, since all the prices paid are recorded. The artist need only transfer the amounts from the bills of sale to the ledger for income. Second, it can help in maintaining an overall inventory of work and keeping track of who owns the artist's work at any given moment. Again, the artist will want to transfer the information from the bill of sale to a ledger, file, or slide book in which all the works created are recorded.

The bill of sale can also be expanded to deal with various contingencies that may occur in a given transaction. These may arise from the nature of the work, the manner of payment, or the artist's desire to enforce certain standards of treatment for the work after sale. Such additional clauses can be added under Terms of Sale.

For example, the artist is the owner of copyright from the moment of creation of a work. However, the artist may still wish to express this in the bill of sale so the purchaser has no misunderstanding about his or her right to make reproductions. At the same time, the artist might want to permit limited reproductions that fall into the category of "fair use." Such a provision might read as follows:

> The Artist hereby expressly reserves all rights whatsoever to copy or reproduce the work to the Artist, his or her heirs, executors, administrators, and assigns. The Artist has placed copyright notice in his or her name on the Work. The Artist shall not unreasonably refuse permission to reproduce the Work for catalogs and other publicity purposes incidental to public exhibition of the Work, provided all such reproductions bear appropriately placed copyright notice in a form identical to that appearing on the Work.

The risk of loss passes to the purchaser on delivery of the work as discussed on pages 208-209. If the purchaser is to pick up the work at the artist's studio, the risk of loss passes to the purchaser at such time as the purchaser could reasonably have been expected to pick up the work. The bill of sale can alter the time that risk of loss will pass to the purchaser. Of course, the passage of the risk of loss from one party to another should, ideally, be determined in view of the insurance coverage that each party has. This clause might read: "The risk of loss shall pass to the Purchaser on the _____ [specify when the risk of loss shall pass, such as 'on the date hereof']."

The bill of sale might include acknowledgment of receipt of the work by the purchaser and receipt of payment by the artist if these events occurred.

It is not uncommon for purchasers to make installment payments in order to purchase a work. Such a clause might provide: "The price shall be paid in _____ equal monthly installments, commencing on the _____ day of _____, 20_____, and ending on the _____ day of _____, 20_____."

If installment payments are used, the artist should consider retaining a security interest in the work until full payment has been made. Such a security interest

would require the filling out and filing of Uniform Commercial Code Form 1 with the Secretary of State or local agency for filing, such as the county clerk. This would protect the artist's interest in the work from other creditors of the buyer until such time as the artist has been paid in full. Form 1 is available at any stationery store that carries legal forms. It is easy to fill out, since it requires a limited amount of information. This includes the name and address of the debtor (the buyer is the debtor until all payments are made), the name and address of the secured party (who is the artist), and a description of the art that is covered. When signed by the artist and filed with the proper agency, the artist has precedence over any other creditor who might seek to assert a claim over the art or proceeds from the sale of the art. In general, the debtor must also sign Form 1 unless a separate security agreement has already been signed by the debtor.

Provisions relating to the integrity of the work, nondestruction, restoration, a right to exhibit, and an art resale proceeds right are discussed in relation to the Projansky contract.

Instead of using a bill of sale, the terms of sale could also be set forth in a brief letter to the purchaser. The artist would sign the letter and the purchaser would sign beneath the words "Agreed to."

<div align="center">

Model Bill of Sale
Artist's Letterhead

</div>

Date: _____

Purchaser:
(Name)
(Address)

Description of work: _____
Price: _____
Sales tax (if applicable): _____
Balance due: _____
Terms of sale: _____

Artist

Purchaser

TAXES: INCOME AND EXPENSES

The artist's professional income—for example, from sales of work, commissions, copyright royalties, and wages—is taxed as ordinary income by the federal

government and by the state and city where the artist lives, if such a state or city has an income tax. The business expenses of being an artist, however, are deductible and reduce the income that will be taxed. Both income, as gross receipts, and expenses are entered on Schedule C, Profit or (Loss) from Business or Profession, which is attached to Form 1040. A sample Schedule C is on page 211.

The artist should also check whether any state and city sales taxes have to be collected. If they do, the artist may be entitled to a resale number that permits the purchase of materials and supplies without payment of any sales tax. The artist must also determine whether any other state or local taxes, such as New York City's unincorporated business tax and commercial rent or occupancy tax, must be paid in addition to the personal income tax. These taxes vary with each state and city, so guidance must be obtained in the artist's own locality.

General guides to federal taxation are IRS Publication 17, *Your Federal Income Tax*, for individuals and IRS Publication 334, *Tax Guide for Small Businesses*, for businesses. These, and other IRS publications mentioned in the income tax chapters of *Legal Guide*, can all be obtained free of charge from any IRS office or downloaded from the IRS Web site at *www.irs.gov*. The IRS Web site also allows artists to download forms, perform limited research on tax questions, file their tax forms electronically, and check the status of their refunds online. The IRS also has a Tele-Tax service that allow artists to use the telephone to check the status of a refund or listen to recorded tax information on a number of subjects. The IRS will also give free tax advice by telephone, as detailed in its *Guide to Free Tax Services*. Another helpful IRS guide is *Your Rights as a Taxpayer*, which explains the taxpayer's rights at each step in the tax process.

The artist should keep in mind, however, that these publications and tapes represent the views of the IRS and are sometimes inconsistent with precedents already established by the courts. The artist may prefer to purchase a privately published guide, such as *J.K. Lasser's Your Income Tax*, which is updated each year. Lasser has also established an Internet presence by which artists can access a wide range of tax literature and advice, after paying a subscription fee of approximately $20 per year (*www.jklasser.com*).

The tax laws are changed frequently. Lawmakers' addiction to almost annual tax-code tinkering requires artists to consult a tax guide that is updated annually.

RECORD KEEPING

Good record keeping is at the heart of any system to make the filling out of tax returns easier. All income and expenses arising from the profession of being an artist should be promptly recorded in a ledger, database, or spreadsheet, regularly used for that purpose. The entries should give specific information as to dates, sources, purposes, and other relevant data, all supported by checks, bills, and receipts whenever possible. It is advisable to maintain business checking and saving accounts through which all professional income and expenses are channeled, separate from the artist's personal accounts. IRS Publications 552, *Recordkeeping for Individuals* and 583, *Taxpayers Starting a Business*, offer details as to the permanent,

accurate, and complete records required. There are many accounting programs, such as Quicken, that can help with the task of record keeping.

A good ledger or spreadsheet might be set up in the following way. The first column is for the date, the second column shows the nature of the income or expense, the third column specifies the check number and the receipt number, the fourth column shows the amount of income, the fifth column shows the amount of expenses, and the sixth and subsequent columns list different expenses based on the artist's special needs. This means that each expense is entered twice, once in the expense column and again under the particular expense category into which it falls. This will be helpful when it comes to filling out Schedule C, Profit or (Loss) from Business or Profession, which is attached to Form 1040. If the artist's expense categories can be made to fit easily into the expense categories shown on Schedule C, the task will be even easier:

1 Date 2 Description 3 Check/Receipt 4 Income 5 Expense 6-End Expense Categories.

SCHEDULE C-EZ

While Schedule C is not a difficult form to complete, the IRS also makes available Schedule C-EZ. This is a simplified form which can be used if the artist meets a number of requirements: (1) the cash method of accounting must be used; (2) gross receipts are $25,000 or less; (3) business expenses are $5,000 or less; (4) there is no inventory at any time during the tax year; (5) there is only one sole proprietorship; (6) there is no home office expense; (7) there is no depreciation to be reported on Form 4562; (8) the business has no prior year suspended passive activity losses; and (9) there were no employees that year. That's a lot of requirements, but some artists—especially those starting out—may be able to use Schedule C-EZ.

FORMS OF DOING BUSINESS

Depending on the success of the artist, various forms of doing business might be considered. There may be both business and tax advantages to conducting the artist's business in the form of a corporation or partnership, but there may be disadvantages as well.

Generally, the non-tax advantages of incorporation are limited liability for the stockholders, centralized management, access to capital, transferability of ownership, and continuity of the business. For the artist, the most important of these non-tax advantages will probably be limited liability. This means that a judgment in a lawsuit will affect only the assets of the corporation, not the personal assets of the artist. Limited liability is quite significant when the work locale, machinery, chemicals, or even artwork are potentially hazardous. The attribute of limited liability applies to all corporations—the regular corporation and the Subchapter S corporation. The tax treatment, however, differs significantly between the two types of corporations.

For regular corporations, net corporate income is taxed at 15 percent on net income up to $50,000; 25 percent from $50,000 to $75,000; 34 percent from $75,000 to $100,000; 39 percent from $100,000 to $335,000; 34 percent from $335,000 to $10,000,000; 35 percent from $10,000,000 to $15,000,000; 38 percent from $15,000,000 to $18,333,333; and 35 percent over $18,333,333. Usually the tax on the corporation can be substantially avoided by the payment of a salary to the artist, which creates a deduction for the corporation. Such an arrangement can effectively average the artist's income from year to year.

The Subchapter S corporation is not taxed at all, but the income is credited directly to the accounts of the stockholders and they are taxed as individuals. Both types of corporations are less likely to be audited than an individual proprietor. It may also be easier to choose a fiscal year (any tax year other than the calendar year) and, particularly in the case of a regular corporation, shift some of the artist's income into the next tax year. Some of the disadvantages of incorporation are additional record keeping, meetings, and paperwork, as well as significant expenses both for the initial incorporation and for any ultimate dissolution.

A partnership is an agreement between two or more persons to join together as co-owners of a business in pursuit of profit. Partnerships are not subject to the income tax, but the individual partners are taxable on their share of the partnership income. Partners are personally liable for obligations incurred on behalf of the partnership by any of the partners. A partnership offers to the artist an opportunity to combine with investors under an agreement in which the investors may gain tax advantages by being allocated a greater share of partnership losses. A variation of the usual partnership is the "limited partnership," in which passive investors have limited liability (but the artist, running the business actively, is still personally liable). Another variation is the "joint venture," which can be described simply as a partnership created for a single business venture.

Many states have legislated into existence a new form of business entity called a "limited liability company," which combines the corporate advantage of limited liability for its owners while still being taxed for federal income tax purposes as a partnership. The limited liability company offers great flexibility in terms of the mode of ownership and the capital structure of the company as well as what corporate formalities the company must observe.

In general, the tax law requires that a partnership, an S corporation, or a personal service corporation (which is a corporation whose principal activity is the performance of personal services by an employee-owner) use a calendar tax year, unless there is a business purpose for using a fiscal year.

The artist contemplating doing business as either a corporation, partnership, or limited liability company should consult a lawyer for advice based on the artist's unique needs.

MORAL RIGHTS

The Visual Artists Rights Act (VARA), a landmark legislation creating moral rights for artists in the United States, was enacted on December 1, 1990, as an

amendment to the copyright law and took effect on June 1, 1991. Copyright, the power to control reproduction and other uses of a work, is a property right. Moral rights are best described as rights of personality. Even if the artist has sold a work and the accompanying copyright, the artist would still retain rights of personality.

Prior to the enactment of VARA, the protections for American artists had been limited and often unsatisfactory. While some legal commentators argued that American laws relating to unfair competition, trademarks, right to privacy, protection against defamation, right to publicity, patents, and copyrights amounted to a satisfactory equivalent of moral rights, the better view was that this mélange did not at all approach the protections offered to creative people and their work under specially designed moral-rights provisions. Many artists' groups recognized moral rights as an important issue and urged the enactment of legislation to guarantee this protection. A number of states responded by enacting pioneer moral rights laws, a trend that helped develop momentum for the enactment of VARA. This chapter will explore the provisions of VARA, compare it to foreign and state laws, and then review other legal theories that protect artists.

THE VISUAL ARTISTS RIGHTS ACT

Drafted and shepherded to passage by Senator Edward Kennedy, VARA gives a narrow definition of a work of visual art as "a painting, drawing, print or sculpture." VARA covers unique works and consecutively numbered limited editions of two hundred or fewer copies of either prints or sculptures, as long as the artist has done the numbering and signed the edition (or in the case of sculpture, placed another identifying mark of the artist on the work). The limited edition provision also applies to "still photographic images" as long as an edition of two hundred copies or fewer is consecutively numbered and signed by the artist.

This narrow definition limits the effectiveness of VARA. Explicitly excluded from protection under VARA are posters, applied art, motion pictures, audiovisual works, books, magazines, databases, electronic information services, electronic publications, merchandising items, packaging materials, any work made for hire, and any work which is not copyrightable. While VARA protects traditional fine art, it appears that it will have no impact at all on commercial art, which is created for the purpose of reproduction. Of course, one can imagine that a unique painting might be altered before reproduction, in which case the provisions of VARA might apply even though the intention in creating the art was to reproduce it in large quantities.

VARA gives an artist the right to claim authorship of his or her work, to prevent the use of his or her name on the works of others, and to prevent use of his or her name on mutilated or distorted versions of his or her own work, if the changes would injure his or her honor or reputation. In addition, the artist has the right to prevent the mutilation or distortion itself if it will damage the artist's reputation.

If the artist wants to prevent the destruction of a work, it must be of "recognized stature." This test for recognized stature is like that under the California law,

which is discussed later in this chapter. However, the statute wisely gives artists rights in their own work regardless of recognized stature and reserves the stature test for works that should be preserved for the culture. As cases are decided under VARA, it will be interesting to see where the boundary is drawn to divide works considered to be of recognized stature from those which are not.

The moral rights of the artist cannot be transferred. However, VARA does allow the artist to waive these rights in a written instrument signed by the artist. The wisdom of allowing waivers is certainly open to question in view of the disparity of bargaining strength so often present when artists deal with larger entities. The written instrument of waiver must identify the work and the uses to which the waiver applies, and the waiver is limited to the work and uses specified. For a work created by more than one artist, any of the joint artists has the power to waive the rights for all the artists. The waiver of moral rights does not transfer any right of ownership in the physical work or copies of that work. Nor does the sale of a physical work, a copyright, or any exclusive right of copyright, transfer the artist's moral rights, which must be exercised by the artist.

For art incorporated in or made part of buildings, VARA seeks to balance the rights of the building owner against those of the artist. If the art would be destroyed or altered by its removal, then the artist has a right to prevent such destruction or modification unless either (1) the art was installed in the building before the effective date of the law, or (2) the artist and owner signed a written instrument in which they specified that the work may be subject to destruction or modification due to removal. On the other hand, if work can be removed without destruction or mutilation, the artist shall have the right to prevent mutilation or destruction unless either the owner makes a "diligent, good faith attempt" to notify the artist of the owner's intended action or, if the owner succeeds in notifying the artist, the artist does not either remove the work or pay for its removal within 90 days of receiving such notice. Of course, an artist objecting to the destruction of a work incorporated in a building would have to show that the work was of recognized stature.

VARA exempts from its coverage changes in a work of art due to the passage of time, the inherent nature of the work's materials, conservation, or public display.

The term of protection for works created after the effective date of VARA is the artist's life. This certainly invites the criticism that the term should have been the same as the term of copyright protection. For works created before VARA's effective date, the artist will have moral rights in works to which he or she holds title, and such moral rights shall last as long as the copyright in the work. This means that works created prior to June 1, 1991, and in which the artist holds title will have a longer term of moral rights protection (the artist's life plus seventy years) than those works created on or after June 1, 1991. The term of moral rights protection when a work is created jointly by more than one artist is the life of the last surviving artist. All moral rights run to the end of the calendar year in which they would expire.

VARA also requires that a Visual Arts Registry be created in the Copyright Office. The Copyright Office regulations (section 201.25) allow either an artist

or building owner to give and update relevant information with respect to art incorporated in buildings, such as the name and address of the artist or owner, the nature of the art (including documenting photographs), identification of the building, contracts respecting the art, and any efforts by the owner to give notice regarding removal of the art. The Copyright Office does not provide a form for giving such information. The fee is $105 for one title and an additional $30 for each group of not more than ten titles.

The enactment of VARA at least extends to visual artists, if not other creators, rights similar to those contained in the Berne Copyright Convention, which provides that "the author shall have the right to claim authorship of the work and to object to any distortion, mutilation or other modification of, or other derogatory action in relation to, the said work, which would be prejudicial to his honor or reputation."

COPYRIGHT: GAINING AND KEEPING PROTECTION

Copyright is the source of all the reproduction rights that an artist sells in an artwork.

An important legal resource for any artist is the Copyright Office's official Web site, located at *www.copyright.gov*. Artists using any Internet-enabled computer equipped with Adobe Acrobat Reader can view copyright forms, circulars, fact sheets, and other informative publications.

The fastest way to acquire these materials is to download them from the Copyright Office's Web site. They can also be requested by mailing the Copyright Office, Library of Congress, Washington, D.C. 20559. The Copyright Information Kit includes the Copyright Office's regulations, the copyright application forms, and circulars explaining a great deal about copyright and the operation of the Copyright Office. Free publications that help give an overview include Circular 1, "Copyright Basics," and Circular 2, "Publications on Copyright." For artists wishing to purchase a copy of the complete copyright law, it can be ordered as Circular 92 for $28, or downloaded at no cost.

The Copyright Office will supply copies of any application form free of charge. In addition to being available on the Internet at *www.copyright.gov/forms/*, the Forms and Publications Hotline has been established by the Copyright Office to expedite requests for registration forms. This twenty-four-hour resource can be reached at (202) 707-9100. Artists may also request forms be mailed to them using the Copyright Office's "Forms by Mail" system, at *www.copyright.gov/forms/formrequest.html*.

WHAT IS COPYRIGHTABLE?

Pictorial, graphic, and sculptural works are copyrightable. The law includes in these categories such items as "two-dimensional and three-dimensional works of fine, graphic and applied art, photographs, prints and art reproductions, maps, globes, charts, models, and technical drawings, including architectural plans."

Audiovisual works form another category of copyrightable work and cover "works that consist of a series of related images which are intrinsically intended to be shown by the use of machines or devices such as projectors, viewers, or electronic equipment, together with accompanying sounds." The form of an audiovisual work, be it a tape, film, or set of related slides intended to be shown together, doesn't matter as long as the work meets the definition just given. A motion picture is a distinct type of audiovisual work that also imparts an impression of motion, something the other audiovisual works don't have to do. The law makes clear that the soundtrack is to be copyrighted as part of the audiovisual work and not as a separate sound recording.

Work must be original and creative to be copyrightable. Originality simply means that the artist created the work and did not copy it from someone else. If, by some incredible coincidence, two artists independently created an identical work, each work would be original and copyrightable. Creative means that the work has some minimal aesthetic qualities. A child's painting, for example, could meet this standard. All the work of a professional artist should definitely be copyrightable.

While part of a given artist's work may infringe upon someone else's copyrighted work, the artist's own creative contributions may still be protected. For example, if an artist publishes a group of drawings as a book and fails to get permission to use one copyrighted drawing, the rest of the book would still be copyrightable. On the other hand, if someone were simply copying one film from another copyrighted film without permission, the entire new film would be an infringement and would not be copyrightable. If new elements are added to a work in the public domain, the new work would definitely be copyrightable. However, the copyright would only protect the new elements and not the original work that was in the public domain.

Ideas, titles, names, and short phrases are usually not copyrightable because they lack a sufficient amount of expression. Likewise, style is not copyrightable, but specific pieces of art created as the expression of a style are copyrightable. Utilitarian objects are not copyrightable, but a utilitarian object incorporating an artistic motif, such as a lamp base in the form of a statue, can be copyrighted to protect the artistic material. Basic geometric shapes, such as squares and circles, are not copyrightable, but artistic combinations of these shapes can be copyrighted.

Typeface designs are also excluded from being copyrightable, but computer programs are copyrightable even if the end result of using them involves uncopyrightable typefaces. Calligraphy may be copyrightable insofar as a character is embellished into an artwork, although the Copyright Office has not issued clear guidelines on this. Calligraphy would not be copyrightable if merely expressed in the form of a guide such as an alphabet.

Computer programs and the visual images created through the use of computers are both copyrightable, unless the image itself is uncopyrightable (for example, because it is a typeface or a basic geometric shape) in which case the computer program is still copyrightable.

If pictorial images on computer and video screens are copyrightable, what about an image composed solely of text? Is this copyrightable? This question raises the larger issue of whether the design of text in general is copyrightable. Or, for that matter, is the design of a book or magazine cover copyrightable if no picture is used? Typefaces are not copyrightable, but can an arrangement of uncopyrightable type elements create a copyrightable cover?

This is a brief introduction to copyright issues and laws do change. If you are interested in learning more, utilize the resources listed in this section for more information.

ARTIST-GALLERY PARTNERSHIPS AND CONSIGNMENTS

Before going into the kinds of contractual arrangements that artists and galleries can make, it may be a good idea to look first at the law as it relates to the consignment of art.

In this country, business dealings in general, and the consignment relationship in particular, are governed primarily by case law and the Uniform Commercial Code (the UCC), a comprehensive statute that has been enacted by every state (except that Louisiana did not enact Article 2). The function of the law is to establish legal parameters covering a range of situations that may arise in commerce. In the absence of a written contract between the parties involved, it details the obligations and responsibilities of each and sets certain guidelines to be followed in a court of law in the event of a dispute. For an extensive discussion of these legal issues, see *The Artist-Gallery Partnership* by Tad Crawford and Susan Mellon.

Artworks are commonly sold on consignment. In such an arrangement, the artist entrusts the artworks to a gallery (whether a cooperative, commercial, or nonprofit gallery, an art consultant, a retail store, or another outlet) and is paid a portion of the price the gallery receives upon the sale of the artwork. Both the gallery and the artist can benefit from this relationship. The artist, who is in the business of creating art, is not forced to go into the business of marketing it. By selling through a gallery, the artist avoids the expenses and the expenditure of time required in maintaining a retail shop. Artists promoted actively by established dealers stand to gain wider exposure than is ordinarily possible as a result of direct studio contacts. Craft artists who normally sell through fairs and wholesale markets may find that consignment in gallery outlets offers a special opportunity to create exhibition-type pieces for display to an art-conscious audience in a prestigious setting that tends to stimulate sales. Creative expression can be an intensely personal statement, and many artists prefer dealing through galleries, rather than promoting their own work.

For the gallery, one clear benefit of consignment is the reduction in capital required: less of the gallery's funds are tied up in inventory. As a result, the gallery can afford the risk of showing unique kinds of artwork for which no sure market exists, and it can introduce promising young artists to the buying public without a substantial financial investment. A gallery dealing mainly in consignment can spend a considerable sum on overhead expenses, yet still maintain a large stock

of artworks and vary its displays frequently, factors which certainly enhance the likelihood of sales. Each party in the consignment relationship makes a serious commitment to the other. Consigning artists give up a measure of control over their creations, entrusting them to an agent whose business is the marketing of artworks. Artists depend on galleries to promote them effectively, to care for the artworks properly, and to keep the works on public display. If consigned artworks do sell, the artist accepts that proceeds will be less than those from a direct studio sale.

The gallery taking artworks on consignment is making as strong a commitment. Although consignment limits its financial risks, the gallery depends on the sale of artworks for its survival. With limited space, the gallery is relying on the marketability of the artworks on hand and on receiving a continuing supply of works from the artists it represents.

As agent for its artists, the gallery has a legal obligation to those artists and a responsibility for the safekeeping of the artworks in its possession.

Because of their interdependence, gallery and artist must depend on the integrity and high standards of professionalism of one another. Before entering into a consignment arrangement, therefore, the parties should first evaluate one another carefully, for the relationship between them should not be a matter of blind faith. Although in practice artists and galleries frequently begin their professional association in an extremely casual manner, it is far better for both to know as much as possible about the reputation for quality, reliability, honesty, and good will of their potential business partner.

The gallery might ask about the artist's training and professional background, finding out how long and how extensively the artist has been in business. It should know where the artist's work has been shown and through which other galleries the artist has been and is currently represented. The gallery should ask about the general scope of the artist's production and the level of output that can be expected in the future, as well as the artist's typical price range. If the artist is interested in accepting special orders or commission work through the gallery, references of past performance are well worth checking; the gallery will be staking its reputation on the artist, relying on the artist's ability to deliver work of consistently acceptable quality in a timely manner. The gallery, accountable to its clients, must look for artists who act in a businesslike manner while creating art of quality.

The artist should evaluate the gallery with equal care. It can be particularly helpful to check with other artists who are familiar with the gallery, since news of any problem tends to travel rapidly. A look around the gallery is revealing in itself. Are the exhibitions attractively mounted and changed at regular intervals? Is there an alarm system or other protective device in evidence? Are the artworks treated carefully? Are the objects on display kept dusted or polished, and are they identified with the artists' names? Are the artworks compatible aesthetically with one's own works? The type of client the gallery attracts and the kind of market it reaches will be significant to the artist, as will be the manner in which the gallery relates to its clients and to art in general.

The artist should certainly ask whether the gallery deals only in consigned works. If a gallery owns a sizeable proportion of its stock outright, will it use every effort to promote the work of consigning artists, especially if the success of these efforts might mean one less sale from its own inventory? It is reasonable, too, for the artist to ask how long the gallery has been in operation, to confirm that the business is reasonably sound fiscally, and to ask something about the background and training of the key personnel to gain a clear idea of their professional qualifications. Once both parties decide to proceed, it is important that they discuss the arrangement fully, outlining procedures and responsibilities. A written receipt for those works accepted on consignment, with a full description of the works, their retail price, the gallery's commission, its terms of payment, a statement that the work is on consignment, and a statement that the gallery assumes full responsibility for the artworks in its custody, is the absolute minimum written record that an artist should accept. A much more detailed contract is preferable, however, to provide a clear-cut record of the terms to which the parties have agreed. For this reason, the heart of this book is devoted to a provision-by-provision explanation of a model contract suitable for use—the Standard Art Consignment Agreement. This discussion is designed to point out many aspects of consignment of which artist and gallery should be aware.

Having once entered into the consignment relationship, the artist and the gallery should work toward strengthening their professional association. They should continue to communicate openly and frankly with each other. It is the responsibility of the artist to provide the gallery with useful information about the artworks, including all materials used and any special care requirements. The artist should also feel free to suggest to the gallery how to display the consigned artworks to advantage, although of course the final decision on display of the artworks is the gallery's. The artist should ask the gallery what its clients say about the work. Such comments can provide constructive criticism about the salability of the artworks that the artist would not otherwise hear. The gallery, in constant communication with potential buyers, may be able to pass on useful suggestions to the artist.

In the event of a disagreement, which is perfectly normal in any close and ongoing relationship, the dispute should be aired promptly and a solution sought without delay to minimize the effects of misunderstandings. By a willingness to share concerns and to work out differences, a truly amicable relationship can be nurtured. After all, people who create and those who sell art are both in business, but their connection to art is usually far more than just a financial one; it is aesthetic and often deeply personal. If, at the same time as the business relationship between gallery and artist develops, a friendship based on mutual respect can grow, both parties benefit.

FOR FURTHER LEGAL INFORMATION

The artist who conducts his or her business affairs with clarity and confidence gains not only a better livelihood but also peace of mind. It is for those artists who

seek self-reliance, confidence, and success that *Legal Guide for the Visual Artist* by Tad Crawford will be most valuable. It opens doors to those who seek to better their business practices, increase their incomes, and protect their art. If you wish to learn more about the issues we covered in this chapter, the *Legal Guide* could be a valuable resource.

Further Reading

Crawford, Tad. *Legal Guide for the Visual Artist.* 5th edition. **New York: Allworth Press, 2010.**

Crawford, Tad. *Business and Legal Forms for Fine Artists.* 3rd edition. **New York: Allworth Press, 2005.**

Crawford, Tad and Susan Mellon. *The Artist-Gallery Partnership.* 3rd edition. **New York: Allworth Press, 2008.**

❧17❧

Fund-raising for Artists
by Kay Takeda

K ay Takeda has been the Lower Manhattan Cultural Council Director of Grants and Services since 2005. Previously, she served as program manager of the Advised Funds & Regranting division at Arts International and as assistant director of the Newhouse Center for Contemporary Art. She serves on the boards of Goliath Visual Space and Trajal Harrell Dance Style, and enjoys speaking and writing on professional topics.

THE FUNDING ECOSYSTEM: WHAT YOU NEED TO KNOW BEFORE YOU START FUND-RAISING

What you don't know can drive you crazy. This is my rule of thumb when trying to explain certain systems and professional practices in the arts field—in particular, fund-raising. There are so many kinds of funders out there, so many requirements and formats to sort through, that it's easy to become confused and distracted.

It might be helpful to imagine the funding world as an ecosystem: like a rainforest or a coral reef. There are many different kinds of funders or donors in the United States, from individuals and small family foundations supporting the causes that personally move them, to government agencies supporting arts projects in local communities, to national funders who help sustain the activities of institutions such as the Museum of Modern Art or of individuals such as MacArthur "geniuses." In the art world, we need all of these funders, working together and complementing one another, in order for the whole community to survive and grow.

Different grants and resources will make sense for you for different projects and at different stages of your career. Therefore, it is an ongoing process to identify the right resources for your current needs and goals. Try not to be overwhelmed, thinking you must apply for every resource that you know about: fund-raising is

time-consuming. It can be worth it, but only if you take a thoughtful approach and apply only for those resources that make the most sense. In forest terms: start with the lowest-hanging fruit.

My goal in this chapter is to demystify the fund-raising process and to help you better navigate the landscape of available funding resources —and as a result, save valuable time and effort.

THE LANDSCAPE: TYPES OF FUNDERS

Arts Service Organizations

Think of these as a friendly face in the crowd. As an artist, especially one just out of school, nonprofit arts service organizations are the best place to start to gather information and advice on fund-raising as well as other aspects of your professional practice. There are hundreds of arts service organizations dedicated in some way to helping artists, usually through a specific set of programs and resources.

One of these resources may be grants, or "regrants," meaning an organization raised one large block of money from a funder, such as a government agency or foundation, and is "regranting" it in smaller amounts to artists and/or arts organizations for a certain purpose. Arts service organizations often try to make their programs accessible to artists, offering grant application seminars or one-on-one assistance to help explain the application process.

Government Agencies: Federal, Regional, State, Local

Since government agencies operate on taxpayer money, and you pay taxes, it's important to know how your tax dollars are used to support the arts. Who are our government funders?

- On the federal level, the National Endowment for the Arts provides direct grants to arts organizations across the country. It also allocates a substantial portion of its budget each year to regional and state arts agencies for local support.

- On the regional level, six nonprofit arts service organizations regrant federal dollars: the New England Foundation for the Arts, MidAtlantic Arts Foundation, South Arts, Arts Midwest, Mid-America Arts Alliance, and Western States Arts Federation. Each of these organizations offers different regrant programs and resources, so check with your regional to see if their grants pertain to you.

- Each state has a designated arts agency. State arts agency budgets and programs vary widely. You can identify state arts agencies and access funding and policy information across states through the National Assembly of State Arts Agencies (NASAA).

- On the local level, check to see how your city or county supports its arts community—not only through grants but through artist-friendly zoning, tax credits, and other special initiatives.

- If you live in a large city, there may be even more local sources of support available through nonprofit arts service organizations with a neighborhood focus.

A significant portion of government grant dollars, particularly at state and local levels, are distributed with the larger goals of serving the public good and reaching a wide range of communities. These goals are often articulated in the eligibility and evaluation processes for government art grants. Read guidelines carefully and consider whether the goals of your project are in line with the goals of the program before you apply.

If your current goal is to have your work shown by a private gallery to generate sales and boost your visibility, this may not be the right project for a government grant, since the goal is primarily personal: the professional advancement of the artist. Such a project might be seen as having limited reach or impact within a larger community or the public.

A public sculpture, a community mural residency, or a hands-on videomaking workshop and screening, for example, might be a stronger fit for government project funding. Such projects allow the artist's work to be shared with a wide range of people and to engage them in different ways—as viewers, creators, collaborators or learners.

These examples are not absolutes. If you think your project is a match, apply. Then make sure to provide information on the public or community impact of your work in your application (who will experience it and benefit from it). Expand the dialogue beyond how you will advance your own artistic goals or practice.

Private Sector Support: Foundations, Corporations, Individual Foundations

Many types of foundations support the arts, from small family foundations, to corporate philanthropies that make contributions in areas related to their business, to multimillion-dollar foundations that were started by individuals or families but now run in an autonomous way, like the Ford Foundation or the Andy Warhol Foundation for the Visual Arts.

In the United States, foundations constitute the lion's share of charitable giving. To give you a sense of scale, 2007 statistics from the Foundation Center (it takes a couple of years for everyone to file this information) show approximately 75,000 foundations in the U.S. donating close to $44 billion. Of the $24 billion awarded by the top 1,339 foundations, arts funding accounted for 11 percent of dollars (around $3 billion). Compare that with U.S. government funding at the national level: the NEA budget in 2007 was $124.5 million.

Why so many foundations? The U.S. tax system offers financial incentives in the form of tax deductions to individuals and corporations that make charitable donations. A private or philanthropic foundation is one structure used to house and disburse funds dedicated for charitable giving. Government incentives for

private sector donations are what make the U.S. philanthropic model unique. Most other countries provide arts support primarily through government funding that, fortunately for them, far exceeds our national spending on the arts.

Corporate Support: Philanthropy vs. Sponsorship

Corporate support comes in two ways: company-sponsored foundations and direct corporate giving. They operate very differently, so it's important to know the difference.

Funding can be made through a **company-sponsored foundation** that is a separate entity from the parent company, with defined areas of giving and designated staff in charge of designing and managing their giving programs. The direct relationship with the company may mean that corporate staff members are involved in funding decisions or that giving will focus on areas related to the company's interests—for example, in communities where the company does business. However, it still works like a foundation and awards grants and related support.

Direct corporate giving, on the other hand, is provided by the company itself and is often treated as a business expense, such as a marketing cost, rather than a tax-deductible contribution. In this case, marketing, PR, or other company staff members will handle the contribution. Why? Because the corporation has a business-related reason for its contribution.

The most commonly understood form of direct corporate giving is **corporate sponsorship**. When a corporation acts as a "sponsor," they give money and/or free goods and services to support a project, but in return, they expect their company to be prominently and publicly recognized for it. Sponsorship decisions are linked to the potential positive exposure generated for the company by association with the project and therefore depend upon the project's reputation, visibility, and audience reach. For this reason, many nonprofit organizations seeking sponsorship create "packages" that clearly state the level of visibility and recognition a company will receive in exchange for a contribution of a certain dollar amount.

For individual artists, corporate sponsorship often takes the form of a more modest contribution that might be in goods or services, rather than cash. One common example is a local brewery donating beverages for an exhibition's opening reception, or a local florist donating a few arrangements for an event, hoping to attract new business.

Individual Donors

Don't forget the people who have encouraged and supported you from the beginning—family, friends, colleagues, and even friendly acquaintances who believe in your work. They may be perfectly willing to make a donation to help enable one of your projects.

An example of an individual donor might be your aunt, who in the spur of the moment gives $200 to support your fledgling art project at your fund-raising party. It might also be a coworker who does his own annual charity ride each year and wants to support your project with $50. It could be a close friend who gets

a lucrative job in a tech firm and supports your projects with $2,000 each year. These are real examples. Unless you ask, you may never know that someone is ready and willing to help.

If you can offer your supporters a tax deduction on their donation by using a nonprofit organization as your "fiscal sponsor," even better. I will cover how to do this a little later, under Considerations for Individual Artists.

In-Kind Donations

Think beyond dollars—donated goods and services mean less money to raise. Donated space, marketing, professional services, and equipment are valuable, so look for these when you can, and keep track of their value. Examples include free food or beverages for events, free graphic design services, studio space, exhibition space, engineering services, surplus materials such as lumber or paint, and used equipment.

Earned Income

Earned income is self-generated, often from your own sales of goods or services. I include it here because it's the final piece of your financial puzzle. Consider what people will pay to experience or remember your work, and find ways to enable that to happen. Common sources of earned income are sales of work, ticket sales/admission, concessions, sales of T-shirts and memorabilia, CDs or DVDs of shows, catalogs, and the all-important artist fee.

CONSIDERATIONS FOR INDIVIDUAL ARTISTS

Not everyone can make a grant or contribution to an individual artist. Many funders will only make awards to tax-exempt nonprofit organizations. Therefore, the first thing you should look for when researching a funder is whether or not they make grants directly to individual artists or to artists with a fiscal sponsor.

A **fiscal sponsor** is a nonprofit, tax-exempt organization that agrees to receive contributions on your behalf, including grants. In essence, the organization extends its tax-exempt status to you and/or your project. Don't confuse this kind of "sponsorship" with corporate sponsorship. It doesn't mean that the organization will directly fund your project; it's an administrative relationship that allows you to apply for resources you can't access without nonprofit status. Numerous art service organizations offer fiscal sponsorship programs to artists, often with an administrative fee of 5 to 8 percent charged on any funds raised through the sponsorship.

How else is fiscal sponsorship useful? Many individuals only make donations to charities, causes, and arts projects if they are tax-deductible. If you have a fiscal sponsor, individuals can make donations to support your work by making out their checks to your fiscal sponsor. The fiscal sponsor turns the funds over to you and provides a receipt to your donors. Donors can then deduct the donation from their taxes, since their donation has gone to a tax-exempt organization.

Keep in mind that even if you have a fiscal sponsor, as an individual artist, you may not be able to apply for the same range of grants as organizations. The most

common grants made to individual artists are **project grants and fellowships**. Project grants are what they sound like—grants awarded to help a specific project happen. Funds may only be used to cover costs associated with the proposed project. Common artist project grants include grants for exhibitions, public art projects, community projects, travel for research/collaboration, and documentation. Fellowships, on the other hand, are merit-based awards to support an artist's practice or research in general. Artists may use these funds in whatever way they see fit.

APPLYING FOR FUNDING

Set Your Priorities

Before you start researching, answer this question: What are your current artistic and professional goals? Write them down. If you know and can articulate what you are looking for at the present time, this will help you focus on relevant resources.

Do Your Research

Doing research the right way can save you time. Most funders state, in writing, what they support and how they prefer to hear from those who are interested in accessing their funds. After all, it's in their best interest. So read. Please. Read the information provided.

When you're carrying out broad research to see who funds what, two great general resources are the Foundation Center, an organization with a comprehensive online grants library, and NYFA Source, a national online grants/resource database offered by the New York Foundation for the Arts. For more timely information, check out relevant arts service organizations to see if they have a Web site or newsletter where they list grants and upcoming deadlines. In addition, it's a good practice to pay attention to lists of funders for exhibitions or artist projects that you feel have an affinity with your own work.

When you are researching a specific funder, always check the Web site. You can often find information on major areas of funding, programs offered to support these areas; how to submit funding requests; program guidelines and application forms if applicable; funding criteria; and past grantees. Lists of past grantees are a great resource. These examples are the most concrete thing you have to go on about whether or not what you are doing might be a fit with a funder. Grant amounts are also often provided, giving you an idea of how much to ask for and to expect.

If you read a funder's guidelines and you are a very close match, but you don't meet one or two of their criteria for being considered, don't prepare an application without having spoken to a staff member to get some indication that they would consider it. The amount of time and care invested in putting together an application is significant and you need to use your energy wisely.

Ways to Apply

The following are common terms used to describe how funders wish to, or wish not to, hear from people seeking funds:

No unsolicited proposals: The funder doesn't want to receive applications they haven't asked for. Unless you have a personal or professional connection to the funder, the best thing you can do is just send them a periodic invitation to an exhibition or event to put yourself on their radar. Note: do not send them your weekly or monthly e-blast. Be judicious.

Nomination process: The funder asks knowledgeable people in the field to nominate candidates for consideration. Generally this means they decide whom to ask for a nomination—they don't just accept nominations from anyone. Then they invite applications from nominated artists or organizations, or simply award them funds. You can't will yourself to be nominated, but you can be active in your field and make people aware of your work.

Letter of Intent (LOI): The funder doesn't want a full application at the outset—they'd rather have a one-page letter that concisely describes the project or activity for which you seek support. Think of this as a one-page summary letter, not a magnum opus. State who you are, what your project is, when it will happen, what its impact will be, and how much funding you are seeking. If they like your idea or project, they will then invite you to submit a full proposal.

Open Call or Request for Proposals (RFP): The funder wants to cast a wide net for applications—the goal is to reach as many eligible candidates as possible. Usually this means the program will be promoted and there will be clear program guidelines and application requirements. Just submit your application before the deadline!

Selection Processes

There are two common structures used for fielding and evaluating grant applications; most funders use some variation of one or the other. Knowing what happens to your application once it is submitted will help you better understand how to put together your application.

Program officers recommend grants to board: This structure is common to private foundations. Designated staff members are responsible for identifying projects for support, which are reviewed by their board of directors for final approval. In this situation, the staff member becomes an advocate for project, so they really need to understand what you are proposing. In addition, as a gatekeeper, that staff member may have a significant amount of control over the process and flexibility in allowing exceptions. Don't expect the staff or board to be arts experts, as this is not always the case.

Peer panel review: This process is most commonly used by nonprofit arts service organizations and government agencies, but some foundations also use this method. Peer panels draw on the expertise of the arts community to make decisions about funding. A panel will be made up of "experts," often artists and arts professionals who represent a range of roles and viewpoints in the field, who will review all eligible applications and make recommendations for support. Staff members bring all eligible applications to the panel and answer questions. Their input in the final decision will vary from partial to almost none.

Panel members often change from year to year to help ensure that multiple voices and perspectives from the field are represented, and to avoid the development of conflicts of interest or decision-making tendencies (or bias) over time. This means that each time the panel changes, you have a "fresh" opportunity for consideration. Another upside of panel processes is that, whether you are funded or not, your work is being exposed to a group of relevant people in the field. In fact, many curators serve on panels in order to be introduced to new projects and artists.

Preparing Your Application

Sitting down to write a grant can be very daunting. My best piece of advice for those who are just starting is this: **think of the writing as a form of journalism**. It should be concise and written in plain English for the general reader; describe things concretely, including the essentials of who, what, when, where, why, and how; and remain neutral in tone while being engaging and persuasive.

Most importantly, your proposal should tell the story of your work or your project with enough detail that those reading it can easily imagine what it will be or what will take place. If someone can imagine what you are doing, you're most of the way there. A helpful exercise is to give your proposal to a friend to read—someone who knows nothing about art or your project—and get his or her feedback.

Once you've developed a description or application you're happy with, remember this: you will have to modify it the next time. Every funder is different and has different requirements. Be prepared to tailor your proposals to make sure you are demonstrating how your work addresses the interests and priorities of that funder. The best way to do this is to refer to any published criteria they use in decision-making and see if your proposal is compelling in terms of each criterion.

Tailoring your proposal includes not only its content, but also format. Many funders have specific technical requirements for proposal submission, such as word or page limits, number of copies to submit, budget format, and work sample format and number. Follow them—they are there for a reason: to standardize the format of a large group of applications to level the playing field and allow reviewers to focus on the content.

Follow-Through

If you are not funded . . .

If you submit an application and you are not funded, it's okay to feel disappointed. The important thing is to take something useful away from the experience, so call for feedback. Arts service organizations and government agencies often record or take notes on panel discussions, and staff members may be able to share with you the perceived strengths and weaknesses of your application. You may learn many things you never expected, and the information can help you develop a stronger proposal in the future. Don't give up after one try, unless a funder tells you your work is not a fit with their goals or programs.

If you are funded . . .

If you are funded, it doesn't end there! Here are some simple things you should do to maintain a positive relationship with your supporters:

- Read your grant contract! It will tell you what your responsibilities are and what the funder's responsibilities are. Don't lose it: file a copy for reference and as documentation of your grant.

- Send a thank-you letter.

- Invite funder representatives to VIP and public events associated with your project and add them to your mailing list. You would be surprised how many people forget to do this.

- File timely reports. Many funders require you to send written final reports on how you have used their funds and what you accomplished.

- Submit reports that contain pictures and result-related quotes such as "Your grant helped me achieve . . ." or "For the first time, we were able to . . ." We're all in this together, and your feedback helps funders advocate for the resources they need to continue offering grants to artists.

- BE HAPPY. You deserve the support!

◄18►

Residencies: Space and Time to Think and Work

Residencies are professionally run communities that offer artists the opportunity to have space and time to think and create new work. These programs can also be referred to as artists' colonies, artists' retreats, studio collectives, and artists' communities, which can take place in rural areas and are also offered in cities. Sometimes a stipend is involved or the artist may have to pay a fee to participate. Materials and equipment may be provided as well. Residencies can run anywhere from a week to a few months to a year. They can be funded privately, through public funds, or through business enterprises. These communities may consist of visual artists or there might be a mix with writers, composers, scholars, and historians.

Residencies are a great platform for experimentation. These experiences give you time to dedicate to your work and helps you build a network and community of artists that you can stay connected to for many years afterward. A sense of community is often encouraged as residents attend lectures, critiques, and share meals. At residencies, you can meet other artists and get a foot in the door for other opportunities down the road.

Artists often don't think of looking for residencies in the immediate area near where they live. Residencies do not have to be places that are far from where you live and work. An example of a New York City–based residency is the one offered by the Lower Manhattan Cultural Council (LMCC), which states on its Web site: "Since 1997, the Artist Residencies department partnered with generous real estate owners in Lower Manhattan to address the critical need for studio, rehearsal, and presentation space for artists working in all disciplines. We secure donations of temporarily vacant ground floor retail spaces, gutted industrial spaces, upper level office floors, and subterranean bank vaults downtown and transform them into incubators for art. Space is granted through open calls for applications. By placing artists into the Lower Manhattan landscape we are simultaneously serving the arts community at large and enhancing downtown's cultural environment." An interview with Erin Donnelly, a former director of the LMCC residency program, follows later in this chapter.

BENEFITS OF RESIDENCIES

- Housing and meals
- Studio space
- Collaboration opportunities with fellow artists
- Access to mentors and a community of artists
- Critique sessions
- Possibility of exhibition opportunities
- Equipment and resources, such as printmaking labs, metal and woodworking facilities, photography studios and equipment, and assorted art materials and special libraries
- Time to reflect and recharge

Alyson Pou has been making installation and performance work for more than twenty years (*alysonpou.com*). Pou has also played many other roles within the arts community including curator, producer, presenter, and teacher. She has been part of the staff of Creative Capital since 1999, where she has designed and implemented the Professional Development Program and currently serves as that program's director. Pou says of residencies, "Having clarity and goals for the things you want to accomplish is important. So, I would say when going into a residency, artists should be open to things changing but should be prepared with a project and benchmarks in mind. For my last residency, I set the goal of getting a script written and had already done most of my historical research and planned a plot structure before the residency began. Once there, I did do more research and interviewed a couple of people, but it helped that I had a work outline already in place. With this kind of preparation, I was able to accomplish more in less time. Residencies are precious chunks of uninterrupted time, and for me, it is that opportunity to think and work expansively that is the true value of a residency.

"Not everyone's priorities are the same. For some, being in a community of artists is important, and so things like studio visits, shared meals, or late-night parties figure largely in their plans. A residency is satisfying and productive as long as you know what you want from it."

STUDIO PROGRAMS AND EQUIPMENT PROGRAMS

A studio program is not like a residency where you live in the space; rather, it is studio space in which to work. An example is the Elizabeth Foundation's EFA print shop in New York City. Other good examples of studio programs are those available to artists in the San Francisco Bay Area. Printmakers can work with presses and get residencies from Kala Art Institute in California, where you can apply to become a member, pay a monthly due, and embark on a residency. There is also the Mission Cultural Center for screen printing, the Graphic Arts Workshop

(a fine art printmaking cooperative), the Center for the Book for book artists, and Crown Point Press, where artists can do internships in these studio programs.

HOW TO MAKE THE MOST OF RESIDENCIES

- Don't view a residency as simply a résumé builder. Look at the bigger, long-term impact the experience will have on you. A residency experience is largely valuable for the relationships you build; you'll have access to other artists' processes and conversations that may have a lasting impact on your practice.

- Have realistic expectations of the residency and be open to new experiences.

- Enter into the experience with a defined set of goals and a plan.

- Artists may go to a residency for a variety of reasons: to complete a specific work or series, to recharge their batteries, to have uninterrupted time to contemplate the next stage in their work, and even to socialize with a group of artists.

- Do your research and select residency opportunities that are relevant to your work; don't just apply to everything you see.

- If you get rejected, document your past applications and keep applying in the future. Judging panels can change from year to year, or even if they don't, the judges may learn to recognize and appreciate your work and its growth over time.

- Remember also that you are a guest in the community, so be gracious to other artists. Send a thank-you note to the residency/organizers at the end of the experience, and stay in touch with them (don't forget to add them to your networking/mailing list). One reason to do this is that you may get special consideration for your application in future rounds, and you may be eligible for a scholarship or work/study arrangement.

- Make sure you research and understand the physical condition of the residency such as housing and the cost of attending the residency (as some expenses such as travel and meals may not be covered).

RESOURCES FOR SEEKING RESIDENCIES AND ARTISTS' COLONIES

The Alliance of Artists Communities

The Alliance of Artists Communities is a national and international association of artists' communities and residencies—a diverse field of more than a thousand programs worldwide that support artists of any discipline in the development of new creative work. The Alliance has produced a book called *Artists' Communities: A Directory of Residencies That Offer Time and Space for Creativity,* which lists residency opportunities worldwide, and comprehensive details on residency centers.

For more information, go to their Web site at *http://www.artistcommunities.org/ about-residencies.*

NYFA Source

NYFA Source is an extensive national directory of awards, services, and publications for artists. For more information, go to their Web site at *http://www.nyfa.org/source/*

In the following two interviews, we will hear from Erin Donnelly, who gives her perspective as a former residency program director who selected artists for inclusion in residencies and exhibitions, and from Angela Ringo, an artist who shares her experience at an artist's residency program at Skowhegan.

INTERVIEW WITH ERIN DONNELLY, SPECIAL PROJECTS CONSULTANT, LOWER MANHATTAN CULTURAL COUNCIL

Erin Donnelly is an arts manager and curator. She recently moved into a role as special projects consultant after five years as Artist Residencies director, Lower Manhattan Cultural Council (LMCC), where she has worked since 2001. She is also exhibition coordinator and curator for Volunteer Lawyers for the Arts (VLA) Art & Law Residency Program.

How do residencies enhance artists' careers?

To balance out such demands as bringing in income to support an artistic practice and managing related practical matters, residencies are absolutely essential to providing artists with the precious time and space needed to develop new work. When I am invited to speak at art schools, I often talk about residencies as invaluable resources, especially in New York City since most artists are priced out of the real estate market. A huge benefit of all of the residency programs in the city is the opportunity to share work with the public and build new audiences around emerging artists' work, through open studio events and exhibitions that are typically scheduled at the middle and/or end of a residency. Although artists may feel the pressure to perform, they ought to use any residency as a laboratory for experimentation and draw upon the many resources it may offer to develop new ideas.

But artists need more than just access to space, so I created additional professional development opportunities within the residency program during my time at Lower Manhattan Cultural Council (LMCC). I will use the Workspace program as a case study of sorts to give a few examples. The Salon series offers weekly studio visits from noted curators and writers who look to the Workspace program to identify up-and-coming artists. Instrumental partnerships with the School of Visual Arts and New York University allow LMCC artists to access their state-of-the-art facilities to be able to produce more fully realized bodies of work that might be financially out of reach otherwise. I also scheduled events such as historic architecture walking tours and visits to the New York Stock Exchange and the Municipal Archive, which contextualize the Lower Manhattan neighborhood in which we work. Artists may not necessarily request such activities, but they are productive in that they expose the residents to ideas and practices outside the arts field.

Finally, the model we have worked with at LMCC has been one of engagement and, while each artist is given a dedicated and individual work space, many of the

spaces are designed as open-plan environments with ample common space to encourage community and dialogue among the residents. Many artists come away with a recommitment to their artistic practice, since the rhythm of working in the financial district has—hopefully—given them a sense of priority of the role, place, and importance of the artist in society. I have always felt that the best outcome of any residency is not what happens within the residency period, but what happens after and as a result of the residency. In turn, are there ways artists can give back to any community that has been supportive of them, whether that means staying in touch with fellow residents, the program staff, or another way?

We noticed that artists often go for only the top residencies. Can you suggest how artists starting out should go about researching and finding residencies?

In general, you should probably never do anything just "for your résumé." Choose programs that are most relevant to you and your work and appropriate to your career stage. There is a wide range of local, national, and international residencies to choose from, in remote settings or in urban centers, and different programs based on media and discipline as well as those that offer different kinds of amenities that may be important to you. What are your artistic and career goals, and how and why will a particular program help you advance yourself and your work? Consider practical aspects as well such as travel, any program costs, and the financial considerations that might be required of a focused period of production. On a technical note, some residencies like LMCC offer only studio space, while others offer temporary stays including room and board such as more traditional art colonies.

Clearinghouses of national artist opportunities such as NYFA.org are very helpful resources. Artist biographies available on program Web sites provide great opportunities to "reverse search" the kinds of residencies artists at a similar career stage have moved through. Artists can also reference such published guides as *Artist Communities: A Directory of Residencies that Offer Time and Space for Creativity*. The commitment of time to research different opportunities will be a worthwhile investment. Be strategic. Don't apply to everything.

What should artists know about the selection process?

Most artist residencies are by application, although a few are by nomination and/ or invitation only. As just one example, LMCC selects residency applications on a competitive basis of artistic merit, career record, and proposal. In the final stage of selection, LMCC factors in such consideration as diversity in all senses of the word when putting together a group of artists. Artists should read the eligibility and criteria carefully before applying for any residency, as well as seek out information about how decisions are made and by whom—for example, by an anonymous committee, a rotating selection panel, or the internal staff. Even if you are not selected for a residency, by applying you are exposing your work to arts professionals who might not be familiar with your work so there are additional benefits that might not be as apparent. With an application pool totaling about a thousand for twenty to thirty spots, which means about 2 to 3 percent of applications are accepted at LMCC, the competition can be stiffer than getting into an Ivy

League institution! But don't be discouraged if you are not selected the first time you apply. Many LMCC artists applied several times before being accepted, but because they were persistent, the program staff during the prescreening process saw their work develop over time.

Can you share tips on how artists should apply to residencies to improve their chances of acceptance?

Almost all selection processes regard the work sample as the key element of an application and view that material as a first step. So planning a clear and compelling work sample that is most representative of your recent work is critical to advancing you through any decision-making process. Finding out how work samples are viewed during the selection process is also important. For example, will images be viewed one at a time? How much video will be played before the panel moves on to the next artist?

Additionally, make sure that the written information you prepare such as an artist statement and proposal work in consort with your work sample. Have a friend proofread your application and read your artist statement out loud while viewing your images. Do those two application elements support each other or work against one another? Artists are often compelled to write theoretical treatises on their work, but the best statements use plain language to explain working methods and materials and the conceptual underpinnings of the work. Ban the use of jargon. As a last step, this may seem like it goes without saying, but check that your application addresses each of the established criteria and that you have followed the instructions exactly.

Assume that late or incomplete applications are not accepted. Remember, an application is a first impression, and putting forward a well-organized and professional application shows that you are serious and that you have respect for the program you want to work with. As much as LMCC uses a panel process to choose artists, I also like to think that artists also self-select the program. Show whichever residency that you are applying for how it will benefit you and why you have chosen to apply to it over others. Artists can be better equipped and empowered to navigate their careers more effectively by being thoughtful about their own decisions.

Can you tell us about the residency programs you helped administer?

Since 2001 I have worked for Lower Manhattan Cultural Council (LMCC), a 501(c)(3) nonprofit organization that has been producing cultural events and promoting the arts through grants, services, advocacy, and cultural development programs downtown and throughout New York City for more than thirty-five years. I have advanced through various positions at LMCC, working to not just recover, but also expand our artist residency programs after the World Trade Center. I recently moved into a role as special projects consultant after five years as Artist Residencies director. Each year LMCC serves approximately two hundred artists in all disciplines through two major programs, Workspace and Swing Space, which provide much-needed space for rehearsals, installations, performances, exhibitions, and short-term administrative needs in temporarily vacant upper office floors, basements, and storefronts donated by Lower Manhattan property

owners. Workspace is a process-based nine-month studio residency program for visual artists and writers. Swing Space is a project-based space granting program in the form of one- to five-month residencies that match visual and performing artists and arts groups with development, presentation, and office space.

Please tell us about your role in arranging a residency program.
Overseeing the capital construction as well as program strategy and development—for example, I helped launch Building 110: LMCC's Arts Center at Governors Island in 2010, which encompasses all the above activities in New York City's newest cultural destination. The island is a former military base and is now a vast urban redevelopment project incorporating educational and artistic uses; in fact, LMCC is the first year-round tenant. On Governors Island, artists are put at the beginning of the conversation around how to make a civic space and, while conducting their residencies, are encouraged to draw inspiration from the unique location only accessible by ferry. Historian Mike Wallace of the Gotham Center, CUNY, best described Governors Island as "in but not quite of the City," and LMCC's location, in a historic setting with stunning views of Lower Manhattan and in a bucolic but open space, offers artists the opportunity to be both connected to the city as well as to retreat from it. It will be a model to watch in the future.

The next interview is from the perspective of Angela Ringo, an artist who shares her experience at Skowhegan, a well-respected artists' residency program.

INTERVIEW WITH ANGELA RINGO: ARTISTS' RESIDENCY AT SKOWHEGAN

Angela Ringo holds an MFA in painting from Parsons The New School for Design, is an experienced trend forecaster and editor for both fashion and design, and is a dedicated artist devoted to the practice of painting and photography. Believing that inspiration can be found anywhere, she maintains an earnest passion for travel and strives to nurture her curiosity through cultural exchange and engaging discourse.

Tell us about your residency experience at Skowhegan.
My time at Skowhegan was a completely immersive experience. Each day was centered around developing our studio practice and included critiques by both the residents and the faculty. The faculty in 2006 included Radcliff Bailey (painter and sculptor), Lisa Sigal (installation artist), George Herms (assemblage artist). This variety of artists allowed for intriguing critiques and dynamic feedback.

What was a typical day like?
Most days started with consuming coffee and walking about a mile and a half to the main campus and then onto Kresge—my designated studio attained through a diplomatic lottery system. Each studio space, named after a famous artist and donor, was unique and offered the chance to create work with natural light and the sounds of nature as a backdrop. It was encouraged to use our time there to

explore new mediums and modes of thought, so the work that I completed at this time was pretty experimental. Most notably, I took an amazing fresco class with the renowned Daniel Bozhkov. This led to the completion of a seven-foot fresco that hopefully still adorns the walls of the Fresco Barn.

What was the artists' community like?

While the main focus was on creating, I feel that I made some really honest friendships while at Skowhegan. All of the participants lived in a community of small houses along a picturesque lake, which was the center of most social interaction. Mealtimes were spent together, which offered another opportunity to build relationships and discuss our varied art practices. With a student body of sixty-five artists, there were many collaborative projects that occurred as well as time for solitary contemplation. The fact that we were in nature awoke the kid in many of us. I actually discovered a love of baseball while there.

Nature played a big part in the Skowhegan experience. The campus is quite secluded, with a wonderful landscape to inspire. Wildlife like moose, loons, owls, and an amazing variety of insects offered both amazement and inspiration, since a lot of my work is an exploration of the natural world.

How did you apply?

The application process was exceptionally simple. It required a curated selection of twenty works (either slide or CD format) and a completed application form. Their application made it obvious that their focus was on the work and how the experience of Skowhegan could help you grow as an artist.

What are you doing now?

Currently, I'm working as the interiors editor and trend forecaster for Stylesight. Since my education is multidisciplinary, trend forecasting has been a great way for me to combine my love of art with my love of fashion and design. While I'd love to say that it's easy to maintain a dedicated studio practice while working full-time, the truth of the matter is that it is very hard to fit both aspects into day-to-day living. Art deserves and requires full concentration for real development. I know that eventually I'll refocus myself back to world of fine arts.

Do you have any tips for other emerging artists?

For longevity, you need to think about developing work over time, not chasing trends/the market and copying other artists' techniques/work. You need persistence, as being an artist is not an easy road. Take time to develop an aesthetic, to explore and learn. Be original and not derivative. Barnett Newman and Mark Rothko were in their fifties when their careers developed. Don't burn out early by putting yourself in a box, by focusing too much on one kind of art practice. You need a strong and distinct point of view. Think about what your goals in art are. Do you want to deliver a significant message that will lead to social change? You also need to think about career readiness and keep running documentation of all your work. Be ready for opportunities with a concise and clear artist's statement and a résumé that reflects who you really are.

ᘦ19ᕈ

Lifelong Learning for Artists

We had the great opportunity to speak with a well-known artist, Chuck Close, and two career professionals in the art world, Theodore S. Berger, former executive director of NYFA, and Robert Thill, director of the Center for Career Development at the Cooper Union. Each has thought about what it means to advance an artist's career from different points of view. This chapter is meant for students, emerging artists, educators, arts administrators, directors of schools and colleges, legislators or policy makers, career counselors, and other professional practitioners who are interested in exploring future trends through the reviewing the past, commenting on the present, and speculating about the future of what it means to be an artist in our world. We hope that readers will consider this an inspiration and a call to action!

INTERVIEW WITH THEODORE S. BERGER

Theodore S. Berger has been part of the nonprofit arts sector for nearly forty years. He retired as executive director of the New York Foundation for the Arts (NYFA) where he was on staff for thirty-three years. During this period, NYFA became one of the country's largest providers of grants and services to individual artists and artist-centered organizations in all disciplines. He is one of the key people in the country focused on supporting artists. Mr. Berger is now continuing his work through a number of major efforts: he is the project director for the Urban Artist Initiative/NYC (UAI/NYC), a consortium program to support NYC artists of color; he also directs New York Creates, an initiative to create more entrepreneurial opportunities for New York's craft artists and artisans, with a special concentration on those forms from immigrant and diaspora communities; and he serves as a trustee and is treasurer of the Joan Mitchell Foundation. He is on the board of numerous other organizations. He writes and speaks extensively on the arts and artists and cultural policy for numerous national and international publications, conferences, academic institutions, and organizations.

What is a main issue facing art students today?

This issue of tuition debt is real, and there are no easy answers, especially with few financial aid packages now being offered to students. But it is also an opportunity. Institutions could think about their moral responsibility and do something about this situation. As one looks at this national systemic issue, the question is, how do we mobilize to do more? Ultimately, there needs to be a forgiveness program for student debt, perhaps, coupled with doing some public service. There is this kind of a program for doctors in the medical community; doctors' tuition debts are forgiven if they work in, say, rural hospitals. There is a lack of leadership on this issue, and we have to figure out how to work together to create a program like this. There is talk of such programs by Ted Kennedy Jr. and the Obama administration. I am afraid the number of defaults will only increase if we don't do something to address this. There needs to be a forgiveness program or a short-term job program; placing academia more with workplace programs as the transition between graduation and the workplace is key for students.

Beefing up career services with a good alumni network is a place to start. The help of an alumni network geographically and through its diversity would be a big help. Technology can help make a difference by making the connections and doing the analysis of where alumni clusters are regionally. It could connect newly graduated students with, say, alumni ten years out or at all different stages of their careers.

Whether you do it for free or pay for it is another question. I believe artists will pay for something that is worthwhile. Whether academia is committed to *long-term* student support is a core issue, I don't know.

You have mentioned that there is a need for a more "nuanced approach" to professional practices/career services for artists. What do you mean by this?

Being nuanced in this field is to understand the broad range of artists needs, from the self-taught to the academically trained artist, and to listen more to figure out what people really need. Artists need to do a self-inventory that lasts them a long time: a plan that addresses financial needs, an escape plan, emergency needs, and so on. There needs to be greater sensitivity to what artists bring to the table, too. And we haven't done enough for artists with the idea of peer-to-peer mentoring; I mean an ongoing peer-to-peer mentoring.

How do we impress on artists that they are lifelong learners with great opportunities?

We must get faculty to think about artists as having a whole life and not just offer them a life of market careerism. We need a broader viewpoint, the arch of the life of the artist, and to give them the tools to think about how to go about creating a meaningful life for themselves. It requires faculty to think: What are they doing? What are they really offering?

Academe could be creating a professional practices program equivalent to the postdoctoral programs. Say, a two-year or eighteen-month program that

helps artists make the transition to a real world and learn skills on how to set up their work lives. This could be accomplished with internships in nonprofits in your discipline or with for-profit organizations or artists developing projects in communities that work to benefit both parties. This kind of a program would help artists with a transition period to function better in the "real world."

Finally, artists of all kinds, a diverse population, all have a different sense of what it means to be supported and what art is about. Professional practices tends to be a top-down endeavor concerned with policies and programs, but not always engaged with working artists' knowledge of a system that is no longer valid or credible.

How can students transition from school to the "real world"?

The student is really in a cocoon in school, so we must think about adult learning. When is an adult ready to get the information they need to succeed? For example, you can be told you need a yearly physical. You can hear it, but when does it take effect, and do you actually do it? When *does* an adult hear what he is being told? It is essential that we start professional practices for artists at the undergraduate level because it is harder at the alumni level, which is typically underfunded.

Career education must be part of an academic institution. After all, after graduating, students don't have access to so much, such as equipment to do their work or a close community of fellow artists, so there is a certain amount of frustration about their situation that occurs. In the long run, this could be dangerous for academic institutions if the attrition levels of these training schools increase.

You believe in the need for professional practices to address the "human needs" of artists as well as the creative needs. Can you say more about this?

Human needs issues, such affordable health care, affordable live and work spaces, how to pay the rent, etc., aren't really on the table in terms of professional practices. The only way I can see these issues coming to the table is through partnerships with people who are trained to be translators, who know the non-arts world and can translate it to artists. They are people who know the rules in order to break them. How do we get our needs on the radar? Where and what are the intersections?

There are some good attempts to address these needs, such as that of LINC, which is looking at national ways to address the space issues for artists in communities. Freelancer Union is a good example, too, of a crossover organization that addresses health benefit needs of which artists can take advantage. There is also a wonderful example of this "translation" in the Artists Access Program with the Public Hospitals Program here in New York City. One of the hospitals that participated is the Woodhull Hospital in Brooklyn. Artists can go there for health care needs and get an assessment of what they need and get hospital services for them. Woodhull acts as a translator for artists about the medical world and insurance policies. They usually deal with artists who are

uninsured and have no health access. And hospitals benefit from having artists in their midst, for some artists can choose to provide some exchange public service back to the hospital and, in essence, build up credits, which they can then apply to any medical costs.

For example, a project where artists and doctors worked together at Woodhull, where doctors have to teach other doctors how to do things—participating actors trained as patients, acting out different types of clients and their needs, so doctors could learn to practice their techniques. It's a mutually beneficial system. It's about leverage and translation.

Joan Jeffri, who is the director of Arts Administration Program as well as the director of the Research Center for Arts and Culture at Teachers' College, Columbia University, is also doing wonderful work with elder artists and non-arts communities. It allows both to benefit from these relationships, working together. Human needs are about lifelong learning and the political good. How do we create a comprehensive system—access to these human needs services when people/artists need them?

In conjunction with this topic, there needs to be a percentage of time that artists carve out not to make artwork but to work for themselves, for their "human needs," taking care of themselves, such as looking at documentation of work, going to workshops, doing taxes, hearing other artists speak. Being disciplined enough to carve out a day a week to do these things is critical for artists.

What is the role of academe/schools in supporting future artists?

Academe needs to train artists to ask questions, the right questions, at different stages in their lives. How to ask the right questions at the right times about the working lives of artists! In a way, the work life of all of us, even in academe, with so many adjunct teachers, independent contractors, and freelancers, increasingly resembles an artist's life, more than ever before. To look at how artists work is to look at all our working lives. Artist's communities are good working laboratories to think about all communities.

A good idea would be to also to create a national system on how to mobilize schools to do more with lifelong issues and to create opportunities for students. Schools need different faculty, ones who look at and address the lifelong issues that artists face. For instance, not sending them out as cannon fodder as adjuncts and not teaching students about "careerism," which suggests it is all about the marketplace. We need a broader view.

We need to have a better historical perspective. We need to understand what existed before there was the National Endowment for the Arts and before the gallery system developed. Historically, Leo Castelli really invented the gallery system, which wasn't really in existence before he came on the scene. That system evolved during the fifties and sixties. He basically invented the system we know now. Knowing what went before is important to understand the context we live in now, so we can say, it doesn't have to be this way.

So how do we set up safe environments to hear more from artists and what their needs are?

When I say safe environments, I mean environments that don't judge artists but rather ascertain their assets. The responsibility of an organization is to roll up its sleeves and say, wait a minute, we are ready to listen, not judge how you conduct your lives. There are no absolute rights or wrongs in this profession. We need to respect artists' worlds and where they are coming from. There is more than meets the eye here. There are a number of people in arts administration who are artist-centered, but by and large, we need to change training programs to be more concerned about artist-centered issues. I think that the arts administration programs ought to require people to be in the studio making work in order to understand the creative spark and how to sustain it.

What is your idea of an Artists Advisory Committee?

Much like the Professional Development Consortium with whom you've been working, getting a group of people together in the field who are dealing with these issues and then collaborating with artists to think about how to address them. It could be about networking with people who are dealing with these problems, understanding the demographic changes going on in our country, knowing the funding sources and the changes taking place in them. You know, there are always funding sources even during hard economic times, as we are in now.

I am a big believer in artists being at the table; they need to be involved in the programming and policy level. It also requires artists to think differently about themselves. For example, Lucy Sexton of the Bessie Awards needed to step back and reassess what these awards were about before moving forward, so she closed down the effort for two years to think about the direction in which they were going. It's fascinating to watch, to see the cross-disciplinary and cross-genre work artists can do!

We tend to think and work in silos and don't think in other disciplines; therefore, we don't look for common issues. For example, what are the implications of time-based work and static work? Artists tend to focus on themselves and not necessarily on the needs of other artists, but they also don't have enough opportunity to do so. The way they work tends to be in silos. It would be interesting for larger institutions to think about communal interests and differences.

An Artists Advisory Community should include a community of color, different kinds of leadership that promote different ways to think about things and to build in different ways to work. For instance, there could be a kind of rotation of leadership, and a way to think about changing the composition of boards, with artists' input from different economic levels, geographic areas, different ages—these are extremely important things to consider.

The Artists Advisory structure was built into the by-laws of NYFA, at least before I retired—an advisory group of artists that rotates and regularly talks about what they are doing and thinking, five years out in their careers—a group that thinks about the larger community of artists.

Any consortium must think about how we invite artists to the table for an honest conversation and not be defensive. How do we break down the silos and move the nonbelievers into the discussion of commonalities and differences? Ultimately, we need to create common ground.

Are there organizations that do this now?

Yes, Working Today advocates for the independent workers in a united effort. Freelance Union values public awareness. It's both a personal and political issue. We have to address how working artists relate to for-profit and not-for-profit organizations in order to enlarge the cultural sector. The cultural sector is linked to the critical role the idea maker and product maker can play.

These issues are related to the study by the Urban Institute, Investing in Creativity, which says that 97 percent of the population values the arts, but only 27 percent want artists in their communities. There is a big disconnect here. There is such a disconnect between the makers and the product. The industry wants the products, but doesn't want to deal with the process of the makers. Also, there is a political element here, which is: I am an artist and I vote!

I hope technology can help. There is a favorite *New Yorker* magazine cartoon of mine that shows two dogs sitting at a computer. One says to the other, "When I'm online, no one knows I'm a dog." Artists alone in their studios can come together with the public through technology by relating to the marketplace with Web sites, blogs, etc., and build audiences and awareness. It can link the consumer to the artists.

What can organizations do about the use of technology with regard to artists?

Artists still need training, skill sets, and access to equipment (which is a huge issue for students just graduating, because once out of school, they don't have access to much of the equipment they had in school), media access, access to labs, etc.— these are huge issues.

There is a big issue with the documentation of artist's work. So much gets lost along the way. Young artists don't think about documentation until they need it later in life, and then it is too late. We need to train young artists, students, to document right from the start of their careers, so that later, when they are older, they have a record of their life's work. A lot of older artists forget what they have actually done, or their work ends up in someone's basement or in a dumpster when they die. Or, at crucial moments in their careers they can't find or bring together their work for a show because they don't know where it is.

The Joan Mitchell Foundation is looking into ways to use technology to help create appropriate ways to help document an artist's career, linking with other organizations in order to get young artists to archive their work and therefore think about what is their legacy. They are creating these methods of archiving artists' work. The earlier this happens in an artist's career, the easier it is—it becomes a habit, like brushing your teeth, a preventative measure. A national network of archival effort would be a great start. The Tremaine Foundation did

this for curriculum development in the visual arts; it was a challenge to get this going in the visual arts, let alone to have it work across disciplines. This is really multi-institutional, cross-disciplinary work.

Where is the field of professional practices today?

By and large, professional practices reaches out and assumes that people have academic training. It believes everyone can deal and doesn't easily deal with the grays of artists' lives. People in the field are not prepared for the nuances of artists' lives. What are we trying to do? How do we help artists define success? What is success to you? What does it look like to you in five to ten years? What do we give to young artists to help them on their way?

My son is teaching in a community college, and he had the bright idea of interviewing every student on the first day of class to get a sense of what they were looking for. He was very interested in this population of different kinds of students with different kinds of experiences.

And what are the current issues for institutions of higher education?

I'd ask from academic institutions, "What do you want to archive for your students?" Academe can no longer ignore real world issues. It needs to educate artists better; artists are not well educated. We need academe to come together in a untied approach on a national level to brainstorm and understand what's needed—to advance a loan forgiveness program, for example, and to understand what an artist will need five years out of school and so on. These institutions need to change and hire faculty that are other than blue-chip faculty, who can relate to close-to-the-ground survival needs of artists.

Students need to stop thinking they can repay their debt quickly because they can't. Just as there needs to be a push nationally for regional support from other sectors, such as the gaming community, etc., that can help create opportunities for young artists today in order for them to live fulfilled lives, so too does there need to be greater preparedness for artists to be participants in the dialogue needed to heal our communities, our society, and planet today.

So why is the "myth of the artist" still perpetuated?

You mean the nineteenth-century notion of the full-time artists making a living from their artwork and not having to do any work outside the studio to support themselves, let alone their families?

Yes.

Well, artists get reinforcement for these myths from popular culture, books, and movies. And the public sees and perpetuates these myths. Then there is the myth of those who can do, and those who can't, teach. Terrible myth. These myths are also perpetuated by the galleries, and the Sundance syndrome, I call it: "I'll wait, do my work, and one day I'll be discovered. I'll sell my work and be forever free!"

It also works against artists when they don't believe in getting help from the not-for-profit world, which artists sometimes think is not relevant to them.

The myth goes like this: "I'm young, I don't need them. I'll go directly to the marketplace (where they are usually not allowed to fail) and I'll be discovered and make a lot of money. I don't have to deal with real world issues. I'm a square peg, and I don't want to fit in a round hole." Artists need to think differently. Hopefully, technology can send out some countermyths. It's very harmful for artists to believe these things yet they are up against popular culture, which is very strong.

Any final words?
We need to think about the arch of an artists' life. Things change over time, and how do artists adapt to those changes? We need to help artists define success on their own terms and what it means over time, five to ten years out. *Creative Capital,* for example, has artists write their obituaries to think about these issues.

If ever there was a time when this planet needed people to look at things differently, to collaborate and raise questions from their core, it's now; this is the moment. The goal: thinking about the whole, not just the parts.

INTERVIEW WITH CHUCK CLOSE, ORIGINALLY PUBLISHED AS "A CAREER IN ART: AN INTERVIEW WITH CHUCK CLOSE" IN CAA NEWS, COLLEGE ART ASSOCIATION, VOLUME 30, NUMBER 6, NOVEMBER 2005.

The following interview with Chuck Close shows the trajectory of a successful artist's career and how much support artists need to achieve their goals. Mr. Close is eloquent in describing his teachers, mentors, and the process he went through in order to sustain a life in the arts, focused on a career in painting.

The artist Chuck Close spoke to Stacy Miller, CAA's director of research and career development, about his life in art, highlighting some of the issues that have challenged him since his early days. Close is interested in advancing the careers of emerging artists and concerned with problems and issues in the art world. An active, generous contributor to the art community on international, local, and personal levels, Close tirelessly serves on panels and presentations, gives lectures, and supports individual artists. His reflections in this interview offer insight into the workings of a successful career. Born in 1940 in Monroe, Washington, Close earned an MFA at Yale University in 1964. Solo exhibitions have been held in major museums and galleries in the United States and around the world, including the Museum of Modern Art, Whitney Museum of American Art, Metropolitan Museum of Art, Los Angeles County Museum of Art, San Francisco Museum of Modern Art, and Centre Georges Pompidou; he is currently represented by PaceWildenstein Gallery in New York. In 2000, Close was honored with the National Medal of Arts Award by the United States government for his outstanding achievement in art; he has also received a Fulbright fellowship for travel to the Academie der Bildenden Kunste in Vienna and a residency at the American Academy in Rome.

How would you describe your career?
I emerged in a period of "lowered expectations," because I never really thought that I would have a career in art. I did want people to see my work, and I wanted

to be taken seriously. I assumed, like most artists, that I would have to teach or work elsewhere to support myself. Living off the sales of my art has been a big surprise. The past thirty-five to forty years have been interesting. I was always in the right place at the right time, which accounts for a great deal. For example, the mid-1960s was the golden moment to be in graduate school at Yale. I came to New York at a great time, when everything was up for grabs. In 1967 and 1968, the whole world was changing, and every institution was being reassessed. It was an interesting time to find reasons to make art. If success is the ability to make work over a long period of time and have people look at it, then I have been successful. But I was also probably a little hungrier than my friends—I wanted it badly. I had nothing else I was good at doing, and I had no fallback position—if I wasn't an artist, I didn't know what I would do.

What was a defining moment in your career?

If I had tried to be a financial success, I would have made entirely different decisions.

If I had decided, for instance, that in order to make money, I would have to seek commissions for portraits of college presidents and CEOs—which would have been the smart or logical thing to do—I probably would have lived in obscurity. Who would think that an artist could make a living by selling nine-foot-high pictures of other people, and that anyone would want to own them? It never occurred to me, and it certainly didn't occur to my first dealer, Klaus Kertess, at the Bykert Gallery, where I first started showing in the 1960s. No one was more surprised than I was—except perhaps him. Kertess and I were hoping that the work would enter public collections—I have always preferred to have my work in public collections for everyone to see. I was recently talking to Elizabeth Murray, whose retrospective is on view at the Museum of Modern Art in New York. She asked me how I felt when I had my own retrospective there a few years ago. Did I worry about it? What did I think about it? After I hung the show, I went through it and thought, well, making art has been a reasonable thing to spend thirty-five years doing. It looked like a serious body of work. Whether or not people like the work didn't matter so much because I felt that I hadn't wasted my time all these years. The work has been consistent—it looked like one person made it. When I reflect on my career, I am amazed that I am still making what I am making: I still find it engaging to paint people's heads. I have found art something I still want to do, and that it still has urgency for me after thirty-five years. As I look back, it looks as if I've had a career.

Did you have a mentor or mentors?

Nobody has a career without mentors. All along I had people who believed in me. First of all, my parents believed in me. They felt it was better for me to be an artist than other things—that's a rare attitude coming from the working-class mill town where I grew up. They helped and supported me when I started studying art at the age of eight. My eighth-grade art teacher was a mentor. In Everett Junior College, the person who saved my life was Russell Day, who is

still alive. I was a lousy student and I couldn't have gotten into any college in the United States. I didn't even think I was going to college, but junior college had open enrollment, and they took every taxpayer's son or daughter. I was learning disabled, and thus didn't take algebra, geometry, chemistry, or physics—and you couldn't get into college without them. I met wonderful people at Everett who believed in me, helped me, and supported me. Two teachers, Donald Tompkins and Larry Bakke, were great. They changed everything for me. Later, I transferred to the University of Washington. My mentor there was Alden Mason, who is still alive and painting—we remain friends. Based on my work at Washington, I was a candidate for the Yale Summer School in Norfolk, Connecticut. This school, which became my out-of-town tryouts for Yale's MFA program, took thirty students from around the country between their junior and senior years of undergraduate studies. The Cuban Missile Crisis and Bay of Pigs Invasion had just happened. I wasn't going to join the army to catch bullets, so I applied to graduate school at Yale. On the basis of my Yale summer school experience, I was accepted.

How important is a community of peers to the career of an emerging artist?

When you live in a large art center like New York, you become part of a community that sustains you. You get turned on by other people's work, which makes you want to go to your own studio and make some art yourself. However, a career doesn't happen without commitment, drive, and hard work. It is much more difficult to live as an artist today than when I started. The degree of sacrifice is much greater. In the late 1960s, I had a 2,500-square-foot loft for one hundred bucks a month. I could work a couple of days a week and paint the rest of the time. Today, the kinds of sacrifices artists make put tremendous pressure on them. Back then, we felt that we had our whole lives to figure out who we were. We didn't think it would happen overnight. Today, the expense, struggle, and sacrifice to pursue a life of art can be so great that an artist may try to rush to make everything happen at once. This situation hasn't always worked out well for visual artists. From a careerist stance, it has put unfortunate pressure on them.

How did your mentors guide you?

I think it was more attitudinal than anything else. My mentors and teachers encouraged me, telling me that I had what it took to be an artist and that I would survive and not starve. At Yale, Al Held, who died in July, told us what it was like to live in New York: how to get a loft, how to do your own plumbing and electrical work, how to live illegally, how to put up sheetrock, and how you support yourself. He made the city seem exciting and less scary. Philip Guston was also one of my critics. Many amazing artists, whom I had only read about in books, taught at Yale, and we had a chance to see them as regular people with all their flaws. That experience knocked them off their pedestals, which is really important because we saw them as human and then focused on the good work they did.

What do you think of students exhibiting their work before they graduate?

Part of the problem is that schools require students to make consistent work instead of encouraging them to bash around and try a lot of different ideas and different styles. Young artists should resist zeroing in on one style and narrowing their vision so early. My classmates at Yale University, among them Nancy Graves, Janet Fish, Richard Serra, Brice Marden, and Rackstraw Downes, later became the who's who of the art world, but none of us could have publicly shown the work that we did in graduate school. When Janet lectures, she shows slides of both our student and recent work—her audiences can never figure out who made what as a student. That is a good sign: we figured out what we wanted to do after we left school. I absolutely believe and have always believed that artists shouldn't go public with work until they are ready to lay their necks on the line—which means that anything an artist did before going public is nobody's business. But the minute you decide to go public, an artist sets a specific trajectory and seems to truncate other options. I think it is really good to bang around for a while and really be sure that you can live with the work that you make for a long time before you decide to show it.

What do you think about getting an education in a small art school as opposed to a large university? Does it make a difference?

I believe in a liberal arts education. I am not a big fan of art schools. I think artists ought to take a variety of courses outside art or art history. I encouraged my own children, both of whom thought they wanted to be art majors, to go to a liberal arts school. Both changed their minds and decided to enter careers outside art. However, I also think that art should fit into a larger college and university experience.

Many artists choose not to pursue an MFA, which I usually find to be a mistake. Most people who didn't go to graduate school say years later that they wished they had.

What advice would you give today's undergraduates, graduates, and perhaps even high school students?

I think a life in art can be a wonderful life. One of the great indictments of the capitalist system is that so few people in America get any pleasure from what they do for a living.

There is something about being an artist that can be wonderful and fulfilling, no matter if he or she is successful or not. But I would caution against having raised expectations—that the world owes you a living or that the art world beats a path to your door. I don't think there is undiscovered genius out there, but I do think that you can be a very competent artist—and even become a better artist than others who are more successful.

However, a lack of success or recognition can be distressing and can make an artist bitter, resentful, and angry. I think it's important to remember that life isn't fair. You had better be doing what you're doing because the very activity itself is

important. The pleasure you get from making art will sustain you because you cannot count on getting or maintaining attention and success. Only a handful of artists make a living from their work. And often the living is barely above poverty level. If you expect to get rich and famous, you will probably be disappointed.

What would you say to students who begin teaching after they graduate?
In my time, the art world was exploding in size, and art education was taking off. Art schools went from a faculty of two or three to a faculty of forty within only a few years.

There were jobs everywhere. It's not the same today, but now there are more artists competing for those jobs. Not everyone should teach, though. Not everyone does well in a teaching environment. Many teachers cannot fit their art making into their work life.

Sometimes it's better to find another occupation to support oneself. Do something different for a living and then come home and do art.

How has the art world changed since you emerged as an artist?
When I came to New York in 1960s, there were eighteen to twenty galleries between Fifty-fifth and Eighty-sixth Streets that showed contemporary art. You could walk it all in one afternoon, once a month, and see everything. If you showed, everyone—particularly friends and fellow artists—saw the exhibition easily. There are so many galleries and so many choices today. It's much harder to have people see what you do, which is a problem. The buzz is more important now, and the artist has to create it. Gallery owners ask, "Who are the hot people?" and flock to see the artists, who are seeking attention. Those artists can become instantly "hot," but then artists live and unfortunately die by that hype.

Any advantages to having so many galleries today?
What is good for the art world is sometimes tough on the individual artist. The art world is such a dynamic place because it gobbles up artists and always demands something new. While there may be a smorgasbord of things to look at, which is a plus, artists often think that they need a career strategy. This kind of strategizing has put an unfortunate pressure on young and emerging artists who feel like they have to do desperate things in order to get attention. If artists stayed home and worked, they would probably be in better shape to make something happen. And yet there is a rich and enormous range of art showing today, which is good for everyone.

Robert Thill, Director, Center for Career Development, The Cooper Union
Robert Thill is the director of the Center for Career Development at the Cooper Union for the Advancement of Science and Art in New York. His writing has appeared *Art Criticism, Flash Art,* and *Leonardo,* and he has written exhibition material for the Drawing Center, the Stedelijk Museum Bureau Amsterdam, and the Art Gallery of Windsor, Ontario. Thill is an adviser to Artsactive Network,

an international organization that strives to promote the presence of artists in scientific and industry projects and the presence of scientists and business people in artistic contexts.

What do you think is *the* most pressing professional development issue for a beginning fine artist?

It is essential for beginning fine artists to consider that art-making takes place within a large and diverse context. While professional development for artists is specialized, with its own set of esoteric customs, skills, expressions, nomenclatures, frames of reference, bodies of knowledge, rites of passage, and career thresholds, it also has a vital relationship to other fields of study and to local and international conditions. In fact, it is very much a part of the increasingly networked world, with online discussions in which English is the dominant language open to those with access to the Internet and the necessary research skills to find them. So, for instance, fine artists around the globe can now observe and participate in discussions surrounding major exhibitions, such as Documenta in Kassel, Germany. These kinds of activities and discussions are held in archives and can be accessed for study. Developing an understanding not only of the dialogues that are taking place between those involved in the academy and the culture industry, but also of the conversations and dynamics of the larger sociopolitical and economic circumstance, both in historical and contemporary terms, is important for artists.

I also think the fundamental question of whether or not individuals perceive "fine artist" as being a professional designation that defines their social role and activities continues to be up in the air, especially among those who see their art pursuits as apart from more conventional employment contexts or those with intentionally hybrid approaches. Even the professional name of "fine artist" is a bit awkward. It evokes a historic or academic category, sounding almost quaint in relation to advanced art, and even connoting a kind of gentility that is at odds with some of the art associated with it. It is far more typical of fine artists to describe themselves simply as artists, visual artists, or studio artists. When considering their fundamental professional development, beginning artists might think about whether or not the traditional models of preparation by attending an art school— and the career trajectory of starting with participation in group exhibitions, which might lead to solo exhibitions, gallery representation, displays in art fairs, and then university art museum exhibitions, biennials and international exhibitions, and corporate-sponsored prize exhibitions, followed by major museum exhibitions— are the most relevant paradigms to follow. It is increasingly important to consider new ways of organizing, fund-raising, and presenting. Creating new kinds of relationships and venues, including potentially reshaping established institutions, rather than being defined solely by existing structures is a challenge for young artists. How one defines his or her creative activity is personal and linked to one's values, ideas, self-conception, life experience, intellectual interests, and social engagement, all of which will probably be philosophically linked to the art. However, "personal" is not intended as a code word for only individualized or isolated approaches; it could mean an emphasis on collaboration or endeavors that

are not immediately recognizable as art, such as art that uses familiar technology or routine human interactions in novel ways to express an idea. On a more pragmatic level, "fine artist" is cataloged by the Department of Labor and described and diligently qualified by the Bureau of Labor Statistics.[1]

In an academic context, artists frequently position their own art-making in professionalized terms; they may refer to themselves as having an art "practice" and define their role as a "professional artist," whose art-making practice includes research and exhibition. The College Art Association issues standards and guidelines that include "Visual Artist Curriculum Vitae: Recommended Conventions," which counsels artists to "keep in mind that the studio artist's exhibition record is the equivalent of a publication record in other academic disciplines";[2] nevertheless, it is still typical, widespread, and expected that artists will write, publish, and present work at professional association conferences, especially in relation to exhibitions. In general, artists in academia adopt terms and positions analogous to those of traditional scholarly pursuits,[3] with the accompanying hierarchy and promotional steps toward tenured teaching posts. On a more mundane level, artists who are educators often belong to labor unions, must navigate workplace politics and work on institutional and learning goals and strategic plans. They must also operate within a work milieu that privileges personal and professional reputation. Despite artists' strategic activity to align their roles with traditional academic models, it can sometimes be difficult for students of studio art to differentiate between their professors' roles as artists and their roles as educators, which is an important distinction, even when the roles overlap or are purposely integrated and seamless, especially when the person in question is considering a career in education. Simply being able to grasp the idea that educating and making art might be part of the same creative practice is significant. At the same time, these professionalized terms might be perceived as being in uneasy company with art practices that subvert convention, critique art as a commodity, and/or question art in relation to professional and institutional paradigms.

I think that the question of artists as professionals continues to be relevant and vital for many, especially when considering whether or not professionalism serves to subtly undermine experimentation or potentially expand it, as fine artists become more aligned with professional conventions. And it certainly comes into play in establishing the position of artists in social and economic hierarchies, considering that intellectual stature has been a primary currency from the Renaissance to the current often overly simplified emphasis on forms existing primarily in the service of concepts. Some mature artists continue to refer to themselves as "students of art" as a way to quash the oversimplified amateur/professional dichotomy. Certainly, many artists do not see a conflict here, and interpret the professionalization of artists as creating more autonomy in practice and increased opportunity, even if the overall professionalization of fine art also produces more competition, since the audience for art has also enlarged.

Many artists wish their art (and themselves) to evade easily fitting into established categories because of the accompanying restrictions on the expectations and reception of their art and the assumption that stimulating, relevant, or advanced art

will always be recognizable as a new addition to an established, ongoing dialogue. Thus there are fine artists who are concerned that their careers might too closely resemble those of popular musicians known only for one hit song or that they might be quickly dismissed as irrelevant and/or regressive. Like other industries, art has its own structures in place that can be difficult to challenge. For instance, it often happens that even expressions that are thought to have been created beyond or without an art context are immediately recontextualized in relation to art's ever-expanding systems. A simple example of this would be so-called "outsider" or "visionary" art—works made by people who are untrained in the arts and who are existing in a variety of conditions and circumstances (and sometimes also made by trained or at least encouraged animals)—which now has its own established realm of dealers, collectors, scholars, institutions, and canon. There is an increasing sense that all areas of expression are or can be readily absorbed into art categories (already colonized or ready to be defined): even art that is interventionist, performative, ephemeral, or based on new technology is examined and interpreted in ways that discover and trace its history, even if that history is unknown to the person who created it. This can have the positive effect of illuminating such works, but it can also be reductive, not allowing for understanding that might only emerge over time.

Young idealistic artists, who are at once easily influenced and quickly rebellious, sometimes dismiss what is often perceived as the traditional path of making a living by teaching in favor of a more independent way of supporting themselves and their art, more aligned with their own values and, by a matter of degrees, more free from institutional support. Thus it is not uncommon for art students to perceive hypocrisy or at least register suspicion when tenured professors advocate for an anti-materialist, independent-thought approach to art. Easy for you to say, with your highly competitive position secured, is a common response. The nuances of this discussion start to become more apparent when the same young artists try to get their art practices off the ground and begin to see that even raising independent funds can be fraught with contradictions. For example, a group of recent graduates of the Cooper Union School of Art who created a thought-provoking and ambitious project called OurGoods.org,[4] which focuses on bartering, 'fessed up in their fundraising pitch to the irony of raising money via Kickstarter.com to help launch the education arm of their organization, which is called "Trade School" and consists of education by barter rather than by direct payment of currency. They saw the contradiction of raising direct funds for a project that espouses bartering, yet chose to do it anyway to propel the project into the world. Engaging these spaces of potential contradiction or paradox presents opportunities for deep thought and learning for artists.

In short, making the conceptual link between the art and the art practice, so that there is a deliberate thrust toward raising questions about prevailing ideas, is an important aim for artists. In fact, the Cooper Union School of Art's philosophy emphasizes "the advancement of the artist's role in initiating critical responses and alternative models in relation to the prevailing forms and institutions of cultural production".[5]

What are some of the best resources you use to help artists start their careers?

While there are many resources for artists, most of the art students I work with seem less inclined to read a book about career development than to seek information through methods that might be more connected to experiential learning, through discussion (career counseling or presentations of other artists' work and career paths), or by following threads in their own related research. I think contemporary variations of the historical apprentice system are still relevant, especially if approached with a critical eye, with special consideration given to the relationship between the ideas and the making. If pressed, I would recommend Steven Henry Madoff's (editor) *Art School: Propositions for the 21st Century* (2009) for its useful examination of the history and forms of fine arts education, as well as its future. The reflections by many prominent artists on the topic of their own educations would be of special interest to beginning fine artists.

What do you think are the most important things an artist should know about the reality of starting a studio practice and being a practicing professional?

I think it is important to acknowledge that becoming an artist takes courage and commitment, and involves great risk. At the same time, it is a pursuit that can be richly repaid. That said, it is essential to consider the individual circumstance of each artist. Three areas of interest are social experiences, education, and finances. It is not so unusual for some artists to be from families in the arts; these beginning fine artists might already have a very direct social experience working as artists, including the attendant struggles, and they might also be better positioned than others with ready-made contacts and, in some cases, a monetary stream. Their struggle might be more involved with establishing their own artistic identity, an obstacle that might seem like a luxury in comparison to those faced by artists with no background in the arts. Likewise, artists who have little social experience with art but have the interest and talent will face more or different kinds of challenges, depending upon their skills and resources. They have to learn an entire world from scratch. On the positive side, they might not have the experiential baggage or the same expectations as someone more familiar with art, and seeing the field freshly can trigger innovation. Education is certainly an important issue. A degree is not necessary, but a lack of understanding of the fundamental discussions in the art realm can create enormous obstacles, especially as more and more artists pursue master's degrees and more (so that debt associated with education is also a problem for artists). Financial considerations are important from the start, because this can be a dynamic in determining the form that art takes. The amount and kind of available resources can also channel students into specific kinds of practices. For instance, some might not see certain kinds of art-making as realistic avenues based on their resources and their ability to raise funds for projects. What will be their source of income? How will their art practice be sustained? If this is not scrutinized in a meaningful way at some point, the art-making can give way to a pursuit of basic survival. I think becoming an artist takes courage and commitment, and involves great risk.

Young artists should be aware that galleries are interested not only in their immediate art, but also in their potential—whether the artist demonstrates the drive, vision, and even the financial means to create future work. They should also be mindful that the costs of creating, framing, presenting, documenting (photographically and potentially as a Web site), crating, shipping, local transportation, insuring, and storing art generally fall on the artist—and the costs can easily far exceed both the material value and the market value of the art. Lastly, it is important to recognize that the continually rising cost of living in art marketplaces like New York City makes living and working as an artist in those areas and communities increasingly difficult.

The costs of creating, framing, presenting, documenting (photographically and potentially as a Web site), crating, shipping, local transportation, insuring, and storing art generally fall on the artist—and the costs can easily far exceed both the material value and the market value of the art.

Can you share any activities or workshop topics that you've found particularly effective in helping artists prepare for their careers?

I have introduced students to the concept of fiscal sponsorship, which is a specific kind of relationship between an artist and a not-for-profit organization. Fractured Atlas, an organization that offers fiscal sponsorship, defines it in the following way: "Fiscal Sponsorship is a financial and legal system by which a legally recognized 501(c)(3) public charity [such as Fractured Atlas[provides limited financial and legal oversight for a project initiated independently by an artist".[6] Fiscal sponsorship donations to artists' undertakings or projects provide donors with tax deductions and also cause artists to be held accountable to their fiscal sponsor in terms of how the funds are used. Fiscal sponsors all have slightly different rules, but in general artists must drive the fundraising process, while some assistance is offered in the form of project descriptions displayed on the Fractured Atlas Web site and reviews of grant applications, to ensure that they best represent the project to the sponsoring organization. Organizations that judge the artistic merit of the projects that they sponsor, such as the New York Foundation for the Arts, lend their endorsement to the projects, and this kind of vetting system can appeal to some donors. I have organized a fiscal sponsorship program as part of a special topics series. It takes the form of an artist's visual presentation: an artist who is fiscally sponsored shows his or her art and discusses how he or she has used this fund-raising mechanism to support specific projects. A representative of the fiscal-sponsorship organization is typically a co-presenter who can discuss how fiscal sponsorship works and effective ways to use it. I think that understanding a fund-raising mechanism, which is part of U.S. tax law, through the art that it fuels is an inherently more engaging way of teaching students about it than simply having a representative of a not-for-profit organization talk about how artists can participate and how they manage these programs. I think it also puts both artist and organization in an interesting dialogue that indirectly reveals the nuances of their relationship. Fiscal sponsorship is a solid approach to fund-raising, and also allows artists to apply for grants, find other opportunities, and access materials that

are only available to not-for-profit organizations. It has been challenging to create interest in fiscal sponsorship, partly because it can be perceived as boring and complicated. Currently, there is a lot more interest in and activity with Kickstarter. com, which has fundraising goals and target dates that create a sense of urgency and uses material incentives in exchange for donations. The Web site describes the latter aspect in the following way: "On Kickstarter.com, project creators inspire people to open their wallets by offering products, benefits, and fun experiences." However, Kickstarter.com cautions that "projects may not offer financial returns under any circumstances".[7] While I think this avenue is important and effective, as well as having the patina of being hip, which can be appealing to students, it does not exclude an artist from also participating in fiscal sponsorship. Like fiscal sponsors, Kickstarter.com takes a percentage of the money artists raise as an administrative fee. Kickstarter.com's Web site is very engaging and also offers an interesting secondary resource, since it publicly displays projects in advance of their execution, which makes it an interesting arena of emerging ideas. (The display of projects at Fractured Atlas is often intentionally broad, making that site less lively.)

We have also focused on key issues in starting a small business, which is a way to structure one's art practice. In this area, beginning artists need an accountant with experience in tax preparation for artists and a lawyer.

Depending on the type of art produced, beginning artists might also need to be able to identify fabricators, framers, Web designers, photographers, and other skilled workers and vendors to help produce their art. Developing good working relationships with those who can produce high-quality work can be a complex and expensive undertaking that is akin to project management: not everyone delivers what is promised.

1. "Fine artists typically display their work in museums, commercial art galleries, corporate collections, and private homes. Some of their artwork may be commissioned (done on request from clients), but most is sold by the artist or through private art galleries or dealers. The gallery and the artist predetermine how much each will earn from the sale. Only the most successful fine artists are able to support themselves solely through the sale of their works. Most fine artists have at least one other job to support their art careers. Some work in museums or art galleries as fine-arts directors or as curators, planning and setting up art exhibits. A few artists work as art critics for newspapers or magazines or as consultants to foundations or institutional collectors. Other artists teach art classes or conduct workshops in schools or in their own studios. Some artists also hold full-time or part-time jobs unrelated to art and pursue fine art as a hobby or second career. Usually, fine artists specialize in one or two art forms, such as painting, illustrating, sketching, sculpting, printmaking, and restoring. Painters, illustrators, cartoonists, and sketch artists work with two-dimensional art forms, using shading, perspective, and color to produce realistic scenes or abstraction." Quote from "Artists and Related

Workers," *Occupational Outlook Handbook, 2010-11 Edition,* the Bureau of Labor Statistics (BLS), http://www.bls.gov/oco/ocos092.htm/.

2. "Visual Artist Curriculum Vitae: Recommended Conventions," "Standards and Guidelines," College Art Association, http://www.collegeart.org/guidelines/visartcv.

3. With their generalized emphasis on technical skills and self-expression, studio fine arts are sometimes viewed as a narrow an academic area, with attendant questions about their value in relation to other fields of study. Yale University is often cited as one of the first institutions in the U.S. to offer the degree of Bachelor of Fine Arts, which was first conferred in 1891. See "Timeline of Selected Events in the History of Yale University," Yale University, http://www.library.yale.edu/mssa/YHO/timeline_text.html.

4. OurGoods.org, http://ourgoods.org/.

5. Mission Statement, The Cooper Union School of Art, *2010--2011 Course Catalog,* The Cooper Union for the Advancement of Art, http://cooper.edu/assets/pdfs/cat1011art.pdf/.

6. "Fiscal Sponsorship," Fractured Atlas, http://www.fracturedatlas.org/site/fiscal/.

7. "Project Guidelines," Kickstarter, http://www.kickstarter.com/help/guidelines/.

Refining Your Goals: Balancing Life and Work

𝔙20𝔯

Inspiration for Refining Your Goals

Often the difference between a successful person and a failure is not one has better abilities or ideas, but the courage that one has to bet on one's ideas, to take a calculated risk—and to act.

—Andre Malraux

These are fundamental ideas about how artists can create a working, artistic life that we have found repeated throughout our interviews and research. There are limitless possibilities for creating the best possible work life as an artist. The following are summaries of ideas we've explored in this book. We invite you to use the space provided below to reflect on these concepts and write your thoughts on how these ideas can influence your life.

Now it's your turn; nobody is going to create the life you want but you. It's all up to you.

Make work! Commit to time in the studio and be safe with your materials.

Reach out and be involved in your community. Don't isolate yourself in your studio.

Do your research, whether it's looking into alternative spaces, contacting galleries in your area, or regularly attending exhibitions.

Be a part of your arts community! These communities are everywhere, and you don't have to participate in the art world of a major city to live a full life in the arts.

Be a hybrid artist/designer/entrepreneur/curator; be anything and everything you want to be.

Get creative outside of your studio; designate a day for all the activities you have to do outside of your studio work to sustain it.

Start now! Don't wait for permission to act.

Taking Action: Refining Your Goals

Now that you've read this book, collected ideas, and done your research, here is space to refine or rethink your goals.

Write down two to three career goals you want to achieve within the next year. Then ask yourself the following questions:

- How can I describe in words or visually define my strategy and specific activities I can act on to get closer to my goals?

- Where do I start my research?

- Who can help me reach my goal?

- Map it out. How can I make this goal or goals happen? This is the beginning of your action plan!

Try exploring some long-term goals. It's a good idea to start thinking about these goals, even if they seem difficult to conceive of at this stage in your career. Ask yourself the following questions:

• Where do I see myself in five years?

• Again, what do I need to do to reach those goals, and who can help me get there?

• What finances need to be in place?

• Do I have studio/work space concerns?

• Do I have role models I can look to or speak with about my plan?

How do you envision your ideal creative community? Ask yourself the following questions:

- How can I take steps now to begin building/reaching out to that community?

- Who is on my wish list of contacts?

- Who are my role models, and who can I look to for mentorship and guidance?

- Whose artistic careers do I draw from and emulate?

The following interview comes from a dynamic and popular figure in the cultural world, Tim Gunn, who was trained as a fine artist and has gone on to create a successful life in the arts, for which he is a passionate advocate.

INTERVIEW WITH TIM GUNN, CHIEF CREATIVE OFFICER AT LIZ CLAIBORNE INC. AND HOST OF PROJECT RUNWAY

Tim Gunn is chief creative officer at Liz Claiborne Inc. where he is responsible for attracting, retaining, and developing the creative talent. Gunn served as a member of the administration and faculty at Parsons The New School for Design for close to twenty-four years, where he had a rich and deep history with the institution, including serving as chair of the Department of Fashion Design at Parsons. He is well-known as on-air mentor to designers on the reality television program *Project Runway*. Gunn's popularity on *Project Runway* led to his spin-off show, Bravo's *Tim Gunn's Guide to Style*, as well as his book *A Guide to Quality, Taste and Style*.

Can you tell us about your own experience as a fine arts student?
I graduated with my BFA in sculpture from the Corcoran College of Art and Design.

I spent most of my life hating school and thinking it's a game and a trick and all the answers are in the back of the book so let's just go there. The Corcoran is where I discovered fine arts and found a new, nurturing world where all the answers weren't in the back of the book. So many worlds opened up for me. The fine arts spoke to my insatiable curiosity and desire to quench it, and there were so many roads to go down.

My experience at the Corcoran transformed how I navigate the world. I learned listening and respect through tough experience and mentors. Through my fine arts education, I learned you must have respect for yourself and what you do. What I learned in fine arts I apply to my life every day. The introspection required of fine arts studies is different than design professions. You are *all* you've got. There is no client whose needs you must serve. In design, you have clients you need to satisfy, and the work sits outside you as you solve someone else's problem. In fine arts, you are the client serving your own needs; it's all inside your self. I learned the value and uses of investigation and research. As an artist, you don't just sit waiting for the muse to strike you; you have to take the initiative.

After I graduated from the Corcoran, I earned my living making models for an architecture firm in Washington, D.C. Then I was hired as a teaching assistant in a high school summer program, and that reestablished my relationship with my alma mater's fine arts department. I taught for two years before deciding not to be a studio artist. Teaching was cathartic, and I was exhausted from giving everything I had to my students. I was drained of my creativity and at first felt very apologetic for not doing my work, but I was teaching 3D design and applying my creative skills through my teaching.

What advice do you have about internships?

When I was a student and an assistant, I did everything 150 percent. I cleaned the windows, cleaned the whole studio without being asked, I just did it all. You must put in this level of effort because you are *constantly* being judged. Do everything 150 percent. Get the coffee and do it gladly! I was mortified recently when I met a young lady at a coffee shop who told me she was interning at Condé Nast, and when I asked what she was doing, she rolled her eyes and said mostly just getting coffee. I told her, "Young lady, if you walk away from this conversation with one thought, you should always do your best, smile, and do it all with great respect and gratitude." View all interviews and interactions as learning experiences, even bad ones. Don't burn bridges.

You are known for being a great mentor. What advice can you give artists on the importance of developing these relationships?

It is important to have a guru for counseling and advice. You need a mentor, someone with the capacity to understand you and your DNA. Find someone with the ability to deliver tough love, not someone who is a coddler or enabler. Artists sometimes choose the wrong person as a mentor, and they can frequently be enablers of delusional and bad behavior. The best advice I got from a mentor was that it doesn't matter if it's only for fifteen minutes—go to the studio *every* day.

Can you tell us where your *Project Runway* catchphrase, "Make it work," came from? And how might this advice apply to fine artists?

I first said it to a concept development class for Parsons seniors during career day preparation. A student was having a problem and said that they were just going to start over. I said, "Diagnose the problem and offer up a prescription and make it work. The easiest thing in the world is to throw it out. Take something you are struggling with and take it to a place where you can be proud of it." It's a profound experience. When designers at Liz Claiborne have a problem or feel frustrated, I tell them to come with me and sit for ten minutes in the designer lounge and then go back and see it all afresh.

What is a valuable interpersonal skill for artists to develop?

Listening is critically important, and the whole capacity for listening is eroding. *Listen* and wait for the other person to finish. That person you might be inclined to be rude to could be someone you have to interview with in the future. You can often tell when someone isn't even listening long enough for you to finish, and they've already jumped ahead to what they assume you're going to say next. Even listening has a dimension of respect to it. Remember, don't take comments personally; it's not just about *you*.

Can you speak about the importance of self-discipline?

Being a fine artist takes incredible self-discipline. You need to have respect for others and present only your best work. There has to be a quality of execution and the ability to know what is superbly executed and what's not. You need a

trained eye on your *own* work. It's all an extension of your quality of character. Be someone who cares. Content issues aside, ask yourself if the work is well executed. If the content is so profound, why would you obfuscate it through poor execution? My refrain is: I can't want you to succeed more than you want to. Show some passion. Show some respect.

What are your opinions on transitioning from being a student to being a professional artist?

Student work or less mature work often tries too hard, with lots of bells and whistles. You need tenacity, love, and passion. You *have* to love it to pursue any career in the arts. Even if you don't live in New York and don't have a gallery and are not selling work, art should still be what you *have* to do.

You need time to mature, life experience, and to keep working. Many *Project Runway* contestants had to audition several times over a few years in order to reach a level of maturity in their work. For example, Seth Aaron, the contestant who won season seven, auditioned four times. Another contestant auditioned three times and finally won, but she sent me a nasty e-mail after she was rejected the first time. I asked her later what she thought about that and she regretted it horribly.

Unless you are really a prodigy, work right out of school is still *student* work. Great work doesn't just happen because time passes. I want to know what you've done *since* school—don't show student work. Student work is often clearly faculty directed/influenced.

What is your opinion on graduate school for artists?

One needs time off to identify what your graduate school needs are. Take time off between undergraduate and graduate school to build life experience. You need space and distance to go to graduate school and identify what discipline you really want to focus on. For example, if you go to graduate school right after undergraduate, you may assume you want to focus on painting, but if you wait five years and gain more life experience, you might realize your true interest is French literature.

Do you have any further words of advice for emerging artists?

A fine arts career is a path, and you shouldn't even *want* to know what's next. Sometimes you'll move fast, and sometimes you'll move more slowly. You need time to synthesize and apply what you learn along the way so it sticks. The whole point of fine arts is to be who you truly are. Take risks and shake off your comfort zone!

You don't have to leave your own backyard to be a great artist. Joseph Cornell, whose work had a heavy influence on me, is a great example. He wedded all the elements of art and culture so they converged in his art (literature, film, poetry, music), all with such depth.

Recommended Books

There are lots of resources and sources of inspiration for artists. We are just going to give you a few suggestions of good resources to get you started in your research.

Bayles, David and Ted Orland. *Art and Fear: Observations on the Perils (and Rewards) of Artmaking.* Santa Barbara: Capra Press, 1994.

Bhandari, Heather Darcy, and Jonathan Melber. *Art/Work: Everything You Need to Know (and Do) As You Pursue Your Art Career.* New York: Free Press, 2009.

Crawford, Tad, and Susan Mellon. *The Artist-Gallery Partnership: A Practical Guide to Consigning Art.* New York: Allworth Press, 1998.

Rossol, Monona. *The Artist's Complete Health and Safety Guide.* New York: Allworth Press, 2001.

Rosenberg, Gigi. *The Artist's Guide to Grant Writing: How to Find Funds and Write Foolproof Proposals for the Visual, Literary, and Performing Artist.* Watson-Guptill, 2010.

Battenfield, Jackie. *The Artist's Guide: How to Make a Living Doing What You Love.* Cambridge: Da Capo Press, 2009.

Basa, Lynn. *The Artist's Guide to Public Art: How to Find and Win Commissions.* New York: Allworth Press, 2008.

Crawford, Tad. *Business and Legal Forms for Fine Artists.* New York: Allworth Press, 2005.

Crawford, Tad. *Legal Guide for the Visual Artist.* New York: Allworth Press, 2010.

Nesbett, Peter, Sarah Andress, and Shelly Bancroft (eds.). *Letters to a Young Artist.* New York: Darte Publishing, LLC, 2006.

King, Ross. *Michelangelo and the Pope's Ceiling.* New York: Penguin, 2003.

Rand, Steven and Heather Kouris (eds.). *Playing by the Rules: Alternative Thinking/Alternative Spaces.* New York: Apexart, 2010.

Lazzari, Margaret R. *The Practical Handbook for the Emerging Artist.* New York: Wadsworth Publishing, 2001.

Thornton, Sarah. *Seven Days in the Art World.* New York: W. W. Norton & Company, 2009.

Lang, Kay. *Taking the Leap.* San Francisco: Chronicle Books, 2006.

Winkleman, Edward. *How to Start and Run a Commercial Art Gallery.* New York: Allworth Press, 2009.

Web Sites, Blogs, and Online Resources

Art in America, Annual Guide to Galleries, Museums, Artists
www.artinamericamagazine.com/directory
Art in America will be launching an online version of its Annual Guide in September. The directory will include galleries, museums, nonprofit exhibition spaces and many more industry-related businesses.

art21
http://www.pbs.org/art21/artists/index.html
This is a PBS Web site with links to extensive interviews with a variety of well-known artists. Also check out PBS's Art Beat blog with current news on the visual, literature, film, music, and cultural scene at *http://www.pbs.org/newshour/art/blog/.*

Artcritical
artcritical.com
This is an online magazine of art and ideas.

Art Forum
http://artforum.com/
Art Forum magazine is online at this site.

artnet
www.artnet.com
A site with an online gallery connected to over 2,200 galleries worldwide. Other services include an online magazine with a guide to the art market with daily news and reviews.

Artkrush
www.artkrush.com
Artkrush is an e-mail magazine dedicated to the coverage of international art, design, and architecture. The site spotlights notable artists, exhibitions, events, and trends.

Artsyshark
www.artsyshark.com
A blog for emerging artists with terrific articles on career issues written by artists, gallerists, and other art world professionals.

ArtTable
www.arttable.org
Through activities and initiatives, ArtTable is dedicated to supporting women in the visual arts at all stages of their careers, documenting outstanding achievements by women past and present, increasing opportunities for women, and in so doing, enriching the nation's cultural life.

BOMBlog
http://bombsite.com/blog
BOMBlog aims to provide emerging artists and writers a platform to articulate and explore their ideas, their own work, and their practice in relation to their peers and predecessors, in a variety of formats.

BRIC Arts Media Brooklyn
www.bricartsmedia.org
BRIC has enriched the cultural landscape of Brooklyn by presenting, producing, and enabling a wide array of quality contemporary art, performing arts, and community media programs. BRIC reaches upward of a million Brooklyn residents each year with compelling and accessible programs. Individuals, nonprofits, community groups, schoolchildren, educators, and artists borough-wide all benefit from our exhibitions, performances, television programs, and education programs as well as the subsidized platforms for artists and community members to develop and present works.

Brainstormers
www.brainstormersreport.net
Brainstormers is an art collective that, through public performance, exhibition, publication, Internet, and video, has forced discussion on a topic that most would rather avoid: gross gender inequities in the contemporary New York art world.

Brooklyn Rail
http://brooklynrail.org/
This online magazine contains critical perspectives on arts, politics, and culture.

Guerrilla Girls
www.guerrillagirls.com
This Web site is the home page for the Guerrilla Girls, offering detailed historical background on the group's activities and information on feminist political issues.

Metropolis M
http://www.metropolism.com/english
This is a great site to read about current, international art news, and trends.

On Verge
www.on-verge.org
On Verge is an online forum for arts and cultural dialogue. Populated by the writing, opinions, and musings of CUE Foundation's Young Art Critic Mentoring Program Alumni, on-verge.org serves as a platform to present to readers art and culture that may not be covered by mainstream media. This site continues the long-lasting relationship with our fantastic emerging writers and gives them the opportunity to highlight emerging and under-recognized artists across the globe.

The Public Art Fund
www.publicartfund.org
The Public Art Fund is New York's leading presenter of artists' projects, new commissions, and exhibitions in public spaces. For more than thirty years the Public Art Fund has been committed to working with emerging and established artists to produce innovative exhibitions of contemporary art throughout New York City. By bringing artworks outside the traditional context of museums and galleries, the Public Art Fund provides a unique platform for an unparalleled public encounter with the art of our time.

TED (Technology, Entertainment, and Design)
www.ted.com
TED is a small nonprofit devoted to ideas worth spreading. It started out (in 1984) as a conference bringing together people from three worlds: technology, entertainment, design. This site features riveting discussions by remarkable people.

The Warhol Initiative
www.warholfoundation.org/grant/initiative.html
The Warhol Initiative is an invitational program designed to bolster the organizational capacity of small- and mid-sized, artist-centered organizations across the country. The Initiative has provided sixty-one participants with cash grants of approximately $125,000, professional consulting services, and triennial conferences that bring the groups' leaders together for networking, workshops and training sessions with nonprofit management consultants.

Arts Organizations

A.I.R. Gallery
www.airgallery.org
A.I.R. Gallery is a nonprofit Organization. It was the first cooperative for women artists in the United States. The goal of the gallery has been to provide a professional and permanent exhibition space for women artists to show work of quality and diversity. A.I.R. is an artist directed and maintained gallery that has provided a sense of community for women and served as

a model for other alternative galleries and organizations. Through lectures, symposia, and a Fellowship Program for emerging women artists, A.I.R. serves to maintain a political awareness and voice and to bring a new understanding to old attitudes about women in the arts.

American Association of Museums
www.aam-us.org
The American Association of Museums has been bringing museums together since 1906, helping to develop standards and best practices, gathering and sharing knowledge, and providing advocacy on issues of concern to the entire museum community.

Americans for the Arts
www.artsusa.org
Celebrating its fiftieth anniversary in 2010, Americans for the Arts is the nation's leading nonprofit organization for advancing the arts in America. Americans for the Arts is dedicated to representing and serving local communities and creating opportunities for every American to participate in and appreciate all forms of the arts. From offices in Washington, DC, and New York City, it serves more than 150,000 organizational and individual members and stakeholders.

Bronx Council on the Arts
www.bronxarts.org/
The Bronx Council on the Arts is a private, nonprofit membership organization that is the official cultural agency of Bronx County. Recognized nationally as a leading arts service organization in providing cultural services and arts programs, BCA serves a multicultural constituency in excess of 1.2 million residents. BCA provides an array of services to artists and arts and community-based organizations.

Chicago Artists Resource (CAR)
www.chicagoartistsresource.org/
CAR is a program of the Chicago Department of Cultural Affairs. CAR describes the landscape of opportunity for Chicago artists working in dance, music, theater, and visual arts through a unique combination of an artist-curated resource directory, and links to local and national organizations.

College Art Association
www.collegeart.org
Promotes excellence in scholarship and teaching in the history and criticism of the visual arts and in creativity and technical skill in the teaching and practices of art, and fosters career development and professional advancement.

Creative Capital
www.creative-capital.org
Creative Capital is a national nonprofit organization that provides integrated financial and advisory support to artists pursuing adventurous projects in all disciplines. Our pioneering approach combines funding, counsel, and career development services to enable a project's success and foster sustainable practices for its grantees.

CUE Art Foundation
www.cueartfoundation.org
CUE Art Foundation is a 501(c)(3) nonprofit forum for contemporary art that provides extraordinary opportunities for under-recognized artists and compelling encounters for audiences. CUE gives artists, students, scholars, and art professionals resources at many stages of their careers and creative lives. We also offer comprehensive arts education programs for artists and students, and interdisciplinary arts events for public audiences from our large storefront venue located in the heart of New York City's Chelsea Arts District.

Elizabeth Foundation of the Arts
www.efanyc.org/
EFA is dedicated to providing artists across all disciplines with space, tools, and a cooperative forum for the development of individual practice.

The Elizabeth Greenshields Foundation
www.elizabethgreenshieldsfoundation.org
The objective of the Foundation is to promote, by its charitable activities, an appreciation of traditional expression in painting, drawing, sculpture, and printmaking, by aiding worthy art students, artists, or sculptors who need further training or other assistance during their formative years.

The Foundation Center
www.fdncenter.org
The Foundation Center is a national nonprofit service organization recognized as the nation's leading authority on organized philanthropy, connecting nonprofits and the grantmakers supporting them to tools they can use and information they can trust.

Fulbright Program
http://us.fulbrightonline.org/home.html
The Fulbright program is sponsored by the U.S. Department of State and is the largest U.S. international exchange program offering opportunities for students, scholars, and professionals to undertake international graduate study, advanced research, university teaching, and teaching in elementary and secondary schools worldwide.

The Joan Mitchell Foundation
www.joanmitchellfoundation.org
The Joan Mitchell Foundation was established in 1993 to fulfill the ambitions of Joan Mitchell to aid and assist the needs of painters and sculptors. The foundation seeks to demonstrate that painting and sculpture are significant cultural necessities. To further this mandate, the foundation annually awards grants to painters and sculptors, supports outside programming such as workshops and residencies serving individual artists, and provides free art education opportunities for New York City Youth.

John Simon Guggenheim Memorial Foundation
www.gf.org
United States Senator Simon Guggenheim and his wife established the John Simon Guggenheim Memorial Foundation in 1925 as a memorial to a son who died April 26, 1922. The Foundation offers Fellowships to further the development of scholars and artists by assisting them to engage in research in any field of knowledge and creation in any of the arts, under the freest possible conditions and irrespective of race, color, or creed.

Lower Manhattan Cultural Council
www.lmcc.net
Lower Manhattan Cultural Council (LMCC), a 501(c)(3) nonprofit, has been a leading voice for arts and culture downtown and throughout New York City for over thirty-five years, producing cultural events and promoting the arts through grants, services, advocacy, and cultural development programs. Lower Manhattan Cultural Council is dedicated to making Manhattan a thriving center of arts activity with relevance to the arts community worldwide. It does this through a range of grants, cultural programs, and advocacy.

The National Art Education Association
www.naea-reston.org
Founded in 1947, The National Art Education Association is the leading professional membership organization exclusively for visual arts educators. Members include elementary, middle and high school art teachers, college and university professors and researchers, administrators and supervisors, museum educators and artists as well as more than 45,000 students who are members of the National Art Honor Society or are university students preparing to be art educators.

The National Council on Education for the Ceramic Arts
nceca.net/
NCECA is a not-for-profit educational organization that provides valuable resources and support for individuals, schools and organizations with an abiding interest in the ceramic arts. NCECA promotes and improves the

Index

ceramic arts through education, community building, research, and creative inspiration.

National Endowment for the Arts
www.nea.gov
The National Endowment for the Arts was established by Congress in 1965 as an independent agency of the federal government to advance artistic excellence, creativity, and innovation for the benefit of individuals and communities.

NYFA
www.nyfa.org
The New York Foundation for the Arts' mission is to empower artists at critical stages in their creative lives. NYFA's *Jobs in the Arts* is an online source for jobs and internships in the arts, culture, and museum industries nationwide. NYFA Source is a free, searchable online database of funding and other resources. NYFA Current is an online magazine within the larger organization's Web site and contains interesting articles and news on current trends.

Volunteer Lawyers for the Arts
www.vlany.org
VLA delivers legal services and legal information to more than ten thousand members of the arts community each year. VLA plays an important role in educating individual artists, arts professionals within arts and cultural institutions, attorneys, students, and the general public about legal and business issues that affect artistic and creative endeavors.

Women's Caucus for Art (WCA) National Chapter
www.nationalwca.com
The mission of the Women's Caucus for Art is to create community through art, education, and social activism

About the Authors

Angie Wojak is the director of career services at Parsons The New School for Design. Trained as a painter and printmaker, she earned her MFA from the University of Missouri and her BFA in Illustration from the School of Visual Arts. Before joining Parsons, Angie was a lecturer at the Museum of Modern Art, where she developed content for school tours. The author of *Spark Your Career in Fashion*, she has lectured on art and design career topics at universities and conferences across the country, including Comic-Con International, Harvard University, Massachusetts College of Art and Design, and Pratt Institute. A member of the Alliance for Sustainable Arts Professional Practices (ASAPP), she lives in New York City.

Stacy Miller has her Ed.D. from Teachers College Columbia University and currently teaches in the photography department at Parsons The New School for Design. Formerly the director of research and professional development at the College Art Association, she earned her MA in Museum Leadership at Bank Street College of Education in New York City and her BFA in sculpture and media studies at Massachusetts College of Art in Boston. A member of the Alliance for Sustainable Arts Professional Practices (ASAPP), she is a practicing artist with an alternative mindset and lives with her artist husband and three rescue cats in New Rochelle, New York.

Books from Allworth Press

Allworth Press is an imprint of Skyhorse Publishing, Inc. Selected titles are listed below.

The Business of Being an Artist, Fourth Edition
by Daniel Grant (6 x 9, 408 pages, paperback, $27.50)

Legal Guide for the Visual Artist, Fifth Edition
by Tad Crawford (8 ½ x 11, 280 pages, paperback, $29.95)

Business and Legal Forms for Fine Artists, Third Edition
by Tad Crawford (8 ½ x 11, 176 pages, paperback, $24.95)

Art Without Compromise
by Wendy Richmond (6 x 9, 256 pages, paperback, $24.95)

Artist's Guide to Public Art: How to Find and Win Commissions
by Lynn Basa (6 x 9, 256 pages, paperback, $19.95)

Selling Art Without Galleries: Toward Making a Living From Your Art
by Daniel Grant (6 x 9, 288 pages, paperback, $24.95)

Fine Art Publicity: The Complete Guide for Galleries and Artists, Second Edition
by Susan Abbott (6 x 9, 192 pages, paperback, $19.95)

How to Start and Run a Commercial Art Gallery
by Edward Winkleman (6 x 9, 256 pages, paperback, $24.95)

The Artist-Gallery Partnership, Third Edition: A Practical Guide to Consigning Art
by Tad Crawford and Susan Mellon (6 x 9, 224 pages, paperback, $19.95)

The Artist's Complete Health and Safety Guide, Third Edition
by Monona Rossol (6 x 9, 416 pages, paperback, $24.95)

Learning by Heart
by Corita Kent and Jan Steward (6 7/8 x 9, 232 pages, paperback, $24.95)

The Quotable Artist
by Peggy Hadden (7 ½ x 7 ½, 224 pages, paperback, $16.95)

Guide to Getting Arts Grants
by Ellen Liberatori (6 x 9, 272 pages, paperback, $19.95)

Caring for Your Art: A Guide for Artists, Collectors, Galleries, and Art Institutions
by Jill Snyder (6 x 9, 192 pages, paperback, $19.95)

Artists Communities: A Directory of Residences that Offer Time and Space for Creativity
by Alliance of Artists Communities (6 x 9, 336 pages, paperback, $24.95)

To see our complete catalog on the World Wide Web, or to order online, please visit *www.allworth.com*.